GIMP 2.8 for Photographers

Image Editing with Open Source Software

GIMP 2.8 for Photographers

Image Editing with Open Source Software

rockynook

Klaus Goelker, klaus@goelker.com

Editor: Gerhard Rossbach

Copyeditor: Beth Bernstein/Judy Flynn

Proofreader: Aimee Baldridge Translator: Jeremy Cloot Layout: Jan Martí, Command Z

Cover Design: Helmut Kraus, www.exclam.de

Printer: Everbest Printed in China

ISBN 978-1-937538-26-2 1st Edition 2013 © 2013 by Klaus Goelker

Rocky Nook Inc. 802 East Cota St., 3rd Floor Santa Barbara, CA 93103 www.rockynook.com

Copyright © 2012 by dpunkt.verlag GmbH, Heidelberg, Germany.

Title of the German original: Fotobearbeitung und Bildgestaltung mit GIMP 2.8

ISBN 978-3-89864-766-3

Translation Copyright © 2013 by Rocky Nook. All rights reserved.

Library of Congress Cataloging-in-Publication Data

Goelker, Klaus.

[Fotobearbeitung und Bildgestaltung mit GIMP 2.8]

Gimp 2.8 for photographers: image editing with open source software / by Klaus Goelker. -- 1st edition. pages cm

ISBN 978-1-937538-26-2 (pbk.)

1. GIMP (Computer file) 2. Photography--Digital techniques. 3. Image processing--Digital techniques. I. Title. TR267.5.G56G644413 2013 770.28553--dc23

2012047191

Distributed by O'Reilly Media 1005 Gravenstein Highway North Sebastopol, CA 95472

All rights reserved. No part of the material protected by this copyright notice may be reproduced or utilized in any form, electronic or mechanical, including photocopying, recording, or by any information storage and retrieval system, without written permission of the publisher.

Many of the designations in this book used by manufacturers and sellers to distinguish their products are claimed as trademarks of their respective companies. Where those designations appear in this book, and Rocky Nook was aware of a trademark claim, the designations have been printed in caps or initial caps. All product names and services identified throughout this book are used in editorial fashion only and for the benefit of such companies with no intention of infringement of the trademark. They are not intended to convey endorsement or other affiliation with this book.

While reasonable care has been exercised in the preparation of this book, the publisher and author(s) assume no responsibility for errors or omissions, or for damages resulting from the use of the information contained herein or from the use of the discs or programs that may accompany it.

This book is printed on acid-free paper.

Table of Contents

Chapter 1

	Basic	s3
1.1	Preface	e4
1.2	Introdu	uction
	1.2.1	Using GIMP 2.8—About This Book5
	1.2.2	About GIMP 2.86
	1.2.3	Overview of the Most Important Improvements and Changes in GIMP 2.8
1.3	Introdu	action to Digital Image Editing9
	1.3.1	Characteristics of Pixel Images
	1.3.2	Resolution
	1.3.3	Screen Colors—Color Models and GEGL, the
		New Graphics Library12
	1.3.4	Important File Formats for Practical Work
1.4	Loadin	g and Managing Digital Photos on the Computer 20
	1.4.1	Using the Operating System's File Management Tools to Import Images from a Camera
	1.4.2	Using Wizards to Import Images23
	1.4.3	Using the Operating System's File Management to Organize Photo Collections
	1.4.4	Helpers: Image Management Programs for Windows, Linux, and Mac OS X
	1.4.5	Converting Camera RAW Image Formats under Windows, Mac OS X, and Linux: Freeware and Plug-Ins

1.5	Get GII	MP Running31
	1.5.1	Where Can I Get GIMP?31
	1.5.2	Installing GIMP and Plug-Ins
	1.5.3	Is GIMP Insecure? Some Comments and Tips39
	1.5.4	The GIMP's Program Windows
	1.5.5	Using and Customizing the Program Interface— Important Menus
	1.5.6	Real Help—GIMP's Help Function
Cha	pter 2	
	-	GIMP: Correcting and Touching Up
	-	Images59
	1001	agc
2.1	Workin	ng with GIMP: Image Adjustment and Retouching60
	2.1.1	Opening, Setting, and Storing an Image: The Steps60
	2.1.2	Opening an Image
	2.1.3	The Image Window—Your Workspace
	2.1.4	Rotating an Image by Fixed Values68
	2.1.5	Changing the Image View Size (Zooming)69
	2.1.6	Cropping (Clipping) an Image72
	2.1.7	Setting the Image Size and Resolution74
	2.1.8	Scaling the Print Size of Images— Converting Resolution and Size
	2.1.9	Saving Your Image
	2.1.10	Before Printing—Calibrating Monitors
	2.1.10	and Color Management83
	2.1.11	Printing Images

2.2	Work	ng with Scanned Images89
	2.2.1	Prerequisites for Scanning89
	2.2.2	How Scanners Work90
	2.2.3	Problems When Scanning Printed Originals—
		the Moiré Effect91
	2.2.4	Calculations to Consider before Scanning91
	2.2.5	Scanning and Editing an Image94
	2.2.6	Typical Errors in Scanned Images
	2.2.7	Setting the Image and Determining the Angle—Measuring 98
	2.2.8	Rotating an Image—Using the Rotate Tool
	2.2.9	Cropping an Image—the Crop Tool100
	2.2.10	Using the Gaussian Blur Filter to Remove the Moiré Effect101
2.3	Adjus	ting and Improving Color and Exposure 103
	2.3.1	Levels (Tonality Correction)103
	2.3.2	Curves
	2.3.3	Adjusting Hue and Saturation112
	2.3.4	Overview of the Functions in the Image > Colors Menu 114
	2.3.5	Saving an Image in Compressed Format (JPG/JPEG)
		for the Internet116
2.4	Touc	nup Work 1—Color Casts
	2.4.1	What Is Touchup Work?120
	2.4.2	Color Correction Options121
	2.4.3	Using the Levels Function to Correct Color Casts
	2.4.4	A Second Method of Removing Color Casts—
		Color Balance

2.5	Touch	nup Work 2—Removing Spots, Dust,
	and S	cratches
	2.5.1	Why You Need Smooth Brushes—the Clone Tool127
	2.5.2	Creating New Brush Pointers in GIMP and Importing Adobe Photoshop Brushes
	2.5.3	Selecting the Clone Tool Options
	2.5.4	Using the Clone Tool for Touchup Work
	2.5.5	The Healing Tool136
2.6	Perfo	rming Magic—Editing Photographs with
	Grapl	nic Filters
	2.6.1	Sharpening Images and Image Elements
	2.6.2	Noise Reduction and "Smoothening" Images141
	2.6.3	Simulating Film Grain—Covering Up Blemishes with
		Noise and Pixels148
Chap	oter 3	
	Using	g Masks and Layers—Painting, Filling,
	and (Color Tools
3.1	Intro	duction to Masks and Selections
	3.1.1	Overview of Select Tools in the Toolbox157
	3.1.2	Tips for Handling Select Tools158
	3.1.3	The Select Menu
	3.1.4	The Edit Menu161
3.2	Touch	nup Work 3—Removing Red Eyes
	3.2.1	Avoiding Red Eye—Using the Flash Correctly
	3.2.2	Eliminating the Red-Eye Effect

3.3	Intro	duction to Working with Layers		
	3.3.1	The Layers Dialog168		
	3.3.2	The Context Menu in the Layers Dialog170		
	3.3.3	Background or Layer with an Alpha Channel		
	3.3.4	Working with Several Images—		
		Inserting Layers from Another Image		
3.4	Toucl	nup Work 4—Correcting Overexposed or		
	Unde	erexposed Images		
	3.4.1	The Mode Settings in the Layers Dialog174		
	3.4.2	Editing Overexposed Images174		
	3.4.3	Editing Underexposed Images		
3.5	Toucl	nup Work 5—Using Perspective Correction to		
	Remove Converging Verticals			
	3.5.1	Trying to Avoid Converging Verticals When Taking Shots 177		
	3.5.2	Steps Involved and Description of Work		
	3.5.3	Removing Converging Verticals from an Image178		
	3.5.4	Removing Lens Distortion, Making Perspective Corrections, and Reducing Vignetting		
	3.5.5	The Perspective Clone Tool		
3.6	Touc	hup Work 6—Freshening Up a "Dull Sky" 188		
	3.6.1	Steps Involved and Description of Work		
	3.6.2	Step 1: Selecting an Area by Color, Deleting It, and Replacing It with Color Fill		
	3.6.3	Step 2: Creating and Positioning an Image Object on a New Layer		
	3.6.4	Step 3: Creating a Multicolor Sky— the Blend Tool		
	3.6.5	Step 4: Adding a New Object or Layer (Sky) to an Image		

3.7	Typin	g in GIMP—Adding Text to an Image 211
	3.7.1	Introduction to Fonts211
	3.7.2	Typing in GIMP—the Text Tool212
	3.7.3	Typing Text and Defining the Text Attributes
	3.7.4	Creating Three-Dimensional Text and a Drop Shadow
3.8	Creati	ng Your Own Image Frames and Vignettes 220
	3.8.1	Single-Color Image Frames220
	3.8.2	Creating a Frame with a Pattern223
	3.8.3	Vignettes for Images
3.9	Creati	ng and Editing Image Elements—Lighting Effects
	and S	hadow Layers226
	3.9.1	Overview of Step 1—Creating a New Image
		and New Image Objects226
	3.9.2	Creating a New Image227
	3.9.3	Transforming a Selection228
	3.9.4	Using the Paintbrush Tool to Create Lighting
		and Shadow Effects: Glazing Technique
	3.9.5	Inserting and Duplicating Layers and Layer Groups230
	3.9.6	Changing the Color of an Image Object—
		the Hue-Saturation Function232
3 10	Evtra	cting Image Objects with Select
5.10		Masking Tools 234
		The Polygon Lasso and Intelligent Scissors Select Tools
	3.10.2	Extracting a Wine Glass with the Polygon Lasso234
	3.10.3	Creating a Selection with the Polygon Lasso,
		FOHOWING & CONTOUR 135

3.11	11 Using the Paths Tool to Create Vector Forms		
	and S	elections—Using Filters for Light Effects 239	
	3.11.1	Copying a Wine Glass and Creating a	
		Drop Shadow—Overview of the Steps Involved239	
	3.11.2	Creating and Editing a Path—the Design Editing Mode 240	
	3.11.3	The Path Editing Mode241	
	3.11.4	The Paths Dialog243	
	3.11.5	Transforming Paths—the Shear Tool243	
	3.11.6	Creating Lighting Effects with Brushes and Filters246	
	3.11.7	Paths and Text	
3.12	Aligni	ing Images—the Alignment Tool	
3 13	The C	age Transform Tool	
5.15	1110	age (14)(3)(1)(1) (2)	
2 1 4		Fedition with Medicard Color (1997)	
3.14		-Fading with Masks and Selections 258	
	3.14.1	Cross-Fading Part 1—Cross-Fading Two Images with Two Different Motifs	
	3.14.2	The Canvas and Canvas Size261	
	3.14.3	Cross-Fading Part 2—Assembling Panoramic Images262	
	3.14.4	Programs for Creating Panoramas Automatically267	
3.15	Comp	posites—Using Masks and Selections to	
	Cut ar	nd Paste Image Objects	
	3.15.1	Copying an Image Object with the Help of a Selection	
		and Inserting It into Another Image—the Procedure	
	3.15.2	The Mode Options in the Layers Dialog	
	3.15.3	The Foreground Select Tool— Extracting Images	
		Automatically271	
	3.15.4	Drawing a Mask Using Paint Tools with Various	
		Edge Attributes278	

3.16	GIMP	and HDR
	3.16.1	What Is HDR?
	3.16.2	HDR Software
	3.16.3	Cross-Fading Part 3—Merging Images into
		One Pseudo HDR
	3.16.4	A Short Introduction to Working with Layer Masks 289
Chap	ter 4	
	Work	ing with Black-and-White
	and C	Color Images
4.1	Conve	erting Color Images Partly or Entirely into
	Grays	cale Images 296
	4.1.1	Hints for Working in Grayscale and RGB Modes296
	4.1.2	Removing Color Partly or Entirely297
	4.1.3	Developing Black-and-White Images with the Channel Mixer
	4.1.4	The Graphical Library GEGL—Developing Black-and-White
		Images with GEGL Operations
	4.1.5	Converting Images into Black-and-White Graphics
	4.1.6	Graphic Effects with Gray Levels—an Example
	4.1.7	Partial Desaturation
	4.1.8	Infrared Effects
4.2	Touch	ning Up Black-and-White Images—
	Levels	s, Brightness, Contrast
4.3	Extrac	cting Hair from the Background—a Tricky Task 311
	4.3.1	The Threshold Function
	4.3.2	Using the Threshold Function to Extract Hair—the Task 312
	4.3.3	Using Channels to Extract an Object from the Background315

4.4	Color	ing Grayscale Images
	4.4.1	Using the Colorize Function to Color an Image
	4.4.2	Using the Levels Function to Color an Image
	4.4.3	Using the Curves Function to Color an Image with One or More Colors
	4.4.4	Using the Colorify Filter to Color an Image
	4.4.5	Using Transparency and the Colorize Filter to Color Image Areas by Brightness
	4.4.6	Using the Sample Colorize Function to Color an Image
	4.4.7	Using Filters to Color and Bleach an Image
4.5	"Hand	d-Colored" Images from
	Black	and-White Photos

Chap	Chapter 5		
	Work	ing with Other File Formats 337	
5.1	Open	ing and Processing RAW-Format	
	"Digit	al Negatives" 338	
	5.1.1	Capturing and Processing RAW Image Files	
	5.1.2	GIMP and UFRaw	
	5.1.3	Working with UFRaw341	
	5.1.4	Features and Elements of UFRaw's Main Window343	
	5.1.5	RawTherapee for Developing RAW Images	
5.2	Using	the PDF Format to Share Print Layouts 364	
	5.2.1	Opening PDF Files in GIMP	
	5.2.2	Using GIMP to Create PDFs	
	5.2.3	Free Alternative PDF Creation and Viewing Software	
5.3	PSD F	iles	
	5.3.1	Opening Adobe PSD Files in GIMP	
	5.3.2	PSD Files Exported from GIMP and Opened in Photoshop369	

Appe	endix
A.1	The IWarp Filter— a Closing Comment 372
A.2	So Far, So Good—How to Proceed from Here: Tips and References
A.3	The Future of GIMP
	A.3.1 Downloading and Installing Developer's Versions of GIMP
A.4	Thank You!
A.5	Further Reading on GIMP: References 375
A.6	What's on the DVD
A.7	Native GIMP File Formats
Inde	x 381

1.1 Preface

good seven years have passed since the first publication of my book *GIMP 2 for Photographers*. In the meantime, GIMP 2.8 has become available. The latest version includes several important changes and a new single-window operating mode. In addition, the *Text* tool has been significantly improved and the new *Cage Transform* tool enables you to transform individually selected parts of an image. Layers can now be grouped, and the painting and drawing tools have been given a range of new settings and functions. An overview of these changes is included in section 1.2.3.

The program's switch to the GEGL library is nearly finished and some GEGL-based functions are already available, although the developers are only now beginning to create tools that allow processing using the greater color depth that GEGL allows. The option to use the CMYK color palette for four-color printing will also become available; however, full integration of these functions won't exist until the next one or two versions.

This new edition of my book offers you a complete introduction to image editing with GIMP. I explain the interface and functions of the latest version, and I've added new chapters that demonstrate various processing techniques, including simulation of black-and-white and color infrared images. Everything is illustrated in detail, including compatible programs and plug-ins.

The additions and updates in GIMP 2.8 offer you an even better opportunity to master the enormous possibilities of digital image editing. I wish you lots of fun learning these new techniques and putting your own ideas into action.

Klaus Goelker

1.2 Introduction

1.2.1 Using GIMP 2.8—About This Book

If you are reading this book, you are probably interested in learning how to touch up your digital photographs or create your own graphics or logos. However, before investing hundreds of dollars in expensive software, you may want to make sure that manipulating digital photographs is something you truly enjoy. That's where GIMP 2.8, a free digital image editing program, comes in: you can learn to improve your photographs with this free software.

This book is designed to facilitate your entry into the world of digital image editing with the help of GIMP 2.8. Using hands-on examples, this book provides solutions to common problems encountered when editing digital images. The instructions are structured in a step-by-step fashion. Each editing tool and function of GIMP 2.8 is explained in simple language. You will learn the fundamentals of digital editing, familiarize yourself with common image editing tools and their functions, and acquire a working knowledge of the GIMP 2.8 program.

This book is not a reference guide for GIMP 2.8. It was created to provide a set of "learning-by-doing" instructions that explain how GIMP works, what the program's most important functions are, and how to easily locate and use those tools.

Since GIMP was born of the Linux world, it is free. GIMP 2.8, along with several plug-ins (add-ons) for the application, are on the DVD that accompanies this book. You'll also find copies of the sample images used in the exercises contained in this book.

Digital image editing programs often seem more complex than the more common software programs, such as word processors. Sometimes you must perform a number of preparatory steps before you can see a result on the computer screen. However, if you're experienced with computers, certain commands should be familiar to you.

With the exception of the installation process, GIMP works essentially the same way in Windows, Linux or a Mac OS. If you have a Mac, your screen might look somewhat different than the pictures in the book, but the windows, buttons, and menus are named the same and are in the same places. GIMP is often distributed with Linux. If you use Windows or Mac OS, you will have to install the program. This book will show you how.

Once you have explored GIMP and learned to use it, you may not want to buy another image editing program. If you do decide to use another program, you will have to familiarize yourself with a new interface. However, the basic commands, functions, and tools of alternative digital imaging programs are similar to those of GIMP 2.8.

GIMP 2.8 also contains a built-in help system. In addition, there are many books about the software, including several free online texts. Please refer to this book's appendix for a list of references regarding GIMP.

1.2.2 About GIMP 2.8

GIMP is an acronym for **GNU Image Manipulation Program**. GIMP was bred from the Linux world and is an open-source software program covered by the **General Public License (GPL)**. **GNU** stands for "GNU's Not UNIX" and refers to a collection of software based on the UNIX operating system and maintained by the Free Software Foundation.

GIMP is the Photoshop of the Linux world—it is *the* best free image editing program. GIMP 2.8 was introduced in May 2012. This enhanced version of GIMP meets the functionality requirements of even the most exacting digital photographer. Once you know your way around, the interface is highly efficient and easy to use.

This book was created using the development version 2.7.3 and the first and second stable versions (2.8.0 and 2.8.2) released in May and August 2012.

Image Editing

GIMP's primary function is to create and edit pixel or bitmap images, but it also can be used for other tasks. The program will help you touch up your digital photographs, create digital art, or design a new logo for your company's web page. And that's just the tip of the iceberg.

Vector graphics programs are often used to create original or complex images and animations. GIMP supports some basic vector graphic features. You can draw an image with the Gfig plug-in and the *Path* tool. However, you should be aware that GIMP was not designed to be a dedicated environment for creating and editing complex vector diagrams.

Video Editing

GAP stands for GIMP Animation Package, and with it GIMP offers a range of useful tools for creating small animations on a frame-by-frame basis. For example, you can use GIMP's GAP package to read or write AVI- and GIF-formatted videos and animations. You can also use GAP to open and read videos in MPEG format.

1.2.3 Overview of the Most Important Improvements and Changes in GIMP 2.8

 Single-window mode: Alongside the usual multi-window image-plustools view, GIMP now offers single-window mode, which shows all active tools and the current image in a single window (see section 1.5.5).

Figure 1.1
GIMP in single-window mode

- In multi-window mode, minimizing GIMP also minimizes the tool windows.
- Multi-column dock windows: Docked dialogs can now be arranged next to as well as below one another.
- Docking bars are no longer shown within dockable dialogs, giving the user more monitor real estate.
- The tool preference sliders have be redesigned. Brush tools have been given new setting options, and size parameters can now be defined and entered in terms of pixels.

• The *Text* tool can now write directly into the active image (on-canvas text editing) instead of via the separate *Text Editor* window, allowing you to give individual words and letters within a text block their own attributes. Settings can be made directly in the window's menu bar. Text itself remains vector-based and can be edited, corrected, and extended at any time (see section 3.7.2).

Figure 1.2
The new GIMP Text tool

- The new *Cage Transform* tool enables you to directly transform, scale, and distort selected image areas (see section 3.13).
- New save and export options: The Save and Save As commands now save images exclusively in GIMP's own XCF file format. In order to save to other formats, you have to use the separate Export and Export To commands. This means that the warnings you are used to (see section 2.1.9) are no longer relevant. GIMP 2.8 also includes an Export to PDF option (see section 5.2.2).
- New functionality enables you to take screenshots of an entire web page (File > Create > From Website).
- Layer groups: Layers can now be grouped, and groups can be grouped too. Groups can be shifted or copied as one and can be merged to a single layer (see section 3.9.5).
- Under Edit > Preferences > Toolbox, you can now select the tools that you
 want to show in the Toolbox, including the Color Tools and Colors options
 from the Tools menu.
- **Brush dynamics**: Brushes are now rotatable and the dynamics engine has been considerably expanded. Brush attributes can be individually defined or selected from a range of presets (see section 2.5.2).
- Size entries can now be calculated with basic math functions. For example, entering 200 + 200 + 50 in the size box in the *Scale* dialog automatically adds the entries to total 450 (see section 1.7).

- GIMP now displays an animated icon similar to the Windows hourglass to keep you informed of progress during long editing processes.
- The GIMP executables now include support for plug-ins written in Python, as well as display and editing of PostScript (PDF) files.
- · The implementation of GEGL is almost complete.

These are the most important changes and improvements. About 30 visible changes have been made in GIMP 2.8, and a lot more has changed under the hood.

1.3 Introduction to Digital Image Editing

1.3.1 Characteristics of Pixel Images

GIMP is used primarily for editing **pixel** or **bitmap** images. Pixel images are made up of tiny dots called pixels; these images are somewhat like mosaics in structure. All photographic images captured by a digital camera or copied by a scanner are pixel images. The pixel image is considered standard.

Figure 1.3
The image dots (pixels) become visible when a pixel image is greatly enlarged.

Pixel Vektor

Figure 1.4a-b
Comparing pixel and vector images

Size and resolution are the most important characteristics to take into account when manipulating pixel images. Since pixel images are composed of tiny dots, it can be tricky to enlarge them. If you overdo it, the individual dots will become visible and the photograph will lose its integrity.

The size and resolution of an image determine its file size (i.e., storage volume measured in kilobytes or megabytes). Uncompressed pixel images normally have very large file sizes.

The manner in which you can edit an image is influenced by the structure of its pixels. Basically, each image dot can be edited in terms of brightness and color. GIMP 2.8 supplies appropriate and easy-to-use tools for editing single dots as well as groups of dots.

When you make a general change to a pixel image, the whole image will usually be affected. If you wish to manipulate only a specific area of an image, you should use a selection tool to designate that area. You may even want to cut a desired selection from the image so you can work with layers (transparent layers containing distinct image objects that can be manipulated separately and are layered one on top of the other).

Selections, masks, and layers are advanced tools that are provided by image editing programs like GIMP for detail work. These topics will be dealt with extensively in the hands-on exercises that follow.

In contrast to pixel images, vector graphics are used when creating original graphics and logos. Rather than editing image pixels, you can use vectors to create novel image elements. Vector images are made up of lines, curves, circles, rectangles, and fills. The size of each of these elements can be scaled, and their contour can be filled with color or gradients. For graphics, this is less data intensive. Vector or contour shapes can also be selected and edited individually. At any time, you can tweak the shape or change the color of a fill. However, this requires another type of image editing program called a "vector graphics "program. For instance, Inkscape is the best-known free, open source vector graphics program (www.inkscape.org). Commercial programs for this type of graphics work are CorelDRAW and Adobe Illustrator.

You should know: Vector graphics are almost boundlessly scalable.

However: Editing vector graphics requires different techniques and specifications than editing pixel images.

Bottom line: Photos and other pixel images can be converted to vector graphics only in an extremely simplified form, and sometimes not at all.

Problems with Pixel Images

You can add text or graphic elements to pixel images. These are also displayed using pixels, but they have a problematic feature called "aliasing" that causes some edges to appear jagged. In text, for example, all but horizontal and vertical edges of letters appear serrated. Anti-aliasing is a countermeasure used to smooth the edges of pixelated letters. Anti-aliasing adds pixels at the edges of a letter. The pixels have the same color as the original text but use an opacity gradient to fade toward complete transparency, thus providing smooth transitions between the text and the background. The edges of the letters lose definition and appear smoother (figure 1.5d).

You can smooth the edges of pixelated graphic elements by choosing the feathered edges. Feathered edges of selections will be dealt with in great detail later in the book.

1.3.2 Resolution

Pixel images are rectangular images made up of little squares made up of image dots, or pixels. The density of the dots contained in any given pixel image is called its "resolution." Resolution is normally measured in **dots per inch (dpi)** or the **ppi (pixels per inch)** units that are commonly used for digital photographic applications. GIMP uses the term "pixels–in" as well as the more common "ppi."

An image's size (the dimension in inches, millimeters, or pixels) is directly dependent on its resolution. If you transform an image with a resolution of 300 dpi to a resolution of 72 dpi using GIMP, the image size (width x height) increases more than fourfold, even though without interpolation the number of image dots remains the same.

It's generally recommended to scan images at 300 dpi, especially if you intend to edit and print the image at a 1:1 scale.

If you want to enlarge an image, scan it at a higher resolution. As a rule of thumb, if you plan to double the image size (width or height), scan at four times the resolution desired for the final image. However, if you simply want to reduce an image's dimensions, the visible image quality will usually stay the same or improve. Scaling the image back up will result in a lower-quality image, because the downsizing procedure with recalculation of the pixels reduces the absolute amount of image data.

ABC AB ABC

Figure 1.5a-d
Text without and with anti-aliasing

Four-color printing uses various standard resolutions (e.g., 150, 300, 600, or 1200 dpi). These are indicative values.

Images on the **Internet** often use lower resolutions, mostly 72 or 96 dpi, values that correspond to the standard resolution of computer monitors. A low resolution keeps the file sizes of images small enough for the images to be efficiently and quickly transmitted over the Internet. Low-resolution images will still yield good-quality printouts on inkjet printers.

Bottom line: A higher resolution (i.e., higher density of finer dots) will result in an excellent image that can be enlarged to a certain extent without compromising quality. On the other hand, if you reduce the resolution of an image without reducing its dimensions, the image quality will drop. It is important to make a copy of the original image when experimenting with size and resolution because the process cannot be reversed.

1.3.3 Screen Colors—Color Models and GEGL, the New Graphics Library

GIMP's version 2.8 employs three color models: RGB (red, green, blue), grayscale, and indexed.

GIMP uses the **RGB colors**, or colors of light, as its default. Together, these colors form what is known as the **additive color model**. It uses the three primary colors—red, green, and blue—to create a color spectrum containing approximately 16.78 million colors. This is called "true color" because it represents the maximum number of colors that a computer monitor or television screen can display.

Mixing two primary colors in RGB mode will result in the creation of a secondary color, such as yellow, cyan, or magenta. Having no color (or the absence of light) creates black, while the sum of all colors is white.

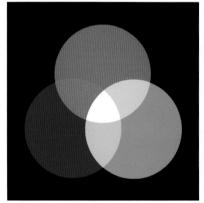

Figure 1.6 The RGB color model

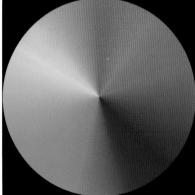

Figure 1.7
The color spectrum of the RGB color model

Figure 1.8
Approximate representation of the set of colors in the RGB color model.
Approximately 16.8 million colors are represented, including gray levels, black, and white.

Figure 1.9There are 256 gray levels in the RGB color model.

If you wish to specify a color for a printer or choose a unique background color for your web page, you should consider the following information:

Specific colors correlate to unique numerical values. In the RGB color model, each of the primary colors (red, green, and blue) has a decimal color value ranging from 0 to 255, with black as 0 and white as 255. Hence, there are 256 color values for each of the base colors of red, green, and blue. The total number of potentially resulting colors is calculated by the following multiplication:

256 x 256 x 256 = 16,777,216 colors

To specify the number of colors of an image or color model, I use the term **color depth**, which is specified in bits. The RGB color model has a color depth of 24 bits (24- bits = 2 to the power of 24 colors = 16.78 million colors).

These values apply to both color and black-and-white images. In the world of digital image editing, black-and-white photographs are called **grayscale images**. In addition to the black and white "colors," grayscale images contain all possible shades of neutral gray.

Since the color values of the three primary colors must be identical in order to produce purely gray levels, the number of gray "color" values amounts to 256.

Grayscale images have a color depth of 8 bits.

In the RGB color model, the colors are normally defined in **decimal numbers**. As mentioned earlier, each single color can have a value between 0 and 255. You can use the eyedropper icon located in the *Toolbox* of GIMP to open the *Color Picker* to measure a color. The *Color Picker* will show you the number corresponding to a color's exact value so you can easily transmit the information to your colleagues.

Color			Francisco de la companya del companya del companya de la companya
Black	0	0	0
Red	255	0	0
Green	0	255	0
Blue	0	0	255
Yellow	255	255	0
Cyan	0	255	255
Magenta	255	0	255
Medium gray	128	128	128
White	255	255	255

The primary and secondary (mixed) colors in decimal notation

If you want to appropriate a color from an existing image as the background color for a web page, you will need to specify **hexadecimal numbers** (base 16). Convert the decimal numbers (see above) into hexadecimal numbers, which are simply denoted by adding a # symbol in front of the number. You can use any tool for this conversion, including the Windows Calculator (*Start > Programs > Accessories > Calculator > View > Scientific*).

GIMP conveniently performs this conversion for you. Its *Color Picker* tool will provide you with the hexadecimal number value for every color.

Indexed Colors

Many image file formats used on the Internet employ indexed colors rather than RGB. Indexed color images don't save the color values in the pixels themselves, but correlate them with a defined color palette. The number of colors in this indexed color palette is limited to 256. Indexed images are usually smaller than RGB images because they possess a color depth of 8 bits instead of 24 bits. When an image is converted to indexed color, a predefined color palette or a set of colors derived from the image itself will automatically be formulated. The palette can contain a maximum of 256 colors. File formats that automatically create images with their own color palettes include the compressed GIF format as well as the 8-bit PNG format. Indexed images can also include gray-level images (with a maximum of 256 shades of gray).

However, you may find using an indexed palette cumbersome because it won't allow you to access all of GIMP's editing options. Indexed images are normally edited in RGB mode. After editing, you can select the indexed palette and attach it to the image before saving and exporting the image in an appropriate format for use on the Internet.

Figure 1.10
The color palette of an image in indexed mode

The CMYK Color Model—Cyan, Magenta, Yellow, Key (Black)

Digital pre-press in **four-color printing** uses the **CMYK color model**. The CMYK model behaves quite differently from the RGB model. For one thing, CMYK has four color channels rather than three like RGB, so the nominal number of colors increases in CMYK. Nevertheless, the reproducible color *range* of CMYK is smaller than that of RGB. Thus, when you convert an image from RGB to CMYK, it may appear paler or darker or contain color shifts due to the loss of image information or the insertion of additional black. To avoid fading or darkening, edit your image in the RGB mode before converting it to CMYK mode. Also, conversions from one mode to another often cause changes, so you should avoid converting your images unless it is necessary.

Since the **CMYK color model** has four color channels, it possesses a total number of approximately 4.3 billion potential colors, which translates to a **color depth** of **32 bits**.

The colors of this model are subtractive primary colors. This means that the CMYK model behaves inversely to the RGB model. For example, if you apply the RGB model to CMYK, then 256 units of cyan, 256 units of magenta, and 256 units of yellow *should* produce black. However, what you will actually see is a dirty dark brown. To obtain real gray and black shades, you have to add black. CMYK is actually an initialism for Cyan, Magenta, Yellow, Key, where Key = Black.

GIMP does not currently have a feature for converting images and editing them directly in CMYK mode. However, it can produce the chromatic components necessary for use in four-color printing processes. If you want to edit in CMYK, you can use the *Image > Mode > Decompose* menu command to decompose your image into the four color channels. Each of these channels can then be saved, edited, and shared as separate images, which can be reintegrated prior to printing.

Alastair M. Robinson's plug-in **Separate+** offers a feature for color separation as well as additional features for soft proofing and duotone coloration. You can find information about the plug-in on the author's website www.blackfiveservices.co.uk/separate.shtml. The improved version can be found at registry.gimp.org/node/471 and on the DVD at the back of this book.

After the installation, you will be able to separate an image into the four color channels of the CMYK color model by using the menu command *Image* > *Separate*. The separate channels will be generated as layers in a new picture that can be retouched individually.

Note: Further information on plug-ins can be found in section 1.5.2. You can find the download addresses in the link list on the DVD. Most of the mentioned plug-ins are gathered there as installable files.

Figure 1.11
The basic colors provided by the CMYK color model are the primary mixed colors of the RGB model plus black. White represents the color of the paper.

1.3.4 Important File Formats for Practical Work

When saving an image, you should select a file format that corresponds to the requirements of the image as well as your stylistic intentions. This section will introduce you to the most commonly used file formats.

XCF: GIMP's Native File Format

GIMP's **XCF format** was created for the primary purpose of **saving images with layers**, but it can also be used to save images that aren't finished yet. The XCF format saves image layers by employing a lossless compression method. So the file size of an XCF-formatted image will be smaller than the file size of the same image saved in most other image file formats and about 30% smaller than if saved in the PSD format described below. XCF is the default GIMP file format, and the *File* > *Save* and *Save As* commands use this format only. To save an image in an alternative format, you have to use the *export* command.

Since overly large files are cumbersome and can be unmanageable, GIMP's native XCF format is the best choice for storing images with layers. The only drawback of GIMP's current version is that XCF files cannot be opened in another image editing program. If you want to export an XCF file into another program, you must first convert a copy of it into JPEG, PNG, or TIFF. If you plan to consistently use other programs in conjunction with GIMP 2.8, you should save copies of your images with layers in the PSD format.

XCF Characteristics

- 16.78 million colors, 24-bit color depth
- Alpha transparency (color gradient from transparent to opaque)
- Lossless compression
- Supports layers

PSD: Adobe Photoshop's Native File Format

PSD (PhotoShop Document) is the native file format of Adobe Photoshop, one of the most popular image editing programs. This file format is considered a defacto standard and can be used by almost all other image editing programs, including GIMP. Its a high-quality format that is frequently used to export images with layers.

The downside of saving images in PSD is that the files are often quite large because the format provides no compression options.

Since GIMP 2.4, Photoshop layer masks have been readable in the program, and GIMP can write in the PSD format. However, GIMP does not support some PSD formats, such as Smart Objects and Smart Filters (see section 5.3).

PSD Characteristics

- 16.78 million colors, 24-bit color depth
- Alpha transparency (opacity from transparent to opaque)
- Supports layers

PNG: Portable Network Graphics

The PNG format is capable of preserving the transparencies of an image with full 24-bit color depth. Moreover, it uses a lossless high compression method that considerably reduces the image file size.

The PNG format is also suitable for Internet use.

PNG Characteristics

- 256 or 16.78 million colors, 8- or 24-bit color depth
- Alpha transparency (opacity from transparent to opaque)
- · Lossless, settable compression
- Can be displayed by web browsers
- Interlaced (immediate display, layered refresh rate in web pages)

JPG/JPEG: Joint Photographic Experts Group

Photographs and photo-realistic images with a color depth of 24 bits can be efficiently compressed with the JPEG format, which reduces image files to a fraction of their original size. However, the compression method used by the JPEG format is not without loss. The image quality will suffer in correlation with the degree of the compression and the decrease in file size. The JPEG format was primarily developed as a way to quickly load photographs on the Internet. JPEG format should be avoided when archiving digital photographs. You should also refrain from repeatedly saving an image in the JPEG format because the quality of the image will drop with each subsequent save. To preserve the integrity of your images, use the PNG format to save and archive your images after you've finished editing them.

For exporting images in the JPEG format, GIMP offers a programmable compression option with a preview feature. This option will display the file size of the compressed photo prior to saving it.

JPG Characteristics

- 16.78 million colors, 24-bit color depth
- High but lossy compression, settable by the user
- Can be displayed by web browsers
- Progressive (faster) display on web pages, layered image refresh rate, comparable with the interlaced characteristic

GIF: Graphics Interchange Format

Unlike other file formats, the GIF format requires a color palette. This means that a maximum of 256 colors can be saved in conjunction with an image. GIMP can create these color palettes automatically, but there is a major drawback to doing so. Converting images with an original color depth of 24 bits (or more) to GIF will usually produce an unsatisfactory result.

However, if you save an image with 256 or fewer colors (such as a simple logo) to GIF, the GIF compression is lossless. In addition, GIF files allow you to save one transparent color as well as simple animations (animated GIF). The GIF format is often used to upload images to the Internet.

GIF Characteristics

- 2 to 256 colors, 8-bit color depth (at least one, possibly transparent, color)
- Lossless compression for images containing up to 256 colors
- Suitable for use on the Internet
- One color can be transparent
- Interlaced (immediate display, layered refresh rate in web pages)
- Animated GIF available

BMP: Windows Bitmap

Microsoft developed BMP, so it is supported by most Windows image editing programs and is a suitable format for image sharing between different programs. BMP has a color depth of 24 bits and the image resolution remains unchanged when exporting. However, because the size of BMP files is normally quite large, the format is not particularly suitable for the Internet.

BMP Characteristics

- 16.78 million colors, 24-bit color depth
- Not universally suitable for web use (for Microsoft Internet Explorer only)

TIF/TIFF: Tagged Image File Format

This is one of the oldest image file formats still in use. Almost all image editing programs can read and write a TIFF image, even if they're being run on different operating systems. For this reason, it is the best file format to use when sharing high-quality images without layers. The file format also allows you to save images in CMYK mode for the four-color printing process.

The TIFF format preserves all transparencies of an image with the full color depth of 24 bits. It uses a lossless, but not particularly high, compression method. With an adapted TIFF format, you may save images with 48-bit color depth (i.e., HDR images). The major drawback of using TIFF is that it doesn't support layers (except in Adobe Photoshop).

TIFF Characteristics

- 16.78 million colors, 24-bit color depth
- Alpha transparency (opacity from transparent to opaque)
- Lossless LZW compression
- Different settings for saving when used on IBM/Intel and Apple Macintosh PowerPC computers

DNG: Adobe's Digital Negative

Adobe's DNG format was developed to replace proprietary RAW files and create an open standard. It offers advantages in the long-term archiving of RAW files and provides photographers with a certain amount of freedom from the camera's own software. GIMP'S plug-in UFRaw can work with DNG and most cameras' RAW formats. Several camera manufacturers have implemented this format to save images in their cameras.

PDF: Portable Document Format

Adobe's PDF is a platform-independent format that enables you to share text and image data that is formatted for print. Where possible, all image and text data is vectorized and the original typeface is embedded. The format's ability to save and share 24-bit color data makes it ideal for pre-press and print applications.

GIMP can open existing PDFs and export data to the PDF format.

1.4 Loading and Managing Digital Photos on the Computer

Before you can edit a digital image, you must import it from your camera, memory card, or scanner to your computer.

Images should be imported to and stored in the format they were shot in, especially if your camera supplies a RAW format known as Digital Negative (DNG). Even if your camera can only save images in JPEG format, you should archive the image files in their initial capture quality so that you can always access and reuse the original files, if needed.

1.4.1 Using the Operating System's File Management Tools to Import Images from a Camera

Your computer's operating system offers options to import images from the camera to the computer.

If you use the Windows platform, your computer probably came with an appropriate USB driver. You may also have received a USB driver along with your camera (typically on a CD packaged with it). However, if you do not have a driver, you can usually find one to download on your camera manufacturer's website. Windows Vista and Windows 7 automatically recognize most devices and install the appropriate drivers.

Figure 1.12
Windows (here
Windows 7) offers
a wizard to import
images from a
camera.

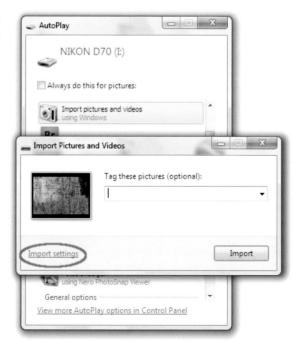

Once you have connected the camera to the computer via the USB port, the operating system will recognize it as a removable storage medium—an additional drive. Simply copy the entire folder by dragging and dropping it to your computer. Once you copy the images to your computer, the viewing, selecting, and editing options offered by your operating system will become available. After you have copied the images to your computer, you can delete them from your camera's memory card.

Windows also provides a wizard to help you select images and assign file names as well as rotate and copy images. To use the wizard, you must install a special driver that functions as an image editing device particular to your camera. Special drivers are available for most camera models and will be downloaded automatically for XP and all later versions of Windows.

If you plug your camera into the USB port and your computer simply detects it as a removable storage medium, you can still use *Computer* or *File Manager* in Windows to select images or entire image folders and copy them onto your computer, as shown in the example in figure 1.13.

Figure 1.13
Windows detects the camera connected to the USB port as a removable storage device and shows it as a normal drive in *Computer*. As in a common file directory, you can view the folder contents and copy individual image files or the entire file contents onto your hard drive.

Under Windows Me or XP, you can also use *View > Movie* in Windows Explorer to see a preview of your images, turn them right side up, or rotate them 90 degrees. The Windows Photo Gallery offered for Windows Vista, Windows 7, and Windows 8 combines the tasks of importing images and managing files. In Windows, you can also use *Computer* or *Photos* to find and view your pictures and adjust the viewing options.

However: The *Quick View* function of Windows supports commonly used file formats, including JPEG, GIF, PNG, and TIFF. Either the codec for your camera's own RAW format is downloaded automatically by the operating system or you must download it from the manufacturer's website. The most common RAW codecs can be found on Microsoft's website: www.microsoft.com/prophoto/downloads/default.aspx.

Figure 1.14

The Windows Photo Gallery with the option to start the import wizard. The import wizard opens automatically when a digital camera or card reader is attached.

The digiKam and gPhoto programs support importing images under Linux. Even if these programs do not support your digital camera, you can load images directly from the memory card if you have a USB card reader. Linux normally uses USB-Storage to support popular USB card readers when reading data from a camera's memory card. Instead of using a cable to connect your camera to your computer, simply insert the camera's memory card into the card reader and copy the data to your hard disk; the process is similar to the one described for Windows.

You can find further information about these programs at the following locations:

www.digikam.org www.gphoto.org wiki.linuxquestions.org/wiki/Digital_Cameras_And_Linux www.gagme.com/greg/linux/usbcamera.php

1.4.2 Using Wizards to Import Images

Many digital camera manufacturers package their cameras with programs that import images and handle basic image management and image editing tasks, such as composing photo albums and slide shows, removing redeye, rotating and cropping images, and so on. In addition, these programs normally offer printing options.

When images are copied to the computer, folders are created and organized by default. However, if you prefer to create and organize your own folders, you can use the options provided by your operating system and do entirely without these programs. Be aware that in some events the installation of a packaged program may block the Windows import wizard.

• NOTE

The Photo Gallery is part of Windows Vista (Home Premium and Ultimate). For Windows 7 and Windows 8, it has to be downloaded and installed as one of the free programs in the Windows Essentials package. Under Windows Essentials, you can find free programs for your PC as well as some online web services for e-mail, chat, and more. You can download the programs from windows.microsoft.com/en-US/windows-live/essentials-home.

• NOTE

The Windows Quick View function doesn't support GIMP's XCF format or Adobe's PSD format. You can find the codec required for adding PSD support at www.ardfry.com/psd-codec. This problem does not occur with the previewing functions of Mac and Linux systems.

1.4.3 Using the Operating System's File Management to Organize Photo Collections

For managing, sorting, collecting, and renaming images, the options offered by all operating systems are usually sufficient. It is important to organize your collection with a logical system so that you can quickly locate images at a later date. You may want to consider the following criteria for the corresponding directories:

- Organizing images by topic (e.g., people: family, friends; and events: vacation, holidays)
- Organizing images by image theme (e.g., flowers, cities, landscapes, stills)
- Organizing images by date

Figure 1.15
In Windows 7, the Change your view menu button in Libraries > Pictures

Use the file management menu of your computer's operating system to create the directories. Then you can sort, rename, move, or copy your images.

Windows offers several **view options** to facilitate the representation of image files in folders. In Windows Vista and Windows 7, you can preview images as slideshows, thumbnails, or as small icons with descriptive text.

1.4.4 Helpers: Image Management Programs for Windows, Linux, and Mac OS X

If you need to comfortably manage large image collections, you can use an image viewer or image management program such as these for Windows:

- ACDSee (www.acdsee.com)
- ThumbsPlus (www.thumbsplus.com)
- CompuPic (www.photodex.com)
- IrfanView (free; www.irfanview.com)
- XnView (for Windows, Mac OS X and Linux; free; xnview.com)
- Google Picasa (free for Windows and Intel-based Macs; picasa.google.com)
- imgseek (photo collection manager for Windows, Mac OS X, and Linux; www.imgseek.net/desktop-version/download)
- ImageMagick (www.imagemagick.org)

The following programs are available for Linux:

- digiKam (for Linux, Mac OS X, and Windows; www.digikam.org)
- ImgSeek (for Linux, Mac OS X and Windows; www.imgseek.net/desktopversion/download)
- KuickShow (for Linux; kuickshow.sourceforge.net)
- XnView (for Linux, Mac OS X, and Windows; xnview.com)
- gThumb (for Linux; gthumb.sourceforge.net)

For additional information about Linux-based image viewing programs, visit linuxlinks.com/Software/Graphics/Viewers.

Figure 1.16
The open source digiKam package includes import and sorting functionality. Sorting is simplified by the various views available, such as the lightbox view shown here.

These programs allow you to **preview images** as well as manage and rename files. Some of them also contain a **file browser** similar to Windows Explorer so you can create new folders and copy images. Some offer a **batch processing** tool, which will enable you to rename an entire image series or create **screen slides**.

Most of these programs provide options for **image correction**, including tools for modifying and adjusting orientation, brightness, contrast, image size, and resolution.

In addition, these programs possess **printing options**, which allow you to output contact prints and image packages, or to print several images onto one page. If you use Windows, you'll find similar options when you launch the *Photo Printing Wizard*. In Windows XP, the wizard is located in the left window, under *Picture Tasks*. Just click *Print Pictures*. In Windows Vista and Windows 7, you will find similar options in the *Print* menu in the *Photo Gallery*.

These programs can also convert files to other formats. The more recent versions can read and convert camera RAW formats.

Particularly notable as image viewers and image management software are the free IrfanView and XnView, which offer the most options. IrfanView is

considered *the* image viewer for Windows because it can open and display nearly any image file or camera format currently in existence. XnView is equally interesting in that it is an image viewer and a comfortable image management tool.

You can find more details about what these programs can do for you if you visit the websites listed earlier in this section.

Mac OS X users can turn to the built-in **Image Capture** tool to import images and **Preview** to view them individually or as a slideshow. **iPhoto**, which used to be free, is a now a paid app.

Other free apps for sorting and viewing images on a Mac include:

Google Picasa (for Intel-based Macs only): picasa.google.com

Phoenix Slides: blyt.net/phxslides

XnView: www.xnview.de

Xee: wakaba.c3.cx/s/apps/xee

1.4.5 Converting Camera RAW Image Formats under Windows, Mac OS X, and Linux: Freeware and Plug-Ins

If your digital camera can capture images in a proprietary or RAW file format, you should use it. Taking photos as digital raw data will result in a higher-quality image after correction, particularly when compared to photos taken in the highest-quality JPEG format. Saving images in their native camera or RAW format will also ensure that you'll get the best possible quality when you archive the originals.

Since version 2.2.6, GIMP has supported RAW formats, so you can directly open and edit RAW formats with the program, although only at 24-bit color depth. Unfortunately, GIMP 2.8 dispenses with direct RAW support, and you will have to install the UFRaw plug-in if you want to use GIMP to process your RAW images.

RAW formats offer more than an optimal means of saving your photos. RAW also permits you to adjust the color and brightness settings, using the UFRaw plug-in with a color depth of 16 bits per color channel. If UFRaw is installed, GIMP loads RAW images directly and automatically uses UFRaw to process them before handing them back to GIMP for subsequent handling. This means, for example, that you can edit underexposed photos with more efficient options than those currently offered by GIMP with only 8 bits per channel. Thus, working with digital RAW images is called "developing" and refers primarily to adjusting color and brightness values, just as it does in analog photography. RAW formats are sometimes referred to as digital negatives.

The Unidentified Flying Raw (**UFRaw**) utility by Udi Fuchs and the **dcraw command-line program** by Dave Coffin are plug-ins that are available for Windows, Linux, and Mac OS X. They enable you to develop digital negatives with 16-bit color depth rather than in the lower quality offered by GIMP (8 bits per channel). You can edit color and brightness settings as well as white balance with UFRaw. It functions with its own dialog box before the image is passed on to GIMP for further editing. Once you've installed UFRaw, it can be used in three different ways: first, as an independent program that can edit and save digital negatives; second, when you open RAW images, UFRaw operates within GIMP; and third, to utilize **ufraw-batch**, a function that can convert several RAW files simultaneously.

You can download UFRaw for Windows, Mac OS X, and Linux on the following website: ufraw.sourceforge.net/Install.html. It is already included in the distributions of GIMP at sourceforge (sourceforge.net/projects/gimponosx) and those from GIMP on OS X (gimp.lisanet.de).

Installing GIMP 2.8 and UFRaw in Windows can be tricky, and following the steps described here will help you get up and running. Start the installation process by double-clicking the executable, then click the *Next* button on the splash screen to continue. Click the *Browse* button in the window that follows to find your GIMP directory. The path on my Windows 7 machine is *C:\Program Files\GIMP 2\32*, which is different from the default location used by the executable. Once you have entered the appropriate location, click *Next* to continue and select *bin* instead of *UFRaw* as the plug-in installation directory, then click *Next* again. The following dialog enables you to select the file formats that you want to open directly using UFRaw. If you don't plan to use any other RAW converters, leave all formats selected. Click *Next* to see a summary of the options you have selected and click *Install* to begin the installation.

After installing, UFRaw can be used both as an independent program and as a plug-in for GIMP. If you want to use UFRaw independently or as a GIMP plug-in, you must have GIMP already installed because GIMP's installation file contains the GIMP Tool Kit (GTK+). In order to function, UFRaw needs GTK+.

To conclude: UFRaw 0.18 is designed for use with GIMP 2.4 and 2.6. If you are using UFRaw 0.18 with GIMP 2.8, you will have to install it to the (non-default) C:\Program Files\GIMP 2\bin\ directory. At present, UFRaw only works with GIMP 2.8.0, not with version 2.8.2, but again with GIMP 2.8.4.

I am assuming that the default installation path will be appropriately adjusted in future versions of UFRaw.

In section 5.1 you will find a short introduction to editing digital negatives with UFRaw as a GIMP plug-in and handing them over to GIMP. Furthermore, you can find detailed instructions on how to use UFRaw on the following website: ufraw.sourceforge.net/Guide.html.

RawTherapee is another free software package for Linux and Windows. It is an extensive and intuitive program used to develop RAW images. RawTherapee doesn't work as a GIMP plug-in, but due to its features and its functional range, it is a good alternative to UFRaw. You can use it to develop your RAW photos and pass them on to GIMP for editing.

RawTherapee is not only a great RAW developer, it also does most common white balance corrections, tone adjustments, input sharpening, and noise reduction in the JPEG, TIFF, and PNG file formats. It is almost an autonomous image editing program. You can find the download and information regarding handbooks on the website www.rawtherapee.com. There is an introduction to RawTherapee in section 5.1.5.

Most camera manufacturers' own RAW development programs work fairly well with Windows and Mac systems, but GIMP'S direct import functionality makes it a lot simpler to process RAW images with UFRaw (or RawTherapee). Using programs like IrfanView or XnView to convert RAW images to usable formats such as TIFF or PNG is as an emergency measure that you should consider only if you have no alternative.

Nevertheless, IrfanView and XnView both offer a number of useful features. They are both universal image viewers, but can do much more than just view images. In addition to its main program, IrfanView includes a secondary file containing plug-ins that support several proprietary camera formats. I recommend that you download and install both. XnView's standard installation already includes support for most common proprietary image formats.

With the additional files installed, IrfanView can read the following file formats:

- CAM—Casio Digital Camera Picture File (JPEG version only)
- CRW/CR2—Canon CRW files
- DCR/MRW/NEF/ORF/PEF/RAF/SRF/X3F—camera formats
- KDC—Kodak Digital Camera files
- PCD—Kodak Photo CD
- RAW—RAW image files

• NOTE

dcraw is included in UFRaw and RawTherapee.

After opening an image, you can rename and save it in a suitable file format, such as TIFF or PNG, using the *File* > *Save as* menu options. You can also use the batch-processing feature built into both programs to simultaneously convert large numbers of images. In IrfanView, use the *Batch Conversion/Bename* command in the *File* menu.

Figure 1.17
Using the batch conversion and file renaming options of IrfanView

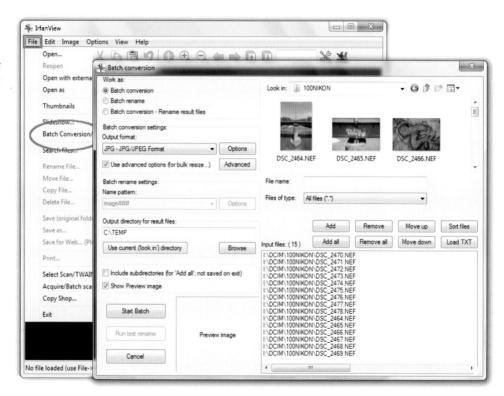

1.5 Get GIMP Running

1.5.1 Where Can I Get GIMP?

GIMP is a free program for image editing, designed and developed for the (usually) free Linux operating system. When Microsoft Windows users discovered GIMP, their interest motivated the development of a Windows version that has been available for several years now. The Windows version and additional helpers or plug-ins can be downloaded for free from the following locations:

- GIMP's home page is at www.gimp.org. You'll find links there to versions available for the Linux/UNIX, Windows, and Mac OS X operating systems as well as many other interesting details. You can find GIMP, GTK+, and additional packages for Windows at gimp-win.sourceforge.net/stable. html. The resources there include GTK+, 32-bit program versions that work on 64-bit-machines as well, and the program's help files.
- www.partha.com is an unofficial download site that hosts 32-bit and 64-bit Windows versions of the program. The site also offers a number of image processing plug-ins for download.
- A Windows installer for the GIMP animation package GAP for GIMP version 2.6 is available at www.box.net/shared/e9i2rgyn9t. It also works with GIMP 2.8.
- Ghostscript and GSview, programs dealing with PostScript and PDF for Linux and Windows, can be found at www.ghostscript.com or www.cs.wisc.edu/~ghost. However, GIMP 2.8 includes functionality that makes a separate installation unnecessary.
- You used to have to install Python and PyGTK to activate this functionality in Windows, but GIMP 2.8 now installs the appropriate packages automatically.
- Visit gimp-savvy.com/BOOK/index.html or www.gimp.org/books for a free GIMP user manual.

• NOTE

If you install Ghostscript automatically and it fails (e.g., does not open PostScript files), you will have to uninstall GIMP. To avoid this, download Ghostscript from the address noted earlier, install GIMP. Click the Customize button to select a customized installation, and choose not to install GIMP's PostScript support.

A revised 2.8 version of the GIMP hack called **GIMPshop** by Scott Moschella has been released for Windows and Mac. This GIMP variant is especially designed for converts who want to abandon Adobe Photoshop in favor of GIMP. GIMPshop features a GIMP menu structure adapted from Photoshop, so its interface differs from the "original" GIMP.

Information about GIMPshop is available on Scott Moschella's website at www.gimpshop.com. The program is available as an installation file for Windows and Mac OS X. For Linux, it comes in the form of source code to be compiled.

Another GIMP hack that simulates the interface, characteristics, and menu layout of Adobe Photoshop is **GimPhoto** plus **GimPad**. For information and downloads, go to www.gimphoto.com. This version is based on GIMP 2.4.3. However, it has some built-in plug-ins such as a CMYK color separator and various photo effects, and it offers a multi-document interface (MDI).

Another image editing program derived from GIMP is **CinePaint** (previously **Film GIMP**). It was developed to edit movie sequences from digital movie productions. CinePaint supports 8-bit, 16-bit, and 32-bit color channels of deep paint. In contrast to GIMP, CinePaint can read and write CMYK images. Most interesting for photographers is the fact that the program is able to compute **high dynamic range (HDR)** images from bracketed exposures.

You can find free download links for the Linux and Mac OS X versions at sourceforge.net/projects/cinepaint/files. A Windows version called **Glasgow** is currently being developed.

There is also an open-source competitor to GIMP: **Krita** (Swedish for "crayon"). It is the bitmap graphics editor software included with the KOffice suite based on the K Desktop Environment (KDE) and is available for Linux. Krita is now continued as part of the Calligra-Suite (www.calligra-suite.org). Krita supports the color models RGB (8-bit, 16-bit, and 32-bit), LAB (16-bit), grayscale (8-bit and 16-bit), and **CMYK** (8-bit and 16-bit). The program supports the OpenEXR format (EXR for short) and can be used by photographers for editing HDR images. You can find information on Krita on its own website, krita.org. As part of KOffice, it is available for all three major operating systems, and the program's developers are working on a standalone version, too.

Krita is capable of converting images to the CMYK color space and can open, process, and save native CMYK files. This means that Linux users can use open source software for all their CMYK image processing needs.

For 10.4 and later versions of Mac OS X, Krita can be installed as part of the KOffice package via MacPorts. An (unstable) developer version of Krita for Windows is available for download at www.kogmbh.com/download.html.

Figure 1.18
Krita's interface, showing its RGB-to-CMYK conversion options

NOTE

The book's DVD includes all files required to install GIMP on Linux, Windows, and Mac OS X.

• NOTE

The GIMP installer automatically chooses the language used by the operating system in current use.

1.5.2 Installing GIMP and Plug-Ins

GIMP works on the three major operating systems—Windows, Mac OS X, and Linux—as well as on some less popular systems, such as BSD and Sun Solaris.

This section concerns itself with installing GIMP on your system.

Installing GIMP under Windows

GIMP doesn't run by itself on Windows. You'll need to install a runtime environment, a separate file provided as GTK+ (GIMP Tool Kit). In earlier versions of GIMP you had to install GTK+ as a separate file. Now GTK+ is included in GIMP 2.8.

Earlier versions of GIMP required the installation of additional packages, such as **Ghostscript** (for PS/EPS files) and **Python** (for Python plug-ins), in order to use their specific functionality. GIMP 2.8 includes the appropriate add-ons in the installer package and allows you to select them through the *Customize* options during installation.

The program's help files, UFRaw and GAP (the GIMP Animation Package) are only installed once you have installed GIMP and, if required, the Python and PostScript add-ons.

Here is the recommended installation sequence for Windows:

- 1. **GIMP** (GIMP-2.8.X- setup-X.exe)
- 2. **GIMP Help** (*GIMP-help-2-2.X.X-en-setup.exe*)
- 3. **UFRaw** (*ufraw-0.1X-setup.exe*)
- 4. **GAP** (GIMP-GAP-2.X.X-Setup.exe)

Note that the new GIMP 2.8 version requires Windows XP SP3, Windows Server 2003, Windows Vista, or Windows 7 or 8. The current version of GIMP won't support older Windows versions. The Windows installer contains code for 32-bit and 64-bit versions of the operating system.

The GIMP and UFRaw files download as executable installations files. After the download, you must double-click the file name to start. Follow the installation program's instructions and confirm the GNU license agreement by clicking the *Accept* button or verify the questions by clicking *Continue* or *Next*. Don't change the factory settings unless you know exactly what you are doing. The default settings are sufficient.

Figure 1.19
The GIMP (Windows) Setup window. The *Customize* button on the left opens a dialog that enables you to select from a range of plug-ins and add-ons. Clicking the *Install* button starts the automatic installation process.

Figure 1.20
The options available in the *Customize* dialog

Installing GIMP under Mac OS X

GIMP version 2 is currently available for Apple computers running **Mac OS** version X 10.2 and higher. For **Mac OS X 10.2**, you need the installation file *X11UserForMacOSX.dmg.bin*, whereas **OS X 10.3** requires X11User.dmg. This file should be on the installation CD that came with your system.

The more recent Mac OS X 10.4 Tiger and OS X 10.5 Leopard automatically install X11 with the operating system and don't require a separate installation. At the time of writing (November 2012), the most recent GIMP installer version available was 2.6.11.

In order to install GIMP 2.8.2 on Mac OS X 10.6 Snow Leopard, Mac OS X 10.7 Lion, or 10.8 Mountain Lion, you no longer need to install XQuartz or X11. For these versions of the OS, there are native build dmg-installers available.

On older machines, GIMP itself is installed once the X Window application has been installed. Native build disk images of GIMP 2.8.2 are currently available only for Mac OS X 10.6 Snow Leopard (Intel only), Mac OS X 10.7 Lion (Intel only), and Mac OS X 10.8 Mountain Lion. The download links can be found at gimp.lisanet.de/Website/Download.html. The files already contain UFRaw, so you don't have to download and install it separately. However, you still have to download and install the help files separately.

Only GIMP 2.2.11 (2.2.11.dmg) is currently available for **Mac OS X 10.2** and **10.3**. It can be downloaded from GIMP-app.sourceforge.net. UFRaw and the help files have to be downloaded and installed separately.

If you are using OS X 10.2 (Jaguar) you will need to install **Ghostscript** (ESP Ghostscript—ESPGS) if you want to take full advantage of GIMP's PostScript functionality. You can download the installation file from gimp-print.sourceforge.net/MacOSX.php. More recent versions of OS X no longer require you to install the file separately.

Gutenprint 5.2.9 (formerly known as GIMP-Print) is the newest stable edition of printer drivers for GIMP for Mac OS X. It comprises a collection of drivers that support more than 700 printers. The DMG file includes an OS X installation package, an uninstaller package, and a user-friendly, illustrated document to guide you through the printer setup routine (in the directory *Programs/GIMP All OS/GIMP MacOS* on the books, DVD).

GIMP and Linux

The easiest way to install GIMP for Linux is by using the software packaged with the Linux distribution (SUSE, Ubuntu, Mandrake, Fedora, etc.). This works in conjunction with the installation interface of YaST at openSUSE or over automatic updates of the respective distributions. However, since prepackaged installation software is normally not up-to-date, you may want to visit www.gimp.org/source to find the current GIMP version. This website also provides installation hints and instructions.

UFRaw is not included in Linux distributions, but you can download RPM files for various distributions, or download source code from Udi Fuchs's website: ufraw.sourceforge.net/Install.html.

The animation plug-in GAP for GIMP 2.8 is available as source code for Linux. Go to ftp://ftp.gimp.org/pub/gimp/plug-ins/v2.8/gap.

If you are an experienced Linux user, you can install GIMP from the source code. The source code can be found on the website mentioned in the preceding paragraph. Note that if you are compiling GIMP yourself, you should consider the dependencies. For a list of preinstallable libraries and other installation hints, go to: www.gimp.org/source.

Expanding GIMP: Plug-ins and Script-Fus—Additional Program Functions

I have already discussed plug-ins such as UFRaw. If you want to add more functions, such as stitching photos together to create panoramas or layer effects as in Photoshop, you will find many of those program expansions (called plug-ins or Script-Fus) on the Internet under registry.gimp.org. The GIMP community hosts a useful website at www.gimpstuff.org, where you can find a wide range of free plug-ins, brushes, and fonts. Search engines lead you to websites where you can download program expansions for free.

Installing GIMP Plug-ins

Most plug-ins, such as so-called Script-Fus (filename extension .scm) and some short programs written in Perl or Python (filename extension .py), are available for download. Python runs on Windows only if you have installed Python as well as the appropriate PyGTK library, an option that you can choose during a fresh install of version 2.8. Some plug-ins for the Windows version of GIMP are available as EXE files.

If you have downloaded and stored the data files on your computer, they have to be installed in the appropriate directory. You may find references to the directory on the web page for some plug-ins or in the compressed download archives. Always follow the instructions, please!

In general, the plug-ins with filenames ending in .exe or .py will simply be copied into the plug-in directory. The path for exe- files under Windows XP, Windows Vista, and Windows 7 is C:\Program Files\GIMP-2\lib\gimp\2.0\plug-ins. For py- files it's the same path with the last directory python.

Script-Fu files with names ending in .scm are copied to the following directory: C:\Program Files\GIMP-2\share\gimp\2.0\scripts. As an alternative, Windows should be at C:\Documents and Preferences\ <username>\.gimp-2X\scripts.

The path for copying Script-Fu files (filenames ending in .scm) in Mac OS X is Applications/GIMP.app/Contents/Resources/share/gimp/2.X/scripts.

I didn't initially find this path on my Mac. GIMP.app wasn't shown to me as a file, but as a program. With the help of my search function, I looked for a GIMP file on my hard drive. The search function immediately found a couple of GIMP files, one of which contained the script folder. Copy the files into the script folder. Restart GIMP. Done.

• NOTE

GIMP 2.8 installs a program module that makes the new version compatible with plugins for older versions of GIMP.

NOTE

Script-Fus and Python-Fus usually don't have an internal preview window or a preview function as offered by most filter plug-ins. Therefore, you must experiment with the settings, see what your result is, and if necessary, make further alterations.

• NOTE

A collection of plug-ins and Script-Fus is available on the DVD that accompanies this book.

In most Linux distributions, you will find that Python and PyGTK have already been installed. At least these files have been added to the distributions for installation. Plug-ins and Script-Fus that you want to install should be downloaded into your *Home* folder. Script-Fu files with the filename extension .scm should be saved at <home-folder>/.gimp-2.x/scripts. Python-Fus (filenames ending with .py) should be added in <home-folder>/.gimp-2.x/plug-ins.

If you can't find the *gimp-2.x* home folder, it could be that your file manager (e.g., Konqueror) doesn't display hidden files. Select *View > Show hidden files* and the hidden files should appear.

As a rule: To begin with, you download the new plug-ins, Script-Fus, and Python-Fus as *exe*, *py*, and *scm* files and store them on your computer. Copy the files into the appropriate subdirectory of your GIMP installation. Then you only have to refresh the script display in GIMP. Choose *Filter* >*Script-Fu* >*Refresh Script* in GIMP or simply restart GIMP. Most plug-ins and Script-Fus appear in submenus of the *Filter* menu or in the new *Script-Fu* menu.

If a Script-Fu or Python-Fu isn't displayed after an installation, it is most likely because the file isn't executable or it doesn't tolerate your GIMP version. Read the instructions carefully to find out which version the plug-in has been written for.

Starting GIMP for the First Time

When you launch GIMP for the first time (by double-clicking the GIMP icon on the desktop or by choosing *Start > All Programs > Gimp*), a dialog box pops up. Use it to set up GIMP according to your personal preferences. For standard use, accept the settings and click *Continue* to proceed. When you are asked to choose a temporary directory for GIMP, you can type *C:\Windows\Temp*, which is Windows' default directory for temporary files. This is the standard directory for Windows temporary files and can be easily cleaned up with a Windows tool (*Start > All Programs > Accessories > System Tools > Disk Cleanup*). Accept the suggestions provided by the installation dialog or create your own directory.

For Linux and Mac OS, you will encounter the same window offering a choice of default settings. Simply accept the settings and the suggested temporary volume. You can also choose another directory, most conveniently on a second hard drive. This will happen only if you are installing GIMP for the first time. When you are upgrading to a newer version, the personal settings from the older installation will be used without prompting.

1.5.3 Is GIMP Insecure? Some Comments and Tips

Unfortunately, computer programs sometimes crash unexpectedly or react strangely. This can happen with any freeware running on Windows. Since GIMP is GNU software, there are no guarantees.

In earlier versions of GIMP, I've experienced some bugs, but from version 2.0 onward GIMP has become very stable. In the event that something doesn't work, it is typically due to incompatibility with other installed software or a specific hardware problem.

GIMP's current version runs on all Windows versions from XP SP3 onward, so there shouldn't be any problems with the installation. However, it may still happen that Windows stalls during the loading process. Don't worry. It takes a few minutes for GIMP to get started, especially if you're running it on Windows and many fonts are installed.

Figure 1.21The startup window of GIMP, which appears while scripts, fonts, and so on are loaded. Sometimes, the program doesn't respond for several minutes at this stage of the startup process.

The stability of GIMP depends on the technical condition of the computer, the drivers, and other installed software. GIMP is more stable when used by a computer running newer versions of Windows than older versions such as Windows 98/98 SE/Me.

Your computer's RAM also plays a key role in GIMP's performance. In general, more memory equals more stability. The minimum memory requirements for GIMP are 256 MB RAM for Windows XP and 1,024 MB RAM for

Windows Vista or Windows 7. For GIMP to work efficiently, you should double these values. They can be applied for any kind of digital image processing.

If you have Adobe Photoshop installed on your computer in addition to GIMP, GIMP may inform you about a missing file called *Plug-ins.dll* that the program will not start without. In this case, look for the file of the same name (*Plug-ins.dll*) in the Adobe Photoshop installation folder. Simply copy it and paste *Plug-ins.dll* into the folder *system32* of your Windows installation.

Support is available from some internet forums. The original help forum is the **GIMP User List** mail.gnome.org/mailman/listinfo/gimp-user-list. The **GIMP User Group** gug.criticalhit.dk/ also answers questions about GIMP on several operating systems. Many forums like **Gimptalk**, a forum of the GIMP community (www.gimptalk.com), **Meet the GIMP** (forum.meetthegimp.org), **GIMPUSERS.com** (www.gimpusers.com), and **Gimper.net** (www.gimper.net) offer help, news, tutorials, and resources. **Gimp on OS X** (gimp.lisanet.de) is a forum especially for Mac users. Additional mailing lists with information about GIMP are available at www.gimp.org/links.

The Worst Case

In the unlikely event that the program crashes or gets stuck each time you start it up, you should uninstall both GIMP and GTK+ (on Windows, choose *Start* > *Control Panel* > *Programs and Features: Uninstall a program*). You should also delete all the GIMP and GTK+ program files from your computer. Please note that there is no need to delete image files created in GIMP before reinstalling!

If you installed GIMP using the default suggestions, you can find the program files at C:\Program Files\Gimp-2.X or at C:\Users\[your username]\. Delete all related folders and their contents. In critical cases, you can search Windows by choosing Start > Find > Files or Folders and typing the name of the file you're looking for (e.g., search terms gimp and gtk).

Once you have removed all relevant files, reinstall GIMP from scratch.

Many consider GIMP a great tool. Despite not being able to compete with Adobe Photoshop's professional pre-press applications, and despite its curious name, GIMP is unbeatable in terms of its value for the money. Photoshop offers many options for editing images that GIMP does not yet provide. Still, the program has a lot to offer for people who want to do professional photo editing or design web pages. The new GIMP 2.8 version marks a new milestone on the program's way to becoming a professional tool.

I would like to point out that GIMP's user interface opens with many windows. This may appear unusual for users of Windows programs. GIMP 2.8 includes a new single-window viewing mode, which makes the GIMP experience similar to that of other Windows-based applications.

1.5.4 The GIMP's Program Windows

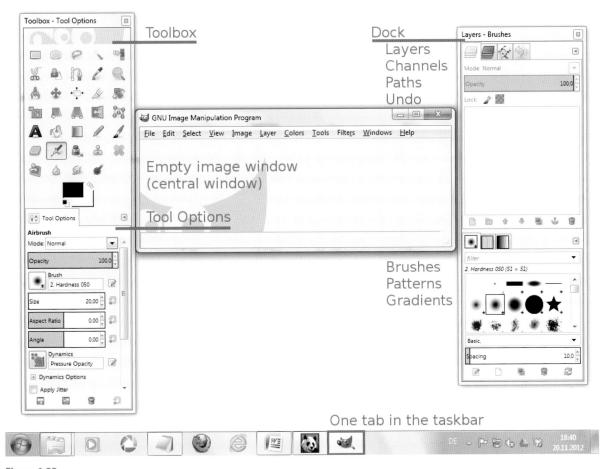

Figure 1.22
The program window as it looks when you start GIMP for the first time. In addition to the *Toolbox*, the 2.80 version of the program automatically opens the *Layers/Channels/Paths/Undo History* panel and the *Brushes/Patterns/Gradients* panel.

When you first open GIMP 2.8, three separate windows appear on the desktop. The *Toolbox* (or *Tools* palette) with the tool settings, an initially empty image window, and a window called a **dock** containing tabbed windows called **dialogs** for managing functions such as *Layers*, *Channels*, *Paths*, *Undo*, *Brushes*, *Patterns*, and *Gradients*. Clicking a tab opens the corresponding dialog. However, the dialogs can be dragged and dropped out of the dock. Then they are displayed as separate windows on the desktop. The main windows (*Toolbox*, image window and dock) are distributed across the desktop. These three windows together produce just one single tab in the taskbar and are

minimized together when you click the minimize button. Each open image creates a new entry in the taskbar. When it is maximized, the image window serves as the background with the *Toolbox* and any other open panels superimposed on it. Once again, all open dialogs for each image require just a single tab in the taskbar. The appropriate settings can be found in the *Edit* menu under *Preferences* > *Window Management*. In the Windows Manager Hints drop-down, select *Hints for docks and toolbox: Utility* window. If you want every window to have its own tab in the taskbar, select the *Normal Window* option. But be warned: using individual window entries can be cumbersome and time-consuming. Confirm your setting by clicking the Save *Windows Positions Now* button. Any changes you make will be implemented the next time you start the program.

I recommend that you keep the default settings, as this leaves all three windows visible and the image window is the only one that has its own tab in the taskbar

Figure 1.23
The Preferences window (Edit > Preferences) with the selection and setting for Window Management.
This allows you to set the image window as your background window.

Figure 1.24
You can set up GIMP so that all windows are open in the background window. Note that there will be only one tab for the image window when you have set it up as the background window.

Have a look at figure 1.24: The first window to the left is the *Toolbox*. The *Toolbox* actually consists of two windows: the top half is allotted to the *Toolbox* containing the various tools and the lower half to the individual tools' *Tool Options* settings. The lower section can be closed and reopened later as a separate window. It also can be reattached to the *Toolbox* again or left in the dock.

The image window in the middle is empty when you start GIMP. Since version 2.6, it has contained all the menus. You will also find all menus in the context menu, which can be opened with the right mouse button. To shut down GIMP, you use the image window's close button.

The third window is the so-called dock, which has two sections. The top section has four tabs where the *Layers, Channels, Paths*, and the *Undo*

History dialog boxes appear by default. Below that you will find the tabs for the *Brushes, Patterns,* and *Gradients* dialog boxes. You can drag these with your mouse onto your desktop. You can find more information on the dock in chapter 2.

Alongside the well-known multi-window view, GIMP 2.8 includes the new single-window mode. You can switch between the two modes by toggling the *Windows > Single-Window Mode* command.

Figure 1.25
GIMP in single-window mode. This new mode groups the *Toolbox*, image Window, and dockable dialogs into a single interface. If you open multiple image Windows, instead of creating multiple entries in the taskbar, the new mode creates preview images in each image's tab, which then appear above the main image frame.

Selecting *Windows* > *Single-Window Mode* groups the familiar windows used by multi-window mode into a single window. In both modes, open windows can be freely selected, positioned, and docked.

The major advantage of single-window mode is that the image window doesn't get obscured by the other windows. This arrangement optimizes the use of desktop space and produces just a single tab entry in the taskbar for the currently active image, making it simpler to minimize the program window.

Single-window mode is also more suitable than multi-window mode for making quick adjustments to an image. It is up to you to decide which mode you prefer. However, to keep explanations clear and simple, the illustrations in this book all show the program in multi-window mode.

1.5.5 Using and Customizing the Program Interface—Important Menus

Regardless of whether you work in single- or multi-window mode, GIMP provides various ways of customizing the interface. Among the various menus and settings, the *Windows* menu is the most important, as it contains the commands for opening subsidiary tool windows called *Dockable Dialogs*. The *Windows* menu also contains commands for reopening the *Toolbox* and recently closed docks.

Additional dialog tabs can be opened from within open dock windows via the "Configure this tab" menu located under the left-pointing arrow button at the top right corner of each dock panel. In the "Configure this tab" menu, select the *Add Tab* command and choose a dialog to open from the resulting list.

Images
 Ø Document History
 Iemplates
 ▲ Error Console

Figure 1.26
The Configure this tab menu located under the arrow icon at the top right-hand corner of each dialog panel enables you to open additional dialogs.

Dockable dialogs, the *Toolbox*, and other dock panels can be freely docked and undocked, giving the user virtually unlimited ways to customize the look of the program interface. The *Toolbox* and *Tool Options* panel are a good starting point for getting a feel for the system.

By default, GIMP 2.8 displays the options panel for the currently open tool beneath the *Toolbox*. These are in fact two separate, docked windows, even if they appear as one at first glance.

The *Tool Options* panel can be closed to save desktop space. To do this, click the *Configure this tab* menu icon at the top right-hand corner of the panel and select the *Close Tab* command. Once you have closed the options tab, double-clicking a tool in the *Toolbox* opens the options panel in a separate window that you can then drag and dock to the *Toolbox* or the dock.

Figure 1.27 "Docking" a window

Use the Configure this tab menu to add tabs to a dialog. You can also add any other open windows that are currently located in the dock or are listed in the Windows menu. If you stick to using just the main Brushes, Layers, and Undo History dialogs, you can do without the dock window altogether and gain additional space on your desktop for displaying the image.

In previous versions of GIMP, it was only possible to dock dialogs vertically or to position them as separate tabs in the dock. Now, in GIMP 2.8, you can dock all dialogs (including the *Toolbox*) horizontally. This way, you can set up

a two-part interface with the maximized image window on one side and all the relevant tools and dialogs on the other, which is perfect for use with dual monitor setups.

Drag your preferred tools to dock them to the *Toolbox* and create a multi-column layout. GIMP saves the current setup automatically when you close the program and reloads it at restart. You can change the components of your layout at any time via drag and drop, and you can revert to the default setup in the *Edit > Preferences > Window Management* dialog by clicking the *Reset Saved Window Positions to Default Values* button and restarting the program.

Figure 1.28
Dividing the interface into a large image window and a multi-column dock is a great way to utilize the program on a dual-monitor system

If you look closely at the docked dialogs in figure 1.28, you will see that the individual title bars no longer appear. Instead, descriptions of each icon appear in the dialog's tab. If there is no space available, the tab's name remains hidden. In both cases, mouseover tips with the dialog's name appear when you move the cursor over a tab.

· TIE

▶ If you would like to equip GIMP (on Windows) with different program interfaces (themes), you can simply start a search for "GIMP themes" or take a look at the following website: art.gnome.org/themes/gtk2

- CAUTION

Changing themes requires quite complex system settings that should only be attempted by advanced users.

• NOTE

On my Windows system, it helped to copy the theme packages that were included in the *gtk-2.0* directory of the downloaded files directly into the themes directory of my GIMP installation (C:\Program Files\Gimp-2.0\share\qimp\2.0\themes).

In addition to the *Windows* menu, the *Edit* > *Preferences* and *View* menus contain important tools and settings for customizing the GIMP interface.

Nevertheless, I have put together 22 themes with various program interfaces and color compositions for GIMP on Windows. There are four standard themes and further themes from the websites gimper.net and gnome-look.org. These can be found on the DVD under GIMP Themes (Windows). You will have to copy the contained subdirectories into either the C:\Program files\GIMP 2\share\2.0\themes or the C:\User[your username]\.gimp-2.8\themes folder. Note that not all themes work equally well.

The themes work on Windows from XP upward. Linux and Mac OS X users can try using the themes from the DVD or try using the GTK+ themes. These have to be copied into the appropriate folder of your GIMP installation.

You can find great wallpapers and desktop background images on gnome-look.org.

In addition to the color picker and the active brush, pattern, and gradient tools, the *Toolbox* can be used to display a thumbnail of the active image. GIMP 2.8 allows you to select which tools appear in the *Toolbox* (*Edit > Preferences*), including tools from the *Color Tools* and *Colors* menus. If you have set up the *Toolbox* to display a thumbnail preview of the active image, clicking the thumbnail opens an image browser dialog that you can also activate via *Windows > Dockable Dialogs > Images*. Try out these settings for yourself. I find that they really speed up my workflow

In the *View* menu, tools such as rulers and a quadratic grid can be blended in and out, and you can choose the background color of your image window. The menu *Windows* offers options to open or re-open additional windows or docks (*Layers, Channels, Paths*, and *Undo*). The *Help* menu offers access to the help functions of the program.

Most of the functions and modules enabling you to create Script-Fus, buttons for websites, 3D objects, and logos with effects that were attached to the *Toolbox* under the *Extras* menu in previous versions of GIMP can now be found in *File > Create, Edit,* and *Filters*.

The next time you start GIMP, you will find the windows that were open the last time you used it.

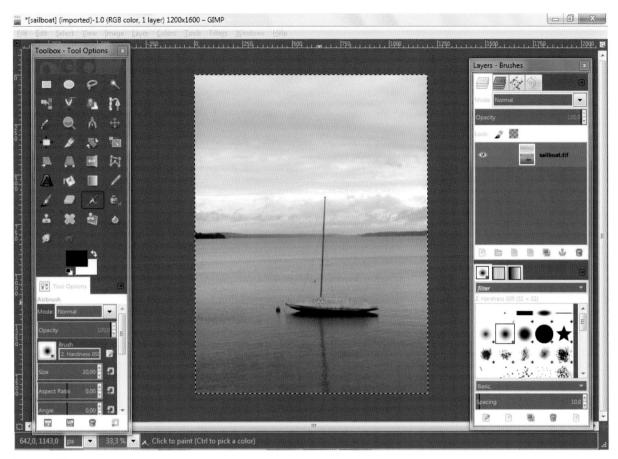

Figure 1.29
GIMP and its new clothes, in this case, the Clearlooks-DarkBlue theme

Program Settings for the Undo History

Similar to many other image editing programs, GIMP lets you undo editing strokes applied to an image. By default, you can revert your image to how it appeared five steps back in the editing process. You can increase the number of steps back you can take if your computer has enough memory to do so. To increase the number of "undo" strokes, access the File > Preferences menu. Select Environment to enter the desired number of undo steps along with the amount of memory you wish to allocate for this process. A number between 25 and 50 will allow you to undo even complex editing mistakes.

If you have enough memory installed in your computer, it is a good idea to reserve more memory for GIMP's document history—the number of undo steps—than the default provides. As a rule, you can reserve approximately 10% of your computer's available memory capacity for document history and about 25% for the GIMP program in general. If these values use too much of your computer's memory, the program or your computer may freeze. To remedy this problem, just reduce the allocated memory.

Figure 1.30
The *Preferences > Environment* window lets you set the number of undo steps and the amount of memory allocated to GIMP.

Figure 1.31
The *Undo History* dialog

When you are satisfied with the new values, click OK to accept your changes (figure 1.30).

If you want to undo one or several editing steps while editing an image, you can use the keyboard shortcut *Ctrl+Z*, which will undo editing steps one at a time. You can also select the menu option *Edit > Undo*.

A more convenient way of undoing multiple editing steps is available in the **Undo History** window, which you will find as a tab in the *Layers, Channels*, and *Paths* dock. This window accesses a preview pane so you can see exactly how many steps you want to go back. Since you will be able to view each change in sequence, you can easily judge whether the editing improved the image. You can also view the document history from your image window by choosing *Edit > Undo History*.

The Toolbox

Since GIMP 2.4, the graphics and tool symbols have appeared in Linux's Tango style. The icons have more detail, are more colorful, and are much easier to grasp. The tools in the *Toolbox* will be introduced in a couple of the following chapters.

The *Toolbox* used to be the central window. The major change since GIMP 2.4 has been that the *Toolbox* has been reduced to a utility window. It contains all the tools that can be applied with the mouse:

- Selection tools for selecting specific areas of your image that you wish to edit, add to, or manipulate
- Tools that can select colors, minimize or magnify the view, and measure and position image elements
- · Tools that can cut or transform the size and shape of image objects
- Text, painting, filling and touch-up tools
- Tools for manipulating an image's or partial image's sharpness, brightness, and contrast
- · Tools that define colors, fills, and fill patterns

In GIMP 2.8, the *Toolbox* is separated into a tool palette and the tool options. What appears to be one window is actually two separate windows. The *Tool Options* window is a dockable window and can be closed to save space on the desktop. Click the button with the small arrow pointing to the left (*Configure this tab*) and select *Close Tab* from the drop-down menu (figure 1.26). The next time you double-click on a tool symbol, the tool options appear in a separate floating window. You can dock the *Tool Options* window to the palette again by hovering the mouse arrow over the tool option's name. A hand cursor will appear. Click on the tool option and you will see a tool options symbol, which can be dragged onto the bottom of the *Toolbox* window. The dockable section there will turn blue. It simply attaches itself (figure 1.27).

You can use the little *Configure this tab* button to add new tabs to the palette. You can also add tabs that are included in the dock or in the Windows menu. If you want to limit yourself to the most important tabs—*Layers, Paths,* and *Undo*—you can do without the dock window. Just open these tab windows in the *Tool Options* window to make more space for the image window (figure 1.26).

The following **overview** will describe the tools available in the *Toolbox*.

Figure 1.32 The *Toolbox*

First row	, from left to right:		
	Rectangle Select Tool Selects rectangular or square regions of an image. Press the Shift key to switch between rectangle and square. Sections 3.1.2, 3.14.3		Ellipse Select Tool Selects circular and elliptical regions of an image. Press the Shift key to switch between circle and ellipsis. Sections 3.1.2, 3.2.2, 3.15.1
8	Free Select Tool (Lasso or Polygon Lasso) Lets you create a selection by drawing it freehand with the pointer (not very precise, but simple and quick) or by setting key points with the polygon tool—for example, following a contour. Sections 3.1.2, 3.2.2, 3.10.1		Fuzzy Select Tool (Magic Wand) Selects continuous areas of the current layer or image based on color similarity. Sections 3.1.2, 3.6.2, 3.15.4
	Select by Color Tool Similar to Magic Wand; it selects areas of similar color all over an image. Section 3.1.2	on on	Scissors Select Tool (Magnetic Lasso, Scissors) This freehand selection tool produces a continuous curve passing through control nodes, following any high-contrast edge it can find according to the settings; it is not very precise. Section 3.1.2
Second	row, from left to right:		
	Foreground Select Tool Selects an image object with the help of an interactive program (automatic object extraction tool "SIOX"; SIOX stands for Simple Interactive Object Extraction). Sections 3.1.1, 3.15.3		Paths Tool Creates and edits paths, creates vectors, and helps to make exact choices for complex forms. Sections 3.1.2, 3.11
8	Color Picker Tool (Eyedropper) Finds colors on the active layer or image. Section 3.6.2		Zoom Tool Changes the zoom level. Section 2.3.5
A	Measure Tool Measures angles and pixel distances. Section 2.2.7	*	Move Tool Moves layers, selections, paths, and guides. Section 3.6.3
Third ro	w, from left to right:		
•••	Alignment Tool Aligns the image layers with various objects. Section 3.12	8	Crop Tool Crops or clips an image or layer. Sections 2.1.6 and 2.2.9
3	Rotate Tool Rotates layers, paths, and selections. Section 2.2.8		Scale Tool Scales images or layers, selections, and paths. Sections 3.6.5, 3.9.3, 3.11.5
	Shear Tool Shifts a partial image, layer, selection, or path to one direction while shifting the rest of the image to the opposite direction. Section 3.11.5		Perspective Tool Changes the perspective of (or rather distorts) layers, selections, and paths. Sections 3.5.3, 3.5.4, 3.1.5

Flip Tool Lets you flip layers, selections, and paths either	0:=n	Cage Transform
horizontally or vertically. Section 3.15.4	000	Allows you to select an area within an image bounded by a hand-drawn "cage" and distort it. Tool selected with either a direct click or Shift+G. Section 3.13
Text Tool Adds text to an image or a layer. Sections 3.7.2, 3.7.3, 3.7.4, 3.11.7	NO.	Bucket Fill Tool Fills a selection with the current foreground color or a pattern. Sections 3.6.2, 3.9.3
Blend Tool Fills a selection with a gradient blend. Section 3.6.4	0	Pencil Tool Draws freehand lines with a hard edge. Section 3.1.3
from left to right:		
Paintbrush Tool Paints fuzzy brush strokes. Section 3.9.4		Eraser Tool Removes areas of color from the current image, layer, or selection. Similar to <i>Paintbrush</i> tool. Section 3.9.4
Airbrush Tool Paints soft areas of color, similar to a traditional airbrush. Similar to <i>Paintbrush</i> tool. Section 3.9.4		Ink Tool Paints solid brush strokes like a drawing pen for calligraphy. Similar to <i>Paintbrush</i> tool. Section 3.9.4
Clone Tool Draws with content selected from an image or with a pattern; repairs and fills problematic areas in digital photos. Sections 2.5.1, 2.5.3, 2.5.4		Healing Tool Removes small flaws in images. Section 2.5.5
from left to right:		
Perspective Clone Tool Allows you to clone image content to repair areas in an image according to the desired perspective. Section 3.5.5	٥	Blur/Sharpen Tool Blurs or sharpens an image depending on the tool settings; sharpening doesn't function well in high- resolution images.
Smudge Tool Smudges colors on the active layer or selection, mixing them and so creating transitions. Section 3.6.4	6	Dodge/Burn Tool Lightens or darkens the colors in an image. Section 3.6.2
ow, from left to right:		
	Text Tool Adds text to an image or a layer. Sections 3.7.2, 3.7.3, 3.7.4, 3.11.7 Blend Tool Fills a selection with a gradient blend. Section 3.6.4 from left to right: Paintbrush Tool Paints fuzzy brush strokes. Section 3.9.4 Airbrush Tool Paints soft areas of color, similar to a traditional airbrush. Similar to Paintbrush tool. Section 3.9.4 Clone Tool Draws with content selected from an image or with a pattern; repairs and fills problematic areas in digital photos. Sections 2.5.1, 2.5.3, 2.5.4 from left to right: Perspective Clone Tool Allows you to clone image content to repair areas in an image according to the desired perspective. Section 3.5.5 Smudge Tool Smudges colors on the active layer or selection, mixing them and so creating transitions. Section 3.6.4	Text Tool Adds text to an image or a layer. Sections 3.7.2, 3.7.3, 3.7.4, 3.11.7 Blend Tool Fills a selection with a gradient blend. Section 3.6.4 from left to right: Paintbrush Tool Paints fuzzy brush strokes. Section 3.9.4 Airbrush Tool Paints soft areas of color, similar to a traditional airbrush. Similar to Paintbrush tool. Section 3.9.4 Clone Tool Draws with content selected from an image or with a pattern; repairs and fills problematic areas in digital photos. Sections 2.5.1, 2.5.3, 2.5.4 from left to right: Perspective Clone Tool Allows you to clone image content to repair areas in an image according to the desired perspective. Section 3.5.5 Smudge Tool Smudges colors on the active layer or selection, mixing them and so creating transitions. Section 3.6.4

Note: Double-clicking the left mouse button on an icon in the *Toolbox* pops up a window displaying the current tool settings, either as a docked window or as a separate, floating window. The window displays options that can be used to configure tools for specific tasks. For example, the *Clone* tool gives you a choice between image cloning and pattern cloning. The *Blur/Sharpen* tool allows you select between a brush to blur and a brush to sharpen an image.

The tool settings sliders in GIMP 2.8 have a new, fresh look.

1.5.6 Real Help—GIMP's Help Function

With this book at hand, you should get along with GIMP easily. If you would like to go into more depth and learn about all of the possible settings, you can use the *Help* function.

It must be rather tedious for software programmers to develop help programs and documentation. They seem to be written after the fact. For GIMP, this definitely has been the case. Sometimes you rely on the *Help* function and it responds by opening a window that says, "Eeek! The Help function is missing here." Fortunately, since the release of GIMP 2.0, the *Help* function has continuously been extended and is rather comprehensive. The user manual has recently been updated to GIMP 2.8. If you have any questions, it has information concerning tools and functions.

Using the Help Function

You can find the *Help* function for GIMP by using the *Help* menu in the image window. Various help topics are available.

To begin with, there is the actual **Help** function, which is the documentation of the program. This user manual can be downloaded from the Internet as an installation program (see section 1.5.1). It will be installed on its own and become immediately available. The program is stored locally in HTML format on the computer. Clicking the *Help* > *Help* menu item opens the built-in Help browser. However, because the Help pages are built with HTML, you have to select your system's web browser to view any downloaded *Help* pages. To do this, navigate to the *Preferences* dialog and select the *Web Browser* option in the *Help Browser* drop-down.

If you scroll down the page, you will find the complete index of the user manual. Since it is in HTML format, you can maneuver just as if it were a web page.

If you choose *Context Help*, the second entry in the *Help* menu, your mouse pointer will turn into a question mark. Click with the question mark (left mouse click) on a tool or tool setting in your tool palette, in a dock, or in another window of GIMP. The *Help* function opens the chosen information in a browser window.

The *Tip of the Day* offers new users a range of useful tips and advice on how to get the most out of GIMP. You can always check the *Tip of the Day* in the *Help* menu if you want to.

Figure 1.33
The *Help* menu in the image window

Figure 1.34 GIMP's *Help* user manual appears in a standard browser.

Take a look at the *Abou*t menu item. GIMP's programmers are mentioned here in an animated image. When you click the Credits button, you will find a listing of those involved in creating GIMP. You can also see which version of GIMP you installed. The next menu item, *Plug-In Browser*, opens a window with an overview of the installed plug-ins and information about them. *Procedure Browser* lists all available procedures. This may not appear helpful at first, but it does help when you are creating your own Script-Fus and plug-ins. The last menu items, *GIMP Online* and *User Manual*, offer links to the website of the developer community, the project home page, the plug-in library, and the online user manual. The link to the GIMP plug-ins is especially interesting because it shows you ways to extend the program's abilities. If there is something in particular you want to do, you might want to look through the library.

Figure 1.35
The Scale Tool window, which you can find under the Image > Scale Image menu or as a tool in the Toolbox. Clicking the Help button opens the corresponding page in the user manual.

The *User Manual* menu item opens the user manual for GIMP that is integrated in the *Help* menu. The user manual is a collection of tutorials and how-tos. It leads you from simple tasks to more complex ones. The manual provides workflows similar to those described in this book.

This menu is not the only way to access the *Help* function. You can also find a *Help* button in the individual windows that open when you're working with a tool from the *Toolbox* or a function out of the menu of the image window (figure 1.35).

You should now have sufficient knowledge to get started with image editing and the GIMP program. In the following chapters, you will learn how to edit images with GIMP.

his is where we begin to actually work with GIMP. The first thing to do is open an image file and set up the user interface. The following sections will tell you all you need to know about scanning images as well as how to correct image brightness, color, and contrast. In addition, I have included tips on retouching, cropping, sizing, printing, and exporting image files. A section on how to use digital filters concludes this chapter.

2.1 Working with GIMP: Image Adjustment and Retouching

2.1.1 Opening, Setting, and Storing an Image: The Steps

Once you have saved an image from an external source such as a digital camera onto your computer, you can do several things to it:

- Open it in GIMP.
- · Rotate it.
- Change its size on the screen (zoom in or out).
- Set its size and resolution.
- Save it in a high-quality format.
- Prepare it for printing.

2.1.2 Opening an Image

From the *File* menu in the *Toolbox*, select the *Open* menu item. The *Open Image* window opens.

Figure 2.1
The Open Image window

Double-click on the drive or directory where you want to search for an image in the left pane.

The middle pane will now display subdirectories, which you can doubleclick to open until you find the folder containing the image you want.

The buttons above the search boxes show where you are within the specified directory path. If you're in the wrong subfolder, use these buttons to move back to the main folders and start again until you've found the appropriate file.

The middle pane will now display the files contained in the selected folder, sorted alphabetically by name (the file used in this example is sailboat.tif).

You'll notice a scrollbar on the right-hand side of the *Name* box. Pull the bar up or down to quickly search through the folder.

Once you've found the desired image, click on it to select it; then click the *Open* button to load it. Or just double-click the image name in the *Name* box.

Figure 2.2

By choosing File > Open Location, you can open an image from a network address or a website.

Here are a few tips:

- You can "bookmark" a folder that you'll be using frequently. Select the
 folder in the middle pane and click the Add button at the bottom of the
 left pane. The folder now appears in the left pane. To open it, just click it.
- Clicking the drop-down menu called All images will display a list of file formats GIMP can read. If you select a specific format from the list, the file browser will display only files in that particular format.

You'll also see an option called *Select File Type*, which is set to *Automatically Detected* by default. Clicking this button will provide a pop-up window listing file formats. If GIMP doesn't automatically recognize the format of the image you selected, you can use this option to specify the file format.

These are additional options for opening images from the File menu:

 Open as Layers: Enables you to open image files as additional layers in the active image. It is preferable that the images have the same size and orientation as the image into which they are being inserted, although you can alter these two parameters after import if necessary.

- Open Location: Enables you to open an image file directly from a network location or web address. However, web-based images cannot be directly saved back to their original location once you have made alterations to them. To replace the original image on the server, you will have to save the processed image locally and then use an FTP application (FileZilla, for example) to upload the new version.
- Open Recent/Document History: Open Recent lists the previous ten images that you have worked on, and all you have to do to open one of them is select the appropriate entry in the menu. The recent files list also includes the Document History entry, which, when selected, reveals a (longer) list of all the files you have worked on recently. The Document History can also be accessed via the Windows > Dockable Dialogs menu, where clicking the command opens the history in a separate window. The options included in the File > Create menu are discussed in section 2.2.

Figure 2.3
The Open Recent submenu and the document index window (History)

• NOTE

If you drag an image from your file manager to an image that is already open in GIMP, the image you drag and drop will be inserted as a new layer.

• NOTE

If GIMP fails to open an image and instead issues an error message, it is possible that the filename contains a non-standard character that prevents it from being correctly read. If this is the case, rename the file using conventional characters.

A much easier way to open images is to use your operating system's file manager; in Windows, for instance, you would use Windows Explorer. Operating system file managers offer a preview function for images. All you have to do to open an image in GIMP is drag its thumbnail to the 'Wilber' icon (figure 2.4). The image will then open automatically in a new window. The same thing happens when you drag an image to the empty image window of GIMP at startup.

Figure 2.4
You can drag and drop images into GIMP from the file manager of your operating system.

2.1.3 The Image Window— Your Workspace

The **image window** is the main window that appears when you open an image. This is your workspace. Although initially the window will show your image at full size, you can decrease its size so you can use the remaining space in the window for your palette and tools.

Figure 2.5
The image window is maximized and now also serves as the background window of the program.

The **title bar** displays a thumbnail of the image, the image's filename, its color mode, the number of layers it includes, and its original size in pixels.

In GIMP version 2 and higher, the image window features a **menu bar** where you will find familiar menus such as *File*, *Edit*, *View*, and so on. We will discuss the items in each menu one by one later on. You will also find these menu items in the image window's **context menu** (right-click the image window to open it). Offering the full menu as a context menu of the image window is a specialty of GIMP. In earlier versions of the program, this was the only way to access the menu. Some users find that it's quicker to work within the context menu.

The image window is bordered at the top and left by **rulers**. By default, the rulers measure pixels. However, if you hover the cursor over a ruler and then left-click while holding the mouse button down and pulling, you can drag **guides** into the image. Guides are very helpful for checking an angle or selecting an area you want to crop from the image.

If you click the *Zoom* button (*Zoom image when window size changes*) in the upper-right corner of the image window, you will notice that the image inside the window will automatically adapt to the size of the window.

The two smaller buttons, \Box and \Box , at the bottom left toggle the view between selection and mask modes (more about using these later).

Clicking the **Navigate the image display button will reveal a small preview image of the open file. This is particularly helpful when you have zoomed into the image and want to see how a change affected the entire image without having to zoom out. If you hold your mouse button down, you can move around the image and click on the areas you want to view. You'll notice that the larger image in the window will move in correlation with your movements on the preview image. If you leave the preview window or close the Navigator window, the chosen section remains visible in the image window.

The **status bar** at the bottom of the main window also supplies useful information:

- If you scroll the mouse over the image, the left corner of the status bar reveals the current cursor position in pixel coordinates.
- The next field from the left displays the unit of measure for the rulers.
 The default is px (pixels), but you can opt to display the rulers in inches or millimeters.
- Next, there is a drop-down-menu for the zoom factor so you can quickly enlarge your image. You may also click in the box and type in a value.
- The next field displays the name of the current layer as well as the
 uncompressed file size of the image. When the image has to be rendered,
 for instance, after applying a change that requires a new calculation of
 the image, a progress bar appears in the status line. In addition, a Cancel
 button may appear so that you can stop the process if necessary.
- In general, the status bar is also used to output various values, such as for the Measure tool.

The image window (and all other windows in GIMP) behaves like a typical Windows window. If you move the cursor to the border or to a corner point of the window, the cursor will morph into a dual arrow, enabling you to manipulate the window size by dragging it while holding the left mouse button down.

To move windows on the desktop, click the title bar, and while holding the left mouse button down, pull the window to the desired position.

All program windows feature the three familiar buttons on the upperright corner that minimize, maximize, and close the window.

Figure 2.6
The image and program windows shown running in the new single-window mode

Selecting the *Window > Single-Window Mode* command unites the three basic program windows in a single window, as described in section 1.5.4. The menus, rulers, and buttons are then arranged directly around the currently active image window instead of in the separate, undocked image window used by multi-window mode.

2.1.4 Rotating an Image by Fixed Values

Suppose the image you just opened is rotated 90 degrees clockwise. To set the image straight, click on the image with the right mouse button. From the main menu, select *Image > Transform > Rotate 90° counter-clockwise*.

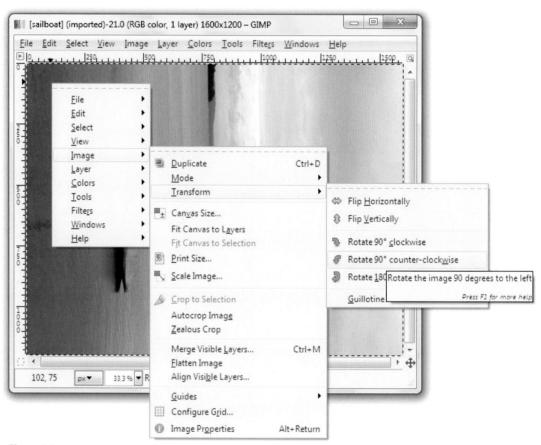

Figure 2.7
The main menu of GIMP will also appear when you right-click on an open image.

2.1.5 Changing the Image View Size (Zooming)

You can zoom in and out on an image by using the *Zoom* tool (*Magnifier*) which can be found in the *Toolbox*. When you click the *Zoom* tool, the cursor will change into a magnifier icon. Clicking the magnifier on your image will enlarge the image, and the spot where you clicked will become the center. If you press the *Ctrl* button, hold it down, and click on the image again, the image section will be reduced in size. You can repeat these steps until your image has been reduced or enlarged to your specifications.

As an alternative, you can use the *Zoom* tool in conjunction with the left mouse button to pull a rectangle over the section of the image you wish to select. When you release the mouse button, the part of the image you "lassoed" with the rectangle will be displayed in the image window.

NOTE

Changing the view size of your image will not affect the actual image or file size. The view options customize how you see the image on your computer screen, allowing for easier editing and detail work.

Figure 2.8
The View > Zoom menu

The *View > Zoom* menu offers options to set the size of an image in the image window:

- **Revert Zoom** returns the window to the zoom level last used.
- Zoom Out makes the image progressively smaller.
- **Zoom In** makes the image progressively larger.
- **Fit Image in Window** makes the image fit inside the existing window.
- **Fill Window** makes the image fill the entire window rather than appear inside it.
- Other lets you customize a scale.

In addition, there are nine specific zoom levels you can use.

The *View* menu has options that allow you to select and hide elements and attributes so you can work on specific areas without distractions. You can also choose to make the guides and grids visible. Choosing a *Snap to* option will cause tools and image objects to automatically orient themselves to the guides and grids. There are two particularly interesting viewing options:

- **Shrink Wrap** resizes the window to the image height or width.
- Fullscreen displays the image so that it fills the entire monitor screen, without a window. Press the F11 key to toggle between fullscreen and the image window.

Remember that the magnification factor (the zoom level) can be quickly adjusted via a drop-down menu at the bottom of the main screen, which is in the status indicator line of the image window. Also remember the symbol in the upper-right corner of the image window (*Zoom image when window size changes*). When you click it, the image zooms in at the same time that you either enlarge or scale down the image window. The *Navigation* window can be accessed by choosing *View > Navigation Window*.

Figure 2.9
The *Navigation* window

You can enlarge the image by using the slider at the bottom of the navigation window. The white frame in the preview image can be moved over the edge of the preview image by pointing into the frame, holding down the left mouse button and moving the mouse. The display in the image window changes as the view in the *Navigation* window changes. This lets you make a quick selection of a certain detail in the image. This dialog can also be opened with the *Window > Dockable Dialogs > Navigation* command and can be docked regardless of which route you take to open it.

The status bar at the foot of the image window contains a drop-down menu for altering the zoom factor. You can either use one of the given magnification factors to change the image size or enter your desired zoom factor directly into the box.

• NOTE

Many settings use a 100% zoom level, which means a pixel in the image corresponds to a pixel of the monitor. The 1:1 enlargement allows you to see changes clearly, for example when using sharpening filters.

• NOTE

Before cropping, check the approximate proportions of your file with the *Image > Scale Image* or *Image > Print Size* command. If you select too small an image size, you will have to upsize the image later, producing a noticeable loss of quality. See sections 2.1.7 and 2.1.8 for more detail on resizing images.

2.1.6 Cropping (Clipping) an Image

The next step involves cropping your image to the 5×7 -inch proportions of a standard print. It makes sense to do this now so that all subsequent alterations are applied only to the relevant parts of the image data.

Cropping with the Crop Tool

For cropping images, the *Crop* tool is available in the *Toolbox*. In general, you can resize your image to any size you wish or crop the image any way you want. Simply click on the image with the tool. Select a point at the top left of the image and drag the cursor to the bottom-right corner point while pressing the left mouse button. This draws a rectangle with a solid border is drawn. At first, the aspect ratio is not relevant. You can drag the rectangle into any form you like. You can use the rulers on the side and top of the window as a guide.

Figure: 2.10
You can crop an image according to the size of your print, select the size you'd like your image to be, and also select the section of the image you want to crop.

Select the *Fixed* option by selecting the check box. You can find the current aspect ratio of the image in the box below the *Fixed* option, measured in pixels. Overwrite this value with the desired aspect ratio of your photo format (in figure 2.10, it's 5:7). If you then draw your rectangle in the image, it will always have this aspect ratio. The advantage is that the rectangle can be drawn up to any size within your image. You can also click in the rectangle and drag it into any position. This lets you very precisely choose the image section you want to keep. Double-click inside your selection to crop the image.

If you want to use the *Crop* tool without a fixed aspect ratio, deselect the *Fixed* setting.

This method is very fast when you want to crop several pictures one after another using the same aspect ratio. However, image size has to be recalculated (again) with the *Image > Scale Image* or *Image > Print Size* function because pixels are being cut out and the image size changes. In fact, it's recommended that you use the *Crop* tool first to set the aspect ratio and to determine the area within the image that you want to keep, and then recalculate the size and resolution. However, if the image section you select is too small and the image is enlarged, the image quality will suffer. The image may appear blurred and pixelated, depending on the method used for recalculating.

Cropping the Image by Numeric Input with the Image > Canvas Size Option

There is a second option for setting the output size: cropping the image numerically. This can be done by using the function *Image > Canvas Size*. It makes the *Set Image Canvas Size* window appear (figure 2.12). Image editing programs call the workspace where the image is displayed the **canvas**. The canvas can be larger than the visible image content, but by default, the canvas size is the same as the image size.

If the canvas is enlarged, an additional image area is displayed around the image. This can be used for adding further image elements or text. However, the actual image remains the same size. See section 3.14.2 for an example of enlarging the canvas to add additional images.

The Procedure

For this example, you have to calculate a bit. The original size is 1200×1600 pixels or 16.67×22.22 inches, the aspect ratio 3:4. Let's say we want to crop to 15×21 inches, with an aspect ratio of 5:7.

- Set the measurement unit to inches.
- Make sure the chain icon next to *Canvas Size* in the upper window is open. If it isn't, click it. This is to remove the link between width and height.
- Set the value for width at 15, and the one for height at 21.

• NOTE

If you want to remove the selection rectangle, simply press the *Esc* key on your keyboard. Generally speaking, hitting the *Esc* key or the *Cancel* button in an open dialog halts the current process and closes the process window.

Figure 2.11
The *Image* menu

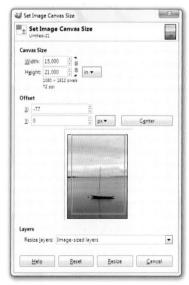

Figure 2.12
The settings of the Set Image Canvas
Size window

- Next, you have to set the offset. This allows you to choose the image section. If you don't, the image will be cropped automatically—on the right and on the bottom, in this case. You can numerically set offsets for the x and y axes. As an alternative, you can click the *Center* button to center the image and crop it equally on both sides. Or you can select the image section by clicking the preview image and moving it within the cropping frame while holding down the left mouse button.
- Under Layers, select the Image-sized layers from the Resize layers drop-down menu. This ensures that the layer really will be cropped to the (smaller) image size. Otherwise, modifying the canvas will only hide the image areas you want to crop, like a photo mount. In that case, the layer would retain its size and be larger than the image. The existing image information would still be at hand but concealed. If you leave Resize layers set to None, you can select the visible image sections in the image window with the Move Tool. To enlarge the layer to image size, you can delete the hidden image information in an additional step by selecting Image > Fit Canvas to Layers.
- Finally, click the *Resize* button to crop the image.

Section 3.14.2 goes into more detail on changing the size of the canvas and how to combine alterations to the canvas with selected objects.

2.1.7 Setting the Image Size and Resolution

The image is now rotated and has the correct aspect ratio for printing. The next step involves setting the absolute size and resolution to approximately 5×7 inches so that two prints fit on a single sheet of paper.

X Scale Image Scale Image Untitled-21 Image Size Width: 5,000 Height: 7,000 in 🕶 1500 × 2100 pixels X resolution: 300,000 300 000 Y resolution: pixels/m Interpolation: Sinc (Lanczos3) • Reset Scale Help Cancel

Figure 2.13
The Scale Image
window. In GIMP 2.8,
this type of window
is capable of performing simple math
functions.

NOTE

As mentioned earlier, you can find all necessary commands in the working menu located on the menu bar above the image as well as in the context menu, which opens when you right-click on the image. If you prefer working with your mouse, the context menu will probably be easier and faster to use. However, if you prefer to work with the keyboard, you'll probably want to use GIMP's keyboard shortcuts. Keyboard shortcuts are displayed next to the corresponding menu items.

The target resolution of the image is 300 dpi. It makes sense to make this adjustment before performing any other corrections, as they will then be applied only to the cropped or resized portions of the image.

Options for setting the size and resolution are located in the image window; just choose *Image* > *Scale Image*.

When the *Scale Image* window pops up, you can set the measurement for *X resolution* to 300 pixels/in (= dpi). In the text field, just overwrite the default value and press *Enter* to accept your changes. Both resolution values should now be 300 pixels/in.

Make sure the chain icon next to the *Image Size* boxes is closed and that the X and Y resolutions are equal (figure 2.13).

The next step is to set the image size (measured in pixels or inches or millimeters). In the upper part of the window, you will see two values: *Width* and *Height*. Use inches as your size unit. To set inches as the measurement unit, click the drop-down menu to the right of the *Height* field and select *inches*. Then enter the number 7 as the value in the *Height* field. Press *Enter* to accept your changes. The value for the width should now be 5.

Now choose the interpolation quality (pixel recalculation). Set *Interpolation* to *Sinc* (*Lanczos3*) in the *Quality* section of the *Scale Image* window. This is the best interpolation method for enlarging an image. Confirm the settings by clicking the *Scale* button. The program will compute the new image size; this also may change the size of the image in the display. To see the entire image in the display, you have a variety of tools to choose from. But first I would like to give you some more information on the relation between resolution and size.

Because this method reinterpolates the pixels, it also affects the quality of the resulting image. You have to use this approach if you want to enlarge an image or reduce it for use on a website or as an e-mail attachment. However, if you want to alter the size of an image for printing, it is preferable to use the *Set Image Print Resolution* dialog described in section 2.1.8, as this alters the size of the image without changing the number of pixels and thus retains the quality of the original.

• NOTE

The fields for numeric input in windows, like *Scale Image*, are now able to do simple math: add (+), subtract (-), multiply (×), and divide (/).

• NOTE

GIMP can be a bit fussy when you're making a selection in the *Scale Image* window. Sometimes it doesn't accept an entry the first time you press *Enter*. Simply repeat the procedure again. I admit I might be imagining this, but pressing the *Enter* key harder seems to help in this case.

• NOTE

Interpolation, the recalculation of the pixel dots during the subsequent computational enlargement of a pixel image, is based on mathematical foundations. The different calculation methods require varying amounts of time and result in various levels of quality. There are four interpolation options to choose from. Cubic calculates new pixel dots from the properties and color values of neighboring pixels. None (no new calculation) simply enlarges the pixels (more about this in the following section). Linear makes an uncomplicated new calculation with a lower quality. Nevertheless, it also processes faster, which is acceptable for very large images. Cubic is the new standard; it results in good quality when you're enlarging images, but it is also supposed to provide better quality for downscaling images. The Sinc (Lanczos3) option provides the best quality for enlarging images. However, it can be problematic for scaling images down because it produces aliasing. Be aware that Sinc is the method that takes the most time.

Try it out if you are not sure what you should choose. The results can vary from image to image.

Since the pixels are being recalculated with this method, it has an effect on the quality of the image. You must apply this function if you want to enlarge the image or scale it down for use on a website or for sending via email. When setting up the image for printing, you may want to have a look at the function described in the next section, which doesn't require any recalculating. The original numbers of pixels and the quality remain the same.

2.1.8 Scaling the Print Size of Images— Converting Resolution and Size

When you open an image imported from your digital camera, GIMP tells you what the image dimensions are in the *Image > Print Size* window. For example, it might read as follows: 1200 pixels \times 1600 pixels = 16.667 inches \times 22.222 inches with a resolution of 72 pixels/inch (the figures in this example refer to the size and resolution of a 2-megapixel image from an older camera). If you want to reduce the image to a print size of 5×7 inches, for instance, you must set the value for *Height* to 7 inches. The size of the uncropped image will be recalculated to 7 inches \times 5.25 inches. The program calculates a new value of approximately 229 pixels/inch (228.571 pixels/inch, to be precise) for the image's resolution. The Print Size function does not change the number of pixels. Therefore, the file size and the information content remain the same. This process does not require a recalculation of the pixels. The quality (= number of pixels = image information) is not changed, just the size of the pixel dots. Depending on whether the pixels are enlarged or shrunk, the dimensions of the image get bigger or smaller. The image is ready for printing at a high quality. The canvas now has to be adjusted to the correct image size (the *Image* > *Canvas Size* option is described in section 2.1.6).

To size your image for use on the Internet, to send via email, or to use on a web page, select Image > Scale Image. Simply leave the resolution at 72 pixels/inch (or 96 pixels/inch) and change the dimensions in inches or millimeters. This will reduce the number of pixels, making a recalculation of the image necessary. The result is a new number of pixels in the image: 378 pixels \times 504 pixels = 5.25×7 inches with a resolution of 72 pixels/inch. Therefore, select Image > Scale Image > Interpolation: Cubic to create the highest-quality image.

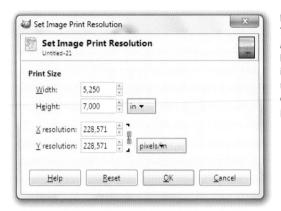

Figure 2.14
The Set Image Print
Resolution window
lets you change the
image size without
reducing image
quality before
printing.

The following representation shows how resolution, image size, and quality interrelate:

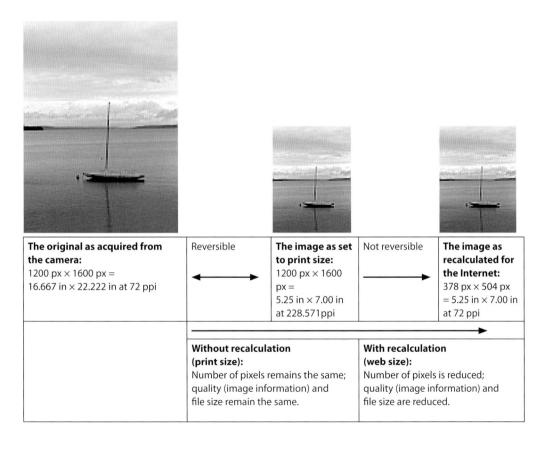

• NOTE

When printing, you should consider the fact that a resolution of less than 150 ppi will often produce poor results, even on a modern inkjet printer. In general, a resolution of 220 ppi is considered the minimum resolution for a good print. If you choose to enlarge an image, you must reduce the resolution by the factor by which you want to enlarge it. In this case, the entire number of pixels remains the same. The resolution and thus the print quality is reduced. To enlarge an image, choose *Image > Print Size*.

There is a way to artificially enlarge an image using interpolation to increase both the size and resolution. This process calculates new image dots and adds them to the image. But if you enlarge an image beyond a certain size with this method, it will usually become mottled and blurred. The existing image information is simply enlarged, and no additional details can be added later through calculation. Existing flaws in the image are enlarged too, such as edges that appear from sharpening the image in GIMP. That said, there are qualitative differences that depend on the interpolation method. Tests with enlargements of a factor of 16x have yielded satisfactory results. My own experience has shown that image editing programs such as GIMP can produce satisfactory results with a factor of 2x to 4x. The source of the image affects the quality. If it has a lot of contrast, sharpness, and detail, you can enlarge it more than if it is faint and blurred. You can enlarge as well as reduce images by selecting *Image* > *Scale Image*.

2.1.9 Saving Your Image

Now that you've finished editing the image, it's time to save it. In fact, you'd be wise to make a habit of saving—or exporting—any image that you are planning to modify immediately after opening it. Just save it as a new file with its own filename. This preparatory step will ensure several things:

- Your original will remain unchanged.
- You will not overwrite your original by mistake.
- You can save any desired change to the new image immediately.

While you are working on an image, it is recommended that you save it in XCF format. Only this file format offers the capability to save all changes available with GIMP. Otherwise, for saving photos after optimizing, export the images to a file format such as TIFF or PNG for your working image. These formats guarantee the best image quality. Of course, if the image contains layers, GIMP will limit your format choice to XCF or PSD.

Compressed files in JPEG or GIF format should be created only as copies of the original or working image.

The submenus for saving images are in the menu bar of the image window. The *File* menu offers a number of options.

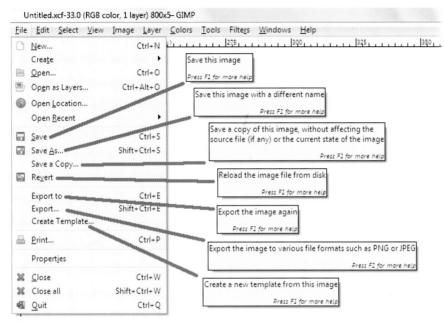

Figure 2.15
The File menu in the image window, showing the new Export options

Figure 2.16
The standard version of the Save Image dialog. This dialog lets you save in XCF or compressed XCF format. The elements are similar to those of the dialog Open File. (Figure 2.17 shows the dialog with all panes open.)

Save: Choose this option if you want to save an image for the first time using GIMP's native XCF format. At this point, you can also choose a new filename. If you are saving an image that has already been saved to XCF, performing this step will overwrite the previous version.

Saving an image cannot be undone. However, if you have not yet closed an image, you can return it to a previous state by using the *Document History* dialog. I highly recommend saving your image whenever you modify it to your liking. This will ensure that you won't lose your work in the case of a power outage or program crash.

Figure 2.17The *Save Image* dialog with the additional pane for saving in compressed XCF format

Save As: Select this option if your image is new or if you want to save your image under a different filename in XCF format.

Clicking the Save As menu item opens a new Save Image dialog window. Here you can enter a name and a filename extension for the image that you intend to save in the text field labeled Name. The Save in folder drop-down list displays the location where the last image you saved was stored. Click the arrow to display the options and select the folder you wish to store the image

in. Click the + sign next to *Browse for other folders* to enlarge the window and to show the pane of the file browser, much like in the *Open Image* dialog. This file browser will let you find and select the folder you want to save your image in. Or you can create a new folder by clicking the *Create Folder* button. Clicking the + sign next to the *Select File Type (By Extension)* opens a new window in which you can select XCF or bzip and gzip archive formats for your image. The zip archive formats enable you to reduce the size of your files by up to 33%. GIMP can open *.xcf.bzip and *.xcf.gzip files as editable images, but you can use popular zipping programs such as 7-Zip to unpack them too.

Save a Copy: This command allows you to save a copy of your image in XCF format, or as a bzip or gzip archive. This action does not overwrite the original image that you are working on, but instead saves it in its current state as a new file with a new name. This command is useful if you wish to save and archive various stages of the editing.

Revert: If you are working on a previously edited image, you might find that you have performed too many steps for the *Undo History* dialog to record. If this is the case, you can revert to a previous state by closing your image wthout saving and opening it again with the *File* > *Revert* command. This opens the file in the state in which it was last saved. Note that this action deletes all steps recorded in the *Undo History* dialog since the image was last saved.

Figure 2.18
The Export Image window showing the open File Type menu

• NOTE

Use the Save or Save As option if you want to save your image in the high-quality native XCF format, and especially if your image contains layer-based adjustments or layer masks. This is the only way to be absolutely sure that all of your adjustments are saved intact.

As an alternative, you can use the *Export* command to hand over your image to Photoshop and save it in PSD format. This makes sense if you want to edit layer adjustments with other image processing software, as GIMP's XCF format is only supported by GIMP itself. However, please note that saving an image as a PSD file can lead to the loss of some path or raster settings (see section 5.3). Use the *Export* command to save to all other file formats.

• NOTE

If you use the Save a Copy command, the image displayed in the program window is the original, not the copy, enabling you to continue smoothly with your image processing.

• TIP

▶ It is a good idea to create a separate folder for your exercises. (Just click the *Create Folder* button in the upper-left portion of the *Export Image* dialog.)

• TIP

► Always export layer-based images to a layer-compatible format (xcf or psd) before exporting them to other formats.

• TIP

▶ When you export an image to a different format, the image displayed in the program window is the original, not the exported copy, thus enabling you to carry on editing. Take care to save your original separately in a suitable format, such as XCF.

If you wish to edit the version you have just exported, you have to use the *File* > *Open* command. You can also continue to work on your original and export a newer version to the same filename as before, which will then overwrite the previously exported version.

• NOTE

GIMP sometimes fails to export images, especially to PDF and PSD. This is often due to country-specific, non-standard characters in the path or filename (ä or ü, for example). This problem can be simply solved by renaming the files and folders concerned and replacing any non-standard characters with ones from your operating system's standard character set.

The *Export* option is new in GIMP 2.8 and is designed for saving an open image to formats other than GIMP'S native XCF. In other words, if you want to save an image to JPEG, TIFF or PNG, always use the *File* > *Export* command.

Always choose a high-quality file format for saving and archiving your images. When you use the Export Image dialog, you can type in a filename extension or select a file type from the *Select File Type (By Extension)* dropdown list in the dialog. The list includes the JPEG, TIFF, and PNG formats, all with compression.

Some of these formats then open another dialog that will prompt you for desired image file attributes. For the TIFF format, select *LZW Compression*. This compression method is lossless and reduces the file size. The remaining format options should be selected only when you are saving them for your own use. If you want to pass the image on to other programs, you should be aware that not all programs support the other file formats or can even open them. Click *OK* to accept. Now your image is "in the can".

When you're exporting an image, the layers it contains will usually be merged into one background layer if you chose a file type (TIFF, JPEG, etc.) that is unable to save layers.

Figure 2.19 The TIFF saving option in GIMP

Create Template: You can also create your own templates with custom image dimensions and attributes. This is particularly useful if, for example, you need to create a series of images with the same dimensions, background, and resolution using a single file format. All you have to do is create a new file with the appropriate attributes and save it using the *File > Create Template* command. Once you have created a template, it will be included in the list in the *Template* drop-down in the *File > Create a New Image* dialog.

2.1.10 Before Printing—Calibrating Monitors and Color Management

The default settings of your equipment, monitor, and printer should work with GIMP without any problems. Should you, however, have any problems printing or find that the printout is too dark or there are color distortions, the information in the following sections will be helpful.

Essential Monitor Settings

Every device (scanner, monitor, printer) has a slightly different color calibration. You can add a color profile to the image so that the color is consistent on all the devices and color shifts can be kept to a minimum. There are two ways to ensure consistent color reproduction on all output equipment.

It may be enough to select a suitable color profile for your monitor and to adjust it to GIMP (or any other editing program). Should the printout still deviate from your screen rendition, you can calibrate your monitor. When you calibrate your monitor, you are optimizing the color rendition and its gamma value (grayscale contrast and brightness) to ensure that the images on the screen have the correct color and brightness values.

There are some basic settings you can change: Adjust the monitor's color depth in the system preferences of your operating system to the highest value. Normally, this will be 32-bit color depth in Windows (24-bit color plus 8-bit alpha channel for transparencies), and for Mac OS X it will be 24-bit color depth. In older versions of Windows, you can find the setting under Start Menu > Control Panel > Category: Appearance and Personalization > Adjust screen resolution. In Windows 7, 32-bit color depth is the default setting. If you have problems with color reproduction, navigate to Control Panel > Appearance and Personalization > Adjust Screen Resolution. From there, click Advanced Settings and select the Monitor tab to make appropriate adjustments.

Furthermore, you have the option of adjusting the settings of the monitor itself. At least for CRT (tube) monitors, set the color temperature to 6500 K (Kelvin), set the contrast to 100% (LCD monitors about 50%), and adjust the brightness. Ideally, you should use a monitor calibrating system.

Selecting a Ready-Made Color Profile

You can find ready-made color profiles for monitors for **Windows Vista and Windows 7** in *Control Panel* under *All Control Panel Items > Color Management*. You can select a color profile as the default setting. For **Windows XP**, you can download a program called **Microsoft Color Control Panel Applet for Windows XP** from the Microsoft website. To install the color profiles, you will need this program. In Windows, you can find all the preinstalled color profiles in *C:\WINDOWS\system32\spool\drivers\color*.

• NOTE

Daylight has an approximate color temperature of 6500 Kelvin. Many monitors are calibrated for a higher color temperature, which lets white appear as more of a bluish tone and slightly shifts the color spectrum. For color prints, you should save your images in the sRGB color profile; sRGB sets white at 6500 K and the gamma value at 2.2.

• NOTE

For Windows, you should set the standard gamma value at 2.2, and for Mac OS at 1.8. The same image will appear darker on the Mac screen compared to Windows. You can calibrate the gamma value under the same path. **GammaToggle** for Mac OS, a free shareware program for private users, offers a way to easily change the standard gamma value. More at: www.thankyouware.com/gammatoggle.html.

Even if you want to calibrate the monitor, it can be wise to set it to the color profile *sRGB.icc* beforehand. This color profile is used as a basis for Windows as well as the Internet. It can be used in every program that has color management, including GIMP.

In Mac OS X, you select the preinstalled color profile for your monitor by choosing System *Preferences > Displays > Color*.

Adjusting the Display with a Calibrating Program

The previously mentioned changes in your default settings lay a good foundation for rendering color on your monitor and for editing your images. Should your images still have strong variances in color and brightness when you print them, you can try using a calibration program.

There are programs that are able to achieve a comprehensive and exact calibration of your monitor. They use a device that measures and calibrates the display of your monitor. For amateur photographers, an affordable calibration program with a measuring instrument is **Spyder4Express** from **Datacolor**: spyder.datacolor.com/portfolio-view/spyder4express. If you would like to dig a little deeper, you can find information on **Norman Koren**'s website at www.normankoren.com.

You can also find programs that just work with the monitor settings without using measuring devices. If you have installed Adobe Photoshop up to CS or Photoshop Elements up to version 5, you can use **Adobe Gamma Loader** in Windows and Mac OS X. The *Gamma Loader* is not included in newer versions. In Windows, you will find it in *Control Panel*. This assistant will help you through the steps to create a color profile for the monitor and optimize the gamma value. An individual color profile is created for your monitor.

Even without Adobe, you can download **QuickGamma**, a free program for Windows, at quickgamma.de. The help function in the program will lead you through the procedure of calibrating you monitor. For QuickGamma, you should set your monitor to sRGB beforehand.

Here are some other freeware monitor calibrating programs:

- Monitor Calibration Wizard (Windows): www.hex2bit.com/products/ product_mcw.asp
- CalibrationAider (Windows, Mac OS X, Linux): www.imagingassociates. com.au/color/software/calibrationaider.jspx#download
- Monica (Linux): freecode.com/projects/monica

You can use an assistant program to calibrate you monitor under Mac OS X; choose *System Preferences > Display > Colors > Calibrate*. An individual profile will be created for the monitor. You can also load the color profile default setting. All installed color profiles for Mac OS can be found in *Applications/Utilities/ColorSync/Profiles*.

From Vista on, Windows also offers its own monitor calibration settings, which can be found under *Start Menu > Control Panel View by: Large icons):* > *Display > Calibrate color*. The application then guides you through the necessary steps.

Color Management in GIMP

Apart from calibrating your monitor, you can install an updated driver to get rid of problems with color rendition and brightness in your prints. Generally speaking, the home printer and photo printer can't be calibrated. This option is only available for professional printers. Nevertheless, with the help of color profiles, most printers can be adjusted to the color rendition of monitors and programs. This is where color management is necessary in GIMP. Since GIMP 2.4, it has been a standard feature.

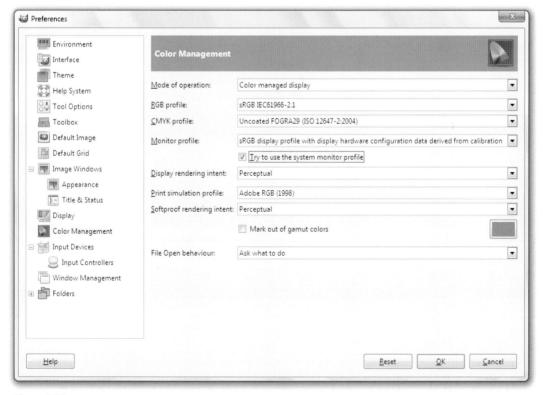

Figure 2.20 GIMP's color management settings

• NOTE

The sRGB color profile is optimized for gamma 2.2 and a color temperature of 6500 Kelvin (D65) and hence for your monitor, for the web, and for prints ordered from a lab. Adobe RGB may be better for printing your pictures on an inkjet printer.

You can find the *Color Management* settings (*Edit* > *Preferences*) in the image window. GIMP doesn't have color profiles in its program. If you want to use color profiles in GIMP, you can load them into the program via *Preferences: Color Management*. From the appropriate drop-down menu, for instance the one at *RGB profile* (figure 2.20), choose *Select Color Profile from Disk* and search your computer for the color profile. In Windows, you will find this under *C:\WINDOWS\system32\spool\drivers\color*, and in Mac OS X, under *Applications/Utilities/ColorSync/Profiles*.

Users who have installed Adobe Photoshop or Photoshop Elements can use the Adobe color profiles in GIMP. If you are interested in using Adobe RGB, you can download the Adobe RGB and CMYK profiles for Windows and Mac OS from Adobe's website at www.adobe.com/downloads, toward the bottom of the page.

In summary, your best choice is to set up your monitor and GIMP with the sRGB color profile. The gamma value will be 2.2 (also for Mac) and the color temperature will be set to D65 (6500 K). If your prints still deviate from how they look on your monitor, you can try the following:

- · Update your printer driver.
- Calibrate your monitor with the previously mentioned programs.

2.1.11 Printing Images

To print images from within GIMP, you'll obviously need to connect a printer to your computer and make sure a recent driver is installed. You can usually find drivers via a *Download* or *Support* link on the printer manufacturer's website. **Gutenprint** offers drivers for Linux and Mac OS X at gimp-print. sourceforge.net.

Altogether, Gutenprint has over 700 drivers available that work with CUPS, LPR, LPRng, and other UNIX printing systems. Therefore, you can use the GNU General Public License (GPL) released drivers not only for Linux but also for Mac OS X. Some of the developers promise that their drivers have a higher printing quality than that of the manufacturers.

Gutenprint used to be called Gimp-print. The name was changed to clarify that it isn't just a plug-in for GIMP. Nevertheless, the plug-in for GIMP remains in the assortment of drivers. Gutenprint also encompasses CUPS and Ghostscript, and it supports Foomatic.

After you install your driver, the operating system recognizes your printer automatically when you plug it into the USB port. You can select your standard printer in the print preferences (in Windows, *Start menu > Devices and Printers*). Whether your printer is connected to a parallel port or a USB port can be a

factor. Older GIMP versions recognize some printers at the parallel port only, even though the printer works flawlessly over the USB port when accessed from within other programs. With a newer version of GIMP, it shouldn't be a problem anymore. If you should still have any problems, you can find help in various forums online. A list of current forums can be found at: www.gimpusers.com/forums.

Nevertheless, driver problems can arise, preventing you from printing directly from the GIMP program. Epson printers seem to have the most problems. But you can work around most of these problems by printing your images from another program, such as **IrfanView**.

The **Print** dialog is found in the image window under the *File > Print* menu. You'll see a standard Windows print dialog to which GIMP adds an *Image Settings* tab. If you installed a print program specific to your printer, a device-dependent program window will appear that you can use to configure your settings.

The following settings are available in the GIMP *Print* dialog:

- Select Printer—A drop-down list for selecting the appropriate printer if
 you have more than one printer installed. This is also where you would
 select the printer at the parallel port (LPT1).
- Page Range—These options are used to print specific pages of a multipage document, such as an EPS or PostScript (PS) file.
- Number of copies—This is where you enter the number of copies you want to print.

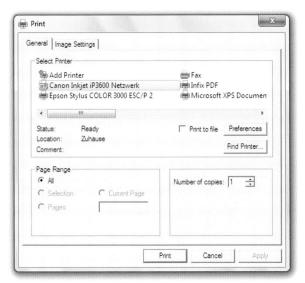

Figure 2.21 The standard Windows *Print* dialog

Clicking the *Preferences* button opens a dialog in which you can set the following options, depending on your printer:

- Page orientation (*Portrait* or *Landscape*)
- Media Choice (type of paper)
- Print type (color, gray levels, or black and white)
- Resolution (sometimes set automatically, depending on the paper selected)

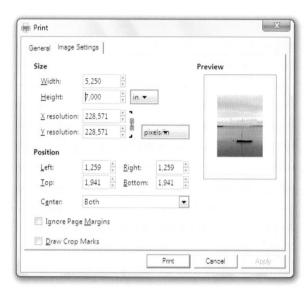

Figure 2.22
The Print dialog showing GIMP's Image Settings tab. Here you can configure the page setup, image size, and image position, and apply a frame to your image.

• NOTE

Most large photo labs print with a resolution of 300 dpi and accept only the JPEG file format. If you plan to take your images to a photo lab, collect and save them in 300 dpi resolution and JPEG format before burning them to a CD or uploading them to the photo service's website.

Depending on your printer, there may be more settings available, such as paper size and other variables.

On the GIMP-specific *Image Settings* tab are various options to configure the page setup, the image size, and the position of the image on the page, as well as to apply a frame to your image.

Keep in mind that you can always burn your images to a CD and have them printed at a photo shop.

2.2 Working with Scanned Images

Of course, you can edit scanned images in GIMP in addition to images from your digital camera. The following sections include detailed instructions for working with scanned images.

2.2.1 Prerequisites for Scanning

Before you can read an image from a scanner in an image editing program in Windows, you must properly connect the scanner to your computer and install the scanning program that came with the device. If you use Linux, you can use the XSane interface.

What image editing programs generally do is provide a scanning connection (usually referred to as the TWAIN source for the Windows platform and Scanner Access Now Easy (SANE) if you're using Linux or Mac OS). An independent scanning program or XSane is necessary for scanning and can be accessed from within the image editing program. Scanning under Windows is described in section 2.2.5; the same process works on all operating systems.

As mentioned earlier, scanning in Linux is supported by the SANE library. You can find SANE in many Linux distributions, including SUSE Linux. The graphical user interface for scanning is called xscanimage or XSane. If you've already installed SANE and XSane, it can be accessed by choosing *File > Create > XSane: Device Selection* (i.e., your scanner) in the *Toolbox*.

XSane provides a graphical user interface that allows you to choose settings for the current scan process, with steps that are similar to those described in section 2.2.5.

Additional information about SANE and XSane can be found on the web at the following locations:

- www.sane-project.org
- www.xsane.org

The SANE library is also helpful for those running Mac OS X. From within the GIMP program, it is accessed over a TWAIN-SANE interface. Mattias Ellert offers the required installation files (Mac OS X binary packages) for download at www.ellert.se/twain-sane.

Depending on your scanner, you may need to customize a few settings after installation for it to work optimally. Information regarding optimal scanner settings can be found on Mattias Ellert's site and on the SANE Project website listed above.

2.2.2 How Scanners Work

Flatbed and slide scanners are popular with many home computer users. Following is a brief summary of how these scanners work and their most important technical features. Flatbed and slide scanners are sometimes used in professional environments in addition to higher-resolution drum scanners.

The decisive factor when choosing a good scanner is it's physical resolution, that is to say, not its interpolated resolution. **Flatbed scanners have a physical resolution of 300/600/1200/2400/4800 dpi and higher.** Keep in mind that the higher numbers boasted by scanners utilizing so-called interpolated resolutions are calculated by "adding" image dots. This type of interpolation (supersampling) doesn't actually increase the accuracy or quality of an image, and you can interpolate your image by using an image editing program.

When using a **flatbed scanner**, place the original face down on the glass plate. Underneath that plate is a sled that carries the scan head on two rails. The head consists of light-emitting components and sensors that measure the light values reflected from the original image and subsequently relay them to the computer as image data. The physical resolution achieved is dependent on the number of light elements and sensors as well as the increments captured as the scan head moves.

There are two types of flatbed scanners: single-pass scanners and three-pass scanners.

In a single-pass scanner, the sled passes only once underneath the original image, capturing the color values for the three primary colors at once. Three-pass scanners use three passes, one pass for each of the primary colors—red, green, and blue.

Some flatbed scanners provide additional features, such as automatic page feeders, and mounts you can use to hold small photos, transparencies, and negatives in place. These negatives and slides are scanned like prints. However, they are exposed to light from both sides so that the scanner can detect the images.

Slide scanners use either the same technical principle as flatbed scanners or a sensor that is similar to the sensor in a digital camera. The maximum resolution depends on the arrangement and density of the sensors on the chip. The highest resolution that can be achieved is dependent on the alignment and density of the sensors or of the photosites on each sensor. Most chips scan up to 4800 dpi, and professional devices provide even higher resolutions. However, many of the scanners in the home user segment accept only mounted slides or film negatives. Professional equipment, on the other hand, can work with medium and larger film formats.

2.2.3 Problems When Scanning Printed Originals—the Moiré Effect

Printed original images—postcards, magazines, books, calendars—are often poorly suited for scanning. The grid pattern of the print may differ from the one on the scanner and cause rippling or superimposed halftone screens, resulting in an interference pattern on the scan, referred to as the **moiré effect**.

Some scanning programs have wizards that automatically prevent the moiré effect. Many image editing programs have several effect filters, such as the *Gaussian Blur* filter in GIMP, that can be used to reduce or remove the moiré effect. Section 2.2.10 provides a detailed description of this function.

Most modern scanning programs are equipped with a prophylactic filter that can be used before the image is transferred to the image editing program to prevent the moiré effect.

Figure 2.23

2.2.4 Calculations to Consider before Scanning

Before you scan something, consider the following:

- 1. How large is the image? (Determine its original size.)
- How large will your scanned image be? (Determine its output size.)
 Enlarging or reducing an image with your scanner will affect the resolution.
- 3. Which output medium are you creating the image for? Internet, screen, or print? Always opt for the highest-quality resolution appropriate to a given medium. (As mentioned earlier, an image for the web will be in a lower resolution than an image for print.)
- 4. What is the color depth—text (black and white), grayscale image (black and white), or full color?

Color Depth				
	Line art, text (one color, bitmap)	Grayscale (BW photo)	Special GIF (indexed colors)	Color (color photo)
Color depth	1 bit	8 bits	8 bits	24 bits (true color)
Power of two	21	28	28	$2^8 \times 2^8 \times 2^8$
Number of color values	2	256	256	approx. 16.78 million

Selecting a Resolution

Let's review resolution because it is tremendously important. The resolution determines the number of image dots (pixels) per length unit (inch or centimeter) in any given image. The screen resolution is normally measured in dots per inch (dpi). In the printing industry, the resolution of the printing screen is usually calculated on the basis of the number of lines per inch.

When scanning original documents on a flatbed scanner for printing purposes, you should select the highest possible resolution. If the image is to be printed in its original size, 300 dpi is a good standard.

When scanning images for publication on the web, it is a good idea to initially select a higher resolution for editing purposes. A high resolution will keep the sharpness and contrast of the image high while you edit, even if you'll eventually be reducing the resolution. Remember to reduce the resolution on a copy of the original image because the process cannot be reversed.

Formula for the Scanning Resolution

When you scan original materials, you can calculate a scanning resolution for your print output. (Professional scanners achieve a much higher resolution than flatbed scanners manufactured for home use.)

Resolution (desired) \times scaling factor \times scanning factor = scanning resolution

A scanning factor between 1.4 and 2.0, inclusive, will normally provide a good result.

Example

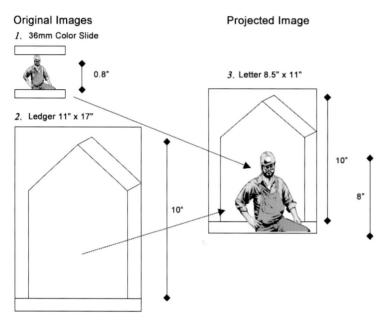

Figure 2.24 An example for scanning

Scaling factor = desired size/original size

For **screen output**, you should initially aim for a target resolution of 100 dpi (rounded up from 96 dpi):

- 1. In the example, the worker in the miniature slide measures 0.8 inches in the original image. Let's say that you want him to be 8 inches in the screen output. This means you have a scaling factor of 10, so you would select 2 as your scanning factor.
- 2. The house measures 10 inches in the original, and you want it to be 8 inches in the new image. So you reduce it, obtaining a scaling factor of 0.8. Again, you can choose a scanning factor of 2.

Calculation by the formula:

- Resolution (desired) for 1 is 100 dpi; for 2 it's 100 dpi
- Scaling factor for 1 is 8 in \div 0.8 in = 10; for 2 it's 8 in \div 10 in = 0.8
- Scanning factor (selected) for 1 is 2; for 2 it's 2
- Scanning resolution for 1 is 100 dpi \times 10 \times 2 = 2000 dpi
- Scanning resolution for 2 is 100 dpi \times 0.8 \times 2 = 160 dpi

In European countries, the resolution for **print output** is measured in lines or dots per centimeter. For our image, let's select a target resolution of 60 dots per centimeter, which is multiplied by 2.54 to convert it to dpi. The other settings remain the same.

Calculation by the formula:

- Printer screen (selected) for 1 is 60 dot/cm; for 2 it's 60 dot/cm
- Resolution (calculated) for 1 is $60 \times 2.54 = 150$ dpi; for 2 it's $60 \times 2.54 = 150$ dpi (rounded)
- Scaling factor for 1 is 8 in \div 0.8 in = 10; for 2 it's 8 in \div 10 in = 0.8 (rounded)
- Scanning factor (selected) for 1 is 2; for 2 it's 2
- Scanning resolution for 1 is 150 dpi \times 10 \times 2 = 3000 dpi
- Scanning resolution for 2 is 150 dpi \times 0.8 \times 2 = 240 dpi

2.2.5 Scanning and Editing an Image

The Procedure

We've come to the point where you've decided to scan a document, import it to GIMP, and use the various editing tools to modify your image. The following sections describe how to use these editing tools.

As mentioned earlier, a separate program (usually the scanning program that came with your scanner) actually processes a scan, even though you're capturing the image within the image editing program. Because scanning programs vary according to the make and model of the scanner, the example dialogs may be slightly different than what you will actually see on your computer screen.

To scan an image from within GIMP, select *File > Create*.

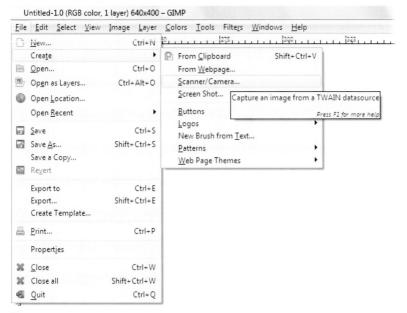

Figure 2.25The *File > Create* menu for the scanner/camera

You now have the following choices:

- You can choose Create > From Clipboard to load an image that you
 previously copied on the clipboard (using the Copy menu item or the
 Ctrl+C keystroke) as a new image in GIMP.
- Use the File > Create > Screenshot command to create screenshots from within GIMP. The command offers options for capturing the entire screen or just individual windows. Once captured, new screenshots are automatically opened in a new GIMP image window.
- You can choose Scanner/Camera if you want to scan an image or download an image from your camera. This opens a dialog in which you can select your scanner or any other active XSane, TWAIN, or WIA source.

For this exercise, choose *Scanner/Camera*. This opens the *Select Source* window, where you can select your scanner (or any other device that is attached to your computer as a TWAIN source, such as your camera). In the Select Source window, select your scanner and click the *Select* button to accept your choice (figure 2.26).

If both your scanner and your scanner's software were properly installed, a dialog box specific to your scanner will appear. Because this dialog comes directly from your scanner's software rather than GIMP, it might look and work a little differently than in the example. If you are a Linux user, you will be using the XSane program instead.

• NOTE

Screenshots can be created in Windows by using the Ctrl+Print Screen (PrtScn) keystroke. The resulting data is stored on the clipboard, and can be opened as a new image or pasted into an existing one. To do this in GIMP, use the File > Create > From Clipboard command.

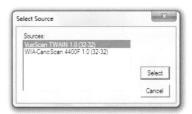

Figure 2.26The *Select Source* dialog

• NOTE

TWAIN is an acronym for Technology Without An Interesting Name; it's also the standard "name" used when referring to image capturing devices for the Windows platform. Microsoft's WIA (Windows Image Acquisition) standard is comparable to TWAIN, but is reported to be more flexible and easier to use.

With the material or image you want to capture placed face down on the scanner, you can use the scanner's dialog to determine how it will be scanned. Most scanning programs provide the following options:

- Number of colors to be scanned, i.e., color depth (black and white, grayscale, color).
- Original document type, such as text, image, or film. Some scanners come with an add-on device that allows scanning of photo negatives and slides.
- Scanning resolution (usually selectable in predefined values, given in dpi).

Furthermore, you normally find two buttons:

- A Preview button that activates a low-resolution preview scan
- A Scan button that starts the scanning process

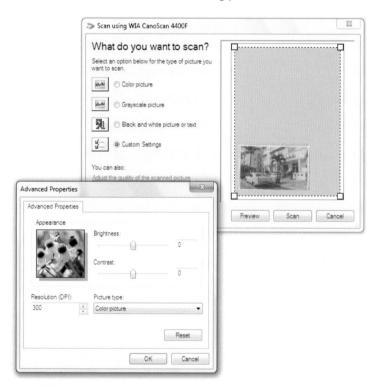

Figure 2.27 Windows WIA scan program dialog

Insert your original image in the scanner. If you click the *Preview* button, the image will be quickly scanned and displayed in the preview window. The scan software will automatically identify the image margins and mark them with a dashed line that is sometimes referred to as the selection frame or marquee. You can resize the selection frame by hovering the mouse above it and then clicking and dragging the dashed line until you've selected the area of the image you want to scan.

Click the Scan button to activate the actual scan process.

Once the image is read, GIMP will open a new document for the scanned image. Close the scanning program, and don't forget to save the new image.

Exercise: Try to scan an image from within GIMP, following the given procedures.

2.2.6 Typical Errors in Scanned Images

To help you practice the editing steps that follow, you'll find an image called *miami-scann.tif* in the *SampleImages* folder on the included DVD. Open the file (select *File > Open*) and save (or export) it as *miami-base* in an exercise folder on your hard disk. Save the image in a high-quality file format, such as XCF or TIFF.

After you open the file, you may notice a few defects. The image tilts to the right because it wasn't inserted properly in the scanner.

In addition, the borders of the image jut out because it wasn't properly cut, so it needs to be cropped.

The image also suffers from the **moiré effect** caused by an interference of the dot pattern of the print with the dot pattern of the scanner. This particular image was captured from a newspaper; this type of moiré effect does not occur in scanned photographs.

Figure 2.28 GIMP's image window displaying the *miami-scann.tif* image. (Photo by Claudius Seidl).

2.2.7 Setting the Image and Determining the Angle—Measuring

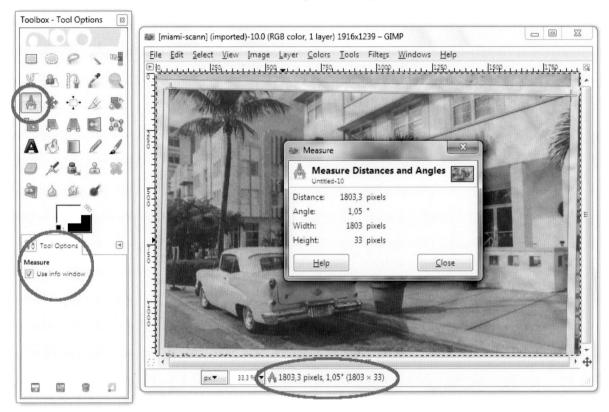

Figure 2.29
Using the *Measure* tool to determine the image angle. By default, the measured values are displayed in the status bar at the bottom of the image window. As an alternative, you can select the *Use info window* display option located in the *Tool Options* tab.

Obviously, the image needs to be straightened out. To specify the rotation angle, drag a guide on the image. Click the top ruler, and while holding down the left mouse button, drag it downward. Position the guide on the upper-left corner of the image. You now have a horizontal check mark.

Using the *Measure* tool , you can, for example, measure the angle of the tilt so you can use the same amount to rotate the image upright. Select the *Measure* tool in the *Toolbox*. Check the *Use Info Window* option to open a window that will show the values obtained by the *Measure* tool. For your convenience, the measured values are also displayed in the status bar at the bottom of the image window.

The cursor should have changed into a crosshair marker or sighting reference. Click on the upper-left corner of the image while holding down the left mouse button and drag it to the upper-right corner of the photo. The status bar (and the *info* window if you opened it) now shows an angle of approximately 1 degree, the exact amount to rotate the image in order to undo the tilt.

2.2.8 Rotating an Image—Using the Rotate Tool

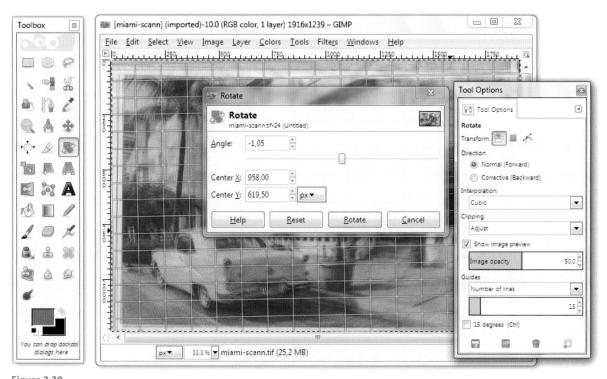

The angle was measured with the *Measure* tool, and now the measurement needs to be entered in the *Rotate* dialog's *Angle* text box. You can also use the slider beneath the text box. Note that the rotation is counterclockwise; therefore, a minus sign is used before the numerical entry.

Rotate a Layer, Selection, or Path

Select the *Rotate* tool: From the *Toolbox*. Then, under *Rotate*, select the layer option next to *Transform*. You can also access this tool by choosing *Tools* > *Transform Tools* > *Rotate*.

Let's take a detailed look at the options available for the Rotate tool:

- **Transform**: Use this option to choose what should be affected by the transform. You can affect the active layer, selection, or path.
- Direction: This option sets the direction in which a layer will be rotated.
 Normal rotates the layer clockwise; Corrective rotates it counterclockwise.

 You can also change the rotation direction by entering a (negative) rotation angle.
- **Interpolation**: Select *Cubic* or *Sinc* from the drop-down list to determine how missing pixels should be calculated from surrounding pixels.

- **Clipping**: You can select whether the transformed layer will be adapted to the new image size or to the original dimensions of the layer.
- Show image preview: Here, you can adjust the opacity of the rotated image. The layer you are altering will then be shown superimposed on the original while you rotate it.
- **Guides**: This drop-down contains options for selecting the number and type of guides you use while rotating an image.
- 15 degrees (Ctrl): This option allows you to rotate to angles divisible by
 15 degrees.

• NOTE

GIMP uses a comma instead of the decimal point.

• TIP

All tools available in the *Toolbox* can also be accessed from the *Tools* menu in the image window.

Start by rotating the image. With the *Rotate* tool selected, click on the image. The *Rotate* dialog pops up. Enter a rotation angle by typing over the default value. If you selected the *Normal* transform direction, the value entered for the rotation angle in this case must be negative.

You can also set a rotation angle by clicking the arrows or using the slider. If you want to rotate an image manually, click on the image and drag or shift with the mouse while holding the left mouse button.

In the *Rotate* dialog, you'll find the options *Center X* and *Center Y*. Use these options to select a **rotation point** other than the image center point (which is the default setting).

Click the *Rotate* button to accept your changes. The image will be straightened out automatically.

2.2.9 Cropping an Image—the Crop Tool

Now that your image is in an upright position, you'll want to crop the jutting borders. The *Crop* tool was introduced in section 2.1.6. In this section, I'll show you the steps to take to crop this image:

- 1. Use the guides to highlight the borders, and then select the *Crop* tool from the *Toolbox*. The mouse pointer will again change to a crosshair cursor.
- Point the cursor to the upper-left corner of the desired image section.
 Click while holding down the left mouse button; then drag it over the image to the lower-right corner. Release the mouse button. The area outside the section you traced is now masked dark.
- 3. You can correct the strips at the edges by pointing the cursor at the sides or corners of the highlighted rectangle and dragging it.
- 4. When you are satisfied with the boundaries of your selection, click on the selected image or press *Enter* and the image will be cropped.

For this exercise, you left the *Crop* tool at its default settings, without selecting the *Fixed: Aspect ratio* check box. The default lets you use the tool freely, without any restrictions.

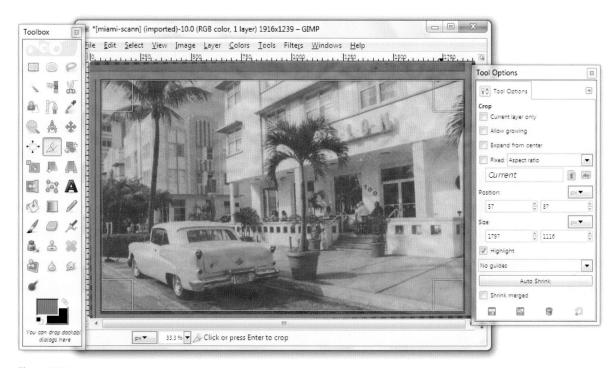

Figure 2.31
The *Crop* tool and its options

2.2.10 Using the Gaussian Blur Filter to Remove the Moiré Effect

Next, you'll want to remove the moiré effect from the image. For this action, you will use a filter called *Gaussian Blur* (Filters > Blur > Gaussian Blur).

After selecting the *Gaussian Blur* filter, use the dialog to set the amount of blur desired. A higher value will produce more blur.

The filter can also be used to blur the background of an image. If you paste a sharply drawn object in the

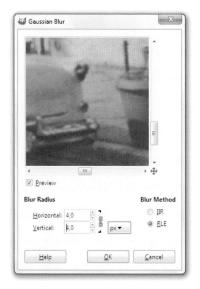

Figure 2.32 The Gaussian Blur window

• NOTE

The Gaussian Blur dialog provides a preview with an image section so that you can see the effect of your settings. Many filter dialogs offer such a preview. Click on the image with your left mouse button and move the preview image slightly to view the unfiltered version of the image. Let go to see the filtered image. In the bottom-right corner of the preview pane, there is a double arrow. Clicking on the arrow pops up a smaller preview window showing the complete image. As in the Navigation window, you can now use your mouse, left mouse button down, to select the image section in the preview.

NOTE

In general, you should only apply filters to a copy of an image that you have already edited and saved. However, a different approach is required when applying filters such as *Gaussian Blur* that are designed to improve image quality. In this case, the filter should be used to remove moiré effects before you make any other adjustments—especially those that accentuate moiré, such as an increase in contrast. You can find more information on the use of filters and image effects in section 2.6.

foreground, it will seem even clearer in contrast to the blurred background because the image gains more depth.

However, since in this case you are concerned only with correcting the moiré effect, the image should retain most of its contour sharpness.

In the *Gaussian Blur* dialog, select the *RLE* option. (RLE stands for runlength encoding, an algorithm for lossless data compression. Repeating values are replaced by specifying a value and a counter.)

Enter a value between 3 pixels and 5 pixels in each of the two *Blur Radius* fields. In this example, I entered 5. You can select non-integer values by typing them in the fields.

To see a larger preview of the filter's effect, enlarge the whole dialog window by clicking on a corner or side and dragging. The preview window will expand along with the dialog window. After examining the result of your settings, click the *OK* button to accept your changes. The program will render the image.

At this point in the exercise, you have completed several important steps. This is a good time to save the image. Selecting *File > Save* or *File > Export to miami-base.tif* is the simplest way to save at this point, particularly since you named the image when you first began the process.

Now take a look at your image: what further improvements can be made to enhance its quality?

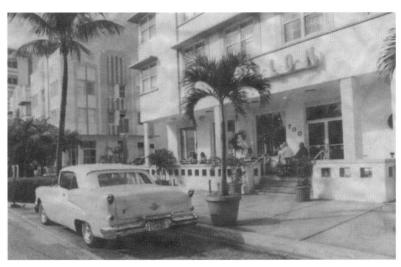

Figure 2.33
The image after rotating and cropping it and removing the moiré effect

The moiré effect is gone. But if you take a closer look, you can still see some of the printing raster. You can correct the image further by using the *Selective Gaussian Blur* filter (*Filter > Blur > Selective Gaussian Blur*). This filter gives the image a soft-focus effect and evens out imperfections in surfaces while leaving contrast at the edges. Therefore, as far as possible, it leaves the

image in focus. You may also notice that there are waves and shadows on the facades of the buildings. This is probably a result of the image being damp or rumpled instead of flat and dry when it was scanned.

2.3 Adjusting and Improving Color and Exposure

The scanned *miami-scann.tif* has now been processed to a degree that gives it about the same level of quality as a normal photo. However, the image is still slightly overexposed and looks a little flat as a result. The following sections introduce the adjustments you can make to improve color and exposure. These steps include:

- Correcting brightness and contrast (Levels, Curves, Hue-Saturation)
- Saving the image as miami-impro
- · Applying commands found in the Colors menu
- Preparing a copy of the image for use as an e-mail attachment (i.e., adjusting resolution and saving to JPEG)

You will find options for setting color depth, brightness, contrast, and color in the *Colors* menu.

But first, let's explore the two most important sets of options in detail:

- Levels (tonality correction)
- Curves (color correction)

If you have followed the steps described so far, you can continue using your own *miami-base* image file. However, if you skipped the scanning section, you can use the *miami-base.tif* file located in the *Samplelmages* folder on the DVD provided with the book.

2.3.1 Levels (Tonality Correction)

Correcting tonality will improve the quality of almost any image. GIMP offers several options to do this.

The **Levels** options (tonality correction) can be found via *Tools > Colors > Levels* or *Colors > Levels*.

You can achieve the most striking effects in the *Levels* dialog with the *Input Levels* curve, which is referred to as the **color histogram** of the image. It is created from the image's RGB color channel (*Channel: Value*).

• NOTE

During the following exercises, I will only mention a particular export format if I need to go into detail on that format's options. In all other cases, it is up to you whether you use XCF or another high-quality format such as TIFF or PNG to save your files. In the appropriate places in the text, I will only mention saving the image as a generic step.

• NOTE

The Levels dialog has an Auto button. Clicking this button will apply a tonality correction that is automatically calculated from the image values. You can also use the automatic tonality correction under Colors > Auto > White Balance. For many images, this function is sufficient to optimize the image quality. However, if you want to develop your pictures to your own preferences, you will have to use the Levels or Curves function.

The curve shows how the color brightness values are distributed in the image. In the recently modified *miami.tif* image, you can see that the curve starts a short distance from the left margin and ends before the right margin. Roughly speaking, this means that the image does not possess "real" black values (shadows). It also tells you that the image has only a small amount of "real" white values (highlights).

Underneath the histogram are the numerical values for the image's brightness (*Output Levels*). There is also a black-to-white gradient bar, which corresponds to these values. You can move the triangles under the gradient to change the brightness of the image. This tool works similarly to the settings in the *Brightness-Contrast* dialog. However, you'll probably find that the handling of the *Brightness-Contrast* dialog is more comfortable.

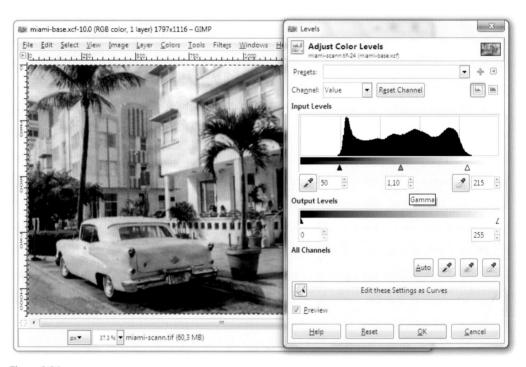

Figure 2.34
The Levels window.

Directly underneath the histogram curve is another gradient bar. Just below, there are black, gray, and white triangles that correspond to the shadows, midtones, and highlights in the image. These are initially positioned at the margins of the histogram window and in its center.

By moving these triangles from the border into the area of the histogram's curve, you can adjust the brightness values of the image toward the target values. If you move the black triangle to the right, just under the histogram, the dark colors in the image become darker. The bright colors become

brighter when you adjust the white triangle. You can correct the brightness of the midtones by moving the gray triangle, which increases the color gamut and contrast of the image.

Make sure the *Preview* option is checked in the *Levels* dialog so you can see the effect of your changes as you edit.

When you are satisfied with the result, click OK to confirm your changes.

Figures 2.35 and 2.36 Comparing the image: before and after

At the top of the *Levels* dialog is a *Presets* drop-down menu. Since GIMP 2.6, this has been available in almost all program windows. You can use this menu to name and save your settings.

Click the *Channel: Value* drop-down menu (top left in figure 2.34) to edit the red, green, and blue color channels individually. This is important when working with images that have a color cast (more about this later).

To the right of the *Channel: Value* menu, you'll see two additional buttons. If you hover your cursor over these buttons, you'll see that the left button is called *Linear histogram* and the right button is called *Logarithmic histogram*. Depending on the button you select, the representation of the histogram curve will change. The logarithmic method is more data intensive, thus also more exact. The histogram you see when you select the linear method is more significant, so that is the method I've chosen for this exercise. For most images the logarithmic histogram is smooth and quite flat. The linear histogram shows more detail, where there are more or fewer pixels with a certain luminosity.

There are also buttons represented by black, gray, and white eyedropper icons. If you select the black eyedropper and click on an area of the image that should be pure black, the program will recalculate the brightness values. The same holds true for the white eyedropper. Using the black and white eyedroppers may be sufficient to obtain a good tonality correction. The additional gray eyedropper can be used to set the midtones of the image. This can be helpful when working with images that have color casts because it

tells the program what hue you want to assign to a gray shade (e.g., a shadow on a white surface).

If you wish, you can open the image with the settings that you just selected for further editing in the *Curves* function (gradation curves) by clicking the *Edit these Settings as Curves* button.

The *Reset* button allows you to discard your settings without closing the window.

2.3.2 Curves

The *Curves* function is the most sophisticated tool for adjusting the color, contrast, and brightness of an image. It does, however, require some effort to learn how to use it. It is easier to work with some of the other tools, such as *Levels* (tonality correction), *Brightness-Contrast*, and *Color Balance* or *Hue-Saturation*.

You can access the *Curves* tool by choosing *Colors > Curves* or *Tools > Color Tools > Curves*.

I'll use the example images in this section to briefly explain how this tool works.

The Options of the Function Curves

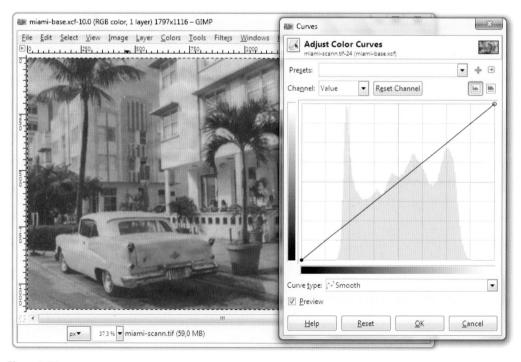

Figure 2.37 The *Curves* tool when it is activated.

Click the *Channel* drop-down menu (top left) to determine whether you want to edit and correct your image by using the RGB color channel (*Value*) or by setting the red, green, and blue color channels individually.

The two buttons in the upper-right corner let you to select a method by which to calculate the color histogram, either *Linear* or *Logarithmic*. The default setting is *Linear*.

The large pane displays a histogram of the image (i.e., the color or brightness value distribution). A control curve has been drawn from the bottom-left corner of the histogram to the top-right corner. This is the neutral gradation curve of the image in its current state.

To the left and at the bottom of the histogram, there are two gradient bars ranging from black to white, which represent the brightness distribution in the histogram.

You can use the two choices of the *Curve type* drop-down menu to select whether you prefer the curve to be a smooth line or whether you want to draw your curve freehand with the mouse.

You can place points on the *Smooth* curve type by clicking on the curve or just above or below it. Moving these points along the curve will change the brightness values of the image. The program will calculate the curve based on the points placed on a smooth line. If you accidentally placed too many points on the curve, just click and drag them outside the window to delete them.

If you use the *Free* curve type, the bright-dark values will be calculated exactly as you draw the curve. In theory, you can use the curve you have drawn to configure all brightness values in the image individually. You can then toggle to the *Smooth* mode and allow the program to recalculate the curve.

The *Preview* option should be checked so that you can see your changes to the gradation curve immediately.

The *Reset* button permits you to delete all changes made to the gradation curve without closing the tool.

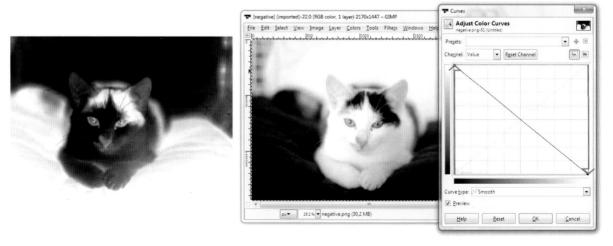

Figure 2.38
A scanned negative and its "developed" positive image, produced by inverting the colors in the *Curves* tool. The *Invert* command in the *Colors* menu has the same effect.

Using the Gradation Curve to Correct the Tonality

The tonality of an image can be corrected by moving the bottom and top end points of the diagonal gradation curve horizontally toward the inside of the histogram while holding the left mouse button down.

You can now place additional control points along the curve. In our example image, we slightly brightened the midtones, producing results very similar to the ones we produced by using the *Levels* tool.

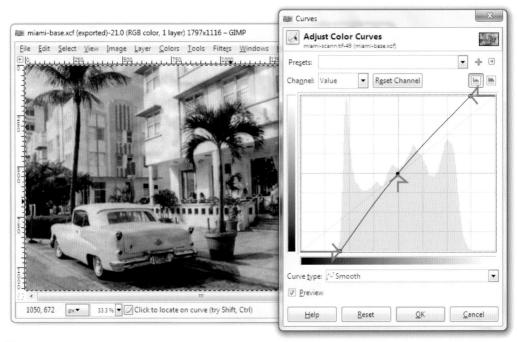

Figure 2.39Using the gradation curve to correct the tonality

Using the Gradation Curve to Set the Brightness

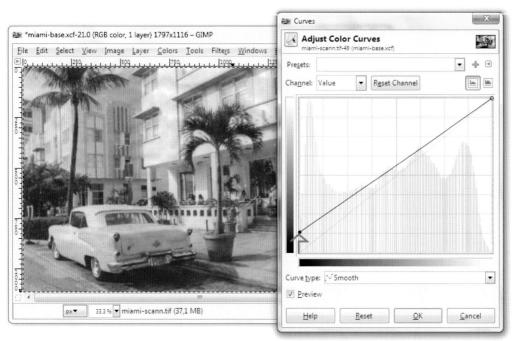

Figure 2.40Using the gradation curve to make an image brighter

Similar to the *Brightness-Contrast* function, the gradation curve can be used to brighten or darken an image. Simply move the end points of the curve upward (for brightening the shadows) or downward (for darkening the highlights). Again, you can insert control points to make specific color areas brighter or darker. You can correct the tonality and set the brightness either in consecutive steps or in one run.

Shadows-Highlights—Correcting Backlit Photographs with the Gradation Curve

Backlit photographs constitute a difficult situation in photography. The surfaces of the photographed objects in the foreground are swathed in dark shadows. In a contrary but similar manner, photographs taken with a flash are overexposed in the foreground. As long as there is enough distinguishable image information available, you can improve these photos considerably. In some programs, you can use a *Shadows–Highlights* function to improve your image. In GIMP, there is a plug-in, yet GIMP's *Curves* function is suitable for making these corrections. Select the image *ship.png* from the *SampleImages* folder on the DVD.

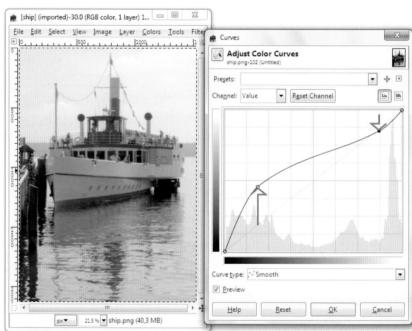

Figure 2.41
The image before and after the corrections. Two points on the gradation curve are enough to improve the backlit photograph.

Generally, the procedure to brighten up shady image sections is to set one or more points on the curve, in the area of the shadows, and to slid them upward. In return, the image gets more detail and contrast in the bright areas because the highlights are darkened. Using the *Curves* function accordingly, you can correct overexposed flash photographs.

Solarization Effects with Gradation Curves

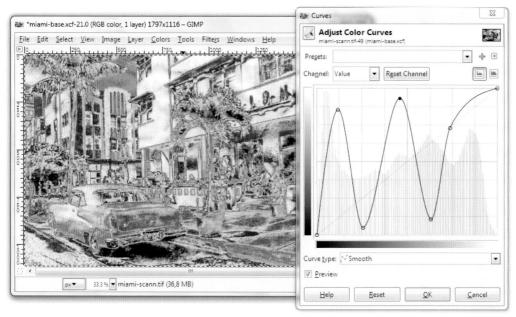

Figure 2.42
Solarizing an image by corresponding settings in the gradation curve

You can use gradation curves to adjust the color values in an image in order to create a similar effect to solarization (a partial color reversal). In film developing, solarization denotes an effect that occurs when the print is exposed to light again during the developing process and then is further developed. After the first developing stage and the exposure to light, the image is graphically altered by brightness or color inversions. In figure 2.42, you can see the result of such an experiment as well as the curves gradient.

• NOTE

Here is a summary of the effects various *Curves* adjustments have on the colors in an image:

- Shift a point upward =
 Brightens the color
- Shift a point downward = Darkens the color
- Shift a point to the left =
 Reduces contrast
- Shift a point to the right = Increases contrast

Points on a curve can be moved freely in any direction, making it possible to simultaneously adjust brightness and contrast by shifting a single point.

2.3.3 Adjusting Hue and Saturation

Have a look at your *miami-impro* image with the *Hue-Saturation* function open (*Colors* > *Hue-Saturation*). What could you do with it?

Let's see: The sky over the houses is cyan and turquoise. Move the *Hue* slider slowly to the right and observe how the color of the sky changes. It slowly changes to blue, but the other colors in the image also change with it. The *Master* button is the default setting for the *Select Primary Color to Adjust* function, so all primary colors are selected. When you move the slider, all colors in the image are rendered.

Suppose you want to change the color of the sky from cyan to sky blue. To do so, check the C button for cyan in the *Select Primary Color to Adjust* section. Now if you move the *Hue* slider, you will be changing only colors in the cyan color range. Move the slider to the right until the sky (and all other cyan tones in the image) becomes more of a sky blue. The sky can be brightened up at the same time by moving the *Lightness* slider to the right.

The image now looks better, but you haven't confirmed the changes by clicking OK yet, so you can continue. What about the color intensity and saturation? I like my images to have intense colors. To see the effect, increase the saturation in the image by moving the *Saturation* slider to the right. But first you must click the *Master* button to process all primary colors. Try reducing the saturation by moving the slider to the left. This changes the image to a grayscale image. Choose a saturation level to your liking. If something goes wrong, you can set the slider back to its default position. If you want to discard all changes and start anew, you can click on the *Reset* button.

Confirm the settings in the window by clicking the *OK* button, and then save your image. If you don't want to save your image under a new name, simply click the *Cancel* button. The changes will be discarded and the image will return to its original state.

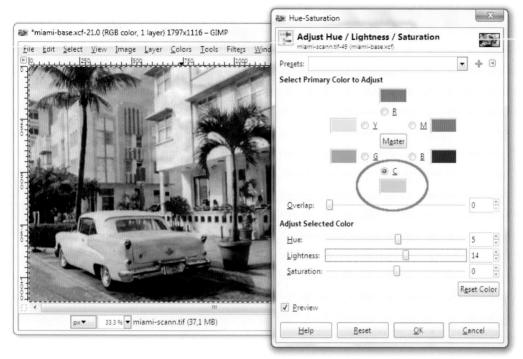

Figure 2.43
The *Hue-Saturation* window with the settings to change the hue for cyan

Figure 2.44 and 2.45
The *miami-impro* image before and after the color correction. The rendered hue of the sky is seen at the top left. Colors have been intensified by increasing the saturation.

2.3.4 Overview of the Functions in the Image > Colors Menu

Menu Function	Explanation	
Color Balance	Used to adjust colors in an image and to modify color levels of red, green, blue, cyan, magenta, and yellow. Each correction can be done separately for different ranges of brightness (<i>Shadows, Midtones</i> , and <i>Highlights</i>). Also used to correct images with color casts.	
Hue-Saturation	Hue: Changes colors in relation to each other. Provides limited possibilities for correcting colors, including images with color casts. Suitable for graphical effects and the distorting or colorizing of image elements. Saturation: Increases or reduces the saturation (intensity) of an image's colors (up to gray levels). Lightness: Lets you additionally adjust the lightness of an image. But keep in mind that this is not a tool like Brightness-Contrast, used to correct the luminosity and the contrast of an image. When Lightness is adjusted with the Hue-Saturation function, the image is uniformly darkened or brightened to black or white. You can decide whether changes will apply to all colors of an image or a specific color only.	
Colorize	Renders the image as a grayscale image as seen through a colored glass.	
Brightness-Contrast	Sets the brightness and/or contrast (light – dark distribution) of an image.	
Threshold	Lets you set a threshold between black and white image sections, which serves as the value from which the image is converted into a pure black-and-white image.	
Levels (tonality correction)	Lets you adjust the brightness of individual tones in an image (together with the color and contrast). Creates real new shadows and highlights (black-and-white tones) in an image. It can also be used to correct the brightness of the midtone colors. Each color channel can be modified separately. Provides an option for automatically setting the levels.	
Curves (gradation curves)	Lets you adjust color curves, similar to <i>Levels</i> and <i>Brightness-Contrast</i> but with a purely graphical interface for the settings. You can use this function to achieve inverted and graphical distortions similar to solarization.	

Menu Function	Explanation	
Posterize (reduce to a limited set of colors)	This tool can gradually reduce the number of colors in an image or harmonize the colors. You might find it helpful when converting a photograph into a graphic for screen printing or when vectorizing the image.	
Desaturate	One click on Desaturate turns a color image into a grayscale image (black-and-white photo). The command can be used on one layer of a multilayered image. The image remains in the RGB color space, so it isn't a real grayscale image with just 256 colors. Therefore, the image can be colorized again.	
Invert	Intended for the developing of scanned color negatives or for inverting a color photo into a negative. Generally speaking, the command reverses the color values and the brightness of the image or the layer. Dark colors appear light and the colors are substituted by complementary colors.	
Value Invert	Reverses the pixels' brightness values in the active layer or the selected area. The color value and saturation should be kept the same. Nevertheless, when the image is rendered or when the tool is applied several times, the colors can appear offset.	
Auto	Offers a couple of automatic corrections; essentially, one-click rendering to improve the contrast or colors.	
Auto: Equalize	Equalize adjusts the brightness values so that all colors have the same luminance. The curve of the histogram is flattened. Either the contrast of the image or levels is raised and thereby improved or the opposite occurs and the result is very bad. With dull pictures, it is worth a try.	
Auto: White Balance	White Balance recalibrates the colors automatically. It is especially useful for images that contain an off-white or -black.	
Auto: Normalize	Normalize renders the image or layer so that the darkest pixels are automatically set to black and the brightest to almost white. This replaces the color correction and is suitable for dull images lacking contrast.	

2.3.5 Saving an Image in Compressed Format (JPG/JPEG) for the Internet

After you finish editing your image, you can save it for use on the Internet (web page or e-mail attachment). Here are the steps:

- 1. Adjust the image size.
- 2. Reduce the resolution to 72 dpi (or 96 dpi).
- 3. Save the image in a compressed format.

The example image *miami-impro.tif* has a resolution of 300 dpi. This resolution is too cumbersome for Internet use. Due to the large file size, the image would take an unnecessarily long time to upload or download.

To adjust the image size, choose Image > Scale Image to open the Scale Image dialog box and set the values. Change the values for the resolution first and the image size second. Using 72 dpi is recommended for the resolution, and about 6.42 in \times 4 in for width \times height. Choose Cubic as the interpolation method because it is the best option for reducing images. Don't forget to set the measuring unit (pixels/in or inches).

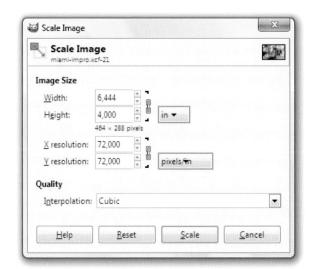

Figure 2.46
Adjusting the size and resolution of an image for the Internet using the Scale Image dialog (Image > Scale Image)

Click *Scale* to accept your changes. The image will become smaller in the image window, but this time, it's not a zoom effect. The image has actually become smaller; the pixel count has been reduced. Because some image data

is lost in the reduction process, you should always use a copy of the original image. If you forget to save a copy first, you can discard the changes when you save the original.

To get a better view of the changes you will be trying out next, use the *Zoom* function to enlarge the view to a zoom factor of 100%.

Choose *Filters* > *Enhance* > *Sharpen* to sharpen the contours of your image. This filter has little or no effect on high-resolution images. Once you have reduced the resolution of an image, however, the *Sharpen* filter can greatly improve the edge sharpness and clarity of the reduced contours.

To save an image in a compressed format (JPEG, PNG), start in the usual way: Choose *File* > *Export*. In the *Export Image* dialog, select the folder where you want to store the image. Enter a filename for the image and select a file format; in this case, you'll choose a compressed file format, such as JPEG or *PNG*. Now confirm and apply your settings by clicking the *Export* button.

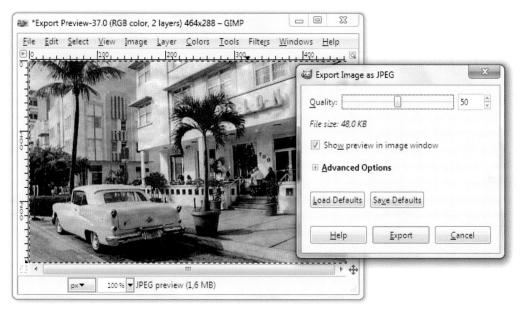

Figure 2.47
The Export Image as JPEG dialog

Exporting to JPEG

At this point, the dialog for setting the file compression will appear. Click the *Show preview in image window* check box so you'll be able to see the changes to the quality in a separate image window as you use the slider to adjust the

CHAPTER

• NOTE

compression. Zoom into the image to better see the **compression artifacts** (squares in which the colors are heavily unified, as in figure 2.48) occur.

Settings for Advanced Options

The *Progressive* advanced option is designed for use with JPEG images that are to be displayed on the Internet and enables browsers to display images before they are completely loaded.

When you click the *Advanced Options* button, the *Export Image as JPEG* dialog expands to show additional options. Here are some guidelines to using these options:

- Make sure the *Optimize* option is checked. This improves the ratio between the quality/compression and the file size (so that as the file becomes smaller, the quality remains the same).
- Select a compression method in the *Subsampling* drop-down menu. The 4:2:2 (horizontal or vertical) option is a good method to use if you want to produce small, high-quality image files.
- Selecting *Floating-Point* from the *DCT method* drop-down menu provides the most exact method for calculating the compression. Although it is the slowest, it results in the highest quality.
- The actual compression (along with the file size in kB, top left) is adjusted by moving the Quality slider. A quality setting of 100 will give you the best image quality and the largest file size. As you move the slider to the left, both the image quality and the file size are reduced. Initially, the deterioration in quality is so small that it cannot be seen, but as you increase the compression (thus reducing the quality), the compression artifacts or block artifacts become visible in the image. Watch the preview in the image window.
- As soon as compression artifacts become clearly visible in the border area, you can slightly improve the image quality while further reducing the file size by using the Smoothing slider.

Figure 2.48
Obvious compression artifacts caused by an unnecessaryily high compression rate. Always select a compression rate that keeps visible aritfacts to a minimum while producing as small a file as possible.

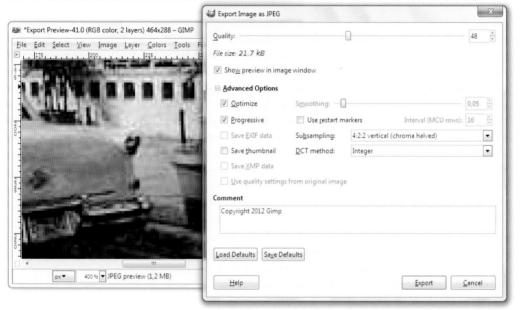

Figure 2.49
Advanced options in the Export Image as JPEG dialog

2.4 Touchup Work 1—Color Casts

2.4.1 What Is Touchup Work?

So far you have learned about the basic program functions and how you can use them to improve the quality of your images. In the previous sections, you have used them to edit, or modify, your image as a whole.

However, an image may have additional flaws that you wish to correct:

- It may have a significant color cast.
- Older, scanned photos may have scratches and spots. Scanned slides may
 have dust, bits of fluff, or unwanted image elements, such as embedded
 text, which can be removed.
- The subjects in the image may have red-eye if the photo was taken with a flash.
- Some images may have a pale, dull, or stale sky that needs to be freshened up.

The work required to remove such flaws is called image touchup or retouching. Tonality correction is also considered touchup work in image editing

The following sections explain techniques and tools for **constructive touchup**. I will use examples to show you how to remove various image flaws. I will also cover two touchup steps in chapter 3, "Using Masks and Layers—Painting, Filling, and Color Tools," because they require masks.

How Are Color Casts Created?

A color cast can be seen as discoloration throughout an image. You might notice the blue color cast that results from taking a photo in bright light under the sky without a skylight filter or the yellow color cast that results from taking pictures without a filter in artificially illuminated rooms. Color casts can also be a result of improperly developing an image in the lab or using the wrong settings. Scanning slides often produces a color cast.

2.4.2 Color Correction Options

Tonality correction (*Levels* function) is appropriate for editing images with a color cast. In this exercise, you will edit the red, green, and blue color channels individually. *Color Balance* can also be employed to remove color casts, particularly when the discolorations are minor. The following section provides step-by-step instructions for using these two functions.

2.4.3 Using the Levels Function to Correct Color Casts

Open the image *colorcast.png* in the *SampleImages* folder on the book's DVD and save it in your exercise folder.

You will notice that the image has a distinct red color cast, which means that the red color channel values are faulty.

Figure 2.50
The colorcast.png image has a strong red color cast.

• NOTE

The automatic functions described in section 2.3.1 are often sufficient for color correction. The Auto function in the Levels dialog and the automatic White Balance function (Colors > Auto > White Balance) are two functions at your disposal that enable you to correct color casts quickly. I often use the automatic functions for difficult cases so I can get an idea of how the Auto function would correct an image. If you want to correct images with color casts according to your own preferences, you will have to use Levels and Curves. The following sections show you how you can do this.

You can use the function *Levels* in the *Colors > Levels* menu to correct the bright-dark values in the image. Using the *Levels* dialog that appears, first change the settings of the **RGB color channel** by clicking the *Auto* button.

The image should be visibly improved, as now the real black and white tones can be seen. For some images with a slight color cast, this action may be sufficient.

By clicking the *Channel* drop-down menu on the top in the *Levels* window, you can choose the **red**, **green**, **and blue color channels separately** so that you can correct each color individually. Select the red color channel.

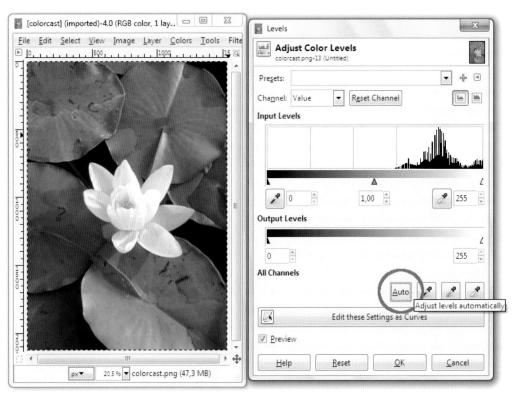

Figure 2.51
The colorcast,png image after automatic tonality correction has been applied (prior to correcting the red color channel)

Now you should see the histogram for the red color channel in the *Levels* window. Underneath the histogram are the adjustable triangles that you are already familiar with. You can skip the black triangle for shadows and the white triangle for highlights—I'd say that the automatic correction did a perfect job balancing them.

Click and hold the left mouse button on the gray triangle and drag it to the right. Doing this will change the **mid-tones of the red color channel**. If you check the *Preview* option in the *Levels* window, you can immediately view the adjusted image.

What next? Simply adjust the color according to your personal preference, and voila! Save the image as *colorbalance1.png* in your exercise folder, and you're done.

Another method for correcting images with color casts is by using the black and white eyedroppers in the *Levels* window. You can click either of these buttons to select a black or white spot, respectively.

If you use this second option, your image must contain true black or white areas. Select the *black* eyedropper (tool tip: *Pick black point*) and click on the black area of the image. Then proceed to use the white eyedropper (tool tip: *Pick white point*) on the white area. This procedure is often sufficient to correct the color levels.

You might notice that there is a third, gray eyedropper (tool tip: *Pick gray point*). Its function is to allow you to select a neutral gray as your reference color. It provides a good means of getting rid of a color cast in an image. The use of this eyedropper is often sufficient to correct your image. But it is important to choose a really neutral gray area in the image; otherwise, it might distort the color levels.

However, if you come across an image with a color cast created by a secondary color in the RGB color model (such as cyan, magenta, or yellow), you may have to adjust two, or even all three, color channels. A yellowish color cast will require correction of the red and green channels, at the very least. In such a case, you should forgo the automatic functions and adjust the color histograms individually.

• NOTE

You can use the *Levels* function to correct almost every "normal" color cast. For images with a red, green, or blue color cast, it is generally sufficient to adjust the individual color channel.

Remember: After you have corrected color casts, you can proceed to edit your pictures with other functions in GIMP. By getting rid of a color cast, you might create other problems. For example, you could cause your image to become too bright in areas. In that case, you could then correct your shadows and highlights with the *Curves* function described in section 2.3.2.

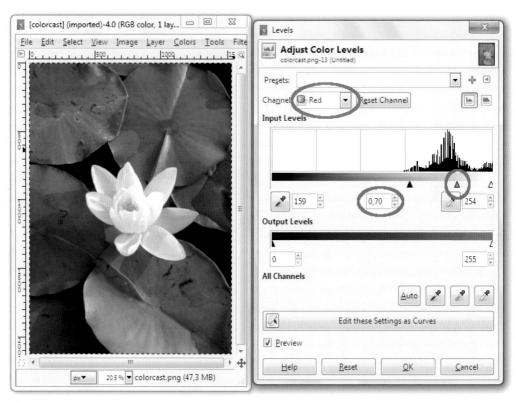

Figure 2.52
The colorcast.png image after the correction of the red color channel

2.4.4 A Second Method of Removing Color Casts—Color Balance

Color Balance not only corrects images with color casts, but it can also be used to adjust colors in general, freshen up colors, or even change or intentionally distort colors.

To introduce this function we will work with an image that has a slight color cast. However, it is better suited for color corrections in images with very little color deviation. Open the *bluecast.png* image from the DVD.

Access the *Color Balance* function by choosing *Image > Colors > Color Balance*.

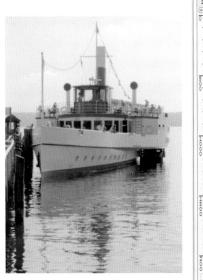

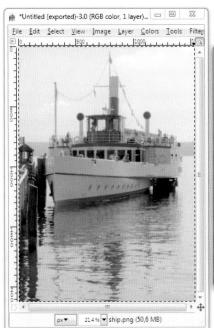

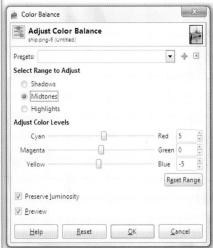

Figure 2.53
The Color Balance window with a preview of the altered image and the original

Within the *Color Balance* window, you will see three sliders set at the zero position. Their purpose is to adjust the selected range's color levels, and there are three buttons, each specifying a range to be modified: *Shadows*, *Midtones*, and *Highlights*.

You can move the sliders to one side to increase the color level of a certain color in the image, or move them toward the complementary color—i.e., red to cyan, green to magenta, or blue to yellow—to balance out the color. For example, more yellow produces less blue tint. You can preselect one of three areas of brightness where the adjustments are to be applied. Start correcting

• NOTE

The **Channel Mixer** is yet another function of GIMP that can be used for color balancing. What's more, you can use this tool to create fancy or even psychedelic atmospheres for your image. Find this tool by choosing *Colors > Components > Channel Mixer*. The *Channel Mixer* has a greater importance in editing black-and-white photography. I will go into more detail in section 4.1.3.

the images by using the *Midtones* range. Within this range of lightness, color tones show the greatest effect.

Leave the *Preserve luminosity* check box and the *Preview* option checked. This function is appropriate for minor color corrections or to intensify colors.

The following values will yield a good result when applied to the example image:

Shadow	Red	0
	Green	0
	Blue	-50
Midtones	Red	-66
	Green	50
	Blue	100
Highlights	Red	-66
	Green	0
	Blue	50

Of course, you can change the other colors and adjust the image to your taste. Feel free to experiment!

If you are in the mood, you can subsequently perform a tonality correction or alter the hue of the sky with the *Hue-Saturation* function.

Save the finished image as colorbalance2.png in your exercise folder.

2.5 Touchup Work 2—Removing Spots, Dust, and Scratches

Older photos and slides often have flaws, such as creases, dog-ears, spots, dust, scratches, and missing edges. When you scan slides, lint and dust often end up on the image. Even digital images can have distracting elements that need retouching, such as overhead wiring in the scene or, dust on the camera sensor. The touchup work involved in fixing such images is called constructive touchup since it involves reconstructing image elements. Constructive touchups also include removing image elements such as unwanted text.

In the past, photographers armed themselves with brushes, masks, and airbrushes when fixing damaged images. Nowadays, images are scanned "as is" and the photographer's repair tools are supplied by the image editing program. But the techniques are similar, the main difference being that the tools are now in digital form. It seems as if every new version of a digital editing program introduces new tools for the correction and stylization of images.

In addition to repairing flaws with the *Clone* tool, you can remove unwanted elements from an image. Don't forget to save your image when you're finished.

• NOTE

If you want to remove small blemishes such as dust from your scanned slides, you can apply various filters. Have a look at section 2.6.2.

2.5.1 Why You Need Smooth Brushes—the Clone Tool

The Clone tool uses image data and patterns to "draw" not only colors, but also color details and textures. These structures are actually pieces of your image that you previously copied from a defined area in the same image. This tool is capable of doing more than just working with "normal" opacity. Since you can set the tool's opacity from opaque to transparent, you can use this glazing technique to create smooth transitions, using a soft, feathered pointer. The Clone tool is considered the touchup tool.

The *Clone* tool uses the same brush pointers available to the drawing tools. Choosing *Windows > Dockable Dialogs > Brushes*, you will find brush pointers with hard, sharp edges that draw like pens with fixed widths as well as pointers with soft edges or feathering that draw more like a paint brush, with rich color in the center that fades as it moves toward the edges. Moreover, there are brush pointers in the form of patterns that apply color in structures.

For this exercise, you will use the *Clone* with "soft" pointers. Brushes with hard edges will create image patterns with sharp edges. That may be acceptable for a single color, but if you are working with structures, even similar structures, the image will look like it's been strewn with confetti. A softer brush pointer creates a smooth transition.

Because GIMP doesn't come with a large array of brushes, it provides a simple way to create new brushes. You can create a selection of additional brush pointers in advance so that you can change a pointer quickly when you're working. Once you have created a brush, you can save and reuse it.

The new GIMP version adds a number of features that make working with brushes simpler and more versatile. The range of available brush presets has been extended and the brush system has been significantly improved.

In previous versions of the program, brush size could be selected using a percent value. Now, you can enter a size value in pixels in a range from 1 to 2000. That said, brush sizes above 500 pixels are seldom genuinely useful. Very large brushes often test the limits of a computer's processing power.

You can now change the *aspect ratio* of a brush while you work using a slider in the tool settings—for example, from a circle to an ellipse.

Rotating brush support has been added, allowing you, for example, to adjust the *pitch* of an elliptical or star-shaped brush while you work.

The *brush dynamics* system has been separated from the other tool options and expanded, making it possible to drive almost all aspects of a brush with a multitude of inputs. You can now save the existing state of any tool as a preset and give it a meaningful name.

These and various other improvements are designed to simplify using GIMP for painting and producing illustrations. There is a short introduction to painting with GIMP in section 3.9.4.

• NOTE

The GIMP 2.8 tool options sliders have been revised and can now be adjusted by dragging them (with the mouse button pressed) or by selecting the value and entering a new one with the keyboard. Manual entries have to be confirmed by pressing the *Enter* key. You can also adjust option values by clicking the arrow icons next the slider.

2.5.2 Creating New Brush Pointers in GIMP and Importing Adobe Photoshop Brushes

To create new brush pointers for future use, just select the *Brushes* dialog from the dock or access it from the *Windows > Dockable Dialogs > Brushes* menu option.

In the *Brushes* window, click the *New Brush* button (second button from the left in figure 2.54). The *Brush Editor* window appears.

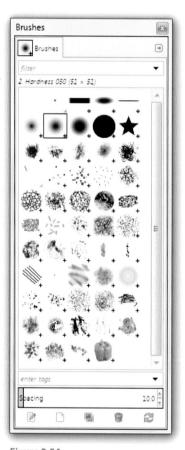

Figure 2.54
The Brushes selection window with the prepared standard brushes. By clicking the little button at the top right, you can access a menu that will let you select the size and alignment of the icons and layout for this window.

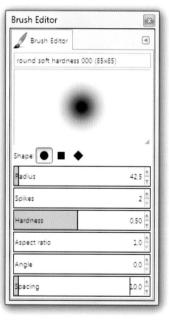

Figure 2.55 Clicking the *New* button in the *Brushes* window opens the *Brush Editor* window.

Begin by selecting a shape for the new brush (figure 2.55): *circle*, *square*, or *diamond*.

Use the *Radius* option to define the radius between the center and the edge of the new brush. However, the resulting brush size will always be slightly bigger than twice the indicated radius.

Spikes has an effect only on squares and rhombuses. The selected value indicates the number of corners the shape has. A square can be changed into a polygon, a rhombus into a star.

Hardness defines the amount of feathering that will occur. A value between 0.00 and 0.50 is recommended for soft, wide feathering.

If you want to create a calligraphic effect, you can use the *Angle* option to build a nicely angled brush. An aspect ratio greater than 1.0 is required.

Leave the value for *Angle* at 0.0 and for *Aspect ratio* at 1.0. A round, even brush is most suitable for working with the *Clone* tool. Give your new brush a name with the size and properties in the text field for future reference—for example, *Circle Fuzzy* (65).

Spacing is the setting for the distance between two points, set by the brush while drawing. A brush stroke in an image manipulating program is not continuous, but a line of dots at a certain distance. Depending on the size of the brush pointer, you have to reduce the default setting of 20 to 10 or less to get a smooth, continuous line; otherwise, the line will look dotted. (You could use this as a special effect.) This setting can be altered while drawing, after defining the brush.

When you close the *Brush Editor*, the new brush is saved permanently in the program. Your new brush can now be found in the *Brushes* window; just click on it whenever you wish to use it.

To speed up your workflow, create a total of seven new brush pointers with soft edges and diameters of 25, 35, 45, 65, 85, 100, and 200 (i.e., set *Radius* to 11.5, 16.5, 21.5, 31.5, 41,5, 50, 100; remember: the resulting brush size will always be slightly bigger than twice the indicated radius). This will give you a good array of brush choices. For finer detail work, it is a good idea to use smaller soft brushes sized from 1 x 1 to 19 x 19.

You can use the *Brush Editor* at any time to edit your custom brush pointers or to create new ones. The maximum brush radius is 1000 px.

When setting the size for a brush in the *Brush Editor*, first use the sliders to get an approximate size. Next, fine-tune your new brush by using the cursor keys (arrows) or by typing the exact value desired in the text fields.

If you want to create more brushes with the same characteristics but different diameters, the program offers you the option of copying an existing brush. Choose the brush with the desired characteristics in the *Brushes* window and then click the *Duplicate brush* button. This is the third button from the left in the *Brushes* window.

The *Brush Editor* opens. Now you can customize your brush according to your preference and give it a new name. The brushes provided by GIMP

• NOTE

It is a good idea to include the brush preset's name in your own tags. This way, you can be sure that your own tagged presets can be selected via standard groups of tags (such as *Basic* or *Sketch*). You can, of course, use your own custom tags to give your brushes meaningful names. The actual name of a brush is independent of the specific tags you might give it.

can only be customized if they are duplicated and then changed to your preference. The default brushes are write-protected and can't be altered.

As previously mentioned, GIMP offers an intuitive way to change the scale of the brush while it is in use. You can do this with all tools that work with a brush pointer, including the *Clone* tool. You can change the size of the brush by adjusting the *Size* option in the tool settings. You can adjust the size of the brush tip to the nearest pixel either by using the *Size* slider or by entering your desired values in the option box.

Another useful new feature is the ability to tag brush presets, which makes it possible to search for presets by name in the *Brushes* dialog. Simply select a brush and enter the appropriate tag in the field located beneath the brush preview window. Clicking a brush type in the filter list or entering a tag manually displays only appropriately tagged brushes in the preview window.

To return to the default *Brushes* dialog view, select and delete any tags that you have entered in the *Tags* field.

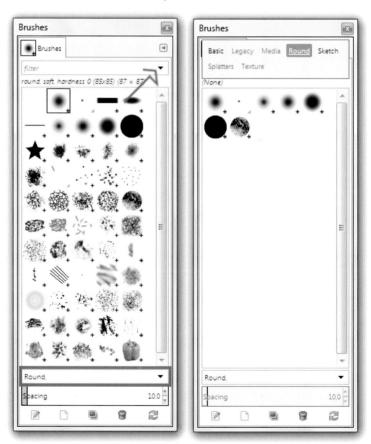

Figure 2.56
The Brushes window: There is a text input box beneath the preview window that you can use to tag brushes. You can then search and select tagged brushes either via the filter list or by entering tags in the input box.

Importing Brush Pointers from Adobe Photoshop into GIMP

It is comparatively easy to import brush pointers from Adobe Photoshop or Adobe Photoshop Elements into GIMP. You simply have to copy the brush set files from Photoshop with the extension *abr*. You can find them in the *Presets/Brushes* subdirectory of your Photoshop installation directory. Copy the file into the brushes folder in your GIMP installation. (The entire path in Windows is *C:\Program\GIMP 2\share\gimp\2.0\brushes*.)

There is large range of free Photoshop and GIMP brush presets available online. For example, GIMP brushes can be found at the GIMP community's own website at www.gimpstuff.org. The website at blendfu.com provides GIMP and Photoshop brush sets sorted according to subjects and themes. If all these aren't sufficient, you can always perform an Internet search for Photoshop/GIMP and brushes. But remember, installing large numbers of brushes can significantly slow down the program's startup time!

2.5.3 Selecting the Clone Tool Options

Before you start editing your image, take a look at the *Tool Options* for the *Clone* tool. As mentioned earlier, these settings can be accessed in the bottom dock window of the *Tools Options* or by double-clicking the icon in the GIMP *Toolbox* (see figure 2.57).

The Clone tool options are as follows:

- Mode: The Mode drop-down menu determines how the color is applied
 to the image and what effect it will have. If you choose Normal mode,
 color will be applied without elements being mixed or stacked from the
 underlying image background.
- Opacity: Many paint tools offer the option of adjusting the opacity of the color or pattern. The Clone tool does too. The default setting is an opacity of 100%. The application of the color initially is opaque, with the exception of features such as a fuzzy edge of the brush pointer (Hardness). In some cases, you may need to use a semi-opaque painting technique to achieve the desired result. For example, you can set the opacity to 10% so that the color or structure will be translucent, which means that the colors and structures underneath will remain visible. Opacity allows you to apply a colored "glow" as well as produce seamless transitions.
- **Brush**: You can access the *Brushes* selection window via this icon.
- **Size**: The slide control and input box allow you to change the size of your paint brush.
- **Aspect Ratio**: Adjusts the aspect ratio steplessly, for example to transform a circular brush into an elliptical one.
- Angle: Rotates a brush tip (with a non-1:1 aspect ratio) around its center.
- **Dynamics**: A selection of preset brushstroke attributes, such as *Pressure Opacity, Fade Tapering* and *Random Color*

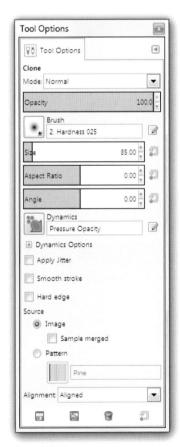

Figure 2.57
The Clone tool options

- **Dynamics options**: A range of options for fine-tuning *Dynamics* settings
- **Fade out**: Like any other tool with a brush pointer, the *Clone* tool can be used to make wiping strokes that fade out. If you click the *Fade out* check box to select it, the brush application will fade toward transparent. You can also select the length of the feathering effect.
- Apply jitter: Initiates a slightly jittery line that looks like it's hand-drawn.
- **Smooth stroke**: Ensures even strokes when painting freehand.
- **Hard edge**: Produces a hard, edgy result, even when you're using brushes with feathering.
- **Source**: Use this option to select whether the information to be cloned should be copied from the image (*Image*) or from a pattern in a palette (*Pattern*).
- **Alignment**: None means that a point in the image will be used as selection area for application with the *Clone* tool. No matter where you apply the *Clone* tool, the information will be taken from the same image point.

If you choose the *Aligned* option, you can first select a point in the image from which the information will be taken. You can then click on the area where you want the image information to be applied. The next time you want to apply image information somewhere else, the point for gathering image information is linked to the brush pointer at the same distance and angle as before. Thus, the *Clone* tool and its gathering point is wandering around the image while you work on it. If you want to change the origin of your clone, you simply select a new source by holding the *Ctrl* key and clicking the mouse.

The *Registered* option requires at least two layers or two images, taking information from one layer or image and inserting it in the other. In both images, the tool's starting point is the upper-left image corner. In *Registered* alignment mode, there is no offset between the point supplying information and the point where color is inserted.

The *Fixed* mode lets you determine a point as the source of information. This point is fixed and you can cover entire surfaces with this image information.

Select the following Clone tool options:

Spacing: 100%

Mode: Normal

Dynamics: Nothing

Fade out: Nothing

Apply jitter: Nothing

Hard edge: Nothing

Source: Image

Alignment: Aligned

Leave the Brushes window open.

2.5.4 Using the Clone Tool for Touchup Work

Open the *dustandscratches.png* image in the *Samplelmages* folder from the DVD and save it in your exercise folder.

You'll see the image window (with the sample image) and the *Toolbox* window. Select the *Clone* tool from the *Toolbox*. In the *Tool Options* window, select a brush with a soft edge (hardness 0.0). You'll need a brush with a diameter of about 85 px to remove spots and one with a diameter of approximately 45 px to remove the dog-ear and the scratches.

Collecting Image Information and Adding It to the Image

The first step is to select the point from which the image information is to be copied so you can transfer it to the area with the flaw and correct it. Point the mouse cursor at an apt spot near a flaw. Press the *Ctrl* key and hold it down. The cursor will take the shape of a crosshair. Click the left mouse button on an unblemished area that resembles the area with the flaw while holding the *Ctrl* key down.

Figure 2.58
The image dustandscratches.png before the touchup

Click on this spot to copy the data from the image. Release the mouse button first, and then the *Ctrl* key.

When you left-click on the flaw, the image information you just copied will be placed there. Point to another flaw and repeat the process. Since you have selected the *Aligned* option, the point from which the image information is taken will move with your *Clone* tool. Continue working until you need to copy new image data to correct flaws in different areas. Repeat the process (i.e., select a new point from which to copy information, press and hold down the *Ctrl* key, left-click, release the mouse button and *Ctrl* key, and then "stamp" out the flaw by left-clicking on it).

Changing Brush and View

The selected brush, 85 px, is ideal for removing spots along the wall and in the flower beds. If you want to remove the scratch or dog-ear in the upper-right corner, you should select a brush with a smaller pointer (say, 45 px) from the *Brush* section of the *Tool Options* window. Or you can simply scale the brush in the tool's options.

In order to edit the scratched area more comfortably, use the *Zoom* tool (you can also call it up from the *View* > *Zoom* menu) to access a more detailed view of the area.

To transfer certain picture information with similar but undamaged content from one point to another, you have to be precise when you're choosing the section in the picture and placing it on the damaged section. Make sure you choose and repair important sections with edges, contours, and distinctive elements first. Uniform surfaces are not as critical and don't need precise picture information. They can be filled out easily.

Figure 2.59
Precise work is necessary to repair distinctive image elements.

Undoing a Step

The **Undo** (**History**) function was discussed earlier in section 1.5.5. If you inadvertently click on the wrong area, just use the *Ctrl+Z* keyboard shortcut (or choose *Edit > Undo*) to undo a step. In the image window under *Edit > Preferences > Environment*, you should have already defined the number of steps you can undo (*Minimal number of undo levels*).

You can also open the *Undo History* tab in the *dialog dock* or by choosing *Windows > Dockable Dialogs > Undo History*.

Figure 2.60
The image after the touchup

2.5.5 The Healing Tool

The *Healing* tool is a relative of the *Clone* tool. It's similar in how it's handled and its settings, but it is for repairing minor blemishes.

With the same steps you used for the *Clone* tool, you can select a section that corresponds in color and structure with the area you want to repair. The difference is that the *Healing* tool takes the surrounding structure and brightness of the spot to repair into account. When you're covering up a section of the image, the surrounding information has influence on the action and its result. Small defects in a uniform surface are easily covered up. The tool also works with larger surfaces; however, the characteristics of the blemished section are more likely to remain. A large bright spot will stay bright even if you paint over it with dark picture information. One countermeasure is to use a brush pointer that is slightly larger than the spot to heal.

Using the *Healing* tool is a simple and fast way to correct your image. Try it out and remove some wrinkles or other skin blemishes in a portrait.

In the previous sections, you learned typical ways to edit images that work with many kinds of photographs.

In the following sections, I will introduce you to simple and effective ways of editing your picture with the help of filters. After an introductory section, I will show you the most important filters for improving your images.

2.6 Performing Magic—Editing Photographs with Graphic Filters

You can find all of GIMP's filters in the *Filters* menu. The Script-Fus are also found there. Script-Fus are output sequences, so-called macros, that work according to a defined yet adjustable procedure.

You have already become acquainted with some effects and even filters for editing your photographs, such as the *Gaussian Blur* filter (*Filters > Blur*) and the *Sharpen* filter (*Filters > Enhance > Sharpen*). We will take a closer look at the *Sharpen* filter and also have a good look at the *Unsharp Mask* filter (*Filters > Enhance > Unsharp Mask*). The *Unsharp Mask* filter can help you find edges and contours even with blurry, high-resolution pictures and enrich them with details. The *Selective Gaussian Blur* filter, by contrast, is capable of flattening photographic noise and adding contours and surfaces to an image.

With the *Noise* filters (*Filters > Noise*), you can reduce the appearance of artifacts caused by strong JPEG compression by adding noise. The image remains slightly noisy because of the added color pixels, but they do cover up the compression artifacts.

So far we have been using filters to edit whole images with just one background layer. If you apply filters to images with multiple layers, you have to keep in mind that the layer that you are using has to be activated.

Some filters can't be used on individual layers, but you can copy one layer to a new picture, apply the filter, and reimport the layer afterward. If you wish to use the filters evenly over an entire image, you have to reduce the image to one layer. Choose *Merge Visible Layers* or *Flatten Image* in the context menu of your *Layers* dialog (right-click on a layer in the *Layers* dialog). Make sure the layers that shouldn't be visible are made invisible by clicking the eye symbol. You can also delete the layer if you prefer. Be sure to work with a copy of your image. I will explain the fundamentals for working with layers in more detail in section 3.3. You can use several filters in succession for the same picture.

GIMP has a variety of artistic and graphic filters. I would especially like to point out the *GIMPressionist* (*Filter* > *Artistic* > *GIMPressionist*). It's a real filter laboratory!

If the range of built-in filters and effects isn't sufficient for your purposes, there are a number of online resources offering additional tools, including the GIMP community's own website at www.gimpstuff.org. There is a package of more than 100 filter effects available from the GIMP FX Foundry page at gimpfx-foundry.sourceforge.net, and these include cosmic color and Roy Lichtenstein-esque graphic effects. There is also a range of photographic correction filters available at www.partha.com.

Keep this information in mind and try things out. Experiment with your pictures. Have fun!

2.6.1 Sharpening Images and Image Elements

No filter or tool can make a major improvement if your photo is strongly blurred. But if your picture is only slightly out of focus or has a shallow depth of field, you can sharpen it easily. However, it is not possible to improve the quality of the picture. Pictures aren't enriched with more detail. Instead, the existing details and contours are accentuated by enhancing the light/dark contrasts at the edges of the objects and contours in the pictures (especially with the *Unsharp Mask* filter).

GIMP offers various ways to sharpen fuzzy photographs. There are two filters to choose from: *Sharpen* and *Unsharp Mask* (*Filters* > *Enhance* > *Sharpen/Unsharp Mask*). These filters affect the entire picture or the active layer. You can, however, also select a section in the image to restrict the filter's effect to that area.

The *Blur/Sharpen* tool lets you use a brush to sharpen or blur sections of your photo. This tool becomes interesting if you want to blur sections after having sharpened them. Pictures that have been sharpened too much get stark contours and increased noise. These blemishes can be fixed with the *Blur/Sharpen* tool or the *Smudge* tool.

Let's have a look at the two available filters.

• NOTE

Most of the filters have their own dialog window. There is also a preview pane in most that shows you a little section of the image with a zoom factor of 100%. This is a good size at which to view the image because one pixel of the image is the same as one pixel of the monitor. If a filter's window is displaying a preview image, you can adjust the size of the window in the normal way by dragging its sides or corners, which then adjusts the size of the preview image. Dragging the navigation box moves it around the preview pane, and you can open the navigation frame by clicking the cross-shaped icon at the bottom right-hand corner of the preview window too. The navigation frame displays the original image while you are moving it and the effect of the filter once it is stationary.

Figure 2.61 unsharp.png in its initial state

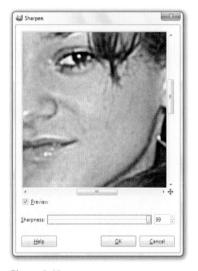

Figure 2.62Distracting artifacts on a over-sharpened image

The Sharpen Filter

Before I start with the following examples, I'd like to point out that that these filters can also greatly improve photographs that are not out of focus. You can gain more visible detail with most pictures through additional sharpening. I use one way or another for sharpening almost all of my photographs. The results make the effort worthwhile. Try it out!

We applied the *Sharpen* filter (*Filters* > *Enhance* > *Sharpen*) in section 2.3.5. This filter has the effect of greatly increasing the sharpness of edges while reducing the pixels in pictures (for example, from 300 dpi to 72 dpi while keeping the image size), even after being applied only once.

You can use the *Sharpen* filter on high-resolution images. However, the *Unsharp Mask* filter is better suited for images with larger numbers of pixels, as I will explain in the next section. To get clear and detailed photos, you can apply the *Sharpen* filter several times. Therefore, you should apply a moderate value to the filter (in the range 0–100) to avoid suddenly oversharpening the image (figure 2.62). If this should occur slightly but the picture otherwise has the desired increase in sharpness, you can apply the *Blur/Sharpen* and *Smudge* tools.

To practice the various sharpening methods and experiment with the settings, open *unsharp.png*, which you'll find on this book's DVD in the *Samplelmages* folder

Start with the *Sharpen* filter. Adjust the value in the *Sharpen* filter window so that noticeable artifacts are visible in the preview window. You will see a polychromatic, highly porous structure when you adjust the sharpness above 90 (as can be seen in figure 2.62). Now reduce the sharpness value until the artifacts disappear. In the example image, this should happen when the value is around 85.

Repeat this procedure several times with a new sharpness value each time until you reach the desired sharpness. In this example, I reached a pronounced sharpness after two repetitions.

The Unsharp Mask Filter

The *Unsharp Mask* filter (*Filters > Enhance > Unsharp Mask*) is the all-around genius among the sharpening filters even though it mimics a method from the darkroom. The filter intensifies edge contrast by changing the adjoining pixels, making the lighter pixels lighter and the darker pixels darker according to the radius you have chosen. Even apparently sharp photos gain contrast and sharpness when you work with this filter. It works particularly well with high-resolution images, and it gives you finer control than with the *Sharpen* filter.

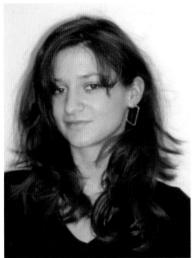

Figure 2.63
The image after applying the *Sharpen* filter twice with a value of 85. There is a noticeable improvement.

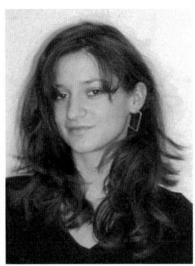

Figure 2.64
The image after several applications or rather excessive use of the *Sharpen* filter. The image is oversharpened, and the noise in the picture has increased.

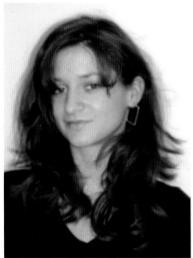

Figure 2.65Again, the image in its initial state for comparison

Figure 2.66
The image after sharpening once with the *Unsharp Mask* filter—a clear improvement. The chosen values were as follows: *Radius* 1.0, *Amount* 3.10, *Threshold* 1.

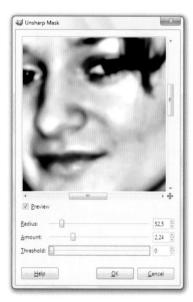

Figure 2.67 Overdrawn light-dark contrasts as a result of *Unsharp Mask* filter settings that are too high

When you open the *Unsharp Mask* filter, the dialog window offers you three slide controls. With the **Radius** slide control, you can set the distance between the edges to obtain a sharper image. **Amount** defines how strong the sharpness should be. **Threshold** indicates how strongly the pixel should contrast with its surroundings before it is registered as an edge pixel and defined. *Threshold* works inversely to the other two settings. The lower the threshold, the stronger the definition. This means if you increase the threshold, you reduce the sharpening effect in your image.

Get to know the *Unsharp Mask* filter through experimenting. Every picture is different. Here are some guidelines that will help you find your own settings:

Radius: Keep the *Radius* value as low as possible. Start with a radius of 0.5 to 1.0 pixels, but also try 2 pixels with your focused pictures. In this case, with the very unfocused photo, I chose a radius of 1.0 pixel. A radius of 0.5 would also be possible. A higher value would lead to a pixelated image like the one in figure 2.62.

Amount: It is difficult to recommend a typical value since the settings strongly correspond with the other adjustable values. Most of the time, lower values don't show an effect except when you apply the filter several times in a row. Values higher that 5.0 to 10.0 are possible if you keep the other settings low.

Threshold: A good value for the *Threshold* setting lies between 0 and 3. Remember, less is more. The lower the threshold, the higher the definition will be. You can reduce the threshold to 0, but you will have to keep the noise in the image in mind.

If you set the values too high in the *Unsharp Mask* filter, the program will exaggerate the display of the image. That leads to white margins and areas at the edges and in lighter sections of the image, as shown in figures 2.62 and 2.66.

That's enough on the subject of sharpening photographs; it's worthwhile to try it on blurry, out-of-focus pictures.

Now let's have a look at ways to flatten the noise in photographs as well as ways to add noise to pictures to get the grainy effect of film. This is done to hide a pixelated effect, dust spots, or compression artifacts.

2.6.2 Noise Reduction and "Smoothening" Images

Noise in digital photography means the presence of bright or colored speckles where there should be none. Noise presents itself in typical RGB "flecks" that appear in darker regions of an image, mainly in the red and blue channels. In digital photography, noise contamination occurs in low-light situations. The darker the picture, the higher the ISO setting, or the higher the surrounding temperature is, the more noise contamination you will get. You can avoid noise while shooting your photos. Many camera manufacturers incorporate noise reduction algorithms that are applied when a slow shutter speed or a high ISO setting is used. The settings are found in the camera's menu.

The filters I will introduce in this section are not only suited for noise reduction, but can also be used to retouch blemishes from minor dust or lint speckles on scanned slides. Some filters are also suitable for removing the moiré effect that occurs from scanning printed images.

The Despeckle Filter

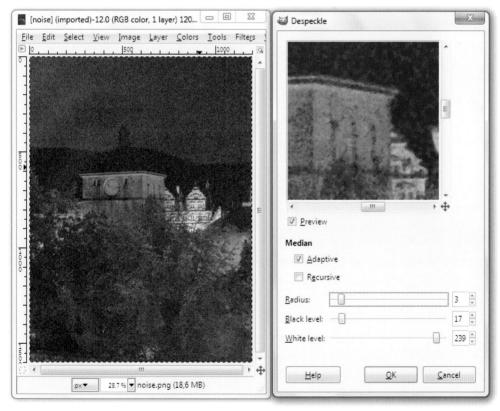

Figure 2.68
The Despeckle window

In the SampleImages folder on this book's DVD, you can find the image noise. png. The photo is a night shot originally saved as a JPEG. The image has been brightened with the Levels tool. This enhanced the noise contamination in the picture.

First we will apply the *Despeckle* filter (*Filters > Enhance > Despeckle*). The filter gives a soft-focus effect that seems to smudge the "flecks" in the image.

When you first open the filter, the window with the available settings appears. At the top you find the *Median* setting, which offers two choices: *Adaptive* and *Recursive*. For now, choose the *Adaptive* setting, which will adapt the radius setting to the contents of the image or selection by applying a histogram from the image. In general, this setting will lead to a better result than setting the radius by hand. The *Recursive* setting automatically applies the filter several times. I only recommend using this setting experimentally, as it usually produces either significant improvements or strong distortion.

You can also configure the following settings:

Radius: The radius relates to the size of the section the filter computes with. Keep the radius as small as possible; otherwise, you might destroy details. Let the program choose the radius.

Black level: A small value (0-20) slightly darkens light pixel noise.

White level: A high value (240–255) preserves bright details. These level settings eliminate noise contamination close to pure white or black, respectively. Edit your image with the filter's default settings. If these don't bring the desired effect, you can experiment.

The filter will be applied when you click the *OK* button and the image will be rendered.

The filter affects the image only slightly. The noise is reduced only in the shadows. Even several applications of the filter won't improve the image. The noise contamination is too high for the filter to have an effect. However, there are other options to "smoothen" the picture.

The *Despeckle* filter is also suitable for removing small blemishes such as dust or scratches on scanned images. In addition, it can remove the moiré effect that occurs when scanning printed images.

The Filter Selective Gaussian Blur

For this example, we will open *noise.png* again and apply the *Selective Gaussian Blur* filter (*Filters > Blur > Selective Gaussian Blur*). This filter doesn't work on the entire surface area of the picture or the selection as other blur filters do. It is applied only to the pixels that deviate in color (however slightly) from the neighboring pixels by a defined delta value (brightness or color difference). The effect is that edges with a hard color or brightness contrast remain while surfaces are blurred—or blended together when pixel colors are similar. The result is that the image is flattened without losing details and contour.

In this example, I chose a *Blur radius* setting of 4 pixels. This value defines how strongly the image will be blurred and, therefore, how the details are preserved. The higher you adjust the value, the smoother, with less noise, your image becomes. Depending on your setting, the disturbing pixel noise disappears, but so does the sharpness of the image. But keep in mind that the higher you set the value, the longer it takes for the program to render the image.

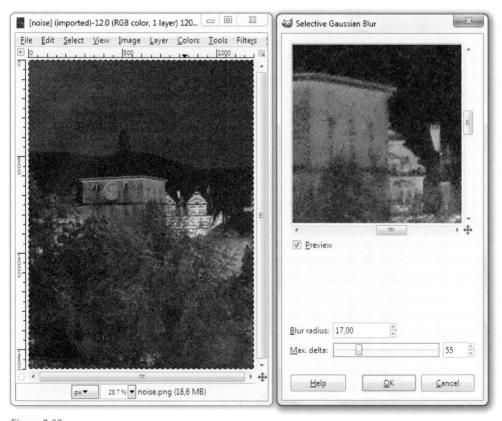

Figure 2.69
The Selective Gaussian Blur window with the flattened image section in the preview window. Next to it is the main window frame with the corresponding image.

I set the *Max. delta* value at 150. The lower this value is, the finer the details remain in the light/dark contrasts, but as a result, more noise contamination remains in the image.

When you smoothen an image, you always lose some sharpness. You can apply the *Unsharp Mask* filter (*Filters > Enhance > Unsharp Mask*) to sharpen the image.

You can then apply the *Clone tool* to eliminate any remaining pixel noise. You can also try to use a different method. Try this: The remaining noise pixels are blue. Select the *Hue-Saturation* tool from the *Colors* menu and select blue as your primary color to adjust and then reduce the *Saturation* and *Lightness* values for your image or selection.

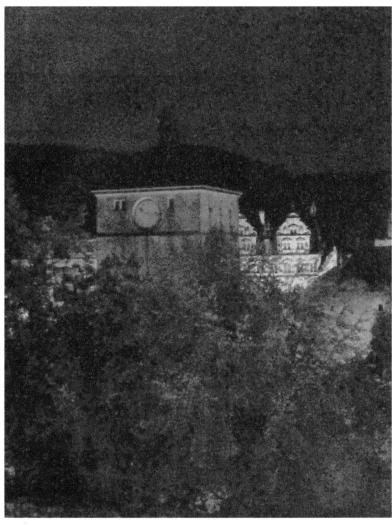

Figure 2.70
The image noise.png after applying the Despeckle and Selective Gaussian Blur filters. After filtering, the remaining blue dots were selected, desaturated (Colors > Desaturate), and darkened (Colors > Brightness-Contrast).

The NL Filter

Another filter that helps reduce noise contamination is the *NL* (nonlinear) filter (menu *Filters* > *Enhance* > *NL Filter*).

This filter was conceived to reduce the noise in pictures. You have a choice of three operating modes: *Alpha trimmed mean*, *Optimal estimation*, and *Edge enhancement*.

Alpha trimmed mean: Use this setting to reduce noise. The filter works as a blur tool that smudges the pixels. You can get good results if you keep the *Alpha* values low and set *Radius* larger than 0.5.

Optimal estimation: This setting applies a soft-focus effect that blurs the pixel noise. However, its algorithms work so that clear edges don't get smoothened. The idea behind this function is that strong contrasts and edges are intended and probably belong in the image. If you choose the *Optimal estimation mode*, the *NL* filter will work similarly to the *Selective Gaussian Blur* filter. The starting values for *Alpha* as well as the *Radius* parameter should be set at 1.0 for our example picture. Based on this value, you can continue adjusting the settings until you get an optimal result.

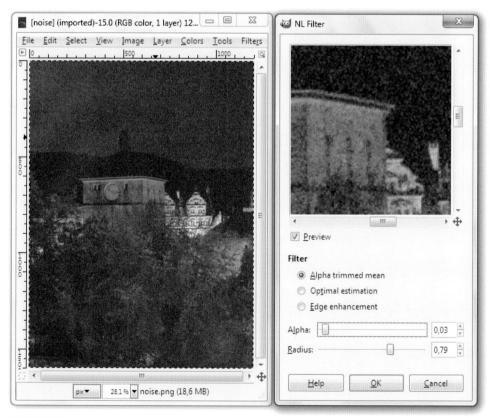

Figure 2.71
The NL filter with the result in the preview window

Edge enhancement: You can use this setting to get an inverse performance of the filter. It enhances edges. The *Alpha* parameter controls the edge enhancement, from subtle (0.1) to intense (1.0). The *Radius* parameter should be set between 0.5 and 0.9. Good starting values are 0.3 for the *Alpha* parameter and 0.8 for the *Radius* parameter.

In section 2.2.10, we gave the scanned newspaper clipping from Miami a new shine. So far, we have been quite successful. Nevertheless, the picture still has some flaws that need repair. For example, there is still a visible cell structure from raster printing at the rear of the car.

Removing Dust and Other Small Irregularities

The Selective Gaussian Blur filter can help if the picture is rich in detail but there are imperfections such as dust or a visible printing raster (Filters > Blur > Selective Gaussian Blur).

We'll open the image *miami-raster.tif* again (in the *Samplelmages* folder on the DVD) that we edited in section 2.2.10. The image has a high resolution of 300 dpi. This is relevant for further work. The resolution can influence the filter setting. High-resolution images are depicted with greater pixel density. The transitions are softer and distributed over more pixels.

Although the picture doesn't show any noise contamination, there are still visible signs of raster printing. We will smoothen the raster with a blurring filter, using the *Selective Gaussian Blur* filter (*Filters > Blur > Selective Gaussian Blur*).

In this case, we will choose a *Blur radius* value of 5 pixels and a *Max. delta* value of 20. With considerably higher values, you could smoothen a noise-contaminated picture as shown earlier.

Nevertheless, smoothing an image always causes a loss of sharpness. Therefore, you should sharpen your image after you apply a smoothening effect—for example, with the *Unsharp Mask* filter (*Filters > Enhance > Unsharp Mask*). If we had applied a sharpening filter beforehand, we would have sharpened the printing screen too.

The Selective Gaussian Blur filter can also be used to remove blemishes from dust and scratches in images from scanned slides. However, you should be especially cautious with the filter settings. The filter could easily change your image into an oversimplified, artificial-looking picture. This also applies to the Despeckle filter.

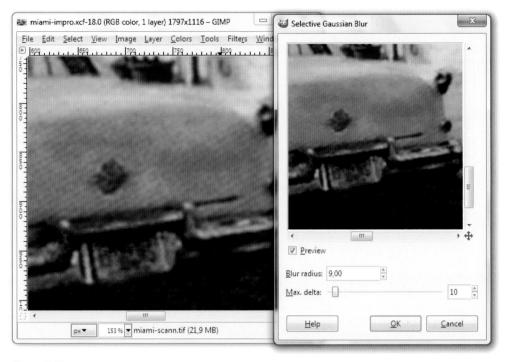

Figure 2.72
The Selective Gaussian Blur window with the smoothened image in the preview window. The printing raster is visible in the image window.

Figure 2.73 The picture after smoothening and sharpening

2.6.3 Simulating Film Grain—Covering Up Blemishes with Noise and Pixels

Covering Up Blemishes

For this exercise, we will use the picture from Miami again. We saved it as a JPEG for the web. What if we compressed it too much and therefore got compression artifacts? What other methods are there to edit images with obvious problems such as compression artifacts? For example, suppose you have an old and highly compressed image from a website. The *Selective Gaussian Blur* filter can help, but let's look at further options.

Covering Up Images with Noise

Open *compressionartifacts.jpg* from the *SampleImages* folder on the DVD. Enlarge the image by 200% so you can make out the compression artifacts.

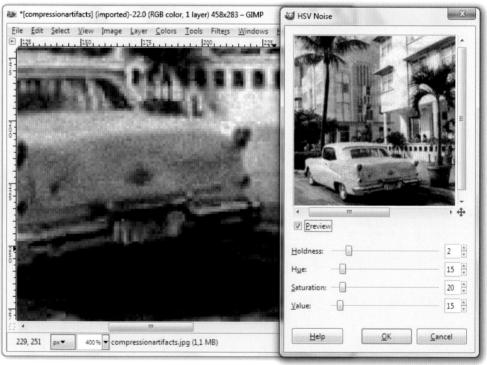

Figure 2.74
The HSV Noise filter window. In the image window, you can see the result of applying the filter.

Select the *HSV Noise* filter (*Filters > Noise > HSV Noise*). The filter scatters pixels through the image. You can control the settings so that the colors of the scattered pixels resemble the surroundings. Admittedly, the entire image becomes very noisy, but the boundaries of compression artifacts dissolve and the image becomes smoother. The settings of the filter work as follows:

- Holdness offers values between 1 and 8. The higher the value, the more similar the colors of the scattered pixels become to the image. I chose a low setting of 2. The colorful noise helps blur the contours of the compression artifacts.
- **Hue** controls the color of the pixels in a random pattern. The larger the value, the more colorful the scattered pixels become.
- **Saturation** controls the saturation (color intensity) of the scattered pixels.
- **Value** controls the brightness of scattered pixels.

The RGB Noise filter (Filters > Noise > RGB Noise) uses the RGB model to scatter the pixels so that they are similar to the surrounding colors—or so that the noise becomes rather multicolored.

Checking the *Correlated noise* box keeps dark colors dark without letting the noise brighten up the image. Checking the *Independent RGB* box allows you to move the sliders independently. When it's not selected, the sliders of the three channels can only be moved as if they were one slider.

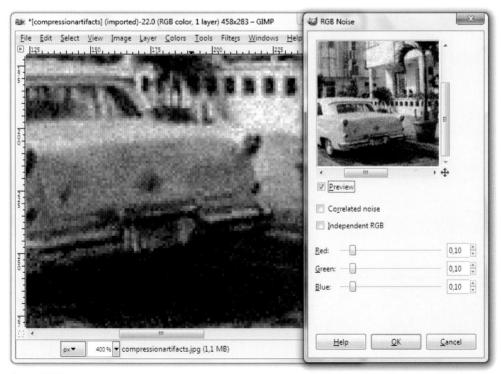

Figure 2.75
The window of the RGB Noise filter

You can dissolve the contours of the compression artifacts with the values shown in figure 2.75 without the noise getting too colorful.

Using the *Spread* filter (*Filters > Noise > Spread*) is an interesting way to distort your image. It creates the effect of looking through frosted glass. Another filter with an interesting effect that can cover up your unwanted patterns is the *Oilify* filter (*Filters > Artistic > Oilify*). This filter simulates the stroke of a brush in an oil painting. The sliders control the size of the brush strokes and the colors remain the same. You can achieve an effect of coarse film grain in high-resolution images.

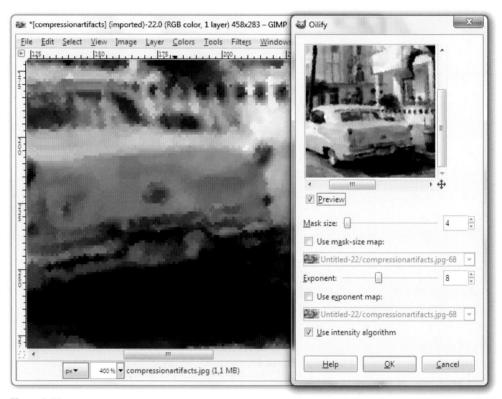

Figure 2.76
The Oilify filter window. The Mask size setting of 3 is the smallest "paint brush" you can select. Selecting the check boxes for the maps helps keep contours.

The **Mask size** slider controls the size of your "paint brush" while the **Exponent** slider controls the vividness of the individual "brush stroke."

To actually emulate a film grain, you can download several plug-ins from registry.gimp.org.

I'll introduce two more filters that can cover up flaws. However, these two alter your image much more than the others.

The Apply Canvas filter (Filters > Artistic > Apply Canvas) applies a canvas structure to your image and makes it appear as if it has been printed on canvas.

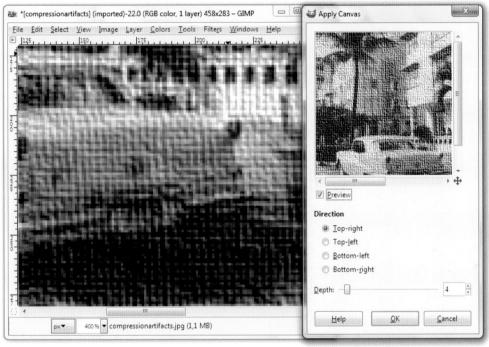

Figure 2.77
The Apply Canvas window and the result in the image window

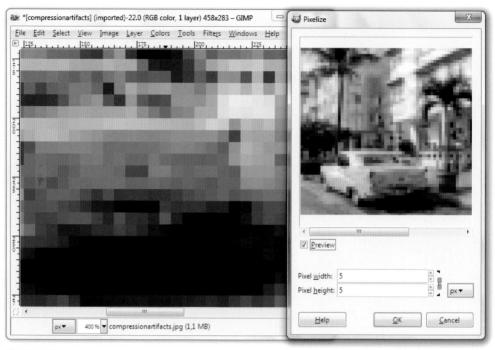

Figure 2.78The *Pixelize* filter and its result in the image window. If you click the chain icon, you can specify varying values for width and height, which lets you create rectangular instead of square pixels.

You can choose the direction from which the light should fall on the canvas structure. In fact, you can decide how the shadow should be cast on the canvas. The *Depth* slider determines the brightness of the highlights on the canvas structure. The higher the value, the stronger and brighter the structure appears in the foreground.

It remains to be said that the filter is dependent on the resolution of the image. The results of the filter are best at a low resolution of 72 dpi or 96 dpi (such as for the Internet). With higher resolutions, the pattern is too finely woven and you get the tiles of the pattern in your image.

The *Pixelize* filter (*Filters* > *Blur* > *Pixelize*) is located among the blur filters. This filter dissolves the image into a coarse, sharp-edged raster. This is an interesting effect because the image will appear sharp from a distance and when you get closer you will see the individual pixels.

Remember that this filter does not change the number of actual pixels (the resolution); rather, it coarsens the depiction of the image.

As you can see, there are many ways to improve flawed images. However, sometimes it's a choice between two evils when your goal is to get as close to a true photographic rendition as possible.

3.1 Introduction to Masks and Selections

asks and selections are two sides of the same coin. Whenever you select an image area for editing, you are, in fact, simultaneously laying a mask over the rest of the image. This mask serves to protect these areas from involuntary changes. (FYI: Editing refers to any kind of adjustment made to an image, including painting, copying, adding shapes or text, rotating, using filter effects, etc.)

The program works with the selection mode by default. If you've done the recommended exercises, you probably noticed that a dashed line of "marching ants" defines a selection. In the image window, you can toggle between mask mode and selection mode with the *Toggle Quick Mask* option in the *Select* menu or the corresponding button in the bottom left corner of the image window. In mask mode, the masked, or "protected," area of the image is masked with an overlay of transparent red, hence the name *mask*.

In this chapter, you'll be exploring select tools, layers, masks, and of course, the options available for these amazing tools.

Figure 3.1

An image in selection mode: "Marching ants" trace the selection area. Take a look at the small button on the bottom left of the window, marked by the red arrow. Now you can freely edit the selected area without worrying about affecting the remaining areas.

The image from figure 3.1 in mask mode: The selected area is covered with a red mask. The effect is the same as with the selection: You can freely edit the unmasked area without worrying about affecting the masked area. But now you can alter the mask, working on it with the paintbrush and the colors black and white.

3.1.1 Overview of Select Tools in the Toolbox

lcon	Function	Icon	Function
	Rectangle Select Tool Selects rectangular regions of the image. Keyboard shortcut: r		Select by Color Tool Similar to the Magic Wand, it selects areas based on color similarity all over the image.
	Ellipse Select Tool Selects circular and elliptical regions of the image. Keyboard shortcut: e		Fuzzy Select Tool (Magic Wand) Selects a contiguous area of an image based on color similarity.
8	Free Select Tool (Lasso and Polygon Lasso) You can use the cursor to make a freehand selection by holding down the left mouse button. Not precise, but simple and quick. The <i>Polygon Lasso</i> is more precise. Click and drag; you can set points to follow a contour.	***	Move Tool Move layers, selection, and other objects. Be careful when setting the tool's properties because selected areas may be cut if inappropriately set.
	Paths Tool Create and edit paths. Paths let you capture regular objects very precisely as editable shapes and convert them to selections.		Flip Tool Reverse the layer, selection, or path horizontally or vertically. This and all other transformation tools can be applied to selections.
80	Scissors Select Tool Select shapes using intelligent edge-fitting. This freehand tool produces a continuous curve that passes through the control nodes and follows the high-contrast edges according to your settings. As with the lasso tool, you must close the selection. Click to finalize selection. Easy to use but not very precise (the precision depends on the contrast of the contours that it is supposed to follow).		Foreground Select Tool A half-automatic select tool to select foreground image objects. Roughly outline and draw over an object with the tool. The object is automatically extracted by GIMP. Depending on the contrast of the extracted object, it is fast and precise but can also be insufficient. Don't expect any miracles.
000	Cage Transform Allows you to select an area within an image bounded by a hand-drawn "cage" and distort it. Tool selected with either a direct click or Shift+G.		

3.1.2 Tips for Handling Select Tools

The select tools are essentially used to select one or more portions of an image for further editing. For example, you might want to create a filled shape to cover an undesirable object in your photo, or you might want to experiment with the functions in the *Colors* menu to adjust a selected image section without worrying about affecting the entire image. Selected image areas can be copied and pasted in as separate elements. You can also use the select tools to cut or delete a detailed area of an image.

The tools can be used to select specific shapes. If you want to select a four-cornered area, you can use the *Rectangle Select* tool. For selecting a round area, you can choose the *Ellipse Select* tool. GIMP also provides the *Free Select* tool (*Lasso* and *Polygon Lasso*), the *Fuzzy Select* tool (*Magic Wand*), and the *Paths* tool. You can also select an area with a color select tool, which can be adjusted to select a certain color or color attributes. Those color select tools select one or more areas in an image, according to the color of the area. All select tools have the common characteristic that areas in the image have to be selected. A new addition to the program is the half-automatic *Foreground Select* tool. That tool makes a selection when you roughly outline or draw over the image object. The program renders the extract automatically. The more contrast the image has, the better the tool works.

Note: You can indirectly create selections by drawing a mask.

The shape tools (*Rectangle Select* and *Ellipse Select*) are also used to create shapes. Just select the tool, click on the image, and while holding the left mouse button down, diagonally drag the cursor over the image where you want to draw the rectangle or ellipse. These shapes are closed, which means that you can easily fill them with any color or pattern. Since GIMP 2.4, these tools have offered the option to adapt the form of the selection to the selected object at a later time and thus transform the selection with the tool.

The color select tools create one or more closed shapes, depending on the options selected. Just select the desired tool (*Fuzzy Select* tool/*Magic Wand, Select by Color*) and click on the color of the image object you want to select.

When tracing any shape with the freehand select tools (*Free Select* tool, *Scissors Select* tool, *Paths* tool), you must use the mouse pointer to trace the contour of the image object to select, and you must return to the starting point of your line; this will ensure that the shape is closed.

With an array of select tools at your disposal, you'll be able to produce complex original shapes and do some very detailed editing work. You can use various select tools one after the other to work on one complex selection.

The following sections provide practical examples showing you how the select tools work. The *Paths* tool is described in detail in section 3.11.

Once you have created a selection, you can modify its properties. Therefore, the *Select* menu contains all options and functions.

3.1.3 The Select Menu

Figure 3.3The *Select* menu options (when a selection is active)

You can access the options available for modifying a selection from the *Select* menu:

- **All**: This option selects the entire image area displayed on the visible layer, which was selected in the *Layers* dialog. You can edit this area and copy it to create a new layer by using the *Edit* menu options.
- None: This option deletes the current selection. You must delete a selection after editing in order to continue working normally and also to create new selections.
- Invert: This option inverts the current selection, producing a negative of it. Say, for example, that you want to select an object on a transparent layer. Often it is easier to use the Fuzzy Select tool (Magic Wand) to select the transparent area around the object than to trace around the object. In the next step, apply the Select > Invert menu item. Now the image object itself is selected.
- Float: This option creates a floating selection. Floating selections are temporary layers that are built when you paste an object that has been copied to the clipboard. This setting enables you to crop and move the current selection with the currently active tool. Floating selections must be anchored, or inserted as a new layer before you can continue working.

- By Color: This option creates a selection from a one-color surface.
- **From Path**: This option creates a selection from a path (this function is also available from the window of the *Paths* dialog).
- **Selection Editor**: This option opens the window of the *Selection Editor*. It offers an overview of the current selection as a black-and-white channel. Even though you don't have the ability to edit your selection, the window gives you the option of choosing all commands without having to return to the menu. Furthermore, the *Selection Editor* offers a few more commands, for instance *Selection to path*.

The following options in the *Select* menu influence the attributes of an existing selection:

• **Feather**: This option adds feathering to a selection, providing it with an additional selection edge. The feathering at the border of the selected object ranges from opaque to transparent.

This means that if a selection has an edge feathering of 0 pixels, it is referred to as "sharp-edged." When you cut or copy a selected object, its borders may appear choppy, as if they were cut with scissors. Feathering an image creates a nice smooth transition between object and background. Image resolution affects the feathering radius you'll want to choose. A radius of 1 or 2 pixels is often sufficient for low-resolution images, while 5 to 10 pixels or more is recommended for higher-resolution images.

- **Sharpen**: When a selection is feathered, you can use this option to reset the feathering radius to 0. However, it is recommended that you use the *Undo* dialog to reset the feathering radius.
- Shrink: This option reduces an existing selection by a numerical value, from the circumference inward.
- Grow: This option enlarges an existing selection by a numerical value, from the circumference outward.
- Border: Use this option on a selection to create a border shaped like the selection. The "border shape" is a new selection with the preset width and can be filled like a frame.
- Distort: This option opens a Script-Fu. You can change the form of your selection with the help of this function. Depending on the setting, you can dissolve, melt away, or explode your selection. You can create drops of water, puddles, or even fire as forms. It's something to experiment with.
- Rounded Rectangle: This option rounds the corners of a rectangular or square selection with a settable radius, either convex (toward the outside) or concave (toward the inside).

- Toggle Quick Mask: This option toggles between selection mode (marching ants) and mask mode (red protective layer). In mask mode, you can use the *Brush* or *Pencil* tool to paint a mask in order to define different border qualities, such as sharp and feathered border areas in one mask; you can also use the eraser to remove or refine a mask.
- **Save to Channel**: If you want to reuse a selection at a later time, you can save the selection to a channel. Then it will be saved with the image and remain in the *Channels* dialog. So, even after deleting the selection by choosing the *Select > None* menu item, it can be loaded again as a selection from the *Channels* dialog at your convenience.
- **To Path**: This option transforms a selection into a path (i.e., a vector shape that can be duplicated and transformed). If you go to the *Paths* dialog, you can set your new path as the active path and work on it.

3.1.4 The Edit Menu

Many of the options available in the *Edit* menu can only be used in conjunction with a selection. Following is a brief introduction to the available options.

Figure 3.4The *Edit* menu options (when a selection is active)

- **Undo**: With this option, you can undo any unwanted adjustments, edits, or strokes; the number of backward steps you can take depends on the amount of memory you allocated when setting up the preferences. This is easy to use if you want to go one step backwards. Otherwise, use *Undo History* in the dock window.
- **Redo**: This option repeats your last painting or editing step or redoes your last undo.
- **Fade**: This option is generally inactive and grayed out. You can activate it when you work with the *Bucket Fill* or *Blend* tool or after using some of the filters. You can change the *Mode* and *Opacity* of your last drawing action. This option allows you to blend the original state of a layer and the last work step executed on it.
- Undo History: This option accesses the *Undo History* dialog in the dock window.
- **Cut**: This option cuts a selected area and copies it to the clipboard.
- Copy: This option copies the current selection and saves it to the clipboard.
- **Copy Visible**: This option copies the image contents of all visible layers to the clipboard, where they can be grouped and inserted as a new layer.
- **Paste**: This option places the clipboard's contents onto the current image. The pasted section is a floating selection.
- **Paste Into**: This option inserts the contents of the clipboard into an existing selection in the current image.
- Paste as: Paste as > New Image inserts the contents of the clipboard into a new image window, creating a new image that contains the pasted data.
 Paste as > New Layer assembles the content of the clipboard in any image as a new layer. There is also the option of using the copied content of a selection and creating a new brush or new pattern.
- **Buffer**: This command cuts the contents of a selection from the active layer, but instead of storing the contents on the global clipboard, it saves them in a special buffer. Use the pop-up dialog to name the buffer.
- **Clear**: This function lets you delete all contents within a current selection.
- **Fill with FG Color**: This option fills a selected closed area (or the active layer if no selection was chosen) with the current foreground color.
- **Fill with BG Color**: This option fills the selected area (or active layer if no selection was chosen) with the current background color.
- **Fill with Pattern**: This option fills the selected area with the pattern currently selected in the *Tool Options*.
- **Stroke Selection**: This option draws a contour on the border of the current selection. The stroke width in the current foreground color can be adjusted. This option is also suitable for contoured fonts. GIMP allows you to select from a variety of dash patterns by using the *Line Style* option in the *Choose Stroke Style* dialog styles.

- **Stroke Path**: This option draws a contour in the active foreground color on the border of a selected path. The width can be adjusted.
- Preferences: This option opens the window for the general settings for GIMP
- **Input Devices**: This option opens the *Configure Input Devices* dialog, where you can enter settings for your mouse, graphics tablet, etc.
- Keyboard Shortcuts: This option opens the Configure Keyboard Shortcuts
 window. Here you can find the shortcut default settings and the options
 for changing the settings according to your preference.
- Modules: This option offers a choice of additional modules for color management.
- Units: This option lets you select which measuring units GIMP offers or uses.

3.2 Touchup Work 3—Removing Red Eyes

3.2.1 Avoiding Red Eye—Using the Flash Correctly

If you use a flash when photographing people or animals, you're probably aware that the eyes of your subjects can sometimes turn red (often a color other than red for animals) and glaring, like a demon's eyes. Known as the *red-eye* effect, this occurs because the flash is mounted close to the axis of the lens. The flash passes into the eye through the pupil and reflects off the back of the eyeball back through the pupil. The camera records the reflected light. The main cause of the red-eye effect is the amount of blood in the choroid, which nourishes the back of the eye and is located behind the retina.

This undesirable effect can be avoided when taking photographs:

- Use a flash with an adjustable head and don't aim it directly at a person.
 Swivel or tilt the head so the flash is aimed at a reflecting surface (like the ceiling) rather than a person's face.
- Connect your flash to your camera with a cable, or use a wireless flash unit, and hold it above you or to your side when photographing.
- Try using a red-eye reduction (pre-flash) setting. The flash will fire once before the image is taken, which will cause the pupils of the photographed person or animal to contract. If the red-eye effect remains, it will be less severe.

If this has happened and you just can't stand seeing a picture of your fiancé glaring at you with eyes as frightening as Dracula's, GIMP can help transform the beast back to beauty (or handsome, at least).

3.2.2 Eliminating the Red-Eye Effect

Since GIMP 2.4, there has been a filter to eliminate the red-eye effect. You'll find it by choosing *Filters* > *Enhance* > *Red Eye Removal*. The filter is easy to use and efficient. You can follow the steps as we go along. To do this exercise, open the image *redeyes.bmp* in the *SampleImages* folder on the DVD and save it in your exercise folder.

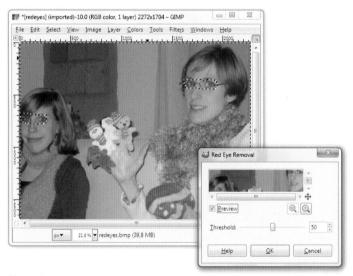

Figure 3.5
The Red Eye Removal window. To focus the effect of the filter, I selected the area around the red pupils with the Free Select tool. Otherwise all red objects in the image would have been converted to grayscale colors.

After you choose the *Red Eye Removal* filter, a window opens with a preview image in which the red pupils are already blackened. You can increase the blackening by moving the *Threshold* slider to the right. To assist the filter, you can use the *Free Select* tool (*Lasso*) to make a selection around the eyes. That's it. Click *OK*. The result is quite convincing.

In our example image, you have to preselect the eyes; otherwise, the reddish skin tone and the red objects in the photo will be altered. Select the *Free Select* tool (*Lasso*) in the *Toolbox*. Then go to the tool's settings. As a setting for *Mode*, select the second symbol from the left, *Add to the current selection*. Now you can roughly draw around the eyes while holding the left mouse button. Create four small selections in the picture. This localizes the filter's operational sphere. Now apply the filter. Done.

As a last step, however, you must deselect your selection. Choose *Select* > *None*.

The *Red Eye Removal* filter didn't exist in versions of GIMP prior to 2.4. You can apply the method used before the *Red Eye Removal* filter was introduced if the filter doesn't have the desired effect. Here's how it works:

Use the *Zoom* tool to zoom in on the area of red in the eyes. It is important that you select only the red section of the pupil.

Prepare the picture by dragging out at least two guides from the rulers. Position them as tangents to the upper and left side of the pupil. Select the *Ellipse* tool from the *Toolbox*. Point at the crossing point of the tangents. Click and hold the left mouse button while dragging it diagonally from the top-left corner of your imagined rectangle around the pupil toward the lower-right corner of the rectangle. Now you have an ellipse around the pupil that is marked by a border of "marching ants." This defines the edge of your selection. You can also use the *Lasso* tool. It is quicker and easier but also a little imprecise.

You now have an active selection on your image. Your adjustments will modify only the actively selected area; the remainder of the image is mask-protected against changes

In this exercise, you want the selection to have a soft border, or feathering. Without feathering, the adjustments you make will have a sharp-edged border, and it will look as if someone cut out an object with scissors and pasted it on. Feathering the edges of the object will create a more natural appearance. Use the Select > Feather menu item to access the feathering function. The Feather Edges dialog pops up. Enter a value of 10 pixels and click OK to accept your changes.

In the next step, remove the color saturation. Access the *Colors* > *Desaturate* menu item. It requires only one click to remove the color levels from your selected area. You should see only the gray values now.

Next, access the *Colors > Brightness-Contrast* menu item to correct the brightness and contrast according to your taste. Finally, use the *Select > None* menu item to deselect the area.

3.3 Introduction to Working with Layers

Imagine you want to compose an image from several images that you've stored on your computer. Well, you can do just that! The process is similar to the production of animated cartoons. You begin with a background image. Then you place one or more transparent foils (which are layers comprising image elements on top of transparent backgrounds) on the bottom, or opaque, background layer. A stack, a composite of single images, is created, one on top of the other. Certain file formats let you save those images with foils and layers to a single file. The layers remain as single images in this one file, so they can be edited and altered afterward. During the editing process, you can move the layers to the front or the back of the image to determine which layer should overlay the other. In GIMP, file formats for saving images with layers are XCF and PSD.

Figure 3.6
The layers of a composite image: (1) aircraft, (2) shadow of the aircraft, (3) hangar, (4) window pane (layer with glass effect showing through, almost transparent), and (5) background with landscape

To edit images with layers in GIMP, access the *Layers* dialog in the *Layers*, *Channels*, and *Paths* dock. If it isn't present, you can call it up by choosing *Windows > Dockable Dialogs* or *Windows > Layers*, *Channels*, *Paths*, *Undo* from the image window. The default view shows the *Layers* dialog in the dock.

• TIP

► You can reopen the *Layers* dialog at any time using the *Windows* > *Recently Closed Docks* > *Layers, Channels, Paths, Undo History* command.

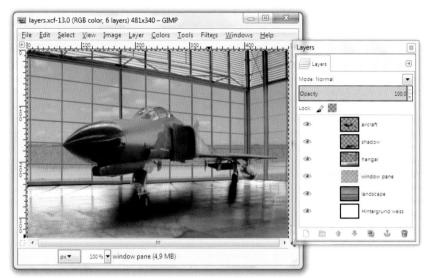

Figure 3.7
Finished image (see *layers.xcf* in the *FinishedImages* folder on the DVD) and *Layers* dialog

There are several advantages to working with layers:

- Images with layers can be composited from a stack of image elements on transparent foils.
- · Layers can be easily duplicated.
- Layers are independent of one another so they can be freely positioned and changed, scaled, and transformed.
- Layers can be linked and edited jointly in order to scale them simultaneously at the same ratio. Afterward, remove the link to edit the layers individually.
- Layers can be grouped and the resulting layer groups can then be edited as one, although the individual layers can still be edited separately.
- The order in which the layers are stacked can be changed; this enables you to create depth by placing one image on top of another.
- Layers can have transparent areas so that objects can be placed on top
 of your image without covering the background. Image objects on layers
 beneath are visible through the transparent image area. Transparent
 areas with no subjacent image object visible show a gray-and-white
 checkered pattern.
- The opacity of layers can be changed (opaque, semi-opaque, or translucent). Translucency allows you to see through an image element.

• NOTE

This is of great importance when working with selections and layers.

An image object is bound to a layer. A selection isn't. You can create a selection on one layer and apply it to any other layer. It works only on the active layer. The active layer is the layer that is selected. It is highlighted in blue in the *Layers* dialog. However, only when you carry out a work step (i.e., filling, color corrections, or copying) does something happen on the chosen layer. Copying is not considered an alteration to the image content; visible changes to the image will only occur with the subsequent pasting/insertion.

3.3.1 The Layers Dialog

You can access the *Layers* dialog either from within the *Windows > Dockable Dialogs* menu item or from the *Windows > Layers*, *Channels*, *Paths*, *Undo* menu item in the image window. By default, when you start GIMP, it displays the *Layers* dialog in a window together with the dialogs for channels, paths, and the undo history. You can click a tab to select one of these dialogs (upper area in figure 3.8).

Figure 3.8
The Layers, Channels, Paths, Undo window (Layers dialog) within the dock window. The names of the windows located in the dock are hidden if there is insufficient space to display them.

Here are the options in the Layers dialog:

- Mode: This option determines how a layer interacts with other layers. The
 default mode is Normal.
- **Opacity**: This option lets you adjust the opacity of the layer. Click the up or down button to obtain a translucent layer fill. In the example image, the *window pane* layer was set to translucent opacity.
- Lock: The button (with the checkerboard pattern) serves the purpose of
 protecting the transparencies. If Lock is activated, you cannot alter the
 transparent section of a layer. If you activate the button with the brush
 icon beside the button with the checkerboard, image areas filled with
 pixels can't be altered either. This button is a new feature in GIMP 2.8.

The main part of the window shows the layer list. The sequence from top to bottom corresponds to the layers stacked in the image. The top layer is on the top of the list, while the bottom layer is at the bottom. This produces the order in which you see the image elements in the image window, one beneath the other.

The blue-highlighted layer is the active layer. If you wish to change active layers, simply click in the preview image of the layer you wish to edit or in the area with the layer's name to the right of it.

The eye icon can be clicked to make a layer visible or invisible. Invisible layers are not printed when you print the stack. (They also won't appear if you save the image in a file format that doesn't support layers, such as JPEG.)

If you click the area beside the eye icon, a chain icon will appear. If you want to edit, move, or scale several layers simultaneously, just link them together. To remove the link, click a visible layer.

Next to each chain icon area is a thumbnail of the image. The checkered surfaces are the transparent sections of the image.

The name of the object on a layer is displayed to the right of the thumbnail. You can rename a layer by double-clicking its name and typing over the existing text. Double-clicking on the thumbnail image will open the *Layer Attributes* window so you can enter a new name. It's wise to use descriptive names for the layers since you can't always see the details in the thumbnails.

• NOTE

Select Lock when you are finished working on a layer so the layer can't accidentally be modified. The program recognizes the layer for which you activated the lock. You can still work with the other layers that haven't been locked.

• NOTE

To save space, the *Auto* button is no longer part of the dock in GIMP 2.8. Instead, the dock menu (accessed via the arrow icon at the top right) includes the *Auto Follow Active Image* command, which determines whether the *Layers* dialog displays the layers in the currently active image when you have multiple images open. If you can't see entries for the active image in the *Layers*, *Channels*, *Paths*, or *Undo History* dialog, clicking this command will reveal all.

• TIP

▶ The arrow icon in the top right corner of the dock reveals a menu that includes, among other things, a setting that alters the size of the preview thumbnails in the *Layers* dialog.

• NOTE

Before editing a layer, click the thumbnail, the layer's name, or the area to the right of it to activate the layer. The active layer will be highlighted in blue in the layer list.

The buttons below the layer list have the following functions:			
	New Layer Creates a new layer (see section 3.3.2). Press <i>Shift</i> to create a new layer with previously defined values.		Duplicate Layer Creates a copy of the current layer (see section 3.3.2).
•	New Layer Group Creates a new layer group and adds it to the active image. Layer groups are new in GIMP 2.8, and enable you to group and edit layers as one. See section 3.9.5 for more details. Raise Layer Moves a layer up one level in the layer stack. Press the Shift key to move the layer to the top of the list.		Anchor the Floating Layer Floating selections are a special feature of GIMP. If you copy and paste the contents of an image selection, it will appear in the <i>Layers</i> dialog as a floating selection. You can then either double-click to paste the floating selection as a new separate layer in the image or click <i>Anchor Layer</i> to merge the floating layer and the previously selected active layer. This is an efficient method when pasting multiple copies of your floating selection to an active layer or when pasting a previously modified selection to a specific layer.
4	Lower Layer Moves a layer down. Press the Shift key to move the layer to the bottom of the list.	9	Delete Layer Deletes the active layer without opening a dialog that will allow you to cancel the action.

☑ Edit Layer Attributes... New Laver... New from Visible Mew Laver Group... Duplicate Layer Lavers - Brushes Anchor Layer Merge Down @ Delete Layer ⊞± Layer Boundary Size... Lock: 🎤 🌃 " Layer to Image Size Scale Layer... Add Layer Mask... Apply Layer Mask Delete Layer Mask Show Layer Mask Edit Layer Mask <u>D</u>isable Layer Mask Mask to Selection . Add Alpha Channe Remove Alpha Channel Alpha to Selection Merge Visible Layers... <u>F</u>latten Image 10.0 2

Figure 3.9
The Layers context (right-click) menu

3.3.2 The Context Menu in the Layers Dialog

Right-clicking on a layer in the *Layers* dialog opens the *Layers* context menu. The context (right-click) menu lists several crucial menu items, some of which can also be accessed through the *Layers* dialog or in the *Layers* menu.

Here are the options in the *Layers* context menu:

- **Edit Layer Attributes**: Lets you change the name of the layer. The name is displayed in the *Layers* dialog, where it can also be changed.
- **New Layer**: Creates a new layer in the image. Most often used when you wish to transform a floating selection into a new layer. This command is equivalent to the *New Layer* button in the *Layers* dialog.
- New from Visible: This option creates a new layer from all current visible layers.
- New Layer Group: Creates a new, empty layer group. You can then drag
 and drop multiple layers from the current image stack to the new group.
 Layer groups behave like individual layers and you can set their attributes
 in the same way using the context menu. This option corresponds to the
 New Layer Group button in the Layers dialog.
- **Duplicate Layer**: This option copies a chosen layer and pastes it as a new layer onto the image. You might use this tool if you created an object on one layer and now want to multiply it on one or more other layers (perhaps to create a pattern or create depth in the background). Use the *Duplicate Layer* menu item to efficiently copy the desired object onto

a new (or previously created) layer. The copied objects will be stacked behind the original, which means that you won't see the multiple objects at first. Select the copied layer in the *Layers* dialog and use the *Move* tool to arrange it on the image. This option corresponds to the *Duplicate Layer* button in the *Layers* dialog.

- **Anchor Layer**: Anchors the floating selection to the active layer. It also assigns a floating selection (pasted layer) to a new layer. This option corresponds to the *Anchor Layer* button in the *Layers* dialog.
- Merge Down: Merges the active layer with the layer below it in the layer list. This action is permanent. You only can undo it with *Undo History*, and only if you have not yet saved and closed the image, so be certain to make a copy if you plan to do more advanced editing.
- **Delete Layer**: Deletes the active layer. This is the same as clicking the trash can icon (*Delete Layer*) at the bottom of the *Layers* dialog.
- Layer Boundary Size: Layers are initially only as large as the object placed upon them (see 3.7.2: Text layer, dashed border). If you wish to add more objects to the same layer, you must extend that layer's size. This option lets you resize the layer.
- **Layer to Image Size:** Same as above, but the layer size is automatically set to the size of the visible image.
- **Scale Layer:** Lets you scale the active layer of an image. It is similar to the *Scale* tool in the *Toolbox*, but gives you the ability to scale the image with numeric values.
- Add Layer Mask: You can add a mask on top of a layer to select just partial
 areas of the layer in order to edit the layer's elements without changing
 the layer itself. A layer mask is directly assigned to the selected layer, but
 it can be edited separately as a black-and-white channel or grayscale
 image (Edit Layer Mask).
- Apply Layer Mask: Once a layer mask has been edited and checked, its
 effect can be applied to the relevant layer. The layer mask itself is deleted
 and the editing is directly applied to the pixels of the layer. Don't use this
 menu item if you want to keep the layer mask for further editing.
- **Delete Layer Mask**: Deletes a layer mask, discarding the changes you made to the relevant layer.
- Show Layer Mask: Makes a layer mask visible.
- Edit Layer Mask: Allows editing of the layer mask. Your changes will be
 displayed in the Show Layer Mask dialog. If you don't use this dialog, the
 changes to the mask will be visible in the image object or in the layer
 content itself.
- Disable Layer Mask: Disables a layer mask or its effect on the layer without deleting the layer mask itself.

CHAPTER 3

NOTE

Even if you duplicate a background layer, it does not automatically add an alpha channel.

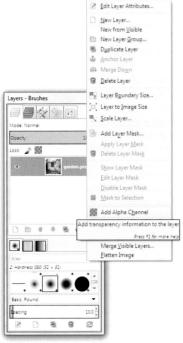

Figure 3.10
Adding an alpha channel to the background layer of an image in the context menu of the *Layers* dialog

- Mask to Selection: Transforms the active layer's mask into a selection.
 For example, if you created a mask with specific border attributes (that means sharp edges or feathering), you can copy the mask's attributes to a new selection.
- Add Alpha Channel: This item is available only for background layers
 without transparency, i.e., without an alpha channel. Adding an alpha
 channel transforms a background layer into a normal layer, enabling you
 to use transparency on the layer as well as to move the layer in the Layers
 dialog.
- Remove Alpha Channel: Deletes the alpha channel of a layer so that the layer isn't transparent but the opacity can still be adjusted. The name of the layer appears in bold in the *Layers* dialog.
- Alpha to Selection: Use this option to easily create a selection based on an existing object and include the feathering and transparency attributes assigned to that object.
- Merge Visible Layers: Reduces all visible layers to a normal layer with alpha transparency.
- **Flatten Image**: This option reduces all layers of an image to one single background layer (with no alpha channel [i.e., transparency]).

3.3.3 Background or Layer with an Alpha Channel

So far we have been editing images without bothering with the features of the layer. Every image that you open with GIMP has a background layer. The background has certain features:

- First of all, background layers always have the file name of the original image. The name appears in bold in the *Layers* dialog.
- Background layers are not movable within the layer stack and always lie at the bottom of the stack.
- If you erase or cut something out of a selection of your background layer, it will appear covered in the chosen background color in the program. The reason is that the background layer does not have an alpha channel to enable a transparency. When you are erasing, cutting, or deleting something on a background layer, the color of the paper (background color) lights up.

New in GIMP 2.8: The background layer is no longer called "background," but instead is automatically given the name of the active file.

However, for simplicity's sake, I will continue to use the term "background" when talking about the original image layer (without an alpha channel).

If you want to have transparent surfaces in a background layer, you have to add an alpha channel from the context menu of your *Layers* dialog. Right-click on the layer in the dock, and then simply select *Add Alpha Channel* from the context menu. Then you can move the layer around in the *Layers* dialog or place other layers under this layer in the stack. In the following exercises, you will be working with these options.

3.3.4 Working with Several Images—Inserting Layers from Another Image

You can view the layers of an active image in the *Layers* dialog. If you have several images open at the same time, the active image will be the one in the foreground; the active image will also have a highlighted blue title bar.

When working with several images, you can easily drag and drop layers from the *Layers* dialog of the active image to the image window of the other picture. (In the *Layers* dialog, click the desired layer of the first image, and while holding the left mouse button, drag it onto the image window of the second image and release the mouse button.)

However, you can also insert a new picture as a new layer in an already opened image. In that case, you must select your image from *File > Open as Layers*. Your picture will be opened as a new layer in the already opened image.

In both cases it is essential that the images have approximately the same size and resolution. It's not hard to scale down the inserted layer. However, if the inserted layer is considerably smaller than the original image, you must enlarge it. This will have a significant effect on the quality as the inserted image is recomputed and may appear blurred.

So far in the editing you have done, you haven't needed to have any prior knowledge about layers. In following examples, you will learn how to work with layers for the first time.

• NOTE

Exporting a layer group from one image to another is done the same way as exporting a single layer from one image to another.

Figure 3.11 Layer Mode options in the Layers dialog

• NOTE

The layer mode groups have been rearranged in GIMP 2.8. The modes that brighten or darken an image are now clearly grouped together.

3.4 Touchup Work 4—Correcting Overexposed or Underexposed Images

The following examples are actually a continuation of the exercise in section 2.3, where we adapted the brightness and contrast in an image. Because adapting the brightness in layers plays a major role in layers and layer settings, I will introduce the editing options at this point.

The Mode Settings in the Layers Dialog

With the *Mode* options in the *Layers* dialog, you can determine how the active layer is superimposed on the underlying layer. Normal is the default setting. In the Normal mode, the layer on top covers the layer below without further mixing effects. All other mix modes change the brightness, contrast, and color values. Their names give you a hint as to what they can do. Most of these modes are effects that are derived from effects used in double-exposing and developing film in the darkroom. The actual effect varies from image to image depending on the features of the overlying layer. Experimenting can be worthwhile because the mode for superimposing can lead to interesting results when blending two layers. Layers can be virtually blended together. You will find a corresponding *Mode* setting in all paint and fill tools as well as the Clone tool.

In the following example, you will learn to edit over- and underexposed images with the help of several layers using the *Mode* option.

Editing Overexposed Images

Don't throw away your image even if it has been overexposed or the flash was too bright. You can improve it by applying the Levels (Adjust Color Levels) or Curves (Adjust Color Curves) function. However, it may be much quicker and more efficient if you use layers and the various layer modes.

If you would like to follow along with the following example, simply open one of your own overexposed images or the image overexposed.png from the SampleImages folder on the DVD.

After opening the image in GIMP, you can see it in the image window and its background layer in the Layers dialog. Duplicate the background layer: right-click on the background and then select Duplicate Layer. A copy of the layer will appear immediately in the Layers dialog.

Now activate the new layer and change the *Mode* setting in the *Layers* dialog from *Normal* to *Multiply*. A multiplication effect will be applied to the two superimposed layers, the image will become darker, and more details will emerge.

Should the image still be too dull or too bright, keep duplicating it again and again. The duplicates will be in *Multiply* mode automatically. You can also duplicate the layer by clicking the icon at the bottom of the *Layers* dialog.

If your image is too dark after the last duplication, simply reduce the opacity of the overlying copy and set the brightness and contrast as you please. When you are satisfied with the result, right-click and select *Merge Visible Layers* from the context menu.

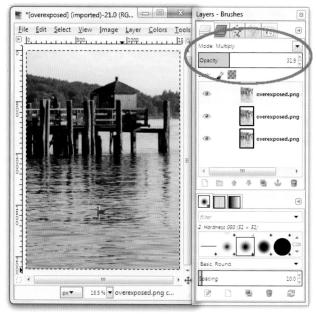

Figure 3.12
The edited image with the settings in the Layers dialog

3.4.3 Editing Underexposed Images

The process for fixing overexposed images works much like the one for fixing underexposed images. To follow along, select an underexposed image or the image *underexposed.png* in the *SampleImages* folder on the DVD. The process I will show you also helps to get the most out of strongly underexposed images.

After opening your image, duplicate the background. This time select the *Screen* mode. Duplicate the copy until your image seems overexposed. Now use the *Opacity* slider to adjust the brightness of your image: 100% opacity is the highest level of brightness; 50% is half as bright. Adjust it to your liking and then merge the layer to create one background layer.

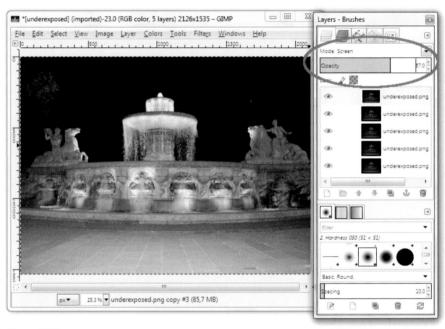

Figure 3.13
The image after editing with the settings in the *Layers* dialog

3.5 Touchup Work 5—Using Perspective Correction to Remove Converging Verticals

3.5.1 Trying to Avoid Converging Verticals When Taking Shots

Layers play an important role when it comes to removing converging verticals in an image. Converging verticals occur mainly in architectural shots, when the camera is pointed upward and focused on an object that is very close to a vertical object. What usually happens is that the building's edges converge vertically toward a third vanishing point.

The following tips can help you avoid or reduce such image flaws when taking pictures:

- The greater the distance to the vertical object (e.g., a skyscraper), the smaller the amount of distortion at the top of the image.
- Try not to use wide-angle lenses because a short focal length will cause additional distortions (such as bulging). The greater the focal length, the fewer problems you'll have with additional distortions.
- Tilt-shift lenses are available for cameras with interchangeable lenses.
 These lenses allow you to shift the lens barrel while keeping it parallel to both the vertical subject and the image plane inside the camera. This will ameliorate the problem.

Because converging verticals may occur in spite of all your careful preparations, most digital image editing programs provide a variety of methods to remove such flaws from architectural images.

3.5.2 Steps Involved and Description of Work

The main steps are as follows:

- Use the *Perspective* transform tool (*Change perspective of the layer, selection or path*) to rectify an architectural shot.
- Add an alpha channel to the background layer so that you can add transparency.

The convergingverticals.png image has a vertical vanishing point, which means that the outer edges of the building converge vertically. You'll use the transform tools and options to straighten the shapes out. As you do this, consider the attributes of background layers compared to layers with alpha channels. You will need layers with alpha channels as you continue your exercises.

3.5.3 Removing Converging Verticals from an Image

Follow these steps to remove the converging verticals from the image:

- Open the image *convergingverticals.png* in the *SampleImages* folder on the DVD.
- Set vertical guides along the outer edges of the building and a horizontal guide at the height of the eaves.
- Use the Zoom tool to zoom out a little, or pull the borders of the image window to enlarge it slightly, so that you will have a larger working space around the image.
- Select the *Perspective* tool from the *Toolbox*. Click on the image. Drag the outer edges and the eaves of the building over the selected corner points parallel to the guides. As a result, the image may be heavily stretched horizontally. You can fix this by stretching the image vertically with the *Scale tool*. If necessary, use the *Image > Canvas Size* menu item (see section 3.14.2) to enlarge the canvas size.
- Use the Layer > Layer to Image Size menu item to resize the layer to the image size.
- Save the image with a new name in your exercise folder.

The *Perspective tool* could also be called *free transformation* or *free distortion tool*. It does offer a way of rectifying perspective distortions on an object. However, the distortions are not interlinked (as in some tools from other programs) and the object can be distorted from its corner points over the two axes. The method should be good enough for images that don't have major distortions, as is the case with this image.

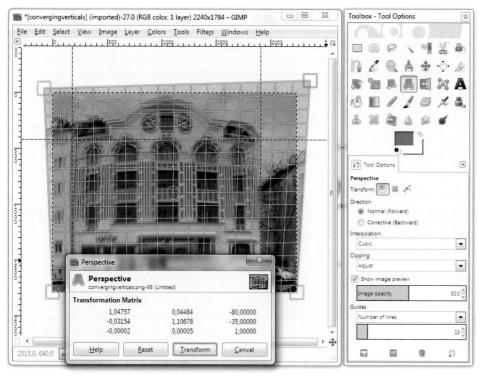

Figure 3.14Perspective correction with the *Perspective* tool. Preview opacity for the transformation has been reduced to about 50% in order to make the guides in the background visible.

Transform Tool Options

When selecting the *Perspective* tool, pay attention to the tool's settings. The following options are available:

- Transform: As with all transformations (changes in form and size), you
 can choose whether you want the transformation to be applied to a layer,
 a selection, or a path.
- **Direction**: The *Normal (Forward)* option performs a transformation according to the direction of the guides. *Corrective (Backward)* will perform the transformation in the reverse direction. This option is used to correct previously applied perspective deformations.
- Interpolation: This drop-down list allows you to choose the quality for the recalculation of pixels in the distorted image. Select the *Cubic* or *Sinc* option. Both require more time, but they produce the highest quality.
- **Clipping**: Depending on which option you select, the result of the transformation will be automatically adjusted to the size of the layer:
 - Adjust: The layer will be adjusted to the canvas size of the layer. The
 function either enlarges or reduces the clipping to fit, irrespective of
 the size of the actual image or layer.
 - **Clip**: The new size of the layer that resulted from the transformation is enlarged or clipped to the original size of the encompassing rectangle. If the layer has the size of the image and is reduced in size during the transformation, the layer size is set to the original image size again after the transformation.
 - Crop to result: The layer and its content will be cropped to the boundaries of the inner rectangle, which is contained within the transformation frame. Sometimes image contents are cut off for that reason.
 - Crop with aspect: The layer is cropped or enlarged to a right-angled image section. It maintains the aspect ratio of the initial layer. The result of the transformation is limited in size by the transformation boundary.
- **Show image preview**: Displays a real-time preview of the transformation while you work.
- Image opacity: The opacity of the superimposed preview can be reduced
 while you work. This reveals the original image and the guides to help
 you perform exactly the right transformation.
- **Guides**: Various grid patterns and spacings can be selected. The guides themselves are not transformed.

• NOTE

You can enlarge the layer to the image size any time in the editing process by choosing the *Layer* > *Layer to Image Size* menu item. If you want to enlarge the size of a layer to the rectangular boundary of your pixel content, choose *Layer* > *Autocrop Layer*.

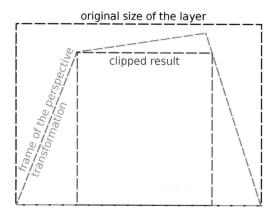

Figure 3.15
The original size of the layer, the transformation frame, and the clipped result

If you choose a grid option from the *Preview* drop-down menu, you can select the number of grid lines and the grid spacing in the drop-down menu under *Preview*.

NOTE

The described tool settings are valid for all transformation tools.

3.5.4 Removing Lens Distortion, Making Perspective Corrections, and Reducing Vignetting

Even after correcting the perspective in the previous exercise, distortions and warping still remain. This is due to the fact that the image was put together as a panorama picture using several individual photos taken with a wide-angle lens. In addition, the image has a left and a right vanishing point.

To correct these defects, GIMP offers the *Lens Distortion* and *Curve Bend* filters. These filters provide not only perspective corrections, but also to a certain extent corrective measures for barrel- and pincushion-shaped lens distortions. If you wish, you can give your image the effect of a photo taken with a fisheye lens (an extreme wide-angle lens). You can also reduce or even eliminate vignetting. Vignetting is the reduction of an image's brightness or saturation at the periphery in comparison to the image center. This effect often occurs when wide-angle lenses are used.

You can find the *Lens Distortion* and *Curve Bend* filters in the *Filters > Distorts* menu.

If you want to tag along again, open the image *convergingverticals.png* in the *Samplelmages* folder on the DVD. We'll begin by using the filter. By handling the filter correctly you can omit practically all distortions in one step.

When you select the *Lens Distortion* filter (*Filters > Distorts> Lens Distortion*), a window opens with six slide controls to choose from.

Main. Positive values make the image more convex (curving outward, in a similar way to a fisheye lens) and negative values make it concave. This means that you can use appropriate values to straighten a distorted image. In technical terms, these are the basic settings for correcting barrel and pincushion distortion. Changes are applied to the entire frame.

Edge works in the same way as *Main*, but only distorts the edges of the image.

The **Zoom** slider changes the scale of the image content. This can be useful, for example, to reduce the image in size when creating a convex (fisheye) effect.

The **Brighten** slide control is useful to manage the vignetting effect by enhancing the dark edges of images.

X shift turns and distorts an image around the vertical axis, depending on the setting in *Main* and *Edge*. **Y shift** does the same on the horizontal axis, thereby making the image look like it's angled backward or forward. This is the setting for correcting a perspective distortion.

Figure 3.16 shows the correct values for fixing *convergingverticals.png*.

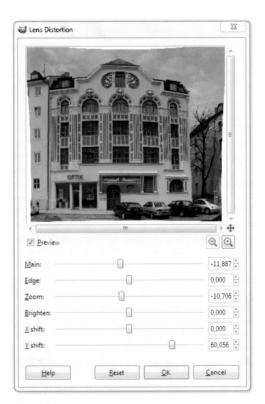

Figure 3.16The *Lens Distortion* preview window showing the suggested settings

After you have straightened the image, continue by applying the correction methods described in section 3.5.3. Unfortunately, even though the image has been set straight, the correction process lacked a grid in the preview to straighten the building completely.

The image has been straightened as much as possible. Yet it is still bulging upward. Now you can apply the *Curve Bend* filter (*Filters > Distorts > Curve Bend*). Leave the default settings and check the Automatic Preview so you can control your editing.

You don't have to rotate the image, so leave the *Options* value for *Rotate* at 0. The picture bulges more at the top, so you can leave *Upper* selected under *Curve for Border*. At first you'll see a horizontal line in the *Modify Curves* graph. Drag the line from the middle section downward (as shown in figure 3.17). Check the result in the preview window. When you are satisfied, confirm the results by clicking the *OK* button.

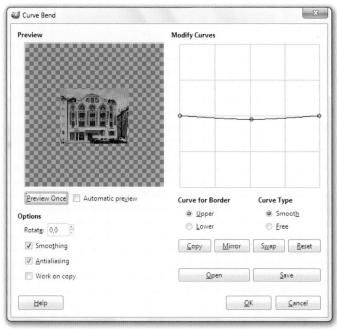

Figure 3.17
The Curve Bend window

Check the alignment of your image along the grid lines. I used the *Perspective* tool to raise the drainpipe at the top-right corner of the building. In addition, I used the *Scale* tool to stretch the vertical lines a little.

The result of all that hard work is a straightened and almost right-angled image of our Art Nouveau building.

Figure 3.18
The original image in comparison

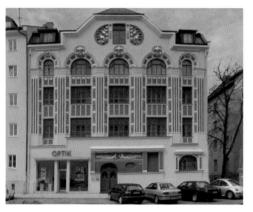

Figure 3.19
The result of editing to reduce the lens distortion of the building

Figure 3.20 Fisheye distortion of the building

Figure 3.18 shows the image before editing, and figure 3.19 shows it after. Figure 3.20 is an attempt to imitate a photo taken with a fisheye lens. Distortions like this are necessary to make the image content look like it's being reflected by a convex surface. I applied the filter several times in a row to achieve this effect, applying *Edge* at maximum level.

The technique described may not work when rectifying distortions that occur when photographing very high buildings. You would have to severely lengthen the building to prevent it from looking disproportionate after the correction. Doing this would cause perspective flaws in the window embrasures to stand out.

3.5.5 The Perspective Clone Tool

To introduce a new image element into an image with the correct perspective, GIMP originally had only the transformation tools, such as the *Perspective* tool. Since GIMP 2.4, the program has offered the additional choice of the *Perspective Clone* tool to copy sections from an image with the help of a clone tool. These sections can then be placed into another image in the correct perspective.

The intended use of this tool is to cover up trouble spots in digital photography with image content or to insert new image content in the correct perspective.

Copying Image Content and Inserting the Image in the Correct Perspective

It is important to mention that this tool requires accurate work. It takes time to learn how to use the *Perspective Clone* tool. First you have to apply the perspective of the image area to be corrected as exactly as possible with the help of the tool. You can work on only one perspective surface at a time. In our example image, you can only work with the area of the billboard. You must very carefully select the source and destination for your clone tool. It may take several tries before you achieve the desired effect.

The Procedure

Open the image *perspective_clone.png* from the *SampleImages* folder on the DVD. In this exercise, we want to make the billboard on the façade disappear.

First you must define the perspective in the image to which the inserted image data will be adapted. Select the *Perspective Clone* tool from the *Toolbox*. The default setting is *Modify Perspective*. With this setting selected, click in the image. You will see handles at the corners of the image that you can move by holding the mouse button.

The perspective alignment of building edges and eaves can help define the perspective accurately. In this case, it is the grid pattern on the front of the building. Keep in mind that the building has horizontal and vertical vanishing points. It's preferable for you to define the corners of the perspective area you want to correct. In figure 3.22, the aligned corners of the perspective selection grid are highlighted in red.

After the surface perspective is defined, switch to the *Perspective Clone* tool settings. Select a suitable brush, set *Source* to *Image*, and set *Alignment* to *Aligned*.

If you want to insert image data from a different image, you must inform the program by holding the *Ctrl* key and clicking on the other image. However, cloning from another image can prove difficult. The best way to approach this is to copy the desired section and insert it into the main image. Then apply the *Perspective* tool to fit the section into the image.

Figure 3.21
The example image of the building with its billboard sign in its original state

CHAPTER 3

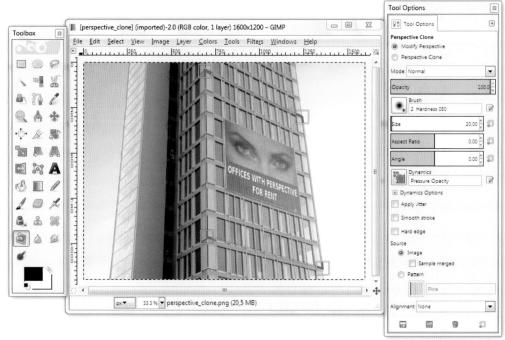

Figure 3.22The surface perspective for which the inserted image data is adapted is applied. To illustrate, the corners are highlighted in red.

For our example, we'll use data from the same image. Next, click on the title bar of the window to activate it again. Then you have to collect image data with the tool. It works just like the *Clone* tool. Select one corner point and apply it exactly on another corner point.

In this example, place it on the corner of the perspective surface. This should be at an intersection of the façade's grid. The mouse pointer is a circle with a white arrow depicting the center point, which helps you select a spot more precisely. Just as with the *Clone* tool, you select a point by holding the *Ctrl* key and clicking the left mouse button at the same time. After selecting a spot, let go of the *Ctrl* key.

Next, search for a corresponding spot in the façade's grid where you want to insert your data. Click and hold your left mouse button and paint over the surface where you want to insert the image data. The brush will paint it into the image.

If the perspective setting was precise, you can simply paint over the entire surface. However, if you seem to be getting an irregular pattern while painting over the surface, you can reselect image data. This time, clone some data from another point, such as, from above the billboard. You can also go back a step in the *Undo History* and correct the cloned perspective.

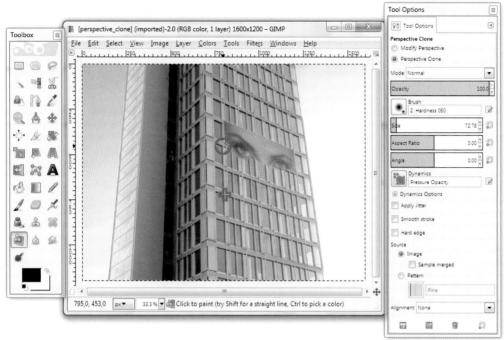

Figure 3.23
Selecting image data and depositing it precisely. The selection point is marked by a red cross and the first spot to place the cloned spot is marked by a red circle.

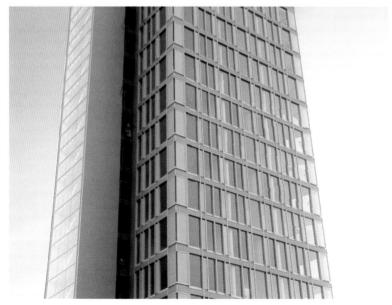

Figure 3.24
The completed image

3.6 Touchup Work 6—Freshening Up a "Dull Sky"

3.6.1 Steps Involved and Description of Work

The exercise discussed in this section involves the following steps:

- Working with selections or masks
- Working with layers
- Working with the FG/BG Color (foreground and background color) dialog and the Change Foreground Color window
- Working with the Gradient tool and the Gradient Editor

In the image *dullsky.png*, we will replace the existing blue-gray sky with a color fill or color gradient on a new layer. To this end, you will use the *Fuzzy Select* tool (*Magic Wand*) to select and delete the existing sky. The layer with the color fill underneath it will then appear through the transparent area of the layer above it, the one with the landscape.

3.6.2 Step 1: Selecting an Area by Color, Deleting It, and Replacing It with Color Fill

Follow these steps to begin:

- Open the image dullsky.png in the SampleImages folder on the DVD.
- Save it in your exercise folder as *bluesky.xcf*. The XCF file format is required to save the layers in the image.
- Run a tonality correction (Colors > Levels) and freshen up the image's colors by using the options from the Colors > Hue-Saturation or Color Balance menu item.
- Access the Layers, Channels, and Paths dialogs for the image from the Windows > Dockable Dialogs menu. Click the Create a new layer button to create a new layer. Save it as Sky.
- Duplicate the background layer dullsky.png (the one with the landscape) by right-clicking on the layer in the Layers dialog and selecting Duplicate Layer. Save it as Landscape. Make the background layer invisible. Add an alpha channel to the duplicated layer, as the transparency feature is not available in duplicated backgrounds (see the context menu).
- Use the Select by Color tool and click on the color of the sky to select
 it. Be sure to set the landscape layer to active in the Layers dialog. Pay
 attention to the settings (double-click on the Select by Color tool to open

the docking window if you need to). Click the *Add to the current selection* button next to *Mode*. For *Threshold* (color similarity), click the up or down arrow to select a value that determines how much tolerance for color variation will be allowed. For this exercise, a value of 20 is recommended because the sky contains several shades of blue. Now use the tool to successively select parts of the sky until it is completely selected.

Select Tool Options

Let's have a closer look at the tool options for selections. Though these options vary depending on the selected tool, they all have a *Mode* option that lets you use different select tools consecutively to create a selection.

Example: Select by Color Tool

The *Mode* function in this dialog offers the following options:

- **Replace the current selection**: Creating a new selection on the image deletes an existing selection.
- Add to the current selection: You can use the tool, or similar tools, consecutively to add to an existing selection. (Note that the Mode > Add to the current selection option must be selected prior to using the tool.)
 The newly selected image areas will be grouped as a single selection.
- **Subtract from the current selection**: This option allows the selected tool to deduct an area from an existing selection.
- Intersect with the current selection: If a selection exists, you can use this option to create a new selection that will be automatically intersected with the existing selection; the result is a new selection, covering the area the two given selections had in common.

Additional options for the Fuzzy Select tool, are listed here:

- Antialiasing: This option removes the aliasing or step effect (i.e., sharp
 "steps" at the border of a selection that result from cutting with a mask
 without feathering). It spreads pixels at the border from opaque toward
 transparent, creating an integral, natural look when copying and pasting
 objects. Without antialiasing, a copied element will look like it was cut out
 with scissors and slapped on the image.
- **Feather edges**: This option creates a "soft border" for the selection. Feather edges is not the default setting, so you'll want to change the settings before editing if you want feathered edges. If you click the check box at Feather edges, a control titled Radius shows up. Click the up or down button in the Radius control to set the feathering width. A value between 2 px and 5 px should be sufficient, depending on the desired effect and image resolution.

Figure 3.25
The options available in the Select by Color settings dialog

• NOTE

The preceding options are common to all select tools. Have fun experimenting with different select tools and settings as you create and edit your masterpiece.

- Select transparent areas: Allows the Select by Color or Fuzzy Select tool to select completely transparent areas like a color. If the option is not checked, transparent areas cannot be selected. The ability to select transparent areas is rather helpful. For instance, to trace the contours of an image object on an otherwise transparent layer, it's often easier to select the transparent area and invert the selection than to select the object itself.
- Sample merged: This option ensures that all visible image areas on all
 layers are included when the selection by color is calculated. If this option
 is not checked, the tool will only select the desired color on the active,
 single layer.
- **Threshold**: This option determines the range of similar colors that will be selected. The higher the threshold, the wider the range of colors.
- **Select by**: This option offers a drop-down menu. *Composite* is the default setting; it calculates a selection of the color values of the pixel chosen with the tool by clicking on it. The other menu options let you choose which component of the image the program should use to calculate the image. The components you can choose from are the three fundamental colors (red, green, and blue), hue, saturation, and value.

Proceed as follows:

- Remove small defects from the sky, if you find any. Select these spots in
 the sky (or selection islands with an animated border) by circling them
 with the Free Select tool (Lasso) while either holding the Shift key down
 or selecting Mode > Add to current selection from the tool's settings
 dialog box.
- Remember that you can use the *Zoom* tool to magnify an image area.
- When your selection is cleared of "islands" (or spots), increase the selection size by approximately 4 px using the Select > Grow menu item. Then choose Select > Feather to add feathering to the selection border (approximately 5 px). The horizon and the contour of the trees will now be feathered. After you delete the area of the blurred sky, the remaining landscape contour will look natural, and the scissors effect will have been avoided. Otherwise, you can do this by using the Feather edges option of the Fuzzy Select tool.
- To complete the following steps and to delete the sky, so that the cleared area will be transparent, you must assign an alpha channel to the layer.
 Select Add Alpha Channel in the context menu by right-clicking the Landscape layer in the Layers dialog.
- Select the *Edit* > *Clear* menu item to delete the sky on the *Landscape* layer.
- Select the *Select > Save to Channel* menu item to save your selection as an alpha channel before deleting it in the image by choosing *Select > None*.

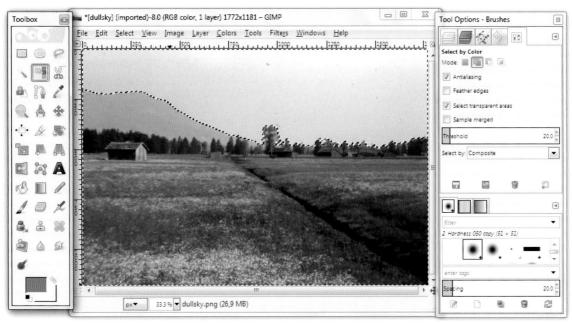

Figure 3.26Extended selection with feathered border

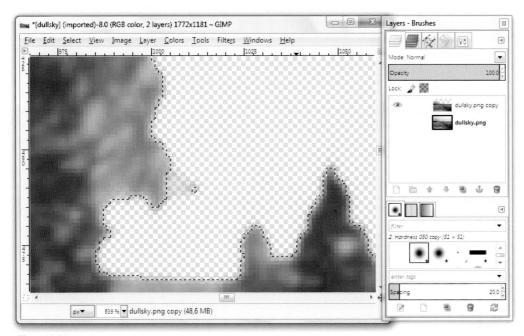

Figure 3.27The *Landscape* layer with deleted sky (transparent area). The result of the feathering is visible as a gradient from opaque towards transparency along the border of the selection.

Take a closer look at the image: Since the border of the selection was feathered, the contour of the image that remains is feathered toward transparency. The transition is smooth and natural looking.

In the following exercises, you will use GIMP tools to select colors and fill layers or selections with a color. These will be described in more detail in the following sections.

To summarize, you will do the following:

- Use the *Color Picker* from the *Toolbox* to select a light-blue shade as the foreground color.
- Make the Sky layer your active layer.
- Select the *Bucket Fill* tool from the *Toolbox* and click on the image. The *Sky* layer will be filled entirely with the selected foreground color.
- If your entire image turned blue, it happened because the *Sky* layer is on top of the stack. Move the layer underneath the landscape by clicking the *Lower Layer* button in the *Layers* dialog.
- You can use the *Dodge/Burn* tool to darken the mountains in the background. Set the *Burn* control in the tool's options. Set *Opacity* to a lower value (about 20%), then select or create a big (about 200 pixels in diameter) brush pointer with a soft edge. This will allow you to edit the area smoothly and avoid abrupt dark patches. You can also lighten up the overly dark meadow areas in the foreground by selecting the *Dodge* tool. You can use the same brush pointer and opacity to touch up the mountains if you so desire. Otherwise, for darkening the mountains, you may select the mountains by color with the *Fuzzy Select* tool and perform a tonality correction on them (*Colors > Levels*). Use feathering for the selection (*Select > Feather*).
- Save the image.

The Color Picker Tool—Using the Eyedropper to Select a Foreground Color from the Image

You can use the *Color Picker* tool to select any color on an active layer or image. If you select this tool and click on a color on your image, you can select this color as the foreground or background color. The foreground color is used when you're painting, filling, or adding text. In GIMP, the foreground color is also the default color for color gra dients.

Using the *Color Picker* is the simplest and most intuitive way to select a paint, fill, or text color. Thus, you'll be learning it first, even though it is not useful for correcting the example image, a process that will require using more complex color select tools.

For now, select the *Color Picker* from the *Toolbox*. The mouse pointer takes the shape of an eyedropper. Clicking an area on the image causes the eyedropper to siphon the area's color, which is also displayed in the *Color Picker* window if this option is selected in the tool's preferences.

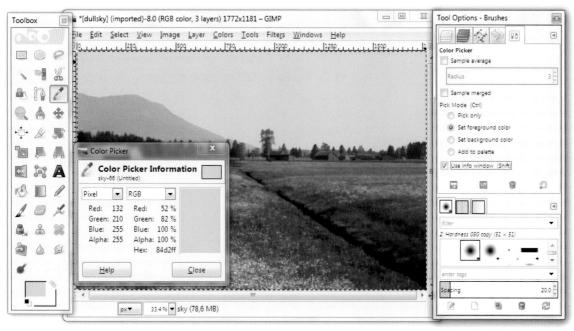

Figure 3.28
The windows of the *Color Picker* (eyedropper) tool

Tool Options: Click or double-click the tool's icon to open the tool options dialog, which has the following options:

- **Sample average**: The *Radius* control adjusts the size of the area used to determine an average color from pixels of your image. By default, this setting is not activated. The default setting is an area of exactly 3 pixels. So you can choose an exact color of a pixel this way. Activate the setting and click the up or down arrow to select an area larger than 1 pixel. This will result in an average color of the selected pixels.
- Sample merged: If the check box for this option is selected, the option
 will display color information from all the visible layers of your image. If
 the check box is disabled, you can only pick colors from the active layer,
 which is the default setting.
- Pick Mode > Pick only: This option tells the tool to display only the color information of the selected area in the Color Picker window, but it won't change the foreground color.
- **Pick Mode** > **Set foreground color**: The foreground color shown in the *Toolbox* color area will be set to the color you click on. It will be used as the painting, filling, text color and serve as the primary color for gradients.

- Pick Mode > Set background color: This is the background color shown
 in the *Toolbox* color area and will be set to the color you click on. It will be
 used as the active background color and serve as a secondary color for
 color gradients.
- Pick Mode > Add to palette: The color you select will be added to the
 existing palette of an image that has its own color palettes (Image >
 Mode > Indexed).
- Use info window: If you select this option, the Color Picker Information
 window will be displayed as soon as you click in the image window with
 the tool.

The Color Area in the Toolbox

Figure 3.29
Clicking the upper-left field in the color area of the *Toolbox* opens the *Change Foreground Color* window.

The field on the top-left of the window activates the *Change Foreground Color* window for the foreground color; the lower-right field activates the window to choose the background color.

The foreground color is the active color for painting, filling, and text tools and the primary color for gradients.

The background color is the secondary color for the color gradient tool and the "paper color" used by the eraser tool for background layers without an alpha channel (without transparency).

Click the bent dual arrow (top right) to quickly change the painting color as you work or to use the preset background color as the foreground color.

Click the small black-white icon to reset the default colors—black and white as foreground and background colors, respectively.

The Change Foreground Color Window

The color area is GIMP's basic color palette. It consists of two colors, the foreground color and the background color, and you can use it to choose colors for painting, writing, or filling. Clicking on any color brings up the *Color Editor* dialogs.

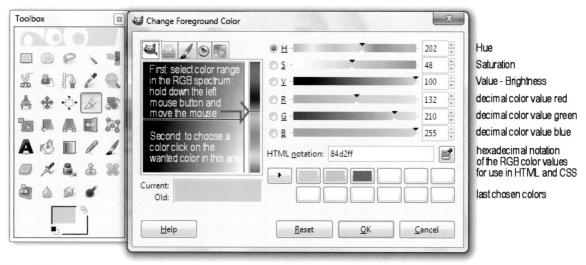

Figure 3.30
The Color Editor dialog Change Foreground Color and the representation of the color selected in the Toolbox

In the *Change Foreground Color* window, there are tabs allowing you to change the way in which color is represented. The most common is RGB mode (and HSV mode), which is set as the default, represented by the tab showing the GIMP icon. This color mode is found in most popular image editing programs.

The other color models are CMYK (four-color printing), color wheel, and watercolors (additive mixing colors).

Probably the most striking area is the square field on the left side, showing the hue of one chosen color. Clicking on this field lets you select the brightness levels for a color. Just click the desired hue to activate it. It will be shown as a new color in the *Current* field.

To the right of this field you can find the RGB spectrum, if the radio button next to *H* is enabled. Click on the sliders in this area and adjust them while holding the left mouse button down to select a color.

- Radio buttons The H radio button should be enabled for the default color display (figure 3.31). The other radio buttons activate different views of the Hue field for selection.
- **Sliders**: You can move the *H* (for *Hue*) slider to produce alternative colors with the same brightness, using the settings in the figure. In general, the sliders serve to mix colors; an alternative for mixing colors is to select a color (or color range) with the mouse, as described earlier.

- Numerical entries: You can also type decimal values for Red, Green and Blue to set or mix a color. In the HTML notation field, you can enter a six-character hexadecimal value to set a specific color. This works well when you want to import an exact color from another program. The HTML notation box displays the hex values of the mixed color. These values can be copied and pasted directly into a page of HTML code.
- Buttons: The OK button adds the selected color to the Toolbox and closes the Change Foreground Color dialog. The Reset button rejects the selected color and lets you select another color. The Cancel button closes the dialog without accepting the color you selected as the foreground or background color.

The Bucket Fill Tool

Getting back to the exercise, let's say you now want to insert a single-color sky. To achieve that goal, you will first need to fill a separate layer with color; this layer will be seen as the sky when viewed through the transparent areas of the landscape layer above it. The *Bucket Fill* tool will be used for this.

The *Bucket Fill* tool also has its own tool options (double-click the tool icon in the *Toolbox*).

You don't need to change any options. The important settings for now, FG color fill and Fill transparent areas, are selected by default. Once you select the desired foreground color and activate the appropriate layer in the Layers dialog, just click the tool on your image. The layer will be automatically filled with the selected color.

Figure 3.31The tool options dialog for the *Bucket Fill* tool

Creating a Sky Graphically—the Difference Clouds Filter

GIMP has a filter that lets you create clouds graphically. To use it, choose *Filters* > *Render* > *Clouds* > *Difference Clouds*.

Try out the following.

Create a new layer in *bluesky.xcf* in the *Layers* dialog. Name the layer *cloudysky*. Fill the layer with the color white using the *Bucket Fill* tool. Then open the *Difference Clouds* filter. The cloud structure is depicted in gray in the preview window and will be colored later. You can experiment with the sliders to adjust the structure and density of the clouds. For our needs, the default setting is good enough. Confirm the selection by clicking *OK*. The *cloudysky* layer will be filled with a gray cloud structure.

Now from the *Colors* menu, select the *Colorize* function. Using the *Hue* slider you can select the color tone of the clouds. By moving the *Lightness* slider, you can determine how bright or dark the clouds should be, and with *Saturation*, you can choose how intense your color should be. Depending on the settings, you can create a stormy or sunny effect for your clouds.

The *Colorize* filter is also suitable for toning your black and white photos. We'll go into more depth on this topic in section 4.4.1.

As the last step, you can compress your *cloudysky* image with the *Scale* tool to get a perspective effect of a view from below. More on the use of the *Scale* tool can be found in section 3.6.5.

Solid Noise Preview Random seed: 0 New Seed Randomize Turbulent Detail: 1 Tilable X size: 5,5 Trubulent Y size: 7,0 Trubulent Letail: Trubulent Company to the seed Randomize Turbulent Detail: 1 Trubulent Company to the seed Randomize Turbulent Detail: 1 Trubulent Company to the seed Randomize Turbulent Detail: 1 Trubulent Company to the seed Randomize Turbulent Detail: 1 Trubulent Company to the seed Randomize Turbulent Detail: 1 Trubulent Company to the seed Randomize Turbulent Detail: 1 Trubulent Company to the seed Randomize Turbulent Detail: 1 Trubulent Company to the seed Randomize Turbulent Detail: 1 Trubulent Company to the seed Randomize Turbulent Detail: 1 Trubulent Company to the seed Randomize Turbulent Detail: 1 Trubulent Company to the seed Randomize Turbulent Detail: 1 Trubulent Company to the seed Randomize Turbulent Detail: 1 Trubulent Company to the seed Randomize Turbulent Company to the seed Randomize Turbulent Detail: 1 Trubulent Company to the seed Randomize Turbulent Company to the seed Randomize Turbulent Company to the seed Randomize Turbulent Detail: 1 Trubulent Company to the seed Randomize Turbulent Co

Figure 3.32The options available in the *Solid Noise* window of the *Difference Clouds* filter and the preview of the created grayscale image

• NOTE

When you select the *Tilable* check box in the *Solid Noise* window of the *Difference Clouds* filter, the edges of the cloud structure will be created (depending on the image size) so that image can be merged together like tiles. This is how you can create seamless merged background images for websites or patterns that you can fill and paint with other GIMP tools.

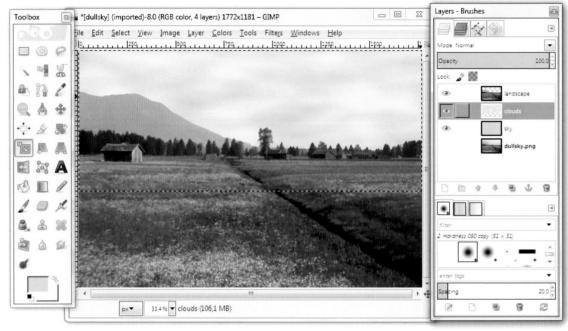

Figure 3.33
The image with the colorized and scaled *cloudysky* layer

3.6.3 Step 2: Creating and Positioning an Image Object on a New Layer

Next, you'll be painting and positioning the sun. Creating a new layer, *sun*, should not prove difficult. The *Move* tool and its options will be described in detail later, but first, here's an overview of the work you'll be doing:

- Create a layer named *sun* and position it underneath the *landscape* layer.
- Select a very light yellow shade as the foreground (painting) color.
- In the *Brush* dialog (*Windows* > *Dockable Dialogs* > *Brushes*), select a round, soft brush. Increase its diameter to approximately 300 px by selecting a brush in the *Brush* dialog, clicking the *Edit this brush* button, and setting the radius in the *Brush Editor* using the tool options *Brush Size* slider.
- Draw a round sun by clicking the Paintbrush tool on the sun layer. Use the
 Move tool's option Move the active layer to move the sun to the desired
 position in your image.
- If required, resize the sun layer by choosing Layer > Layer to Image Size.

Positioning Layers and Objects with the Move Tool

In this exercise, you'll use the *Move* tool on a new image object that is positioned freely on a separate layer. This is one of the most important functions of this tool. You can also use the *Move* tool to move guides and selections paths, but those functions will be introduced later on.

Figure 3.34
The *Move* tool setting for positioning layers or objects

The Move Tool Options

The three *Move* buttons allow you to choose which entity the *Move* tool should affect: *Layer*, *Selection*, or *Path*.

If you want to move a *guide*, select the *Pick a layer or guide* option.

The *Move the active layer* option allows you to move the layer defined as active in the *Layers* dialog.

If you select a layer (or image object) in the *Layers* dialog and then click the *Move* tool on this object (or layer), you should be able to move the object freely while holding the left mouse button down, releasing it after you've positioned it where you want it.

You can also use the cursor or arrow keys on your keyboard to move an element with pixel-size accuracy. Each time you press one of the four arrow keys, the element will move in the direction of the arrow by exactly 1 pixel. To move 10 pixels at a time, hold the *Shift* key down while pressing an arrow key. Note that you have to make the image window active by clicking on it when you want to position an image object with help of the arrow keys.

That was a simple exercise. The next step, creating a color gradient, is more complex. Let's take a brief look at the steps involved.

3.6.4 Step 3: Creating a Multicolor Sky—the Blend Tool

The *Blend* tool works with two colors by default—a gradient blend of the foreground and background colors. Once you set these two colors with the appropriate *Color Pickers*, you can use the *Blend* tool directly on the image to fill an area or background with a two-color blend. Select the tool, click on the image, and drag it while holding the left mouse button down. A "rubber band" trailing behind the pointer shows you the direction of the (linear) blend.

If you wish to use a more sophisticated blend of colors, you can access prefabricated gradients by choosing the *Windows > Dockable Dialogs > Gradients* menu option. In addition, you can create and save custom gradients.

Creating a Gradient—the Gradient Select and Gradient Editor Windows

Figure 3.35 shows the *Toolbox* palette, *Blend* tool settings, and *Gradients* window. The icons at the bottom of the *Blend* tool settings are: *Save options* to..., *Restore options from...*, *Delete saved options*, and *Reset to default values*. The options at the bottom of the *Gradients* window are: *Edit gradient*, *Create a new gradient*, *Duplicate this gradient*, *Delete this gradient*, and *Refresh gradients*.

You can call up the prefabricated color gradients from the *Blend* tool's options. If you want to edit a color gradient, you can find it in the *Layers, Channels*, and *Paths* dock, or you can open the *Gradients* window by choosing *Windows > Dockable Dialogs > Gradients*. Both ways offer you a set of premade gradients. However, they are write-protected and can't be manipulated. You have to duplicate the gradient by right-clicking with the mouse in the *Gradients* dialog box.

Double-clicking the default gradient blend (preset foreground to background color), or clicking on the *Create a new gradient* button (figure 3.35) will cause the *Gradient Editor* dialog to appear so that you can edit the gradient blend.

The *Gradient Editor* dialog displays the preselected gradient blend (in this case, the default blend ranges from black to white). Underneath the gradient blend, you'll notice a gray slider with black arrows at the left and right margins and a gray one in the center.

Right-click on the slider to open the context menu for the *Color Editor*. In the context menu, click the left mouse button on the *Left Endpoint's Color* option. Another pop-up window, *Load Left Color From*, will appear. Select a color as described earlier and click *OK* to accept your changes. The color you selected should now appear at the left endpoint of the color slider.

Repeat the steps to select a color for the right endpoint.

• NOTE

GIMP 2.8 includes a "hard" preset gradient called FG to BG (Hardedge) for creating dual-color fills (figure 3.35).

Figure 3.36
The Gradient Editor

ABCD 12345

Figure 3.35
The *Toolbox, Blend* tool settings, and Gradients window

Because this exercise requires you to create a three-color gradient blend, you'll need to right-click on the slider underneath the blend in the *Gradient Editor* window to open the context menu. Select the *Split Segment at Midpoint* option.

The gradient blend is now split in the slider underneath the gradient display, but it initially appears the same. Double-click the left half of the slider to see how it works. You'll notice that the left section turns dark gray, while the right half turns light gray. Next, open the context menu and select the *Right Endpoint's Color* option. Double-click the right half of the slider, and then open the context menu and select the *Load Left Color From > Left Neighbor's Right Endpoint* option.

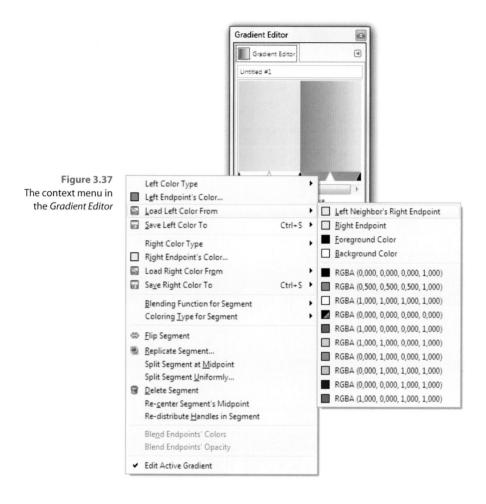

Figure 3.38 Color sliders for gradient blends with an option to set the opacity (A)

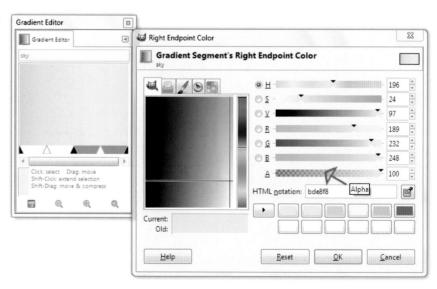

You will now be able to hold the mouse button and move the center triangle on the slider. When you're satisfied, enter a name for the new custom gradient in the *Gradient Editor* window and save it by clicking the *Save* button (bottom left in figure 3.36).

A final note about the *Color Picker*: You can also add *Transparency* to a gradient blend to create interesting effects. To decrease the opacity of a gradient, change the *value* (A) in the *Color Picker* window. The default setting for opacity is 100%.

Next, you have to apply the gradient blend to the intended layer of your image.

Make sure that you've selected the desired gradient blend in the *Gradients* window. Then select the *Blend* tool from the *Toolbox* and double-click on it to reveal the tool options.

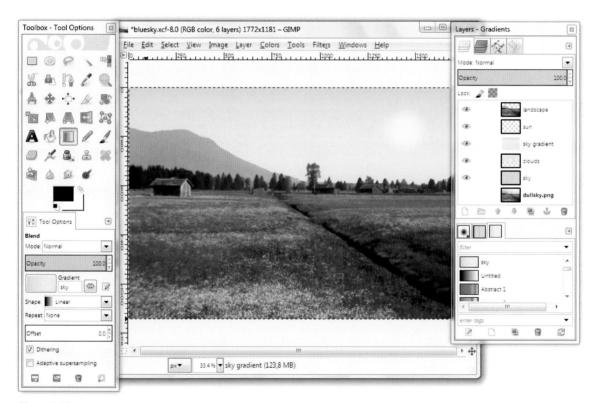

Figure 3.39
The Toolbox and Gradients window with the selected gradient blend and the Blend tool options

CHAPTER 3

Figure 3.40The *Shape* menu for gradient fills

The Blend Tool Options

The *Blend* tool includes an option called *Opacity* that allows you to create a fully opaque, slightly transparent, or fully transparent gradient.

The *Mode* drop-down list provides a selection of paint application modes. Leave the default, *Normal*, which is opaque without mixing attributes.

Gradient allows you to choose from a drop-down list of gradient patterns. You can also click on the *Reverse* button to interchange the foreground and background colors.

The *Offset* value determines the "slope" of the gradient. When you increase the offset value, the center of the gradient moves to one side (which side it slopes to will depend on the direction chosen for the gradient).

The *Shape* drop-down list offers a choice of several gradient shapes. *Linear* refers to a parallel color gradient. You'll be using a linear gradient in the following exercise.

Here is a list of other shapes:

- Bi-linear: Proceeds in both directions parallel from the starting point; mirrored color gradient.
- Radial: Gives the appearance of a sphere.
- Square: Renders an equal-sided pyramid.
- **Conical (symmetric)**: Renders a cone; the gradient is mirrored.
- **Conical (asymmetric)**: Renders a cone with a simple gradient.
- **Shaped (angular, spherical, or dimpled)**: These shapes create color gradients that adapt to the contour of a selection in the image.
- Spiral (clockwise or counterclockwise): Renders spiraling gradients.

Use the *Repeat* option to decide whether the gradient should be applied once (*None*) or whether it should be repeated with hard transitions (*Sawtooth wave*) or soft transitions (*Triangular wave*).

Dithering applies the dithering method on gradients. Dithering creates a smooth color transition by dispersing the colored pixels.

Adaptive supersampling applies antialiasing to sharp color transitions to avoid a stepped color rendering with harsh transition lines.

Set the gradient options for the sample image as follows:

Opacity = 100%

Mode = Normal

Offset = 0.0

Shape = Linear

Repeat = None

Using the Blend Tool

Make the layer you would like to fill the active layer in the *Layers, Channels,* and *Paths* dock. Click on it so that the layer turns blue. The *Blend* tool should be selected in the *Toolbox*.

Point your cursor over the image; it will turn into an arrow. Click and drag by holding the left mouse button. A "rubber band" appears to be hanging from the cursor. When you release the mouse button, the selected gradient is applied.

Depending on where you click on the image first and in which direction you drag the mouse, you can give your gradient a direction or angle.

Furthermore, you can determine the length of the gradient, according to how long you pull your "rubber band." Experiment with the tool. You can repeat the application of the gradient several times. When you are satisfied with the result, remember to save your image.

Painting with the Blend Tool

All paint tools in GIMP offer the option of painting with a gradient instead of a color. The stroke of the paintbrush changes the color according to the selected gradient.

The Gradient Map Filter

The *Gradient Map* filter allows you to tone or re-tone your image with a gradient of your choice. You can find the filter by selecting *Colors > Map > Gradient Map*. Depending on the selected gradient, you can achieve an amazing result.

Here is an overview of the most important steps in this exercise:

- Create a new layer.
- Open the Blend dialog in the image window.
- Create a tricolored gradient with the colors dark sky blue, silvery light blue, and light sky blue and apply it to the new layer.
- The gradient now resembles a silvery cloud bank on the horizon. If you
 wish, you can apply the Smudge tool and with a big, round soft brush,
 wipe cloud structures into the cloud bank.
- Save the image as bluesky.xcf.

You have used graphical tools to replace the sky in the image. Now have a look at a third method: substituting a dull sky completely with a photo of a move vivid sky.

3.6.5 Step 4: Adding a New Object or Layer (Sky) to an Image

GIMP offers several alternatives for importing images as layers and combining several different image files into a single file. Importing images is pretty easy: simply drag and drop a layer from the *Layers* dialog onto another image window. However, it is a good idea to adjust the size and resolution of the image layers you intend to import so they correspond to the target image's size and resolution. When importing images, only the layers are copied. The original images remain unchanged.

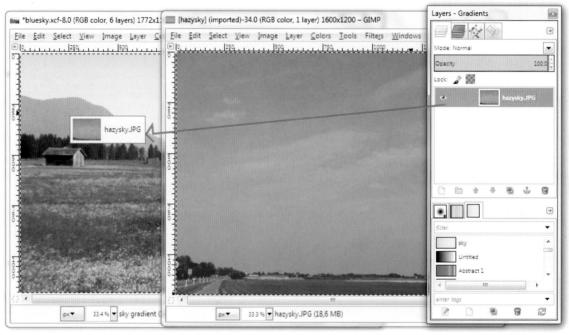

Figure 3.41
Dragging a layer

Here is an overview of the most important steps of this exercise:

- Open the images bluesky.xcf and hazysky.jpg from the Samplelmages folder on the DVD.
- Position the two image windows so that they partly overlap, arranging the Layers dialog on the side.
- Click on the hazysky.jpg image to make it the active window. Click the
 background layer hazysky.jpg in the Layers dialog and drag it partly over
 the visible bluesky.xcf image while holding down the left mouse button.
 Upon releasing the mouse button, the layer will be pasted into the
 bluesky.xcf image. This process copies layers rather than moving them.
- Rename the background layer Hazysky. Move Hazysky in the Layers dialog
 so that it is positioned beneath the Landscape layer. (The easiest way is
 by dragging and dropping, or you can use the arrow keys at the bottom
 of the Layers palette. Remember that the layer must be active if you are
 going to move it.)

Finally, you must scale the layer so that it fits into the image. To scale the layer, choose *Tools > Transform Tools > Scale* or just use the *Scale* tool from the *Toolbox* and follow the steps described in the next section.

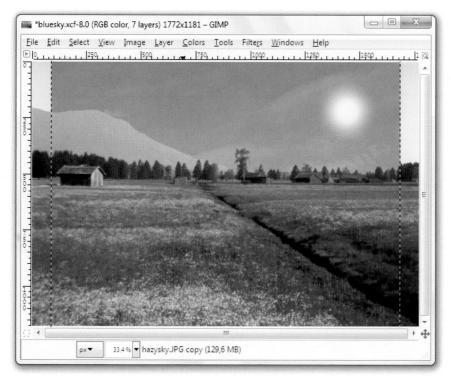

Figure 3.42
Copied layer with dashed border

Transformations—Scaling a Layer

In previous exercises you scaled entire images, changing their size by using the *Image* > *Scale Image* menu item. In this exercise, you will scale a single layer and transform it.

Take a look at your image. You will see the *Hazysky* layer in the image window. The largest part of the layer is hidden behind the landscape layer, but if you set the *Hazysky* layer to active in the *Layers* dialog, you will see its contour, indicated by a black-and-yellow dashed line. You will now freely transform this layer and fit it into the image. Make sure it is activated in the *Layers* dialog.

As an alternative, you can enter numerical values by choosing *Layer > Scale Layer*. This is the preferred method when changing a layer to a size that has already been numerically defined. However, for this exercise, it is preferable to use the mouse because you will be scaling to fit the layer aesthetically within the image. The *Scale* tool from the *Toolbox* provides you with the options necessary to do this. You can also find these options by choosing *Tools > Transform Tools > Scale*.

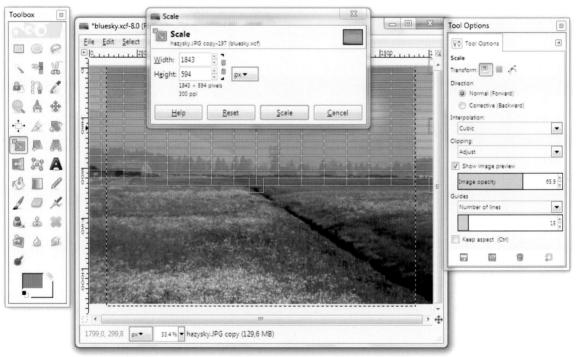

Figure 3.43 Scaling a layer

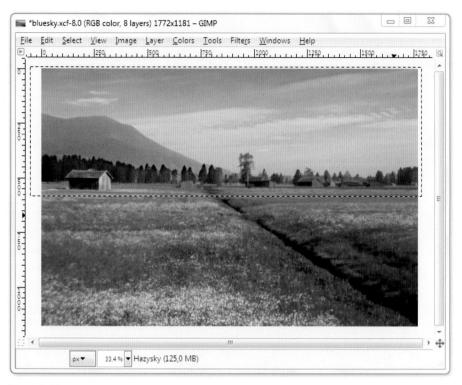

Figure 3.44

After scaling. The dashed border marks the new size and shape of the scaled layer. It was touched up with the tonality correction.

When the *Scale* window opens, you can enter numerical values to scale your layer. However, it's best to manually transform the image by using the mouse and a bit of visual judgment. Therefore, select *Show image preview* in the tool options. Also, use the *Image opacity* slider to reduce the opacity to about 70%. Now after you click on your image with the tool, the *hazysky* layer will show a transformation frame with square handles in the middle and on the corner points. You can drag the frame by pulling at its border while holding down the left mouse button. Due to the reduced opacity of the layer that is to be transformed, you can see the underlying layer shining through. Thus you can better adapt the transformation.

Increase your working space around the image by pulling the window borders outward. Then click the mouse on the frame's borders and drag or move them so that they look the same as the second image.

Click the *Scale* button in the *Scale* window to produce the preset scaling. If you are not satisfied with the result, undo the process and repeat the steps. Save your image.

Another option is to apply the *Supernova* filter (*Filters* > *Light* and *Shadow* > *Supernova*) to create a sun. It lets you add small light reflections to shiny surfaces or objects, as well as create multicolored, radiating stars. Try it out!

You have now learned several important methods for "freshening up" a sky in an image. You learned how to handle a number of complex tools. Perhaps you're so proud of your beautiful picture that you want to create a greeting card with it. All you need now is to learn how to use the *Text tool* so you can add some words.

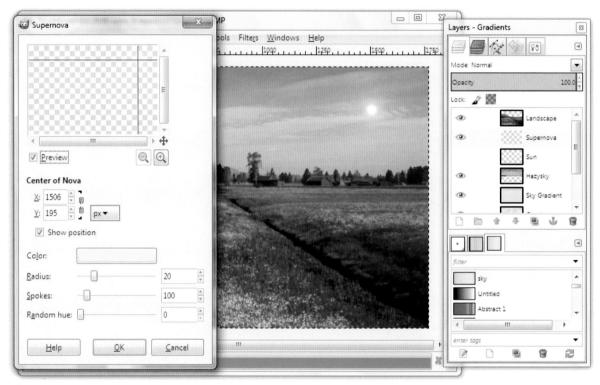

Figure 3.45

The window of the Supernova filter. With a click in the preview window, you can determine the approximate position of the generated light reflection in the picture. If you apply the effect at an individual level, you can subsequently position it more precisely with the Move tool.

3.7 Typing in GIMP—Adding Text to an Image

The new, revised *Text* tool is one of the major improvements in GIMP 2.8. Before we go into detail on the tool itself, the following sections describe the most important attributes and creative characteristics of various types of fonts.

3.7.1 Introduction to Fonts

This section will cover features that you'll need to know when dealing with fonts.

Sans-serif fonts, such as Arial, Avant Garde, Verdana, and Helvetica, possess a clean, sober, contemporary style. They are often used for titles, captions, and heading. They are not suitable for lengthy reading material because the harder lines can tire the eyes.

Serifs are stylistic flourishes, like cross strokes or curves, added to the end of the strokes in a character. Popular serif fonts include Times New Roman and Garamond. Serif fonts are the primary fonts used in books, magazines, and newspapers because the softer shapes of the letters make them easier to read.

Another feature that distinguishes fonts refers to the space between characters.

With **proportional type**, each alphabetic or numeric character takes up only the space it needs. Today, most fonts are proportional, including those previously mentioned. Using proportional type can add visual variety to your text, especially in web pages.

In contrast, monospace type is familiar to anyone used to working with a typewriter or teletypewriter. In monospace type, each alphabetic or numeric character takes up the same space. For example, a monospaced l takes as much space as a monospaced w. Today, monospace types are commonly used to highlight source code in documents or web pages, or to imitate typewriter text. One of the most commonly used monospace fonts is Courier New.

Extraordinary stylistic flourishes are the defining characteristic of so-called **ornamental** or **fancy fonts** like Comic Sans MS or Dauphin, which sometimes imitate handwriting or calligraphy. These fonts are suitable for short text like invitations or to achieve a creative graphical effect with type. Fraktur and Comic both have a futuristic flair.

Font sizes are defined in **points** (pt) or **picas** (pc). Standard font sizes are as follows:

1 point (pt) = 1/72 inch = 2.54 cm/72 1 pica (pc) = 12 points (pt)

• TIP

▶ If you are on the lookout for unusual or exotic fonts for your graphics, a quick web search will take you to a number of websites with free downloadable fonts. Also take a look at www.gimpstuff.org. All you usually have to do to install a font is unzip the downloaded file and copy the font file to your operating system's Fonts folder. You will find further details in your computer's help files.

3.7.2 Typing in GIMP—the Text Tool

The *Text* tool A creates editable vector-based text that can be inserted and freely positioned within an image. The attributes of text elements, such as color and font, can be altered at any time. Inserting text creates a separate text layer, ensuring that text doesn't become irretrievably integrated into the background or other layers.

Text in GIMP 2.8 is entered directly into an "on-canvas" text box. You can change the height and width of the text box by dragging its edges, and text that you have already written is automatically adjusted to fit the new proportions. The text box also includes formatting tools for adjusting the font and type size.

This new tool is great for inserting titles and descriptions into images, and allows you to adjust the attributes of individual letters within a piece of text. This enables you to produce more sophisticated text elements, making the production of graphic objects such as flyers and posters much quicker and easier.

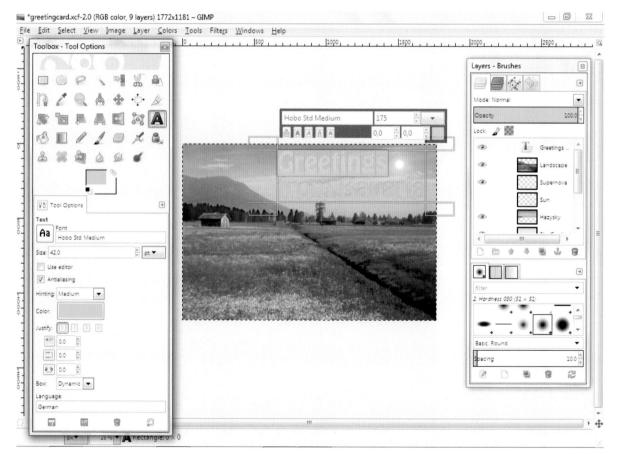

Figure 3.46
The GIMP interface showing the *Text* tool settings, a text layer, and the accompanying *Layers* dialog

3.7.3 Typing Text and Defining the Text Attributes

Select the *Text* tool in the *Toolbox* and, if necessary, double click its icon to display the tool's options as a dockable window.

Clicking on your image with the text cursor now opens a new, empty text box with integrated tools for adjusting text style, size, color, and letter and line spacing. There are also buttons for adding bold, underscore, italic, and strikethrough attributes to selected text.

If you write continuous text (i.e., without artificial line breaks), this makes it easier to format your text by adjusting the size of the text box. Text can be edited at any time by selecting the text layer in the *Layers* dialog. Text on a GIMP layer can be edited just as it can in most word-processing programs.

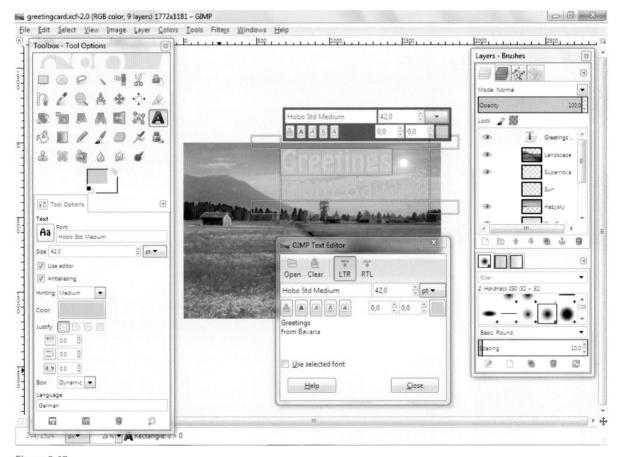

Figure 3.47
The new text box tool compared with the GIMP Text Editor. You can see the frame of the text box in the image window, which can be used to adjust line breaks once you have finished typing.

• TIP

► In addition to the new on-canvas text tool, you can still use the standard GIMP Text Editor to create text elements in a separate window.

Use the *Open* button to access text that you have saved elsewhere on your computer. The *Clear all text* button deletes all the text in the editor's window and the corresponding text on the text layer in your image.

In addition, the drop-down menu at the top right of the GIMP Text Editor window allows you to switch the text direction to right-to-left. For some reason, this function didn't work for me with the program's language settings set to German.

The GIMP Text Editor shows text in a standard font unless you activate the Use selected font option, which then displays text in the editor's window using your selected font (even if it doesn't display the selected type size). Text entered in the editor appears simultaneously in the image and is inserted into a new layer that is created automatically and inserted into the Layers dialog.

All text settings, such as alignment, font, size, and color can be found in the *Text* tool options. You can set these in advance of typing or alter them while you work. To alter text attributes, you have to first select the text layer in the *Layers* dialog, start the *Text* tool, and then use the cursor to select the text you want to alter. You can now alter the attributes of the selected text.

- **Font**: Clicking the *Font* button displays a list of all fonts installed on your machine with a sample of how they look.
- **Size**: This is where you can enter the font size. The drop-down menu next to the size box allows you to choose units of px (pixels), in (inches), mm (millimeters), pt (points), pc (picas: 1 pica = 12 points = the standard font size), and more (please note: 1 point (pt) = 1/72 inch).
- **Use editor**: This opens the GIMP Text Editor window.
- Antialiasing: If you don't activate the antialiasing option, text (and especially smaller fonts) will appear pixelated, and diagonals and curves will have jagged edges. Antialiasing introduces pixels with a gradient towards transparency along the edges of letters, providing optical smoothing (see also section 1.3.1 and figures 1.3a-d at the beginning of the book).
- **Hinting**: Hinting is a method used exclusively by GIMP to optimize the display of smaller fonts.
- Color: GIMP uses the foreground color selected in the Color Picker as the
 default text color, but you can alter the setting in the Text tool options
 dialog by clicking the colored button, which then opens the familiar
 Color Picker window.
- Justify: You can select either left, right, centered, or justified alignment for blocks of selected text. Contiguous text elements can only be aligned using a single option.
- **Indent**: This sets the indent spacing for the first line of a text block. Negative values are also possible.
- **Line Spacing**: This setting enables you to adjust line spacing numerically for multi-line text blocks.
- **Letter Spacing**: This allows you to adjust the spacing between letters (also called tracking) to create spaced text.
- Box: The drop-down list offers options for two basic types of text box.
 Dynamic is the default option, and makes the size of the text box increase
 as you type. The *Fixed* option allows you to produce a fixed-size text box
 by dragging its borders. Line breaks are automatically placed to fit your
 chosen dimensions.
- **Language**: This is where the language settings for the operating system are displayed.

- In addition to the usual Cut, Paste, Copy, and Delete commands, the Text tool's context menu contains Path from Text and Text along Path commands.
- **Text along Path**: Use this command to fit text to a path you have drawn. See the appropriate chapter for more details.
- **Path from Text**: This command converts selected text into a vector-based object (i.e., a path). You can then use the *Path* tool to create a selection using the outline of the object you have created.

Please note: There is a major difference between the *Text* tool options located in the *Toolbox* and the on-canvas *Text* and *Text Editor* tools options:

- Changes you make with the standard Text tool settings are applied to all
 text on a single text layer. Such settings are fine for use as presets, but
 are of no use for making changes to individual letters or words within a
 single text element.
- If you want to make changes to individual words or letters within a single text element, you have to use the settings of the GIMP Text Editor or the on-canvas Text box to select and alter your chosen text.

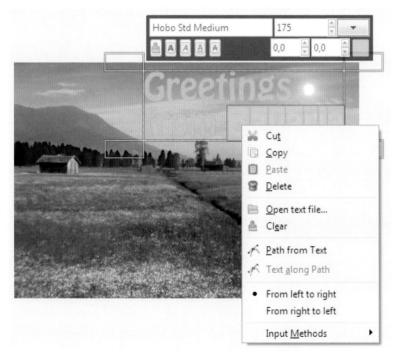

Figure 3.48
Selected text and the *Text* tool's context menu, showing the additional *Path from Text* and *Text along Path* commands

3.7.4 Creating Three-Dimensional Text and a Drop Shadow

If you want to create three-dimensional text with rounded corners, you can apply the *Add Bevel* filter (*Filters > Decor > Add Bevel*). The filter works with any selected layer on an extracted image object. However, the effect is rather slight on large-surfaced objects because the rounding has a comparatively small radius. The beveling on those image objects will hardly be visible. You will meet the filter again in section 3.8.1, where you will round the borders of a picture frame three-dimensionally. The effect works rather well with text. You should choose a wider, bold font if you want to create three-dimensional text. The filter can then be applied to a greater breadth and the effect is more apparent. And, of course, you may use the filter more than once, with different radiuses, to produce distinct three-dimensional edges.

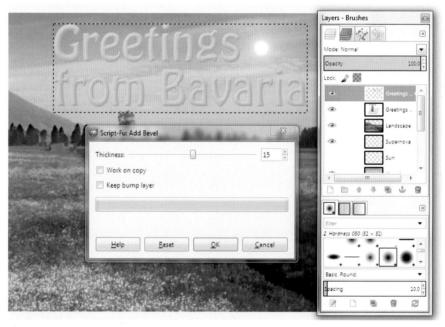

Figure 3.49
The window of the Add Bevels Script-Fu and the three-dimensional text in the image window.
Notice that the text layer has been duplicated, because the Script-Fu renders a text layer to pixels, losing text information; otherwise, the check box Work on copy should have been checked.

In the *Add Bevel* Script-Fu, you can select the radius of the edge. For the font size I had chosen, I selected a radius of 15 pixels for the first run, and 7 pixels for the second. You can also choose to work on a copy of your original so the original isn't changed. If you don't want to apply this option, be sure to at least duplicate the text layer in the *Layers* dialog. When the filter is applied, text layers are turned into pure pixel layers and are not editable afterward.

A drop shadow adds dimension and depth to image elements and text. The following sections describe how you can use selections and fills to create shadow layers for any image object, including text.

The simplest way to produce a shadow effect is by choosing *Filters* > *Light and Shadow* > *Drop Shadow* to open a dialog in which you can set the attributes for the shadow.

The Offset values will determine the direction of the shadow in relation to the image object. Positive values for Offset X will place the shadow at the right, while negative values will place it at the left. Positive values for Offset Y will place the shadow below the selected object or character, while negative ones will place the shadow above it. The program defaults are set to mirror morning light, which comes from the top-left corner. The drop shadow is automatically created on a new layer, and it can be positioned afterward at will.

To make the shadow appear more natural, you can apply a soft edge to the borders and set the *Blur radius* (edge sharpness), since shadows normally don't have hard edges.

The default color for the shadow is black, but you can select any color you wish to attain the desired effect. For example, if you select a white shadow on a dark background, the image object will appear to glow.

Real shadows are rarely pitch black and opaque. For a realistic look, you can move the *Opacity* slider to give the shadow some transparency.

A drop shadow is larger than the object casting it. For this reason, leave the box next to *Allow resizing* checked. The shadow will then grow proportionally larger than the object casting it.

When you are satisfied with your changes, click *OK*. The drop shadow will be automatically generated and inserted as a new, separate layer into the image.

GIMP is a true filter workshop. In this book, you'll be introduced to only a few of the filters available, so don't be afraid to explore the effects of the filters on your own. The next section provides descriptions of certain filters along with tips on how to use them.

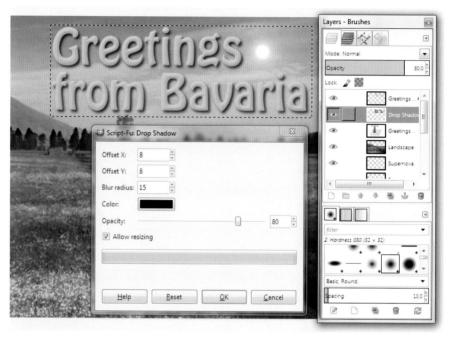

Figure 3.50
The window of the *Drop Shadow* Script-Fu and the automatically generated *Drop Shadow* layer in the *Layers* dialog. Because it is created on a separate layer, the drop shadow can be easily shifted with the *Move* tool.

Using the Text Tool and Drop Shadow—a Practical Exercise

It's now time to practice what you've learned about the *Text* tool. And while you're at it, you can play with some filters and effects, such as the ones available via the *Filters > Light and Shadow > Drop Shadow* menu option:

- Open your image *bluesky.xcf* and save it, using a new name such as *greetingcard.xcf*.
- Set the text color (foreground color) you want to use.
- Create some greeting card text, using the default settings. (As you create
 the text, keep in mind that you will be painting Easter eggs to add to the
 image later on.)
- Modify the text attributes in the Text tool options dialog.
- Choose Filters > Decor > Add Bevel to create a three-dimensional look for the text. Remember to duplicate the text layer beforehand and to apply the filter to the copy.
- Choose Filters > Light and Shadow > Drop Shadow. By using the settings
 described in the previous section, create a shadow effect for the active,
 duplicated layer with text.
- Save your image.

The Script-Fu Layer Effects

Adobe has special effects in Photoshop, the so-called *Layer Styles*. This collection includes effects like *Drop Shadow, Bevel and Emboss, Outer* and *Inner Glow,* and so on.

Jon Stipe developed an equivalent Script-Fu for GIMP called *layerfx. scm.* You can download it from registry.gimp.org/node/186. You can also find it on the DVD in the folder *GIMP Script-Fus.* Installing Script-Fus and filters is described in section 1.5.2. After the installation in GIMP, you must select *Filters > Script-Fu > Refresh Scripts.* A new entry, *Script-Fu,* then appears in the menu bar. Under *Layer Effects,* you can find a dozen different layer styles with a multitude of settings. Unfortunately, there isn't a preview function in the Script-Fu. However, the appropriate Python-Fu includes a preview in the image window. The plug-in is available in the *Layer* menu, regardless of which version you install. You will have to experiment with the various settings and choices. But it is worthwhile.

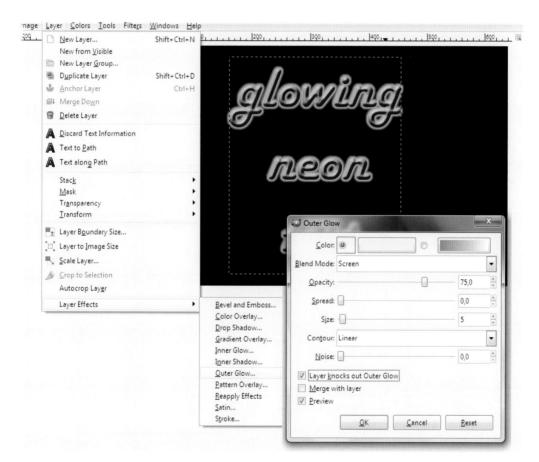

Figure 3.51
The window of the Layer Effects Script-Fu and an example of text

3.8 Creating Your Own Image Frames and Vignettes

You've learned quite a bit about filters and effects. Now let's look at the options available for designing an image frame. It could be a single-color frame or a frame filled with patterns, such as a wood texture. Or you might decide that your image will look more impressive in a frameless glass picture holder. You could also create a vignette in the form of an oval overlay—or another shape such as a keyhole—as was often done with old black-and-white photos. Any shape created with a select tool can be transformed into a frame. Of course, you can find effects to individualize your new frame in the *Filters* menu.

3.8.1 Single-Color Image Frames

Single-color image frames are the easiest to create. In the dialog box of the *Script-Fu Add Border (Filters > Decor > Add Border)* you can choose the settings for the width and the color of the frame. Clicking *OK*, the border is produced automatically. All you have to do ahead of time is enlarge the canvas, that is, if you want to frame the image so that it appears to be on a mount. Or you can place the frame directly on the image.

The Procedure

Here is the procedure to create a single-color image frame:

- Open the girl-color.png image, which is in the SampleImages folder on the DVD.
- Access the Image > Canvas Size menu item to increase the width or height
 of the canvas to the desired size. Press Enter. The chain icon should be
 closed so that the sides of the canvas will adjust proportionately. Click the
 Center button and then click Resize to enlarge the canvas.
- You can also add an alpha channel (right-click menu in the *Layers* dialog) to the background layer of your image. Add a new layer underneath the existing one and colorize it; white or any other color will do.
- Select the *Filters* > *Decor* > *Add Border* menu item. In the *Script-Fu: Add Border* window that pops up, select a width and height for the frame in the *Border X size* and *Border Y size* options. Clicking the *Border color* button opens the familiar *Color Editor*, where you can select the desired color for your new frame. The *Delta value on color* option can be used to set the brightness for various sides of the frame. The higher you set the value, the more variance in the brightness of your frame. Click *OK* to accept your changes. You've created a frame with four different shades of your desired color to set off your image. The frame is placed on an automatically generated layer called *Border Layer*.

• TIP

There are more details on the canvas and canvas size in section 3.14.2. At this point, it suffices to tell you that you can use the *Image* > *Canvas Size* command to adjust the length of one, two, or all four sides of the canvas to give you space to insert new image content or text.

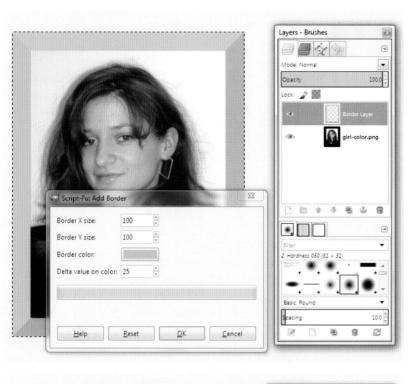

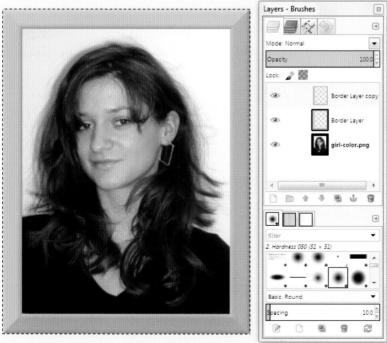

Figures 3.52 and 3.53Settings in the *Script-Fu: Add Border* window and the image, after applying the *Add Bevel* Script-Fu

Now you can add a three-dimensional bevel or a shadow to your frame. You'll be once again using the automatic tools from the *Filters* menu:

- Before beginning with the automatic filter, you should select the frame
 in the Border-Layer layer and duplicate it (right-click on the layer in the
 Layers dialog and choose Duplicate Layer). The new layer is set as active.
 This is not at all necessary, but you might want to keep the first version.
- Now select Filters > Decor > Add Bevel. The Thickness option sets the bevel width, limited to 30 pixels. I put the value at 25 pixels for this example. The Work on copy check box determines whether the effect should be applied to the original or a copy of your image. We have already copied the layer, so it is not necessary to work with a copy of the image. Checking Keep bump layer lets you choose whether the layer that was automatically generated by the effect will be saved as a new layer in the image or if the effect should only be applied on the previously selected frame layer. I had to apply the filter three times in a row to get a visible effect.
- Finally, use the Filters > Light and Shadow > Drop Shadow menu item to add a shadow to the frame layer. This will result in a strong three-dimensional effect, adding considerable depth and richness to your image. Therefore, the canvas, the visible area of the image, has to be enlarged on the side in which the shadow should fall. This will be done automatically if you check Allow resizing.
- Save your image.

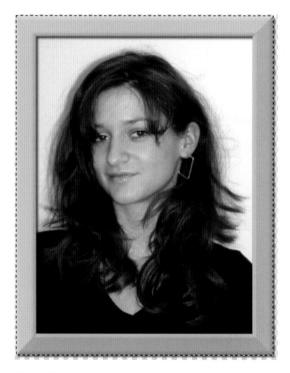

Figure 3.54
The finished image with frame and drop shadow

3.8.2 Creating a Frame with a Pattern

The basic steps for creating a frame with a pattern are almost identical to those previously described. The only difference is that you'll need to create a selection for your frame.

The Procedure

Follow these steps to create a frame with a pattern:

- Open the girl-color.png image from the Samplelmages folder on the DVD.
- Choose Image > Canvas Size to increase the width or height of the canvas
 to the desired size. Press Enter. Since the chain icon is closed, each side
 will be increased proportionately. Click the Center button; then click
 Resize to enlarge the canvas.

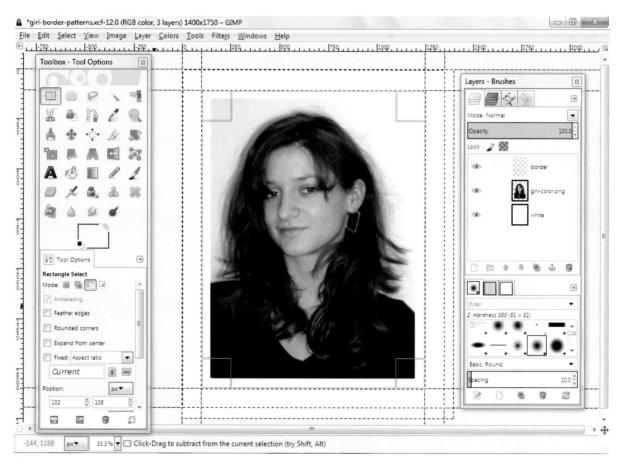

Figures 3.55The image with guides and selection

- Add an alpha channel (using the right-click menu in the *Layers* dialog) to the background layer of your image. Add a new layer underneath the existing one in the image and colorize it white or with any other desired color.
- Choose View > Zoom > Fit Image in Window; adjust it so you can see the
 entire image in the working window. Make the rulers visible (View > Show
 Rulers). Pull guides from the rulers and position them at the same distance
 from each side, thus marking a frame with equal width to all sides of the
 image. The dimensional information provided by the rulers will help you
 measure the border accurately.
- Use the Rectangle Select tool to draw a rectangular selection over the guides, showing the outer border of the frame. Use the Select > Invert menu item to invert this selection. Then set the tool's option to Mode: Subtract from the current selection and select the inner area of the frame. This selects the frame area to be filled.
- Create a new layer called *frame* in the *Layers* dialog.
- Choose the Patterns dialog from the dock window or open it by choosing
 Windows > Dockable Dialogs > Patterns. Select a filling in the Patterns
 window that appears. Note that the patterns appear smaller as image
 resolution increases.
- Select the Edit > Fill with Pattern menu item. The selected area is filled.
- Remove the selection (Select > None).
- You can repeat the steps you followed when you created the single-color frame if you wish to bevel this frame or add a drop shadow. Don't forget to save your image.

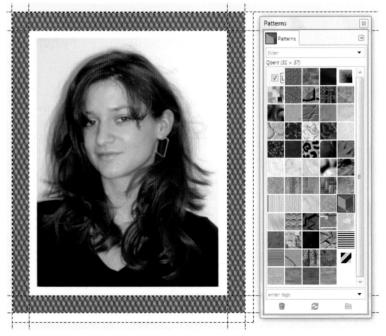

Figure 3.56
The Patterns window with the prepared fillings and frame

3.8.3 Vignettes for Images

In the early days of photography, creating photo vignettes was all the rage. For example, an oval-shaped cutout overlay might be placed on top of a photo. With the help of a select tool, it is easy to create a vignette. The vignette can have any form that you can create with a select tool.

Follow these steps:

- Open the girl-color.png image from the Samplelmages folder on the CD.
- Select the Ellipse Select tool from the Toolbox. Create an elliptical selection
 in the image by clicking the upper-left image corner and pulling the
 ellipse diagonally to the bottom-right corner.
- Choose Select > Invert. Click to invert the selection.
- Access the *Select > Feather* menu item to give your selection a wider border feathering; 75 pixels will be appropriate for this image.
- Select the *Edit* > *Clear* item to delete the surrounding image contents within the selection.
- Save your image.

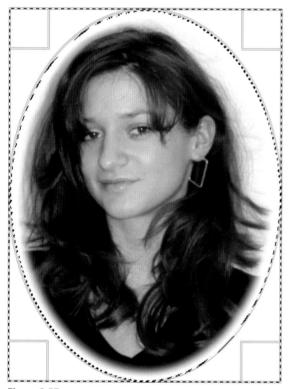

Figure 3.57The image with the selection for producing a vignette. The image contents within the selection have been deleted.

You've learned how to use several of GIMP's effects to artistically manipulate images, including shadows, which give the image a neat, three-dimensional look.

In the following section, you will create your own three-dimensional objects and effects. Of course, you will also continue to work with layers and selections as well as discover how to apply more complex tools, such as the painting and transform tools.

3.9 Creating and Editing Image Elements—Lighting Effects and Shadow Layers

Although GIMP is an image editing program, it includes tools you can utilize to create new image elements and objects, such as logos. In this respect, GIMP also serves as a painting program.

In the following exercise, you will learn several ways to create new image objects. You can use *greetingcard.xcf* to produce an Easter greeting card, complete with a few Easter eggs that you painted yourself. You will learn how to use masks to create simple image objects. And you will learn how to create, copy, group, change, transform, and position image elements. The exercise also provides a useful introduction to working with layer groups, which is a new feature with GIMP 2.8.

3.9.1 Overview of Step 1—Creating a New Image and New Image Objects

Suppose you want to turn your vacation image into a spring greeting card with Easter eggs that you've painted yourself. Of course, you could create the eggs directly in the *greetingcard.xcf* image. However, there is a safer and more practical way of doing this: Create a new image, construct an egg in this new image, and add lighting and shadow effects to it. You can then export your "generic egg" and insert it into the final image by using the familiar drag-and-drop layer (or layer group) export technique.

- Create a new image (choose *File > New*) with the following settings:
 - Size (width x height) = 4 x 6 in or approximately 10 cm x 15 cm
 - Resolution = 300 dpi
 - RGB color model
 - Background color = white

- Save it in the file format = xcf. Name it easteregg.xcf or something similar
- In this new image, create a new layer, egg, in the Layers dialog.
- On this layer create a circular selection by using the *Ellipse Select tool* while holding the *Shift* key down.
- Fill the circle with the color red.
- Delete the selection (Select > None).
- Create a guide on the horizontal center axis of the circle.
- Then create a new rectangular selection over the top half of the circle.
- Use the Scale tool to transform it, vertically pulling the transformation grid from the upper border while holding down the Alt key. When the shape resembles an egg, accept your changes in the Scale window.
- You will now find a Floating Selection (Transform) layer in the Layers
 dialog. Right-click on this layer and select the Anchor Layer option from
 the context menu because you want to apply this transformation to the
 egg layer.
- Use a brush with low opacity to create light and shadow effects on the egg. Create a new layer for each effect. Use the *Fuzzy Select* tool to produce a selection of the egg so that its contours will be maintained. Finally, delete the selection.

3.9.2 Creating a New Image

The image window's File > New menu item enables you to create a new, empty

image document. If you select this menu item, the *Create a New Image* dialog opens. Enter the image size. The values for width and height are not linked in this case. Select the desired measuring unit if you prefer not to work with pixels. You can also select a predefined size from the *Template* drop-down list.

Click the plus sign (+) in front of *Advanced Options* to select a resolution for your image using the settings that are revealed. The values for X and Y resolution are linked.

In the *Color space* item under *Advanced Options*, you will normally select *RGB color*. *Grayscale* is used for black-and-white or grayscale images. However, it is often preferable to use the RGB color space for grayscale images as well because the RGB option supports all of GIMP's features.

Fill with provides you four options to choose from: the foreground and background colors as shown in the *Toolbox* as well as white and transparent. Select *Transparent* if you wish to create an empty layer.

You can use the *Comment* text field to write a descriptive comment. The text will be attached to the image file.

Figure 3.58
The Create a New Image window

Frogress bar: GIMP 2.8 includes a new, time-based progress bar that appears in addition to the familiar, green, graphic-based progress bar. These icons appear during transformations and

other operations that use a lot of

computing power.

3.9.3 Transforming a Selection

You've already used the *Ellipse Select* tool to create a shape on the new layer titled *egg*. It will appear as a real circle only if you hold down the *Shift* key while dragging the elliptical selection.

Use the *Bucket Fill* tool or choose *Edit* > *Fill with FG Color* to fill the object with the red shade selected in the *Color Editor* (pure red is RGB 255.0.0).

First, drag a horizontal guide to the center of the circle. Then drag a rectangular selection across the upper half of the red circle (lines within the grid area) on the *egg* layer. This selection can be larger than the intended object. The program will find the object borders automatically because the remaining area is on a transparent layer.

Select the *Scale* tool. In the tool options, select the *Transform Layer* option and check the *Show image preview* box. Click on the image to access the *Scale* dialog. The transformation grid that was initially limited to the selection surface now must be pulled upward from the upper edge (figure 3.59). Click the *Scale* button in the *Scale* dialog to accept your changes.

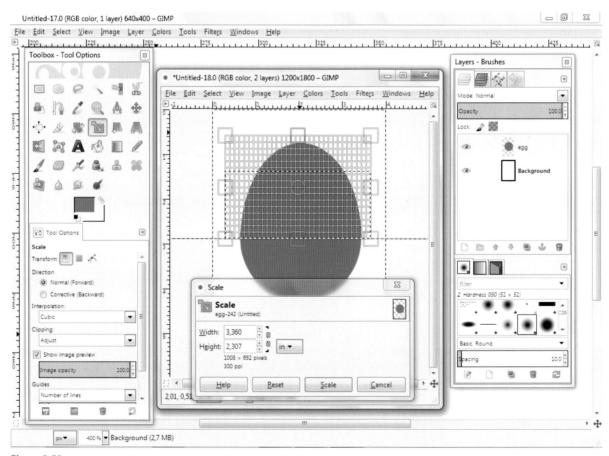

Figure 3.59A selected area on a layer can be transformed.

You'll also have to apply this transformation to the *egg* layer in the *Layers* dialog because the transformation produced a floating selection, which needs to be anchored. Right-click the *Floating Selection (Transformation)* layer and select the *Anchor Layer* item from the right-click menu, or simply click on the *Anchor the Floating Layer* button at the bottom of the *Layers* dialog window.

3.9.4 Using the Paintbrush Tool to Create Lighting and Shadow Effects: Glazing Technique

Lighting and shadow effects add depth, realism, and three-dimensional effects to an image or object. There are several methods available to produce such effects. One way is to simply paint them on.

Use the *Fuzzy Select* tool to create a selection across the red egg. The selection is helpful as it prevents you from painting outside the contour of the selection.

• NOTE

Create a separate layer for each lighting effect. If something goes wrong, you can simply discard that layer and start fresh.

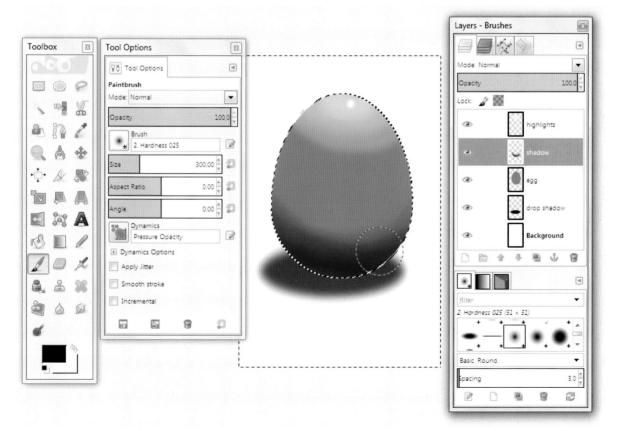

Figure 3.60
The Paintbrush tool options, the image, and layers for lighting and shadow effects in glazing (translucent) painting technique

• NOTE

If you use painting tools regularly, it is a good idea to use the *Brush Editor* to create a range of different sized brush tips with various attributes, which you can then select quickly from the *Tool Options* panel when needed (see section 2.5.2). GIMP 2.8 also includes a range of brush presets that you can fine-tune using the options included in the *Tool Options* dialog.

Access the *Brush Editor* to create a new brush. Select a radius of 300 px and a feathering of 100% (*Hardness* = 0.00). Reduce the spacing to 10 to get an even brush stroke. The *Spacing* value indicates how many painting dots the brush produces within a certain distance. Use a large, round brush with full feathering when painting surfaces without transitions.

In the *Tool Options* dialog, set the opacity for the brush application to a value of about 10%.

With these settings in place, you should now paint in semicircular strokes, one stroke after the other. For the lights, start at the tip; for the shadows, start at the bottom of the object. Begin painting outside the egg; don't worry about staying inside the line. The outside area is protected by a mask. Paint across the object in steady strokes. While painting, hold down the left mouse button, release it after each stroke, and apply it again. If you want to increase the opacity at the bottom of the shadow, you can repeat this process several times.

Use a smaller, softer brush to set a white highlight on the lighter area. You may have to repeat these strokes if you want to achieve a uniform application of color.

The *Eraser* tool may be helpful. It works similarly to the *Paintbrush* tool. You can reduce the pressure sensitivity/opacity in the *Tool Options* dialog so that you can erase in "fuzzy" strokes rather than erasing everything at once.

Now add the shadow thrown by the egg on the surface beneath it. To do this, create an elliptical selection with a soft (approximately 75-pixel) edge on a new layer (*Select* > *Feather*). Fill the new selection with black using the *Bucket Fill* tool or the *Edit* > *Fill with FG Color* command. Now delete the selection and, if necessary, position the new layer with the *Move* tool. Make sure that the new layer is located beneath the egg layer and save your image.

3.9.5 Inserting and Duplicating Layers and Layer Groups

We will now insert the egg into the postcard image. In previous versions of GIMP, this would have entailed merging all layers of the egg (with the exception of the white background) into a single layer and dragging and dropping it into the postcard image using the tools in the *Layers* dialog, as described in section 3.6.5.

This is done with the *Merge Visible Layers* command in the context menu of the *Layers* dialog. In this case, you have to make sure that you hide the background layer before merging by clicking the eye icon next to the layer thumbnail in the *Layers* dialog.

Once the layers are merged, you can no longer edit them individually.

Now, in GIMP 2.8, you can group layers to form a single object that can be dragged, dropped, exported, and edited (for example, scaled) just like a single layer. All layers in a group can still be edited individually. We will use this new functionality to help us create our Easter greeting card.

In section 3.9.6, I will discuss the subsequent re-toning of image objects, which in this case would save you the work of creating the egg again.

- Save the image as workingegg.xcf.
- Delete the *background* layer (white background) by selecting that layer in the *Layers* dialog and clicking the *Delete* button (garbage can icon).
- Right-click on the Layers dialog and select New Layer Group.
- Rename the new layer group *egg* using the *Edit Layer Attributes* command in the *Layer* dialog context menu.
- Now, drag-and-drop all of the egg layers into the new layer group entry in the *Layers* dialog. This is simple to do if you start with the bottom layer first and work upward, although you can adjust the layer sequence in a group later the same way as you can for conventional layers.
- Open the *greetingcard.xcf* image. Save it again as *eastercard.xcf*.
- Drag the new *egg* layer group from the image *workingegg.xcf* onto the *eastercard.xcf* image window, and drop it.
- Give the new layer group a descriptive new name in the *Layers* dialog (for example, *red egg*). Now position the group underneath both the text and the text shadow layers.
- You can now manipulate the red egg group the same way you
 would a single layer. Use the Move tool to position the egg in
 the image so that you can see it entirely, including the drop
 shadow. Otherwise, you might chop some of it off in the
 following steps.
- Scale the size of the egg (choose Layer > Scale Layer or Tools > Transform Tools > Scale or just use the Scale tool from the Toolbox). Then place it in the image and use the Rotate tool to slightly adjust it.
- Reduce the size of the layer group by only including the egg with its shadow. Then, select the Layer > Autocrop Layer menu item.
- Right-click on the red egg layer in the Layers dialog, then select
 Duplicate Layer from the context menu. Click on Duplicate
 Layer twice to make two new layers. Name one layer blue-egg
 and the other yellow-egg.

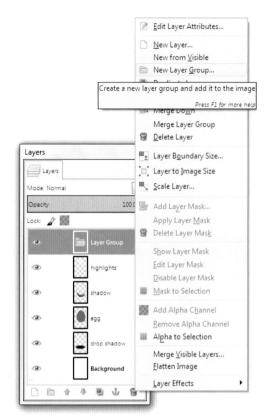

Figure 3.61
The Layers dialog showing the New Layer Group command in the Layers dialog's context menu and the new group

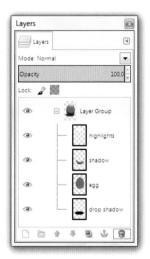

Figure 3.62
The individual layers after insertion in the correct sequence

- Position the newly created eggs (which are still red) on the image where they are entirely visible. (Activate the layer group, click the *Move* tool on it, and drag.)
- Switch the newly created layers around in the *Layers* dialog in the spatial arrangement and the order you prefer.
- Scale and rotate each egg according to your liking. Be sure to check the *Keep aspect* box in the *Tool Options* or hold the *Ctrl* key while scaling an image.
- Select the blue-egg layer in the Layers dialog and, if necessary, open its
 layer group by clicking on the plus sign next to the group thumbnail
 preview. Now activate the "circle" layer within the group. Choose Colors >
 Hue-Saturation. Move the Hue slider until the egg turns blue. Repeat for the
 yellow-egg layer, but tweak the Hue slider to color the egg yellow this time.
- Save the changes as eastercard.xcf

In the following section, you'll take a closer look at the *Hue-Saturation* function.

3.9.6 Changing the Color of an Image Object—the Hue-Saturation Function

Hue-Saturation is an extremely flexible tool. It can be used to completely change an image's color scheme, increase the saturation of one or more colors, create shades of gray by intensifying or decreasing color, or adjust the color of a selection. You can even use the Hue-Saturation slider to easily colorize old black-and-white photos or add color to new black-and-white photos to produce an artsy, nostalgic effect. In the following exercise, you'll use Hue-Saturation to color your Easter eggs.

Activate the layer within the group that you wish to modify (i.e., all "circle" layers). Choose *Colors > Hue-Saturation*. Click the *Master* button in the center of the color rectangles. You can move the *Hue* slider in the *Adjust Selected Color* area to change the hue of the selected object. Moving the *Saturation* slider will either intensify the colors in the image or reduce them (until it becomes a grayscale image). To correct the image's (LAB) lightness, move the *Lightness* slider.

Check the *Preview* control at the bottom of the *Hue-Saturation* window so you can interactively view your modifications as you go in the image window. What's still missing?

- If you have not done so yet, add text with Easter greetings.
- Duplicate the text and remove the attributes in the new layer by using the
 Discard Text Information command in the Layers context menu. You can
 now use the Add Bevel filter with the Work on Copy check box deactivated.
- If you wish, add some bevel and a drop shadow to your text.
- You'll need to position, scale, and rotate the eggs until your composition is balanced to your satisfaction.
- Save your image as eastercard.xcf.

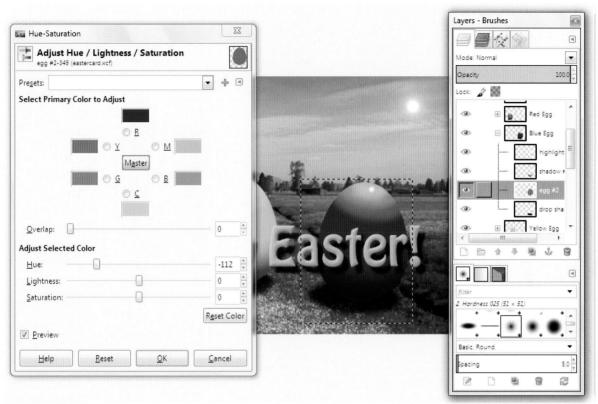

Figure 3.63
The options for the *Hue-Saturation* menu item

You have learned quite a bit about working with layers and masks. You know the most important color tools, and you can now create digital brushes, which allows you to produce new image objects and layer groups, paint existing and new objects, insert text, and transform objects. And this is only the tip of the iceberg. Now you will learn how to select free forms by using the *Free Select* tool as a polygon select tool. And you will get to know a tool that enables you to create arbitrary shapes. It's called the *Paths* tool. You can use it to cut an image object exactly at its contour or to create free, transformable shapes. The following section will define how the *Free Select* tool and the *Paths* tool work and what they are typically used for. You will also learn more about filters for light effects.

3.10 Extracting Image Objects with Select and Masking Tools

You have just learned about layers and the tools for handling them. You have also learned a considerable amount about selections and select tools. And you have begun to make composite images.

The subject of this section is selecting and extracting image objects and assembling them to create new images. In the following sections, I will introduce the most important tools for extracting and cutting out image objects, and I will illustrate the use of some more complex selection and masking tools. The topic will be composites and image compositions, and you will put together and compose the content yourself.

3.10.1 The Polygon Lasso and Intelligent Scissors Select Tools

The *Polygon Lasso* was introduced to GIMP in version 2.6 and has now been revised and improved in version 2.8. Using the *Polygon Lasso*, you can cut out image objects precisely along their contours and quickly extract them. I'll show you how to use the *Polygon Lasso* in the following section.

You must work cautiously when you are making a selection, and you must adjust the settings when you are extracting a rounded form such as a wine glass. Actually, GIMP has a tool better suited for these kinds of tasks—the *Paths* tool. But you will notice that you can manage just as well with the *Polygon Lasso*. Therefore, I will compare the two. I will introduce the *Paths* tool in the following chapter.

3.10.2 Extracting a Wine Glass with the Polygon Lasso

The Procedure

- Open the image wineglass.png from the SampleImages folder on the DVD.
- Create a selection by outlining the wine glass with the Free Select tool in Polygon Lasso mode.
- Give your selection a 3 px radius soft edge (feathering).
- Save your selection using Select > Save to Channel.
- Copy the wine glass with the command Edit > Copy and paste it as a new layer (Floating Selection > New Layer) with the command Edit > Paste.

- Save the image as a file with layers called wineglass.xcf.
- Add a new layer under the layer with the wine glass: background.
- Colorize your background layer with a color of your choice.
- Erase some of the wine glass with a large and soft eraser (*Eraser* tool) with an opacity of 10% to show the transparency of the glass.
- · Save the image.

3.10.3 Creating a Selection with the Polygon Lasso, Following a Contour

First, determine the starting point of your selection by clicking on one point on the contour of the image object you want to select. A yellow dot will appear at this point. Now let the mouse button go and shift the mouse cursor along the object's contour: you are pulling on the "rubber band" of the lasso tool. Apply the "rubber band" to the contour and set another point on the contour by clicking. By additional clicking and dragging, set further control points along the contour. You must know on which side of the mouse pointer the tool is applied.

In figure 3.64, you can see an enlarged depiction of the mouse pointer when the *Polygon Lasso* is selected. The point of the arrow is where the tool places its anchor point. The same applies to the *Free Select* tool as a freehand lasso.

In fact, the *Free Select* tool and the *Polygon Lasso* are combined in a single tool. The mouse commands you use determine which version is activated:

- Left-hand mouse button pressed = Free Select
- Click, release, and drag = Polygon Lasso

The *Polygon Lasso* is definitely the tool of choice if you want to follow a straight contour. You select a corner as an anchor point, click on it, and drag the tool to the next corner, thereby applying the rubber band to the contour. You follow the contour until you reach your starting point again. This is where you close your selection. The form is selected.

Double-clicking the mouse closes the selection at any time. The tool returns in a straight line from the point where you double-clicked to the starting point, thus closing the selection. If you accidentally double-click, you will have to undo the entire selection and start again from the beginning. You can keep on working if you switch to the mode *Add to the current selection*. Then you continue by applying the tool to where you previously left off and close your selection as you had intended to.

Unfortunately, it is not possible to go back and correct part of a selection that you are actually drawing. You can, however, adjust a selection after finishing it by adding a new selection or subtracting areas.

Figure 3.64
The arrow indicates the starting point of the tool.

Next, select the rounded form of the wine glass with the *Polygon Lasso*. Take your time, zoom in on your image, and break up the selection of the contour into several stages; you may have to click several times. *Panning* is a great feature when you have zoomed in on your image: moving the mouse in any direction while pressing the spacebar moves the visible part accordingly. This works with the *Free Select* tool and other similar tools. In GIMP 2.8, it is also possible to move the picture detail beyond the edge of the monitor. Try it with the little navigation window that can be opened by clicking the icon of the crossed arrows (*Navigate the image display*) at the bottom right of the image window.

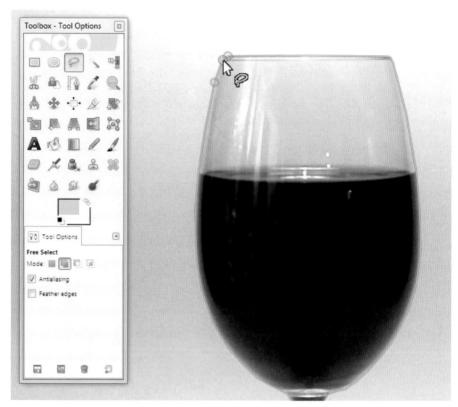

Figure 3.65

Zoom into your image, enlarging the picture. Follow the contour of the curved glass by breaking it up in stages when setting the control points. The outline is the contour that has been applied to the glass so far. The selection has not been closed yet.

Next, start at a distinctive spot on the image and set the first control point with a left mouse click. In the end, you must return to the first control point. Follow the contour of the wine glass with the tool, applying the rubber band to the contour. Then click again to set another control point. A line now connects the control points that you have set. If your image has a curve, you must set several control points, splitting up the curve in a polygon. If there is less of a curve, you can reduce the number of control points, drawing out the length of the line between the points. Continue the procedure until you have circumnavigated the entire figure. At the end, connect the selection with the first control point to extract your figure.

That's basically it. You can continue editing the extracted selection as you would any other selection in the *Select* menu.

Now you will continue editing the image. First you should save the extracted figure by choosing *Select > Save to Channel*. Then you should feather your selection (*Select > Feather*) with a gradient of 3 pixels.

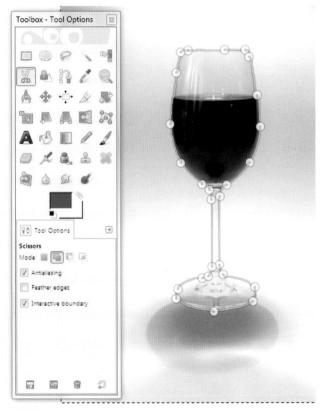

Figure 3.66As a comparison, this image shows the outline drawn with the *Intelligent Scissors*. Unlike the *Polygon Lasso*, this tool automatically follows the outline of the object and can be adjusted and enhanced later on.

Copy the wine glass (*Edit* > *Copy*) and make sure the layer from which you want to copy is selected in the *Layers* dialog. Then paste the extracted image (*Edit* > *Paste*) as a new layer back into the image. Place the new inserted layer (*Floating Selection*) in the *Layers* dialog as a new layer (right-click on the *Floating Selection* layer and choose *New Layer*). Label the new layer *wine glass*.

You can check the quality of your work by making the background layer invisible via a click on the eye symbol.

Create a new layer, background. Now delete the selection (Select > None). Fill the background layer with a color. Make the the wine glass translucent by using a large and soft eraser (Eraser tool) with an opacity of 10% to show the transparency of the glass.

The image is finished. With a little practice, the *Polygon Lasso* is rather easy to use. However, the result with figures having rounded contours is not entirely precise, because the contour has to be traced with a polygon. Now let us have a look at a tool that lets you work precisely with curved contours. This is the *Paths* tool.

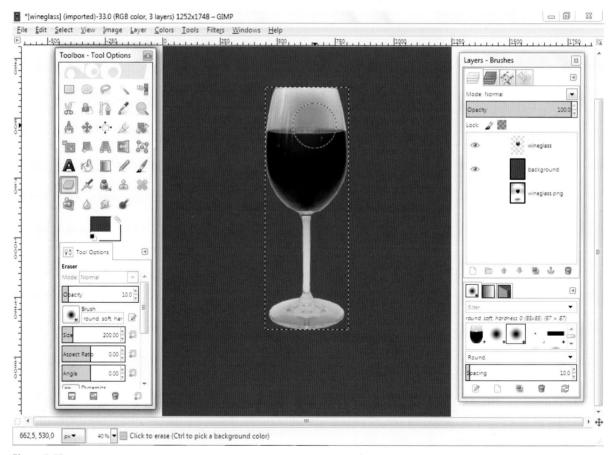

Figure 3.67The finished image, wineglas1-polygon.xcf

3.11 Using the Paths Tool to Create Vector Forms and Selections—Using Filters for Light Effects

The *Paths* tool has multiple uses: On one hand, it enables you to produce free (vector-based) shapes that can be transformed, filled, and otherwise edited. On the other hand, GIMP supports a variety of methods to create selections from paths and transform selections into paths—for example, in the *Paths* dialog or in the *Select* menu.

Paths are not limited to straight-line objects and edges. On the contrary, they are extremely useful when creating and tracing complex objects and shapes. Paths can be aligned to the contours of even very complicated image objects with great precision. They can be used to extract regularly shaped, curved objects: glasses, cars, etc.

In the next exercise, you will use paths to copy a wine glass (a somewhat regularly curved object) from an image, which is a more difficult task with other *Select* tools.

3.11.1 Copying a Wine Glass and Creating a Drop Shadow—Overview of the Steps Involved

Follow these steps to copy a wine glass and create a drop shadow:

- Open the wineglass.png image from the SampleImages folder.
- Select the Paths tool to create a path, following the contours of the wine glass.
- Create a selection from the path; add 3 px of feathering to the selection.
- Select the Edit > Copy menu item to copy the wine glass. Choose Edit >
 Paste and insert as a new layer in the image. Remember to name the layer.
- Save the image (without combining the layers) as wineglass2.xcf.
- Copy the path and transform it so that the wine glass casts a perspective shadow.
- From the shadow path, create a selection with a strong, soft border, and then fill the border with the color black on the shadow layer.
- On the background layer, create a linear gradient blend from pale pink to burgundy red (from top to bottom).
- Reduce the opacity of the layer with the pasted wine glass to about 90%.
 You can also use a large eraser with 10% opacity to erase some color from the wine glass. Whichever method you choose will serve to increase the transparency of the glass.
- Use the *Light and Shadow > Lens Flare* filter to create two highlight spots: one at the upper rim of the glass and another at the base of the glass.
- Save your image.

3.11.2 Creating and Editing a Path—the Design Editing Mode

Select the *Paths* tool to create a path. Make sure the *Design* editing mode is selected in the tool options. The *Polygonal* option should also be checked.

Click the tool on a distinctive point on the image object you want to outline. Black dots, or "control points," will appear. Find the next distinctive point and click again. A line now connects the two anchor points along the path. This is a segment of the path. Continue setting control points until you have almost outlined the entire object. Set the last control point near the first. Then close the path while holding down the *Ctrl* key when clicking on the first control point.

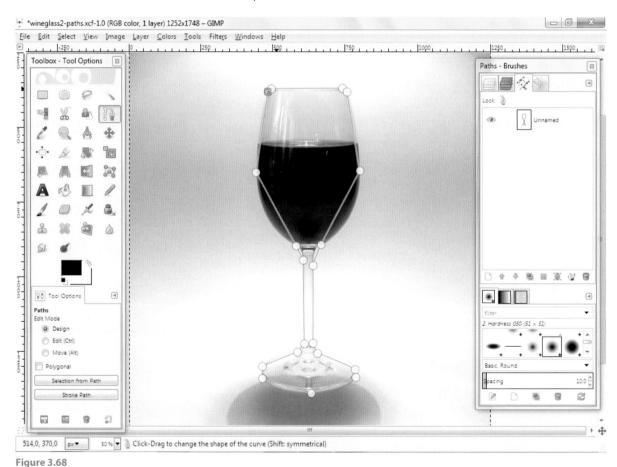

The *Paths* tool and options used to create a path and, subsequently, a path with control points (in the image window) as well as the *Paths* dialog (on the right in the dock)

To avoid setting unneeded control points, take a closer look at the figure you would like to extract. Where are the corner points? Where are the so-called inflection points of the curves (points where the curve changes the direction of its curvature)? In most cases it is sufficient to set control points at the critical points of a contour. Now it is possible to draw spline lines, bent lines from those control points, which can be applied to the curvature of the contour. Furthermore, you can insert additional control points as needed.

As you can see in the example, control points were placed only on spots where there is a bend in the figure or where the outline changes its direction. Even with curves at regular intervals you will need only a few control points. For example, with a circle, you need only three and the outline is developed from the control points.

3.11.3 The Path Editing Mode

Continue using the *Paths* tool in the *Edit* mode. To position the anchor points, *Polygonal* must be selected in the tool settings.

You may want to take advantage of the *Zoom* tool and zoom into your image. Feel free to add more path control points by clicking the mouse on any path line while holding down the *Ctrl* key. You can also delete any superfluous control points by clicking on them while pressing *Ctrl+Shift*.

When you are satisfied with the positioning of the control points, convert the path segments to curves so that the path line will precisely trace the contours of the object. Stay in *Edit* mode, but click the *Polygonal* setting to disable it.

If you click on a control point and drag while holding the left mouse button down, two empty squares at either side of the point will appear: These are "handles" that can be used to define the direction and

Figure 3.69
Path control points and linear segments on an object.
Handles are drawn out from a control point to bend curved segments (highlighted red).

bending of the path's curve. Each control point has two handles. To adjust a curve on a specific section of the path, you simply move the handle of a nearby control point with the left mouse button. Play around with the handles until you've succeeded in creating a path that exactly traces the contours of the wine glass.

• NOTE

CHAPTER 3

If you press the *Shift* key while clicking and dragging on a control point, the handles of that anchor point will work in parallel to each other (i.e., be dragged in the opposite direction with the same length). This option enables you to easily create tangents and turning points while avoiding awkwardlooking sharp bends.

Manipulate the path using the control point handles until you're totally satisfied with the selection path. If you feel you need a more precise curve, just add another point to the path.

Click the curve next to an existing control point and a new one will be created. If it got there by mistake, you can quickly get rid of it by using *Undo History*, or simply click on the point while pressing *Ctrl+Shift* to delete it. While the point is being deleted, the mouse cursor becomes a *Paths* tool icon with a minus sign.

When you have completed the path around the wine glass, your image should look similar to the one in figure 3.66. Remember to close the path selection by merging the first and last control points while holding down the *Ctrl* key (see section 3.11.2).

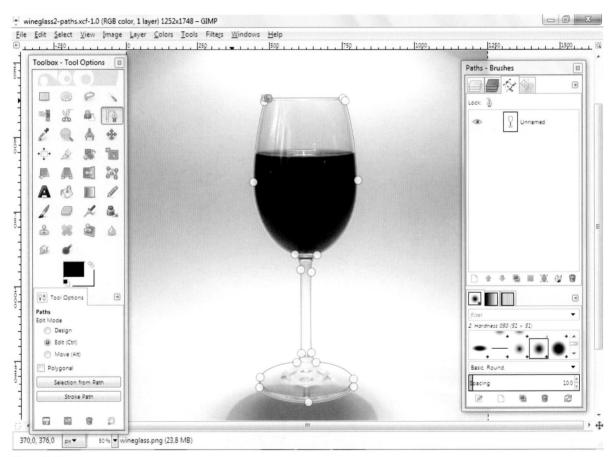

Figure 3.70
A path in the image window (contour line) and the Layers, Channels, Paths, Undo History dialog with the Paths dialog activated.

3.11.4 The Paths Dialog

Paths created in the image window will also appear in the *Paths* dialog. Either call it up from the registers of the dock window or choose *Windows > Dockable Dialogs > Paths* in the image window. Here you can manage several paths in one image, and by clicking, you can activate them. Active paths appear blue in the dialog and are visible in the image (eye icon). Nonactive paths are not displayed or shown in the image, but they exist nevertheless. You can save paths in an image if you save the image in the XCF file format.

When you create the first new path, it will be called *Path*. Subsequent new paths will be named *Path #1*, *Path #2*, etc. To rename a path, click on the text field next to the preview thumbnail and enter a name. (It is wise to choose a descriptive name so that you can easily find it if you want to copy or modify it for use in another image.)

The *Paths* dialog works similarly to the *Layers* dialog. You can click the eye icon to make a path visible or click the chain icon to link a path to other paths in the image so that you can manipulate them together.

To complete the exercise, you'll need to use the buttons at the bottom of the dialog. From left to right, these buttons are *Create a new path, Raise this path* (move upward in the palette), *Lower this path* (move downward in the palette), *Duplicate this path*, *Path to selection, Selection to path, Paint along the path* (create a contour), and *Delete this path*.

3.11.5 Transforming Paths—the Shear Tool

Now you'll continue working on your image. In the *Paths* dialog, click the *Duplicate this path* button and enter a name for the new path, such as *wine glass shadow*. Activate the *wine glass shadow* path and click the *Path to selection* button. You'll know the object has been selected when you can see the "marching ants" around it. Access the *Select > Feather* menu item to define a border feathering of 3 px.

Choose *Edit* > *Copy* and make a copy of the wine glass. Check the *Layers* dialog to make certain that the layer that you're copying from is active. Then choose *Edit* > *Paste* and insert the copied object as a new layer into the image. A floating selection will appear in the *Layers* dialog (the inserted new layer), but it won't be visible on your image. To see the selection in the image, you must first change it from a floating selection to a new layer. Simply right-click on the *Layers* dialog and select *New Layer*.

You can now check the quality of your work more precisely by making the background layer invisible. Just click on the eye icon in the layer.

Make *wine glass shadow* your active path. You'll be using the *Shear* tool from the *Toolbox* to tilt the glass. In the tool options, the *Transform > Path* button should be selected to ensure that the tool affects the path.

From within the image, drag the cursor to the right until the path is tilted to a 30-degree angle or thereabouts. Then click the *Shear* button in the *Shear* dialog to accept your changes.

Next, the *Scale* tool is used to scale down the path vertically in a similar procedure. In the following step, use the *Perspective* tool to narrow the cup of the wine glass. Play with the options until you've attained a perspective shadow.

Use the *Move* tool to position the path. Select the option *Move: Path* and also the *Move the active path* option in the *Tool Options* dialog to move a path.

Now switch back to the *Paths* tool and adjust the shadow of the foot of the glass to fit with the glass itself. Use *Edit* mode and activate the *Polygonal* option.

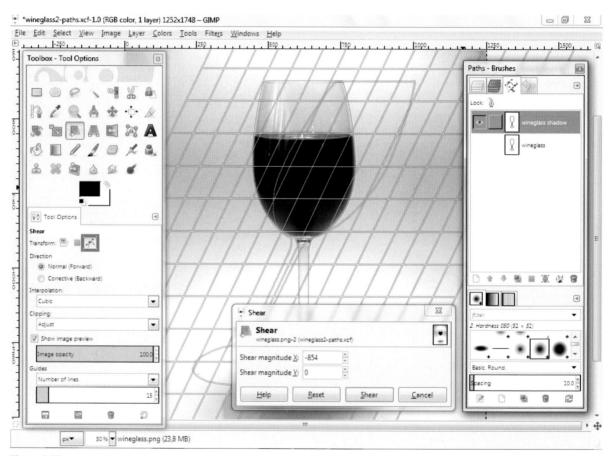

Figure 3.71
The Shear tool and the tool options for transforming paths

For the next step, click the button in the *Paths* dialog to create a selection from the *wine glass shadow* path. Access the *Select > Feather* menu item to define a border feathering of approximately 25 px. Create and activate a *wine glass shadow* layer. Then use the *Bucket Fill* tool or choose *Edit > Fill with FG Color* to fill the selection with black. The layers should be stacked as follows: *wine glass > wine glass shadow > Background gradient > Background*.

Reduce the *opacity* for the active layer (wine glass shadow) to approximately 70%.

The *Eraser* tool can be used together with a large, soft brush and a reduced opacity (about 10%) to produce transparent surfaces in the wine glass and its base. Experiment until you're satisfied. Then fill the *Background gradient* layer with a two-color gradient blend of your choice. Save your image.

If you have used a different tool to make a selection, you can convert or save it to a path using the *Select* > *To Path* command.

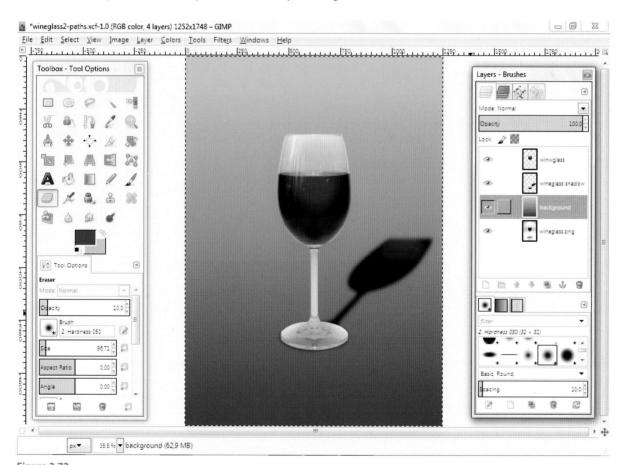

Figure 3.72
The finished image with the Layers dialog and the Eraser tool options. The paths are set to invisible in the Paths dialog.

3.11.6 Creating Lighting Effects with Brushes and Filters

In the previous exercises, you learned how to use painting tools and some filters to create highlights and lighting effects to emphasize the sculptural appearance of objects and to add three-dimensional depth to an image. On matte surfaces, reflections are more likely to be shiny with a round, soft luster, while shiny surfaces such as water or glass tend to have reflections that are brilliant and sparkling.

Constructing Light Reflections with Paths

You can also use paths to produce light reflections and highlights. You can use paths to create small star-shaped paths in the image, which can be transformed into selections. (**Note**: Always duplicate the path first so it won't be replaced by the selection.) The selections are given a soft border or feathering and are filled with white color, sometimes repeatedly, until the desired effect is achieved. This is done so the filling will be visible in very small stars.

Painting Light Reflections with Star-Shaped Paintbrushes

Perhaps you can find a paintbrush on the Internet with the appropriate form. Use the following keywords for your search: gimp, brushes, reflex, star. Or browse one of these websites:

www.gimpstuff.org

 $www.noupe.com/gimp-brushes/1000-free-high-resolution-gimp-brushes. html \\ www.techzilo.com/gimp-brushes$

www.cybia.co.uk/illustration.html

You can also create your own brushes with four, five or six spikes in the *Brush Editor* (see section 2.5.2) with the settings shown in figure 3.73.

Creating Light Reflection with Filters

In addition to graphic and painting techniques, GIMP offers a number of filters that simulate special lighting situations or simply set highlights and also can be used to create lens reflections in an image. The *Supernova* filter (menu *Filters > Light and Shadow > Supernova*) can be used to make radiating reflections depending on the radius setting. You were introduced to this filter in section 3.6.5.

The Lighting Effects Filter

The Lighting Effects filter (found in the Filters > Light and Shadow menu) is new in GIMP 2.8 and helps to simulate the effects of single or multiple light sources in an existing image. The filter is capable of simulating the reflective properties of various types of materials.

For the filter to work, you have to activate the layer that contains the object you wish to "light," or in this case, the *wine glass* layer.

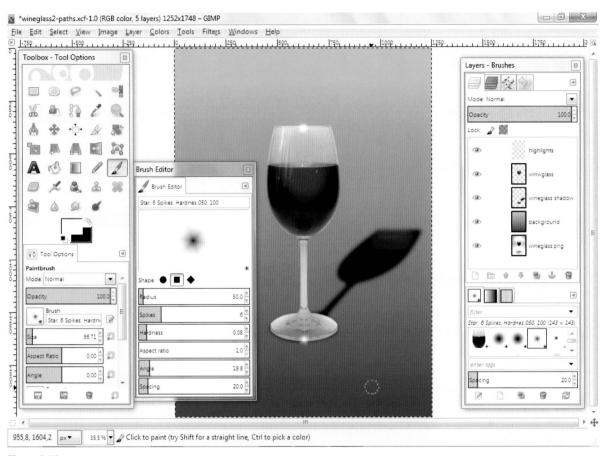

Figure 3.73
Light reflections created with self-made brushes and the corresponding settings in the *Brush Editor*

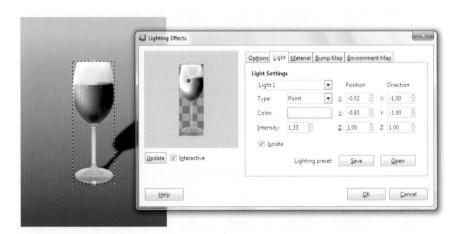

Figure 3.74
The Lighting Effects filter window, in which you can position light sources using your mouse.
The preview image shows the effects of your settings.

The Lens Flare Filter

Glass especially will look more three-dimensional and shiny in your image if you set photographic lighting effects. The *Lens Flare* filter (*Filters > Light and Shadow > Lens Flare*) is ideal for this effect. It works on the active layer, so be sure that the layer with the wine glass is activated.

When you select the *Lens Flare* filter, a dialog with a preview image appears. Use this dialog to numerically define the position where you want to set a highlight.

If you select the *Show position* option and subsequently click the preview image in the dialog, things get easier. You can now simply use your mouse to select or change the position of a highlight. When you're done, click the *OK* button to accept your changes. The effect will be calculated and added to the image.

Repeat these processes if you wish to increase the brilliance, modify the position of the highlight, or set another highlight. From the *Filters* menu, simply select the *Repeat Last* option (if you want to repeat the exact process) or one of the filter options.

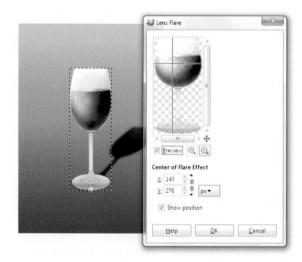

Figure 3.75The *Lens Flare* filter dialog and the filter's effect on the image

Yet another filter you can use to produce sparkling effects on a shiny surface is the *Sparkle* filter (*Filters* > *Light and Shadow* > *Sparkle*). To start, just select the filter and use it with the default settings by clicking *OK*. The effect should be a brighter, soft, sparkling contour of the wine glass, if you apply it to the respective layer. If the effect is not strong enough, increase the values for *Flare intensity* and *Spike length* and also for *Transparency*.

When you're done working with filter effects, save your image.

. TIP

▶ If you want to repeat the process to intensify the effect, alter the position of the center point, or add another flare point, simply select the *Repeat Last* command from the Filters menu. This repeats whichever step you made previously and opens its settings dialog.

3.11.7 Paths and Text

In section 3.7.3, I mentioned the settings *Text along Path* and *Path from Text* that are a part of the *Text* tool's context menu. These options are only active if text is selected with the *Text* tool. In this section, I will present two examples that will show you how to work with them.

Text along Path

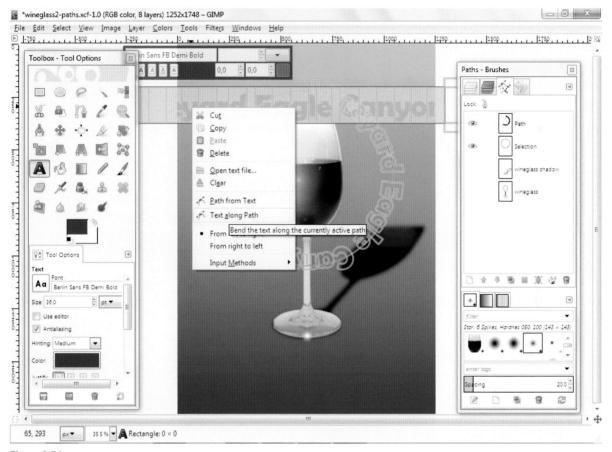

Figure 3.76
The Tool Options and context menu for the Text tool, the result of the adjustment in the image window, and the paths, the circle, and the text in the Paths dialog

In this example, we will use the wineglass2-paths.xcf image to create the cover of a wine list. The first step is to save the image as wine_list-cover.xcf. Next create a new layer called text on circle. The text from the path will be filled in here. Next create a circle from the Ellipse Select tool (hold down the Shift key as you use the tool to create a circle). After that, select To Path from the Select menu. A circular path is created that you can set to visible with the eye

symbol in the *Paths* dialog. Give it the name *circle*. Then delete the selection by choosing *Select > None*. Now you can write the actual text with the *Text* tool and select it. It is important to be sure that the text is written on a single line, and in order to make this possible using a sufficiently large font, I first extended the canvas by using the *Image > Canvas Size* command.

In figure 3.76, you can see the font characteristics that I have chosen and the result of clicking on the *Text along Path* menu item in the context menu of the *Text* tool.

The generated text layer can immediately be made invisible again (using the eye symbol) because it is not needed. Instead, activate the *text on circle* layer that is, in contrast to the text layer, the same size as the image. Therefore, the entire image size can be used later for filling. Next, connect the paths in the *Paths* dialog using the chain symbol to the left of the preview image in the *Layers* dialog. This way, they can be scaled and rotated together using the *Scale* and *Rotate* tools. In the tool settings of the *Scale* tool you must select *Transform: Path.* To keep the path's aspect ratios fixed while scaling them, you must select the *Keep aspect* check box at the bottom of the tool settings. As an alternative, you can press *Shift* during the transformation. Use the same settings for rotating and positioning with the *Move* tool.

I use the following method to make rotating objects easier: Once I have selected the *Rotate* tool, I click on my image to display the tool's builtin grid. Next, I drag the center point of the grid (which is also the center of rotation) to the approximate center of the circle. Now, when I enter an angle of rotation, both paths rotate virtually "on the spot," so I only have to make minor adjustments using the *Move* tool.

You still have to add the text. In the next step, remove the link between the two paths in the dialog by clicking the chain link symbol next to the preview image. You just want to add the text and not the circle. Then click on the path with the text to activate it. Click the *Path to selection* button at the bottom of the *Paths* dialog (or alternatively choose *Select > From Path*). You can't use antialiasing for a color pixel filling as would normally be the case when using the *Text* tool. However, you can add some feathering to the selection. In this example, this is not necessary because soft borders are automatically created along the curved and slanted letters as they are added.

Activate the *text on circle* layer and fill it with the selected color. This time choose *Edit > Fill with FG Color*. Keep in mind that you should deselect the selection before you give your text a drop shadow and a beveled edge with the following filters: *Filters > Light and Shadow > Drop Shadow* and *Filters > Decor > Add Bevel*.

• TIP

► The path you use for a text element can have any shape you wish and doesn't have to be closed.

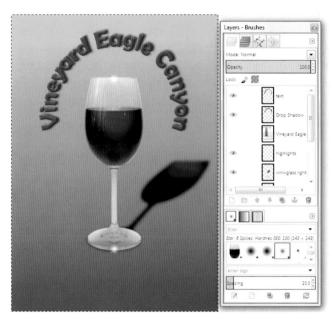

Figure 3.77
The finished image with the filled text containing a drop shadow and a 3D effect for the font

Experiment to see what you can add. The path where you place your text can have any form, and it doesn't have to be closed. You can also place your text on a rolling wave.

In order to return the image to its original size, you have to perform the following steps:

- Delete the text layer and the wineglass.png layer, as these reach beyond the desired dimensions.
- Select the remaining layers one at a time and apply the *Layer > Autocrop Layer* command to remove the excess edge pixels.
- Finally, apply the original size settings by applying the *Image > Fit Canvas*to Layers command before saving the image.

Create Path from Text

Here is just a quick example of how to use the *Path from Text* feature that is in the *Text* tool context menu settings. Again, open the *eastercard.xcf* image and write a short line of text. In this example, I used "Happy Easter!" Then create a path by clicking on the *Path from Text* button in the *Text* tool settings. Next, select the remaining text with the *Text* tool and right click on it to open the context menu, where you can create a path by using the *Path from Text* command.

Create a new layer called path from text in the Layers dialog. It is immediately active. In the Paths dialog, set the newly created path to visible and active. Now with the transformation tools (with the tool settings *Transform* > Paths), you can scale, tilt, rotate, and distort the path. You can also reshape individual letters with the Paths tool in the edit modes Design and Edit.

Continue as follows: Create a selection, fill the selection, add a drop shadow, etc. You can follow the same procedure as with the text along path layer. However, first I used the Bevel filter (Filters > Decor > Add Bevel), then the Curve Bend filter (Filters > Distorts > Curve Bend), and last, the Drop Shadow filter (Filters > Light and Shadow > Drop Shadow).

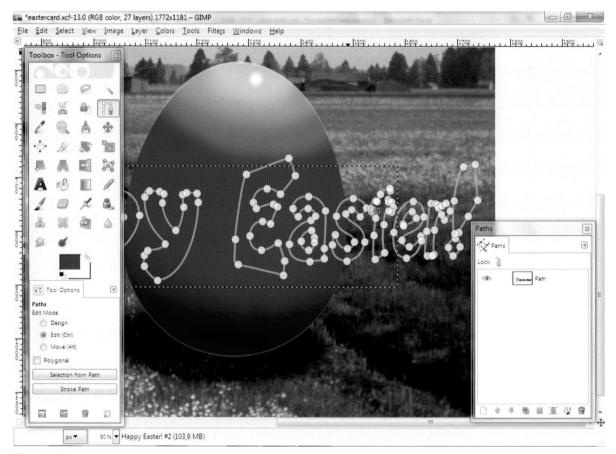

Figure 3.78 Path from Text: The path was distorted with the Perspective tool and individual letters were edited with the Paths tool in Design and Edit modes.

3.12 Aligning Images—the Alignment Tool

So far you have learned to position image objects freehand with the *Move* tool (see section 3.6.3). You can use GIMP's built-in guides and rulers to help you position objects precisely within the frame. The *Align* tool gives you even more dedicated options when positioning objects in relation to each other or within the frame.

As a rule, you must reduce the layer to the size of the image object itself, and maybe also the layer of the image object where you want to place it. Then you can align it in the next step. For example, if you create a new layer in order to insert or otherwise create an image object, the layer will be the size of the entire image, even if the image object itself is smaller. If those layers were then aligned, they would be aligned in their full size, which would not be the desired effect.

Thus, before you align image objects, you must resize the layer to the size of the image object. You can do this by setting the desired layer to active in the *Layers* dialog. Then select the *Layer > Autocrop Layer* menu item in the image window.

The *Alignment* tool in the *Toolbox* can automatically align and position layers in an image. The layers can be centered in the image or correlated to each other. The layers can be aligned at the top, at the bottom, or to the sides. You will find the buttons in the tool settings under *Align*.

The tool settings under *Distribute* work in the same way as the tools under *Align*. The difference is that you can adjust with *Offset* how many pixels the image object is offset in relation to the reference object. Just put a minus sign in front of the value if you want it to be a negative value.

In the drop-down menu under *Relative to*, you can choose the image content to which the layer is to be aligned:

First item: If the Alignment tool is active, the cursor turns into a hand. You
can then click on several layers in the image by holding the Shift key, thereby
selecting one after another. You can recognize the selected layers by the
markers at the corners of the enclosing rectangles. Therefore, you can align
the layers to the layer you first selected.

The tool offers the option of selecting several layers at once with the rubber band function. (With the rubber band, click on the image while holding the left mouse button and drag a rectangle around the objects you want to select.) If you select this method, there is no first item.

- Image: The layers that you want to line up will be aligned with the image borders themselves.
- **Selection**: The layer will be aligned according to the enclosing rectangle of the existing selection.
- Active layer: The layer will be aligned according to the active layer in the Layers dialog.
- Active channel: The layer will be aligned according to the active channel in the Channels dialog. This still hasn't been fully implemented in GIMP 2.8.
- **Active path**: The layer will be aligned according to the active path in the *Paths* dialog. This also still hasn't been fully implemented in GIMP 2.8.

- Here is an exercise to show you the essential functions of the *Alignment* tool:
- Open the image align.xcf in the SampleImages folder on the DVD.
- Then successively activate all layers in the Layers dialog and resize them to the outline size of their image object with the Autocrop Layer function (Layer > Autocrop Layer).
- Select the *Alignment* tool in the *Toolbox*. Click on every image object in align.xcf with the tool. Take note that the markers appear at the corners of all selected objects, enclosing the frame. As an alternative, you can select the objects by using the previously mentioned rubber band function.
- Activate the background layer in the Layers dialog.
- Select Active layer from the Relative to drop-down menu in the Alianment tool settings. Then align the image horizontally and vertically by clicking the corresponding buttons in the tool settings.
- Set the Square layer to active in the Layers dialog. Select Active layer from the Relative to drop-down menu. Using the tool, activate the layer with the green triangle. Align it vertically at the top.
- Save your image.

It is not very likely that you will be using this tool for usual applications in image editing or compositing. The tool's strengths lie rather in creating logos, graphics, and navigation buttons used for designing web pages. You will appreciate the tool when positioning text layers in navigation buttons.

Figure 3.79 **align.xcf-15.0 (RGB color, 4 layers) 1772x1772 - GIMP - 0 Edit Select View Image Layer Colors Tools Filters Windows Help layer in the image Toolbox - Tool Options Layers - Brushes **9**00 4 -Mode Normal Opacity 100.0 A & 282 VO Tool Option 4 Alian Relative to . (h) 43) 43) 罚 Align middle of target 20.0 윤 용 관 8 [3]

Adjusting the Square

3.13 The Cage Transform Tool

You now know how to use tools like the *Polygon Lasso* to make selections. You also know that objects and selections (and their contents) can be transformed, like we did with the Easter egg in section 3.9.3.

The *Cage Transform* tool is new in GIMP 2.8 and enables you to directly select and warp parts of an object using an adjustable, user-defined polygonal frame.

The principles of the tool can be illustrated using the *redpoppy.png* file included in the *Samplelmages* folder on the DVD provided with the book. The poppy petals in the center of the image can be warped to appear enlarged in the foreground.

Before you begin the actual transformation, add a new alpha channel to the image via the *Layers* dialog context menu (command *Add Alpha Channel*) and duplicate the image layer (also via the context menu) to give yourself raw material for subsequent uses of the *Eraser* and *Clone* tools.

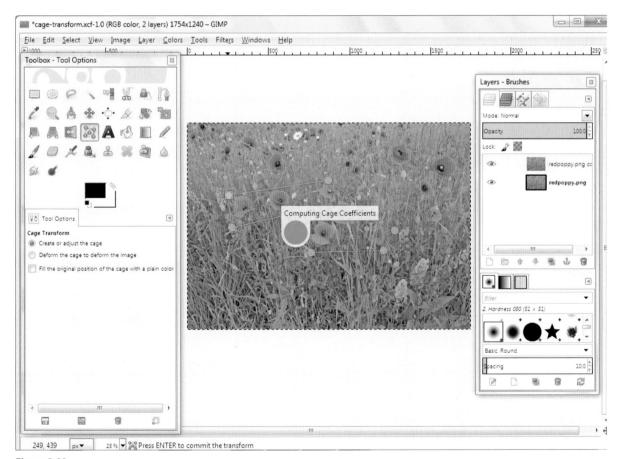

Figure 3.80
The cage is closed and its corners are marked for emphasis. The program is shown here calculating the cage coefficients.

• NOTE

Processing this type of transformation requires a lot of computing power, so once the program begins processing, you should cease any other GIMP activity until the process is complete.

Now select the *Cage Transform* tool in the *Toolbox*. Starting the tool automatically selects the *Create or adjust the cage* option in the tool's options. You can now select the area you wish to warp using the *Cage Transform* tool just like the *polygon lasso* (*Free Select*) tool. To do this, click where you wish to set the starting point of your selection, drag the cursor to the next point, click again, and continue until you have completed your desired shape. Double-click the final point to close the cage. A progress icon with the message "*Computing Cage Coefficients*" will now appear.

Once the coefficients have been calculated, the program automatically switches to the *Deform the cage to deform the image* option. You can now begin to warp your selection by dragging the corner handles. The program computes your changes after each adjustment. This process uses a lot of resources, so be patient and don't try to start the next warp until the previous one is finished.

Once you have positioned all of the corners to your satisfaction, you can make any required adjustments to the positions of the corner handles by once again selecting the *Deform the cage* option. You can then begin the actual transformation by pressing the *Enter* key. Once the transformed object is rendered, the cage disappears, and you are finished.

For our sample image, all we now have to do is retouch the obvious transitions between the warped and original image areas using the *Eraser* and *Clone* tools.

If you decide to reduce the size of the contents of the cage, you can check the *Fill the original position of the cage with a plain color* option. The program then automatically fills any gaps left by the reduction in cage size with a color taken from the surrounding pixels.

If you want to know more about the tool, search for "Cage tool screencast" at **YouTube** (www.youtube.com). There, you will find various video tutorials that demonstrate how to use the tool and ideas on how to apply it creatively.

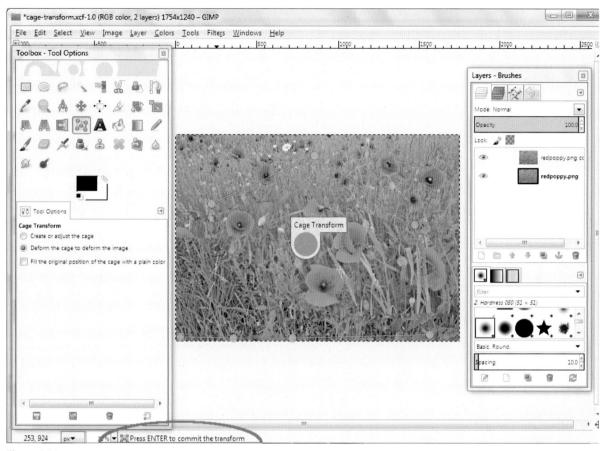

Figure 3.81

Here, you can see that the corners of the cage have been moved prior to rendering the transformation. The program now calculates the actual transformation.

Figure 3.83
The finished, retouched version

3.14 Cross-Fading with Masks and Selections

Now we will return to learning about the techniques of using select tools for masking images or for combining images. There may be times when you would like to cross-fade images, or you might want to create a panorama picture from a series of photos. Both can be achieved by using masking techniques or selections with soft borders.

3.14.1 Cross-Fading Part 1—Cross-Fading Two Images with Two Different Motifs

The prerequisite for cross-fading two images is that both images are of the same image size and resolution. They don't necessarily need to be of the same format. The images for this example exercise have been prepared for you accordingly.

The Procedure

- Open the images lido.png and shells.png from the Samplelmages folder on the DVD.
- Duplicate the *background* layer of the *shells.png* image. Name the duplicated layer *shells*, for example. Allocate an alpha channel to this layer using the context menu in the *Layers* dialog (right-click on the layer and choose *Add Alpha Channel*). This layer will be used in later steps of the editing process and will be exported. The *background* layer *shells.png* can be made invisible by clicking the eye symbol.
- Switch to Quick Mask mode, by either choosing Select > Toggle Quick Mask
 or clicking the Toggle Quick Mask button at the bottom left of the image
 window. A red protection layer, a so-called mask, covers the image.
- Fill the mask with a gradient from the foreground color (black) to white (the standard colors in the color area in the *Toolbox*). You can find such a gradient in the gradient settings of the *Blend tool*. The gradient should start at the bottom with black and end in white at the top. The image content at the bottom is to be kept, whereas it will be deleted gradually toward the lighter areas.
- Switch back to the select mode (marching ants mode) by clicking the *Toggle Quick Mask* button. Now a selection appears that fades out according to the gradient.

- Set the shells layer to active.
- Delete the selected image content on this layer using the *Clear* command (*Edit* > *Clear*). The content is deleted, according to the mask's gradient. Where the mask had 100% covering power, nothing is deleted. Where it had 50%, the image content is deleted to 50% opacity. Where it had 0% covering power, all image content is deleted. If needed, repeat the procedure.
- End the selection by using the Select > None menu item.
- Now export the shells layer by drag-and-drop onto the second image, lido.png, which should be open in the image window. Position the layer, and then scale it so that the shells reach to the visible horizon.
- If necessary, adjust the brightness and the contrast of the *shells* layer and the *lido.png* image (*Colors* > *Brightness*–*Contrast*).
- Save your image under a new name (for example, *fenice.xcf*) as an image with layers. This image will be needed for another task.
- Save the shells.png image in the XCF format.

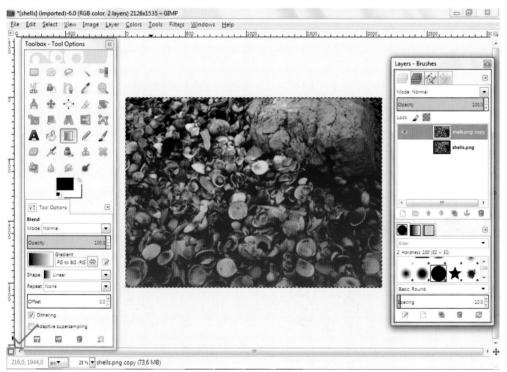

Figure 3.84
The gradient from black to white in the selection of the entire image viewed in the masking mode

Figure 3.85
The gradient is applied to the layer with the shells, after a selection was made from it. Then the image content is deleted with Edit > Clear.

Figure 3.86
The finished composite image with the inserted and transformed layer with the shells. If the opacity of the layer shells is too low, you can increase it by duplicating the shells layer.

3.14.2 The Canvas and Canvas Size

The canvas is the surface on which you can insert image or text data when creating and editing digital images. In general, the size of the canvas is the same as the size of the image you are working on, but can be enlarged or reduced in all directions in the Set Image Canvas Size dialog (figure 3.88) in order to:

- · enlarge the image to accommodate additional objects or text
- produce an image with dimensions that equate to a specific number of pixels (see section 2.1.6)

Enlarging the size of the canvas doesn't change the size of the contents of an image, but does add space for more.

Figure 3.87
This is the image of Miami after copying the car and inserting multiple versions of it. In this illustration, you can see that the canvas has been enlarged all around the original image.

Here, I have used our familiar image of Miami to demonstrate how to enlarge the image canvas. Enlarging the canvas makes previously cropped content once again visible. The fact that some objects appear to reach beyond the physical borders of the image is known as the "out-of-bounds effect."

We have learned how to apply all of the other techniques, including making selections with the *Polygon Lasso*, inserting layers, using the *Move* tool, altering colors with the Hue-Saturation settings, creating graphic objects (our Easter Egg, for example), inserting text, and adding bevels and drop shadows (which don't always have to be black, by the way). If you want to see how the out-of-bounds effect is achieved, check out the file *miami-out-of-bounds.xcf*. in the *Samplelmages* folder on the DVD.

The following URL leads to a gallery of images that use the out-of-bounds effect to produce 3D images: www.chip.de/bildergalerie/Grenzenlose-Fotos-Out-Of-Bounds-Pictures-Galerie_36418387.html

• TIP

When you are repositioning objects on separate layers, the layer's black and yellow edge markings can reach beyond the edge of the image. This doesn't delete the content concerned, and it will be displayed again as soon as you move it back within the image frame or increase the size of the canvas.

3.14.3 Cross-Fading Part 2—Assembling Panoramic Images

Figure 3.88The *Set Image Canvas Size* window with the recommended settings for our example

• NOTE

When combining photos into panoramic images, prepare them first so that they are all the same size and, more importantly, the same resolution. Many digital cameras offer a panorama function to help you capture images for a panorama. Portrait-format images make better panorama source material than conventional landscape-format shots. They usually contain less edge distortion while providing greater height if you are shooting a single-row panorama.

Panoramic Photos

Images composed of several distinct shots are often called panoramic photos. You can shoot such images freehand. Unfortunately, panoramic photos often suffer from horizontal or vertical mismatches, distortions, or canted sides. If you use a tripod when shooting panoramic photos, it will be easier to combine the images. In any event, make certain that about one-third of each image can overlap onto the other images so that the dissolve will appear natural and smooth. It is extremely important to use the same focal distance and depth of focus when taking the photos. If you don't, you'll end up with a disjointed, odd-looking panorama made up of parts that just don't fit together.

Depending on the model and focal length of the lens, your images might have distorted edges. You might have to adapt the images with additional transformations to enable the stitching process. Although this is a delicate operation, it is possible with GIMP.

The pictures for the example exercise were taken with a telephoto lens and a single-lens reflex (SLR) camera. They are predominately free of distortions.

The Procedure

- Open the *Garda1.png* image in the subfolder *Gardapanorama* in the *SampleImages* folder on the DVD.
- In the Layers dialog, add an alpha channel to the background layer. This
 will add transparency attributes to the layer, including the ability to
 reposition the transparency or other objects. Just right-click to open the
 context menu and select Add Alpha Channel.
- In order to stitch the images together, you must expand the image window. Enlarge the image surface to the right. Select *Image > Canvas* Size and enter a width of 80 in and a height of 19 in.
- Match the image to the canvas size by selecting the View > Zoom > Fit Image in Window menu item.
- Use the *Move* tool to position the *Garda1* layer at approximately the center of the left edge of the canvas.
- Save the image as gardapanorama.xcf.

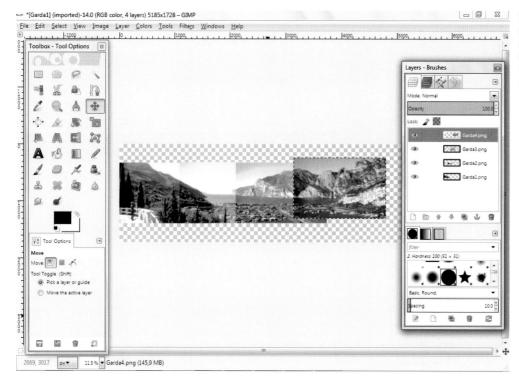

Figure 3.89 gardapanorama. xcf with the prepositioned imported layers and the open Layers dialog

- Load the images garda2.png through garda4.png, one after the other. These
 will be the additional layers for the panorama. Set them both to active
 status. From the Layers dialog, drag and drop the background layers to
 import them into the image window of the gardapanorama.xcf image. Try
 to position them so that they overlap. You can also use the File > Open as
 Layers command to select multiple files and open them as layers.
- The new layers will automatically be named according to the original names of the images. After you import them, you can close the original images.
- Add an alpha channel to every layer (right-click on each layer to access the context menu).
- Save your *gardapanorama.xcf* image. It should look like the example in figure 3.89.
- Next, adjust the color level in the individual layers (Colors > Levels or Colors > Curves) to match the color, contrast, and brightness of the images. Use the imported layer from the Garda3 image as a starting point, since its color and brightness are of average quality, compared to the others.
- Mark the overlapping sections in the individual layers with vertical guides. Drag them into the image by clicking on the ruler and holding the left mouse button.
- Now create a selection with the Rectangle Select tool. This selection should begin at the center, where the Garda1 and Garda2 layers overlap, and should reach to the left beyond the border of the Garda2 layer (as in figure 3.91). Choose a soft selection edge of about 120 to 200 px (Select > Feather). The value of the feathering depends on the size (width) of the overlap.

Figure 3.90
Gardapanorama.
xcf after the tonality
correction and with
guides marking the
overlapping areas of
the layers

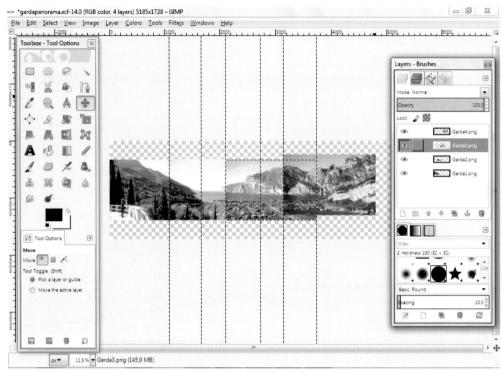

Figure 3.91
The entire selection including the masking of the layers Garda1 and Garda2. Garda2 is active.

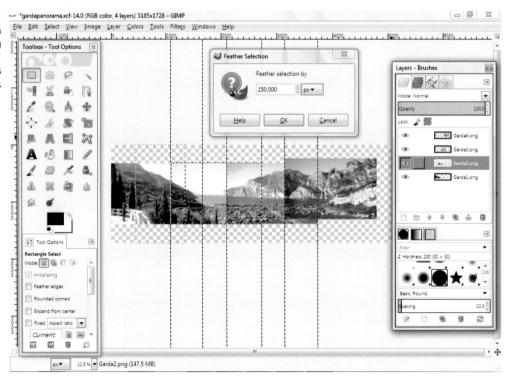

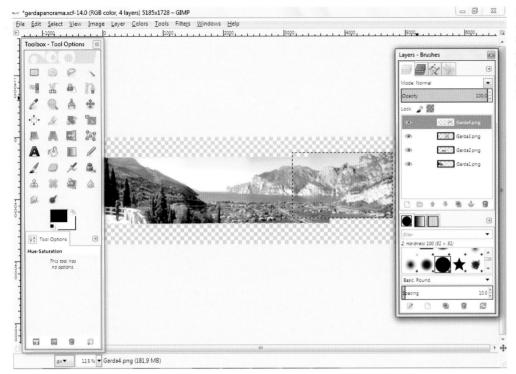

Figure 3.92
Gardapanorama.xcf
after deleting with
gradient selections
from the overlapping
layers and after the
tonality correction

- The *Garda1* layer remains unchanged. Make *Garda2* the active layer and delete the left part of the overlapping area with *Edit* > *Clear*.
- Repeat the previous steps for the Garda3 and Garda4 layers.
- After you delete the overlap of layers 2 through 4, choose Select > None
 to remove the selection. Next, remove the guides by deselecting View >
 Show Guides (Show Guides is a toggle option). Your gardapanorama.xcf
 image should now look more or less like the example shown in figure 3.93.
- You still have to position layers *Garda2* through *Garda4*. First, you must enlarge the image window as much as possible (full screen). Then zoom into the image with the *View* > *Zoom* > 1:1 (100%) menu item.
- Next, look at the overlap between layers 1 and 2. Make the overlapping layer the active layer. Start with *Garda2*. Position it with the *Move* tool so that you don't have anything double in the image. The partial transparency of the layer is a great help.
- If required, use the *Eraser* tool with a soft brush pointer and reduced opacity to achieve better transitions in the sky sections.
- After the transitions have been smoothened out, crop the extra canvas around your image.
- · Save your image.

· TIP

▶ Instead of using the *Edit* > *Cut* command, you can delete selected content directly with the *Del* key.

• NOTE

The Move tool settings must be switched back (Tool Options: Tool Toggle: Move the active layer).

• TIP

▶ You can position the existing selection over the overlap between the *Garda2* and *Garda3* layers with the *Move* tool, and so on. Be sure to select the *Move: Selection* option in the *Tool Options* panel; otherwise, you will end up deleting part of the *Garda2* layer below.

An enlarged section during positioning and adjusting of the layers. When you are working with the Move tool, you can use the arrows on your keyboard to position the selected layer at pixel level.

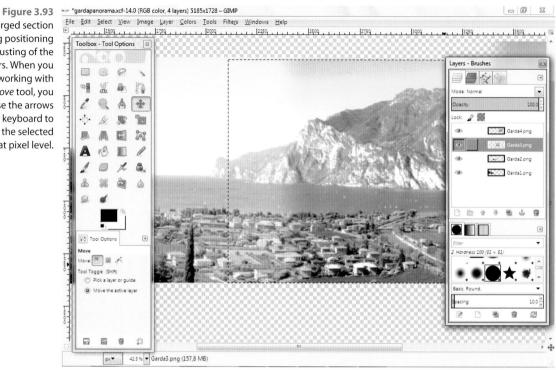

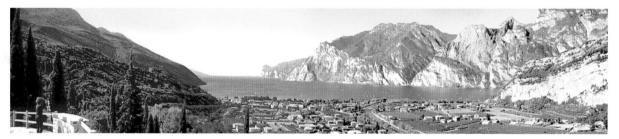

Before the layers were assembled, the cyan/turquoise sky in the individual layers was corrected with Colors > Hue-Saturation and the contrast in the mid-brightness range was adjusted with Colors > Levels or Colors > Curves. After it was assembled, the image was sharpened with the Unsharp Mask filter (Filters > Enhance > Unsharp Mask).

3.14.4 Programs for Creating Panoramas Automatically

Several programs are available through the open-source community that will automatically produce panoramic images. The tools Hugin and PTGui are available for Windows, Linux, and Mac OS operating systems. **AutoStitch**, a shareware tool available only for Windows, is easy to use but handles JPEG files only. PanoTools is a plug-in for GIMP 2.0 (Windows). However, so far it can't be used with the newer GIMP versions under Windows. But it is worthwhile to download it as a standalone program.

Details on downloading, installing, and using Hugin, PanoTools, and AutoStitch can be found on the following sites:

hugin.sourceforge.net/download panotools.sourceforge.net www.cs.bath.ac.uk/brown/autostitch/autostitch.html

Pandora is another GIMP plug-in for creating panorama images. You can find the download and an introduction to the program at the following website: www.shallowsky.com/software/pandora.

3.15 Composites—Using Masks and Selections to Cut and Paste Image Objects

In the previous sections, I introduced you to several techniques for putting images together or creating composite images. I will now demonstrate further the principle of compositing by showing you examples of a simple procedure, an automatic procedure, and a sophisticated procedure.

3.15.1 Copying an Image Object with the Help of a Selection and Inserting It into Another Image—the Procedure

The *Copy* and *Paste* functions in the *Edit* menu can be used to easily transfer image objects from one image to another. To copy and paste image objects, the objects must be selected first. Then the border attributes can be set by choosing *Select > Feather* and entering a value. The *Edit > Copy* function pastes the selection into the global clipboard of your computer. The *Edit > Paste*

• NOTE

Within the *Edit* menu there is another menu item, *Paste as*, that lets you insert the clipboard content in different ways:

- Paste as > New Image opens a new image window and pastes the clipboard content into a new image.
- Paste as > New Layer pastes the clipboard content directly into a new layer in the opened image.
 You don't have to create a new layer for a floating selection.
- Paste as > New Brush creates a new brush pointer in the Brushes dialog from the content of the clipboard.
- Paste as > New Pattern creates a new pattern in the Patterns dialog from what is in the clipboard.

function pastes the selection onto another image (or into another application, such as a word processing program).

Here are the steps to copy an image object by selecting it and inserting it into another image:

- Open the fenice_base.xcf and moon.png images from the SampleImages folder on the DVD.
- The following option offers the ability to work precisely, but it isn't essential: In the image *moon.png*, use guides to select a rectangle around the moon. The guides should be used as tangents to the moon's circumference. You can drag the guides into the image by clicking on the rulers while holding the left mouse button. To subsequently correct the guides, there is a setting in the *Move* tool.
- Draw a selection of the moon with the *Ellipse Select* tool (with the help of the guides).

Since version 2.4, GIMP has allowed you to transform and adapt selections made with the *Rectangle Select* and *Ellipse Select* tools. By holding the left mouse button, you can grasp the visible edges or corners of the enclosing rectangle (transformation frame) to adjust it to the desired size and form. Then, you can work on the selection with other tools. When returning to the select tool, you simply click on the selection to make the transformation frame available again. The same is true for the *Crop* tool.

Figure 3.95
The transformation frame around the selection in the image and the extended tool settings of the Ellipse Select tool (Image courtesy of NASA)

- Reduce the feathering in your selection to about 5 px (Select > Feather).
- Access the *Edit* > *Copy* function and copy the object within the selection—the moon—to the clipboard. Then close the *moon.png* image.
- Switch to the fenice_base.xcf image.
- Set the top layer to active in the *Layers* dialog.
- Choose Edit > Paste. Since the top layer is active, the content from the clipboard—still the moon—is inserted on top of this layer.
- Accept the pasted layer as a new layer by right-clicking and selecting New Layer. Call this layer moon.
- Position the layer and use the *Scale* tool to enlarge it until you're happy.
- Now transform the moon into a sickle. To do this, first drag an elliptic selection with strong feathering (about 200 px) partially over the moon. Choose Edit > Clear to delete the contents of the selection. Select Select > None to delete the elliptical selection. Reduce the opacity of the moon to about 75% in the Layers dialog.
- In the Layers dialog, select Addition or Screen in the Mode drop-down menu.
- Save your image.

As you can see, most of the work steps slowly become routine as you repeat them. So far, however, we haven't used any *Mode* options. The *Normal* mode produces overlays that act as you would intuitively expect them to, covering the object without changing the representation. Sometimes, however, it is necessary to change the manner in which the superimposed layer and the background layer are "blended" in order to achieve a specific effect. Have a look at the following section to learn more about *Mode* options.

3.15.2 The Mode Options in the Layers Dialog

The mode in the *Layers* dialog lets you determine how the active layer will interact with the underlying layer. The default mode in the drop-down menu is *Normal*. With this setting applied, the underlying layer is covered by the layer above it without any further blending effects. All other blending modes alter the brightness, contrast, and color values. Their names will give a clue to what effect each mode might have. Several of the modes are effects that derive their names from techniques used in chemical photo developing. The outcome of applying a given mode varies from one image to another, depending on the attributes of the underlying layers. It is worthwhile to experiment since some of the various blending modes will yield better results than others. You can even optically melt layers together.

Keep in mind that a matching mode is available in the tool settings of all paint and fill tools as well as the *Clone* tool.

Figure 3.96
The selection of blending modes in the Layers dialog. The Screen mode is applied to the moon layer of the image.

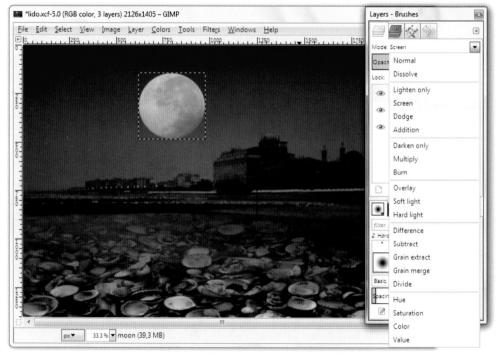

3.15.3 The Foreground Select Tool— Extracting Images Automatically

Before we turn to a work-intensive method by which we will mask image objects by hand, I will show you the automatic method. The *Foreground Select* tool that has been included in GIMP since version 2.4 offers a way to easily extract objects in images. Let's have a look at what the tool can do.

First of all, an easy exercise: extract an orange basketball that is in front of a green background. Open the image *basketball.png* from the *SampleImages* folder on the DVD. Select the *Foreground Select* tool in the *Toolbox*. You will work with the tool in several steps.

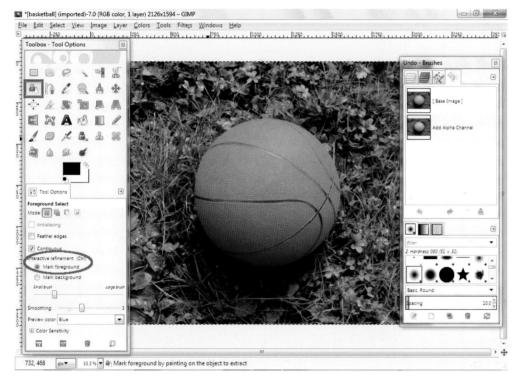

Figure 3.97
The foreground is roughly selected and a transparent blue mask covers it.

Once you have selected the tool, the cursor will turn into a lasso, just like the Free Select tool. For the first work step, the handling of the Foreground Select tool is similar to using the Free Select tool as a freehand lasso. Just make a rough selection of the object you want to extract. Hold the left mouse button and draw around the object. Try to incorporate as little of the background as possible (though it's impossible to be precise). If you don't close your selection entirely, the tool will close it automatically with a straight line as soon as you let go of the mouse button. Then a transparent blue mask will cover the foreground. Depending on the Interactive refinement option you select, the Foreground Select tool will mask either the object itself or the surrounding background: If you select the Mark foreground option, the object itself will be roughly selected, whereas the Mark background option selects the details surrounding it. Evenly colored backgrounds are often easier to select than foreground objects, but result in a "negative" selection. However, if you are sure the selection closely matches the outline of the object, you can invert it by using the Select > Invert command. Always take a close look at your image before deciding which selection option to use.

The foreground is painted over to cover all shades and colors.

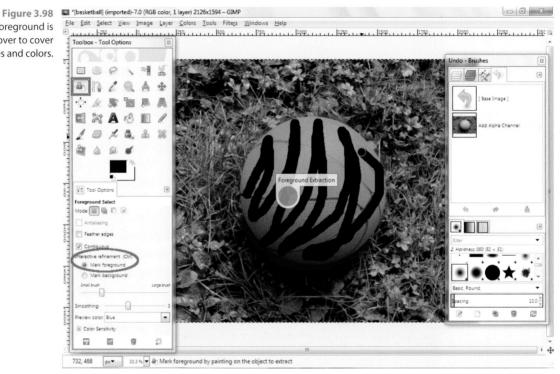

The cursor changes shape; it is now a paintbrush. In the second step, you must inform the program which colors the object to extract has. Thus, you paint over the entire surface of the foreground so that all possible colors and shades are covered. Take care to stay inside the selected area when painting. You can paint over the area to select in several steps. As soon as you let go of the mouse button, the program begins to compute and the surfaces that have been selected are covered. However, if not all areas to select have been detected by the tool, you can paint the surfaces again. They will be added to your first selection. If you accidentally selected too much, you can switch the tool setting to Mark background below Interactive refinement. Otherwise, you can simply hold the Ctrl key.

This way, you can select sections in your image that should be deleted from the selection. The program recalculates the selection and creates a new mask. You can refine the result again if you wish.

 Finally, after you press the Enter key, the entire process is finished and a real selection is created from the mask.

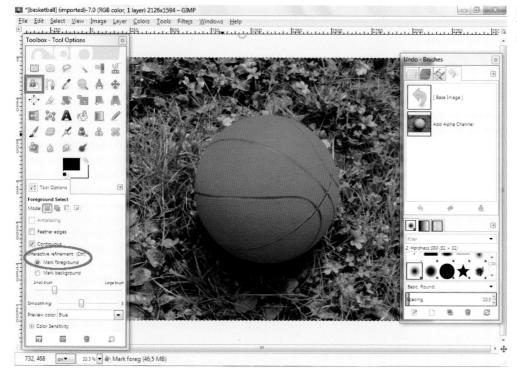

Figure 3.99
The mask around the selected basketball

Perform the steps—selecting, painting over, pressing *Enter*—in one go. Once you have begun working with the *Foreground Select* tool, it is not possible to reverse any steps, neither with *Undo History* nor with *Ctrl+Z*. The entire process appears as one work step in the *Undo History* once it is completed. If you mess up somewhere in the process and you would like to start again, simply select another tool in the *Toolbox*. The *Foreground Select* tool is discontinued and you can start anew.

Nevertheless, corrections can be made during work as previously described with the tool itself. When working with the paintbrush (step 2), you can select a coarse brush to cover large surfaces. Afterward, the details can be worked out with a smaller brush. The brush size can be selected in the tool settings.

If you marked too much as foreground, you can switch the tool settings to *Mark background*. In a way, this lets you erase the over-drawn selection.

The finished selection

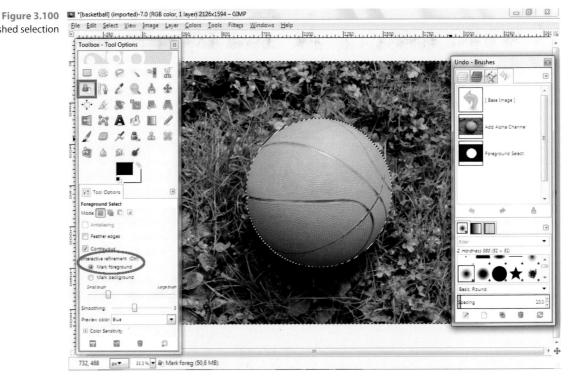

Before we start to view the results of the tool in an image with low contrast between foreground and background, I would like to give you an overview of the tool settings. We will be looking at only the tool settings that you are not acquainted with:

- Contiguous: This feature is selected by default. It indicates that only cohesive surfaces are selected with the paintbrush. If you deselect this option, other areas in the image that are the same color will be selected when you use the paintbrush. For example, if you selected a flower in a field full of flowers, all similar flowers would be selected automatically.
- **Interactive refinement**: The choices under *Interactive refinement* allow you to alternately select colors from the foreground or background, depending on what you want to add to your selection.
 - Mark foreground: This option is the default setting. The paintbrush paints with the foreground color when creating a selection. The colors that have been painted over mark the object that should be extracted.
 - Mark background: This option can be selected when it is easier, due to the colors, to select the background rather than the foreground. Moreover, you can switch to this option while working by holding down the Ctrl key. With the Mark background option selected, the program paints in the selected background color (in the *Toolbox*). You can also subtract colors from the selection. This is useful if, for instance, you have overdrawn the boundaries of the area you

want to select. Colors within the images that have been marked as background (with the background color) are not selected.

- **Small brush Large brush**: The slider lets you select the size of the paintbrush. A small brush lets you work with fine details.
- **Smoothing**: This slider lets you determine the sharpness of the edges of the selection border. If you smoothen the selection with the brush, you can remove or cover up small holes.
- **Preview color**: Lets you select the color of the overlay mask, which covers up the background in the image.
- Color Sensitivity: This feature works with the LAB color model. If your selection has a color with a variety of tones, you can increase the sensitivity of the selection for this color.

Let's have a look at an image object that because of its characteristics is more difficult to extract. Open the image *lion.png* in the *SampleImages* folder on the DVD. The lion in the picture has a color that's similar to the background. It is difficult to extract the fringes and the strands of hair in the lion's mane.

You can tag along again for this exercise. The result can be used for exercises later in the book.

- Open the *lion.png* image in the *SampleImages* folder on the DVD.
- First, perform an automatic color level adjustment (Colors > Levels > Auto) on the image. The contrast of the background colors will come out stronger.
- Choose the Foreground Select tool. Select the lion and his mane, applying
 the tool's lasso with as little distance to the object as possible. If your
 result isn't to your satisfaction, you can adjust the Color Sensitivity setting.
 Set the values of L, a, and b up to around 500 to enhance the contrast
 sensitivity of the tool.

Again, the tool switches and turns into a paintbrush. With it you can mark the foreground color of the object you want to extract. First, I chose a medium-sized brush to paint over the lion, and then I painted within the contours and finally tried to cover all the various shades of the lion's fur. For the tail and the tassel, I reduced the size of the brush. Take care not to paint into the background.

If you want to make any changes because there are still surfaces to select or that have been overselected, this is the time to do it. If you have selected too little, you can apply the paintbrush a second time. If you selected too much of the image, you can switch to *Mark background* under *Interactive refinement* in the tool settings. You can then erase the sections that you don't want.

When you are satisfied with the result, confirm your selection with the *Enter* key. The blue mask disappears and a selection is made around the lion.

The result is pretty good, but altogether the contour is a bit too jagged and there are still selection islands visible on the lion. In the next section, I will show you how you can subsequently improve the result, and how to make the preselections with "conventional" select tools.

Figure 3.101
A rough preselection of the lion

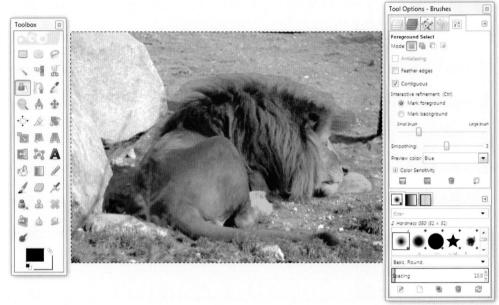

Figure 3.102
Selecting the foreground: the lion overpainted

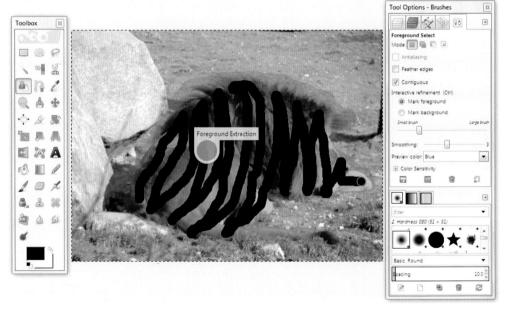

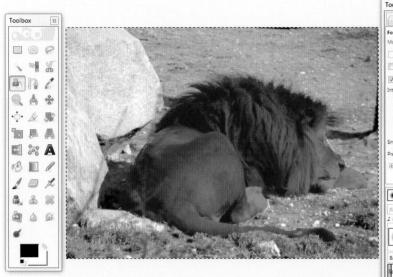

Figure 3.103
The extracted lion.
Now you can make corrections with the tool's paintbrush.

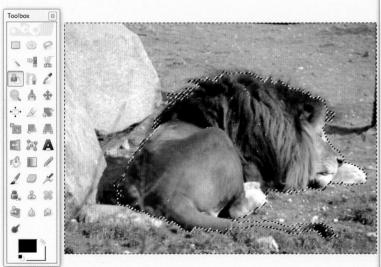

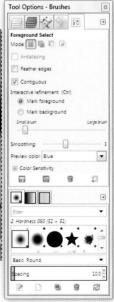

Figure 3.104
The selection of the lion still can be improved.

3.15.4 Drawing a Mask Using Paint Tools with Various Edge Attributes

So far you have learned about select tools that are based either on shapes (Rectangle, Ellipse, Lasso, and Paths) or on the basis of color and color-connected areas (Fuzzy Select tool [Magic Wand], Select by Color tool). The edges of the selection are initially "sharp-edged" and this affects the entire selection equally.

However, GIMP provides two ways to either draw or edit masks with paint tools. Selections made by determining edge attributes with the paint tools or the *Eraser* tool can have a variety of edges, depending on the brush pointer that is applied.

With the first method, you can paint a mask on a separate layer using different paint tools and the color black. Then, create a selection with the Layer > Transparency > Alpha to Selection menu item.

In the second method, you must first create a rough selection of the image object or section with the "usual" select tools. Then you switch by clicking the *Toggle Quick Mask* button at the bottom left of the image window, switching to *masking mode*. You can then use the *Paintbrush* and *Eraser* tools (with a variety of tool pointers) to add, delete, or edit masking sections. When you are finished working, you switch back into selection mode by clicking *Toggle Quick Mask* again.

We will have a look at the second method, using an example.

Extracting an Image Object with the Help of a Painted Mask

The first steps in the process consist of preparing the selection with the "regular" select tools as far as possible. It makes sense to first select the background around the actual object you want to extract. For example, if the background has similar, contiguous colors that are easy to select with one of the tools for selecting by color, it might be easier to select the background of the image object first. This also reproduces the contours of the object, from the outside. The selection can then be inverted. Then you'll have selected your image object, exactly as you wanted it.

The Procedure

- Open the *lion.png* image from the *SampleImages* folder on the DVD.
- Perform an automatic color level adjustment (Colors > Levels > Auto) to further offset the background from the lion.
- Select tool. I suggest starting at the top of the lion. Your aim is to get a good selection of the lion's scraggly mane. You won't be able to select individual strands of hair, but at least you will get a good grasp of the mane's contour. Select the Add to the current selection mode in the Fuzzy Select tool's settings. You might need to reduce the Threshold setting to about 15 so that not too much is selected at once. You will certainly have to click several times, and you will have holes in your selection. Some of the selection might go over the surface of the lion. Most importantly, take care that the lion's mane gets a good contour. Selecting hair strands is among the most difficult tasks when selecting objects.
- Use the Free Select tool to roughly enclose the background around the lion. Enclose the yet to be selected "islands" in the selection by drawing around them. To be able to add these "islands" to the existing selection created with the Fuzzy Select tool, choose the Add to the current selection mode in the tool's options.
- When the area around the lion is roughly selected, invert the selection
 with the Select > Invert menu item. Previously the area around the lion
 was selected; now the lion himself is selected.

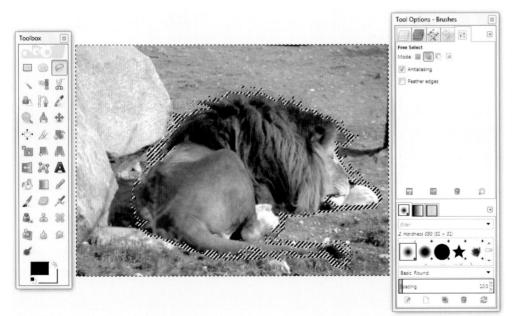

Figure 3.105
The selection around the lion was created by using first the Fuzzy Select tool for the contour and then the Free Select tool for selecting the background area completely.

NOTE

Selected areas in an image appear in natural colors. A red translucent layer, the mask, covers the other areas in the image. These sections of the image are exempt from further editing; however, the mask itself can still be edited (e.g., using the paint tools).

You can see where the mask reaches into the surface of the lion's body, and you can erase any unwanted areas with the *Paintbrush* tool set to white. You can also see the holes and inexact contours around the lion, which you can fill by painting the appropriate parts of the mask black. The mask can be edited further with the paint tools as well as with the select tools and color fillings.

The next step is to switch into masking mode. It shows you the covered area of the image (the red "protection layer"). Now you can start editing the mask with selection and paint tools. Switch to masking mode by either clicking the *Toggle Quick Mask* button in the lower-left corner of the image window or choosing *Select > Toggle Quick Mask*.

- Select the entire image with the Select > All command and use the Free Select tool in subtractive mode to subtract the rough outline of the lion from the selection.
- Fill the remaining selection with black using the Edit > Fill with FG Color command.
- Fill the mask with the paintbrush with a 50% hard brush pointer using various sizes. You can also scale the brush over the tool settings to fill the holes around the lion and, if needed, trace the contour of the lion. Using the same brush pointers and the *Eraser* tool, remove the red masked areas within the lion. This works when the foreground color is set to black and the background color is white. You can enlarge the image with the *Zoom* tool. Take your time and work accurately.
- Check your result by switching back and forth between the masking and the selection modes with Toggle Quick Mask.
- If you are satisfied with the result, switch to selection mode.
- Use the Clone tool to remove the grass and twigs still showing on the lion's back and tail. The twigs on the lion's back can also be removed by using the Healing tool.

The lion is selected and the unwanted elements have been removed. In the next steps, you are going to extract the lion.

Figure 3.106
The selection was switched to masking mode using Toggle
Quick Mask.

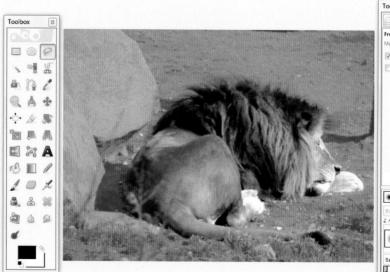

- Give your selection a soft edge of about 5 px using the Select > Feather menu item.
- Now copy the lion with the selection onto your clipboard (*Edit* > *Copy*).
- Open the fenice_base.xcf image.
- Add your lion from the clipboard by pasting it into a new layer (Edit > Paste). Then select New Layer in the Layers dialog and name the new layer lion.
- Next, flip the lion horizontally with the Flip tool from the Toolbox. This
 way, the lighting is correct if you placed the moon as it is in the example.
 Select the tool, and then activate the lion layer in the Layers dialog. Click
 on the image with the tool to flip the image. An alternative method
 would be to choose Flip Horizontally from the Image > Transform or Layer
 > Transform menu.
- Position the lion in the image. If you'd like, you can also scale the lion.
- You can adjust the brightness of the lion to the surrounding environment by choosing Colors > Brightness-Contrast. You may have to repeat this process.

The lion is now inserted in the image. Next you'll create a drop shadow of the lion on the background. Proceed as follows:

• Choose *Layer to Image Size* from the *Layer* menu. The layer is resized to the size of the image. This step ensures that only the lion section, rather than all other image sections, will be filled.

• NOTE

On masks, black serves to add to the mask surface. Applying white color on masks would cause an effect corresponding to erasing on the mask. You can also use the *Eraser* tool to delete a section of the mask if the background color is set to white.

Figure 3.107
Touching up the contours of the mask with the *Paintbrush* tool

[4]

-

20

2

Figure 3.108
The finished mask

Figure 3.109
The finished selection.
Toggle Quick Mask
was used to switch
from mask mode to
selection mode. The
unwanted details
in the image were
removed with the
Clone and Healing
tools. The lion can
now be copied
with the Edit > Copy
command.

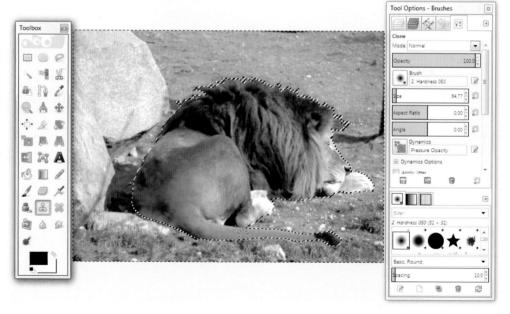

- Next, select the area around the lion with the Fuzzy Select tool. This
 selects an area of the current layer on the basis of color similarity. Make
 sure the Select transparent areas box is checked. Sample merged should
 be deselected.
- Invert your selection (*Select > Invert*). Give your selection a soft feathering of about 25 px (*Select > Feather*).
- Create a new blank layer in the Layers dialog. Give it name (such as lion's shadow) and make it the active layer.
- Fill the selection with the Edit > Fill with FG Color menu item.
- Choose Select > None to remove the selection.
- Position the layer in the Layers dialog underneath the layer with the lion.
- Then scale the *lion's shadow* layer from top to bottom and slightly to the right.
- If necessary, position the layer with the shadow in the image window
 with the *Move* tool. Your shadow should be to the right and below the
 lion according to the direction of the light source. Be sure to select *Move*the active layer in the tool settings.
- If you like, you can correct the shadow with the *Eraser* and *Paintbrush* tools. You can also add some shadow under the lion's paw.
- Set the opacity in the *Layers* dialog to about 70%.
- Save your image.

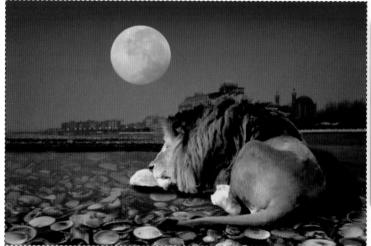

Figure 3.110
Fenice.xcf with the
Venetian lion and the
Layers dialog on the
right

3.16 GIMP and HDR

3.16.1 What Is HDR?

In the last few years, photographs with amazing detail, fantastic color, and incredible luminosity have appeared in magazines and on image sharing websites. These photographs have been created with what is known as high dynamic range (HDR) photography.

HDR images have a greater dynamic range of luminance in comparison to normal digital and analog photographs. Common digital cameras have a dynamic range of 1000:1. HDR images have a dynamic range that is above 10,000:1, enabling images to be rendered with dark shades and bright surfaces and more detail. This can't be done with just one single exposure.

Indeed, to create an HDR image, you need to capture at least two photographs of the same subject before merging them into one image. The process of making a sequence of exposures is called exposure bracketing. The photographer takes one picture at a given exposure, another picture one or two stops brighter, and a third picture one or two stops darker. The overexposed picture shows more details in the dark areas, the underexposed in the bright ones. All three exposures are put together with the help of special software to create one detailed image with a greater range of luminance.

Many professional cameras and advanced amateur cameras can automatically take a bracketed series of pictures. Have a look in the menu of your camera and see if there is an **exposure bracketing** menu item. This function lets you take a series of three to nine pictures, each taken within a range of + or - 3 stops either way with half-stop increments. For a normal landscape photograph taken in normal light conditions, you would actually need up to nine such pictures due to the contrast range (the dynamic range of daylight is 100,000:1).

It should be obvious that HDR photography can only work when you're using a stable tripod. Certainly it can be problematic assembling the images, such as with landscape photography, when trees are moving in the wind. The focal length, ISO values, and white balance should remain unchanged while you're using exposure bracketing.

Original file formats for HDR images and special HDR cameras are HDR, TIFF with 32-bit-LogLuv encoding, and OpenEXR. These file formats have a color depth of 16 bits per channel. Bracketed exposure series can be saved in 8-bit color depth, which is the JPEG file format. However, all sources point out that the quality is far better when the images are saved in a camera's own RAW image format with 16-bit color depth.

Let's have a look at the hardware prerequisites before we start on the necessary software.

There are special high dynamic range imaging (HDRI) cameras available, but so far they are bound to and controlled by a computer. They are also very expensive. Nevertheless, there are many digital cameras (compact as well as digital single-lens reflex, or DSLR) that have an automatic exposure bracketing mode.

As to the rendering and output on the monitor and printer, neither the graphics board nor the monitor or printer is able to render the original dynamic range of HDR images. These are known as low dynamic range (LDR) media. Another step is necessary to maintain the richness in detail of an HDR image when you're rendering and editing it. The image needs to undergo a process called tone mapping. The overall contrast of the image is reduced to facilitate the display on devices with lower dynamic range. The photographer, therefore, chooses which details can be kept. A loss of detail is to be expected, yet the resulting file retains the desired brightness and color contrasts and can be viewed and saved. The actual result is an LDR image, which is developed after and from the original HDR image with the help of the tone mapping technique. The HDR image itself can be saved separately.

3.16.2 HDR Software

To create HDR images, you need special software. GIMP can be used to edit only images with 8 bits per channel, but there is a Python plug-in that will create HDR images with the help of GIMP. More information and the download can be found at registry.gimp.org/node/24310.

The open-source community offers **CinePaint** (previously known as FilmGIMP or Glasgow) for Linux, Windows, and Mac OS for creating HDR images (as mentioned in section 1.5.1). You can find the download at www.cinepaint.org.

The current version of CinePaint is available only for Linux and Mac OS (www.sourceforge.net/projects/cinepaint/files/CinePaint). So far, there is only an older version (0.17) available for Windows.

For Linux and Mac OS, you can also use **Krita** (also mentioned in section 1.5.1). The program supports the **OpenEXR** file format. It can be used to edit HDR images in this format. However, the programmers are still working on a range of functions for creating HDR images. Information on **Krita** can be found at: krita.org/download.

A developer version of Krita for Windows can be downloaded from: www.kogmbh.com/download.html.

Adobe Photoshop, of course, is a very well-known commercial software that includes the functionality for creating HDR images. Starting at version CS2, it can merge pictures into HDR images. You can also use **Photomatix Pro** from HDRsoft (www.hdrsoft.com). Both programs offer free trial versions. Be aware, though, that the Adobe Photoshop download is about 980 MB and Photomatix is about 13 MB.

Freeware Programs for Creating HDR Images

There are two programs for creating HDR images that are open source or freeware.

The first is the open source **Luminance HDR**. It can be downloaded from qtpfsgui.sourceforge.net. It is available for Linux, Mac OS X, and Windows. The programs manual is at sourceforge.net/apps/mediawiki/qtpfsgui/index.php?title=Luminance_HDR_Manual.

The second program, named **FDRTools Basic**, is available as freeware for both Windows and Mac OS X. Here is the download address for FDRTools: www.fdrtools.com/downloads_e.php. In my experience, this program offers, even in the basic version, better editing capabilities and results than most professional image editing software for HDR. The developer's website at www.fdrtools.com/front_e.php offers downloadable HTML and PDF quick start guides and detailed step-by-step manuals.

Both programs, Luminance HDR and FDRTools Basic, have grown to such complexity that it would take a book for each alone to describe and show all their features. The manuals for both are already written and freely available, so I leave it to those who are interested to find information there.

3.16.3 Cross-Fading Part 3—Merging Images into One Pseudo HDR

GIMP doesn't offer any features for merging HDR images. However, I would like to show you a method of achieving similar results. It is generally used to cross-fade parts of images, letting you merge images, but you can also merge bracketed photos with this method. In addition, you can create the basis for a pseudo HDR image by editing one preferably underexposed image with the tonality corrections in three different variations, saving each variant as a new image.

The Procedure

In the SampleImages folder on the DVD you will find a subfolder named Exposure Bracketing. In it are the RAW files DSCN0832.NEF, DSCN0833.NEF, and DSCN0834.NEF. For this example, I have developed these RAW images as median.png, details-shadows.png, and details-highlights.png, which are also included in the subfolder. The first image was taken with normal exposure settings and serves as the reference image. The second image is overexposed. This is required so that darker parts of the image appear lighter. The last image is underexposed, but it shows the most details in the brighter parts of the picture.

If you like to do the RAW development yourself, the first step is to open, develop, and save the RAW images, one after another, with either UFRaw or RawTherapee. During the developing, each image should be prepared so that its brightness is optimized. Remember when editing that you have to keep the intended result in mind. You can define the brightness and color combination according to your taste. In the first image, the brightness should be optimized in the median areas (temple); in the second image, the dark areas (foreground), and in the third image, the bright areas (sky). After developing the images, you should save them as median.png, details-shadows.png, and details-highlights. png in a folder on your computer. Select a color depth of 8 bits/channel when saving. The steps for this exercise are described in detail in section 5.1, and you can refer to them for information on RAW development. For now, I will only describe how the images are supposed to look after developing. If you want to skip the RAW development, you'll find the prepared images median. png, details-shadows.png, and details-highlights.png in the same subfolder as the RAW files.

Figures 3.111, 3.112, 3.113
The developed images with optimized areas of brightness: shadow details, medians, highlight details

The first step to produce the pseudo HDR image is to merge the pictures into one file. First, open the *details-shadows.png* image. It provides the base for the stack of layers. Next, open the *median.png* image. As described in section 3.6.5 and section 3.14.3, drag the image from the *Layers* dialog of *median.png* and drop it into the open image window of *details-shadows.png*.

Now you have it as a layer in the *Layers* dialog of this image. Follow the same procedure for *details-highlights.png*. As a result, you should have three layers for the image *details-shadows.png*. You can close the other opened images now.

In the next step, you should take care that the layers are aligned in the image window. They shouldn't be askew. Adjusting the images according to the image content isn't necessary. The photos are all the same size and have been taken with a tripod, so there shouldn't be anything out of registration. It would be different if the pictures were taken freehand. In that case, the image layers would have to be aligned on top of each other as in the method described in section 3.14.3. The overlying layers would have to be made invisible, and in the other layer, the opacity would have to be reduced to 40% in order to align the undermost layer. After the first two layers were aligned, the opacity of those layers would be raised to 100% again and the procedure would be repeated with the next layer.

Label your layers in the image as *details-highlights, median,* and *details-shadows*. All three layers are missing an alpha channel, so add one for each using the context menu (right-click on the layer and choose *Add Alpha Channel*). Then save your image as *ldrcollage.xcf* in the XCF file format.

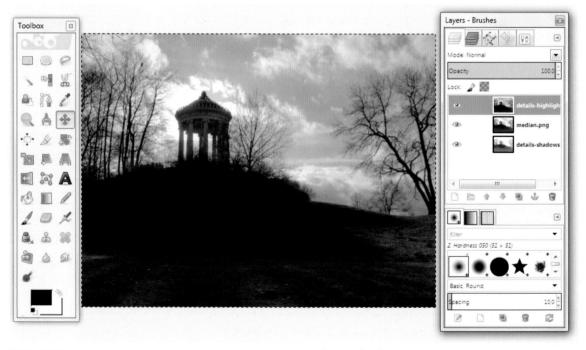

Figure 3.114
The image in XCF file format and the corresponding layers in the dock

3.16.4 A Short Introduction to Working with Layer Masks

To proceed from here, you must first consider what you want to take from which layer. Starting with the topmost layer, *details-highlights*, you will need the sky and the branches of the trees. You can delete or, better, hide the rest of the layer, using a layer mask. Next, you will need the temple and the tree trunks from the second layer. Since the sky remains in the topmost layer, you won't need to worry about the sky on the *median* layer. It will be covered by the sky of the topmost layer. You want to see the hill in the foreground as well as the bushes from the *details-shadows* layer, so you will have to hide these areas in the *details-highlights* and in the *median* layer.

You can paint a mask for the areas in the image that should remain. First select *Quick Mask* and then switch to selection mode to delete the remaining contents of the layer. This is the procedure that was used in section 3.15.4. Permanently modifying or otherwise deleting visual content is called destructive editing. There is nothing objectionable about working this way; just remember that you should only work with a copy of the image. The original should always be kept as a backup. This way, you can fall back on it in case you make an irreparable mistake or you want to do something else with the same image.

The nondestructive editing capabilities in GIMP are to be increased with the further implementation of the GEGL library. The intention is to have a function similar to the adjustment layers in Adobe Photoshop, where tonality correction (Colors > Levels) is not applied directly to the pixels. Rather, some sort of mask is placed over the layer and subsequent changes are applied later.

Edit Layer Attributes... New Layer... New from Visible New Layer Group... Lavers - Brushes Duplicate Layer Anchor Layer 80 Merge Down Mode: Norma Delete Layer 100 Opacity + Layer Boundary Size... 2 99 Layer to Image Size Scale Layer... 0 Add Layer Mask... Apply Layer Mask 100 B Delete Layer Mask Show Layer Mask Edit Layer Mask Disable Layer Mask Mask to Selection Add Alpha Channel Remove Alpha Channel Alpha to Selection Merge Visible Layers... Flatten Image Basic Round Spacing Layer Effects 2 8 2

Figure 3.115
The layer's context menu in the *Layers* dialog with an active layer mask

Image contents don't have to be irrevocably deleted. **Layer masks** provide a non-destructive way to edit image content and to help avoid permanently changing or even damaging your image. Actually, the initial approach is the same. Select the desired image or layer that is to remain visible with a selection method of your choice. Edit the selection with any of the previously learned masking and selection techniques. However, instead of inverting the selection and deleting remaining image content, apply the selection to the layer that needs editing with a layer mask. The layer mask hides the unselected image contents. This illustrates an essential nondestructive editing method.

Create the selection on the layer that appears to be best for selecting the preferred image areas. Then select the layer in the *Layers* dialog that you want

• NOTE

The individual layers are named after the level of brightness that is to be depicted on an area in the image. The topmost layer is called *details-highlights* even though it is the darkest image. That's because the brightest areas are depicted here with the most contrast. Inversely, the bottommost layer is called *details-shadows* even though it is the brightest image. The dark image sections are the best exposed and feature the contrast you want.

to edit. Right-click and choose *Add Layer Mask*. Then in the dialog box that opens, choose *Selection* from the *Initialize Layer Mask to* menu. The layer mask will be applied and the selection will be masked.

The result is that you will see a second image that shows the layer mask as a black-and-white channel next to the preview image of the layer. Initially, it displays a white border, which means that the layer mask is active.

The following entries in the context menu of the dock also become active:

- Apply Layer Mask: Deletes the masked image content and subsequently deletes the layer mask.
- Delete Layer Mask: Deletes only the layer mask. The previously masked image area will be displayed again.
- Show Layer Mask: Displays the layer mask as a black-and-white image in the image window.
- Edit Layer Mask: Allows the editing of the layer mask with the paint tools. The masks are painted in black; white deletes the mask or adds areas that should be visible.
- **Disable Layer Mask**: Allows you to disable the layer mask without deleting it. The masked section can be seen again.
- Mask to Selection: Converts the layer mask into a selection.

The Procedure

Begin with creating a selection of the area that is to be left as it is. In the topmost layer, *details-highlights*, it is the sky. You can easily select the sky by using the *Select by Color* tool. Do this work on the bottommost layer, *details-shadows*, where the depiction of the sky is the brightest. Here the tool will find the area of the sky most easily.

Then switch to the *Quick Mask* mode (*Select > Toggle Quick Mask* or click the button at the bottom left of the image window). Edit the selection in this mode with paint tools until only the areas that are to be hidden are masked. You don't have to work precisely at pixel level. Your image in the mode should look like figure 3.114.

After the mask has been completed, switch back into the selection mode. Apply a soft edge with a 4-pixel radius (*Select > Feather*). Now set the top layer, *details-highlights*, to active. As previously described, insert a layer mask by right-clicking and choosing *Add Layer Mask*, and then choose *Selection* from the *Initialize Layer Mask* to menu.

Depending on the accuracy of the mask, the areas of the hill and the temple will be hidden on this layer. The underlying layer will shine through. If you are not satisfied with the mask, you can edit it. Right-click in the active layer and choose *Show Layer Mask* or *Edit Layer Mask*. A simpler way to achieve the same result is to click on the layer mask thumbnail in the

Layers dialog. You can now edit the mask with a black brush to add masked areas or a white brush to remove masked areas and reveal more image detail.

Before you edit the mask, you can delete the selection. Once you have created a layer mask from it, you can recover the selection from the layer mask (*Layer* > *Mask* > *Mask* to *Selection*). You can also leave the selection as it is to apply it to the second layer, *median*.

Make the *details-highlights* layer invisible by clicking the eye icon in the *Layers* dialog. Set the *median* layer to active. As with the *details-highlights* layer, we are now going to create a new layer mask. Delete the selection before proceeding so that it doesn't limit the image areas on which you can work.

The new layer mask on the *median* layer currently masks the temple, the trees, the bushes, and the outline of the hill, so we have to edit it accordingly. To do this, activate the layer mask by clicking its thumbnail in the *Layers* dialog.

Now you are going to "erase" the areas of the mask that should stay visible in the median layer. This will be the trees and the temple. To erase here means to paint white directly into the image. Your image should look like the example in figure 3.117.

• NOTE

Selections are independent from the layer on which they are created. In the example image, you select the sky on the *details-shadows* layer because you can easily select it with the *Fuzzy Select* tool. The selection is then applied on the *details-highlights* layer.

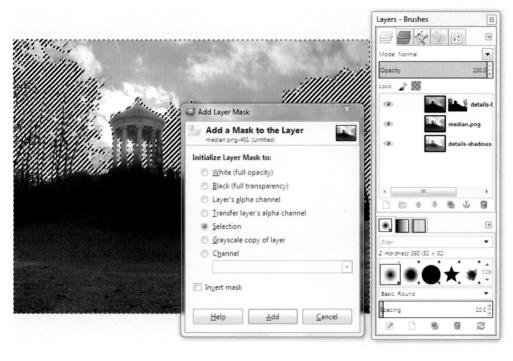

Figure 3.116
In the Layers dialog
on the right, you can
see a second preview
image next to the
details-highlights
layer. This indicates
the layer mask, which
you can activate and
edit with the black
and white paint tools.

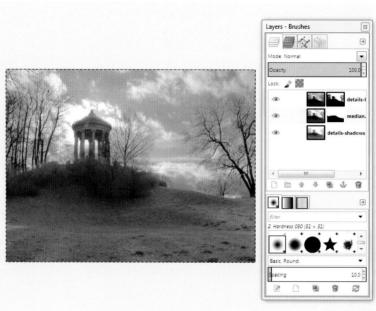

Figure 3.117The mask for the second layer, *median*

The next step is to switch back into selection mode. You won't have to hide the selection this time. It still has a soft edge from your previous work. Now right-click and choose *Add Layer Mask* from the context menu of the *Layers* dialog. Basically, that's it. You just need to delete the selection. Don't forget to save the image.

If you see the need to make any corrections, you can always use a black brush to adjust an active layer mask.

This way of working is very labor intensive, with the finished image being rather satisfactory, but producing "real" HDR images using dedicated software can also be quite hard work. Basically, it depends on the right choice of program settings. You will have to experiment a little. This can take some time as the processing of the finished HDR image takes time, depending on the file size.

Compare the three images (figures 3.118, 3.119, and 3.120): the reference image that hasn't been edited since it was taken, the "real" HDR image that was created with FDRTools Basic, and the LDR image that was created with GIMP by blending the images.

Here are some links to interesting tutorials and examples suggesting similar methods of editing bracketed images in GIMP:

A good tutorial:

 www.gimp.org/tutorials/Blending_ Exposures

And two further tutorials:

- www.luminous-landscape.com/tutorials/ digital-blending.shtml
- en.wikibooks.org/wiki/The_GIMP/ Blending_Exposures

On the topic of HDR formats:

www.linux.com/articles/50413

And an article on HDRI in Wikipedia:

 en.wikipedia.org/wiki/High_Dynamic_ Range_Image

So this ends the important chapter about layers, selections, masks, and layer masks. Until now, we have been working with color photos and images, but GIMP is not restricted to that; GIMP also offers ways to work on black-and-white images. These processes, including ways to colorize an image, will be discussed in the next chapter.

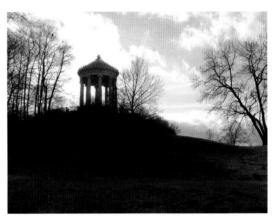

Figure 3.118The reference JPEG image from the camera

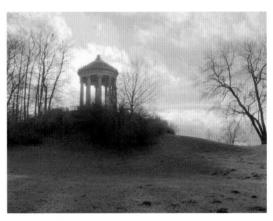

Figure 3.119
The HDR image created with FDRTools

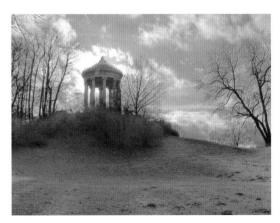

Figure 3.120The pseudo HDR image created with GIMP

aturally, GIMP is not limited to color representation. You can also edit black-and-white photos with GIMP. In addition to the functions and tools used when editing color images, the program offers specific tools for modifying black-and-white images. What's more, you can use GIMP to colorize old black-and-white photos.

4.1 Converting Color Images Partly or Entirely into Grayscale Images

4.1.1 Hints for Working in Grayscale and RGB Modes

By default, GIMP works in **RGB color mode**, which supports the representation of approximately 16.7 million colors. This color mode supports all the tools available for manipulating colors, or color values, in an image.

In addition, GIMP offers a **grayscale mode**. Grayscale corresponds to a limited color palette of 256 gray levels, including black and white. All tools used to manipulate brightness and contrast levels are supported in grayscale mode. However, tools, filters, and options that directly manipulate colors are not supported in the grayscale mode. This means that certain tasks, such as the subsequent coloring of black-and-white images, must be performed in RGB color mode. So what is the point of working in grayscale mode?

There are occasions when the conversion of color images into grayscale images may be required for the following reasons:

- Image design
- There are technical concerns, such as the need to create a selection on a high-contrast original document (although this task can be accomplished to some extent by using a copied layer of an image).
- Optimization of an image's file size. Grayscale images have a maximum number of 256 colors, so changing to grayscale mode will reduce the file size because less color information has to be saved.

Nevertheless, you'll normally be editing black-and-white photos in RGB mode. When an image is scanned as a grayscale image, it will initially be available in grayscale mode. Even so, it is recommended that you convert the image into RGB mode prior to editing it.

4.1.2 Removing Color Partly or Entirely

You can easily convert a color image into a black-and-white photo by opening it in RGB mode and selecting the *Grayscale* menu option. To toggle between *RGB* and *Grayscale*, just choose *Image > Mode* in the image window. When an image is converted, the color information is discarded and you're left with the brightness values of the image in the form of gray levels. If you convert the image back to RGB mode, the gray levels will remain, but you will be able to colorize the image again.

When you open an image in RGB color mode, there are two other methods to partly or entirely remove color from it. These methods modify color saturation, making it unnecessary to change the color mode:

- Select the Colors > Hue-Saturation menu item (for individual layers in the Layers dialog) and move the corresponding slider to the left to reduce the color saturation of an image to pure gray levels, or as desired.
- Select the *Colors > Desaturate* menu item to discard the color information of an image or a layer and reduce it to just brightness values (grayscale).

Have a closer look at the *Desaturate* function. It offers three options to determine the grayscale value: *Lightness, Luminosity,* and *Average*. The idea was perhaps to create a notion of variations in exposure and developing time. The differences are not very obvious, as you can see in figures 4.2 through 4.4.

Figure 4.2Grayscale using *Lightness*

Figure 4.3
Grayscale using *Luminosity*

Figure 4.1 The *Desaturate* window

Figure 4.4Grayscale using *Average*

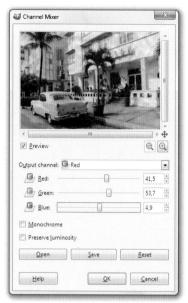

Figure 4.5
Modifications of color in an image using the *Channel Mixer*. The role of the default setting in the *Output* channel is secondary; the sliders are more important for changing the color components of your image.

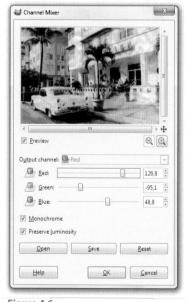

Figure 4.6
Developing a grayscale image using the Channel Mixer

4.1.3 Developing Black-and-White Images with the Channel Mixer

The results of turning images black and white with the *Desaturate* function are not very satisfying. It doesn't give us much influence over the way an image is altered. You can only change the brightness and contrast after desaturating the image by using the tonality correction (*Levels*) and gradation curves (*Curves*) or the *Brightness-Contrast* function. These can be found in the *Colors* menu.

More options for black-and-white development can be found in the **Channel Mixer** (Colors > Components > Channel Mixer). This function lets you adjust the amount, or rather the brightness, of the red, blue, and green color components in an image. Therefore, you are able to desaturate the image as long as the image is available in RGB mode. The Channel Mixer also allows you to reposition the color channels to modify and shift the colors of your image (figure 4.5).

As soon as you check the *Monochrome* box, the image is turned into a grayscale image. At the same time, the *Output channel* is deactivated. In essence, you can only adjust the brightness of the grayscale image. Thus, the function does not enable you to develop the image any further.

When you select *Preserve luminosity*, things start getting interesting. This setting causes a modification of the color components in brightness and contrast in the individual color channels. Therefore, many variations in developing the image from color to grayscale are possible.

The performance of the function is somewhat different with grayscale photographs, even those taken in RGB mode. When you select a color channel in the *Output channel*, you can colorize the image with the red, green, and blue sliders. By selecting another color c hannel, you can further modify your image. Once you select the *Monochrome* check box, the *Output channel* is deactivated and the image is turned into a grayscale image again. By using the three color sliders, you can then adjust the brightness of your grayscale image. However, selecting *Preserve luminosity* will not modify your image any further. On the contrary, the image will be reset to grayscale without any further option for editing.

Figures 4.7 and 4.8 exemplify the differences in black-and-white development when using the *Desaturate* function and the *Channel Mixer*.

Figure 4.7Developing a blackand-white image using the *Desaturate* function

Figure 4.8
Developing a blackand-white image
using the Channel
Mixer

CHAPTER 4

4.1.4 The Graphical Library GEGL—Developing Black-and-White Images with GEGL Operations

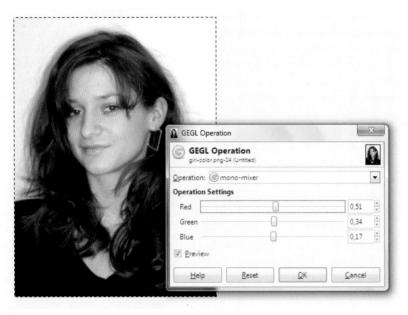

Figure 4.9
Developing black-and-white images using the GEGL Operation mono-mixer

The Generic Graphics Library (GEGL) has been integrated into GIMP with version 2.8. There are plans for it to be expanded to allow image editing with more than 8 bits per channel in GIMP. Some of the computation functions based on GEGL are already assembled in the GEGL Operation window, which can be found by choosing Tools > GEGL Operation.

In the *Operation* drop-down menu, there are three operations especially for converting images into black and white.

The *mono-mixer* is a simple function that automatically converts a color image into a grayscale image. It also offers the possibility of changing the brightness and contrast by modifying the RGB color values. With a little experience, the *mono-mixer* offers rather sophisticated results.

The results of the *contrast-curve* operation, on the other hand, are quite puzzling. This function also converts color images to grayscale, but modifying the values with the sliders doesn't change the rendering of the image, and what can be adjusted with the sliders remains a question. The help function doesn't have any information either.

A far more sophisticated option is the *c2g* (*color-to-gray*) operation. *c2g* is an interesting tool that, along with providing exposure and contrast control, can also simulate effects such as film grain and print hardness. Figures 4.10 and 4.11 show some of its more creative options.

It should be noted that this setting is very demanding on your hardware, as are most of the GEGL operations. My computer, an AMD Athlon 64 X2 Dual-Core 3800 + machine with 2 GB of RAM, regularly took a while to process a 2-megapixel image. Nevertheless, the application is stable; you do get a result after quite some time. It is, however, difficult to handle; every adjustment leads the program to compute without giving the option to adjust the value. You can be specific by entering the values on the right side, and to some degree, you can edit low-resolution images with few pixels in real time. Overall, *c2g* is an interesting tool that, in addition to controlling brightness and contrast, can simulate film grain.

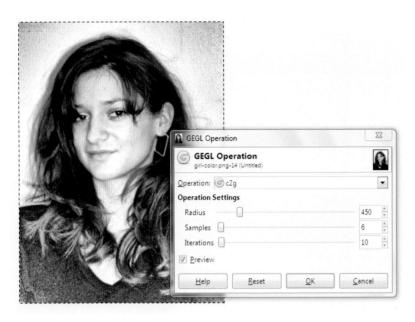

Figure 4.10The possible results of black-and-white developing range from the coarse grain and high contrast produced by the settings shown here ...

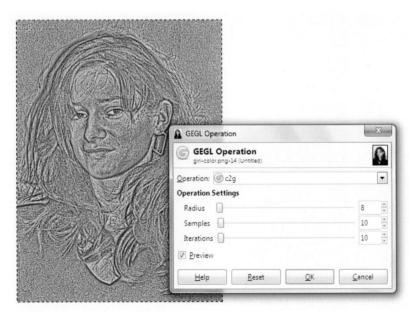

Figure 4.11 ... to the graphic relief effect.

4.1.5 Converting Images into Black-and-White Graphics

It is possible to convert images into pure black-and-white graphics with GIMP. *Threshold* is the quick-and-dirty function used to convert images. It can be found in the *Colors* menu. It doesn't matter if the image is a color or grayscale image—Threshold converts it into a pure black-and-white graphical image. The only option for adjustment is the triangular slide control under the histogram, marking the point where the contrast is inverted. The GEGL operation *threshold* (*Tools* > *GEGL Operation*) works in a similar fashion.

Threshold achieves this effect of black-and-white inversion by means of a value from which the inversion from black-and-white occurs, but without considering gradients and shades of brightness.

You obtain a pure black-and-white graphic image by inverting the image with the **Indexed Colors** mode (*Image > Mode > Indexed*), using *Color dithering*. The result is a simulation of brightness gradients through dithering (in this case, diffusion of black pixels to achieve grayscale simulation). In the *Convert Image to Indexed Colors* window, first select the option *Use black-and-white* (1-bit) palette. Then select *Dithering*, thereby selecting the method of diffusion. Experiment a little. The results depend on how much contrast the image had beforehand and which dithering you choose. If you want to dye your image afterward, you must adjust the RGB mode (*Image > Mode*) again. Otherwise, further editing will not be possible.

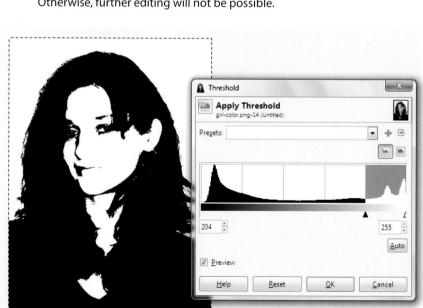

Figure 4.12Using the *Threshold* function to achieve graphic effects in black and white

► TIP: If you export an image to GIF, you first have to convert it to indexed mode (with a maximum of 256 colors) using the *Image > Mode: Indexed* command.

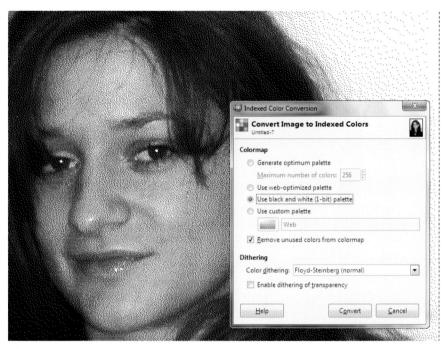

Figure 4.13Using dithering in the *Indexed Colors* function to achieve a grayscale simulation

4.1.6 Graphic Effects with Gray Levels—an Example

An effective way of enhancing an object that will be the main focus within an image is to reduce colors surrounding the main object. There are several effective approaches.

For example, in the photo with the vintage '50s car in Miami, you could highlight the car by making the houses in the background appear in black and white.

Here's how:

- Open your optimized image, miami-impro.tif or miami-impro.xcf.
- Save the image as miami-car.tif.
- Create a path along the car's contour (or simply use the *Free Selection* tool to create a selection).
- Click the Path to Selection button in the Paths dialog to create a selection from the path.

- Access the Select > Feather menu item to define a soft edge of 5 pixels for the selection.
- Choose *Colors* > *Hue-Saturation* and adjust the *Hue* slider to colorize the car in a color of your choice.

Next, make the background grayscale:

- Invert the selection.
- Choose *Colors > Hue-Saturation* and adjust the *Saturation* slider to remove the colors from the surrounding area of the image.
- Access the Filters > Blur > Gaussian Blur menu item to heavily blur the selected image area with a radius of about 20 pixels.
- Choose Select > None to remove the selection.
- Save your image.

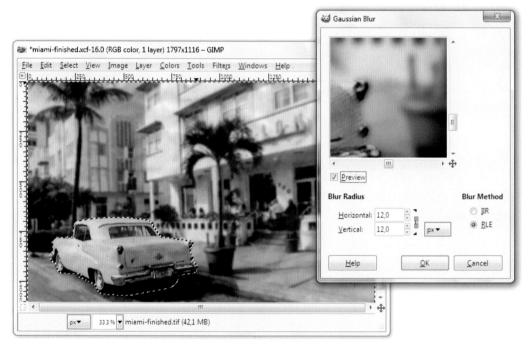

Figure 4.14
The image with the selection from the path around the car before the last editing step. With the Gaussian Blur filter, a focused object seems to have a more three-dimensional appearance in front of a blurred background. The picture has more depth.

4.1.7 Partial Desaturation

You can achieve similar effects without making a selection. If an image is dominated by a single color or is composed of clearly differentiated color areas, you can partially desaturate them by using the *Colors > Hue-Saturation* command. This converts nearly all the colors to grayscale values.

Using our *miami-impro.png* image as an example, navigate to the *Colors* > *Hue-Saturation* dialog and move the *Saturation* slider all the way to the left for each color zone (except yellow and green) in turn. If you want to enhance the overall effect of the image, you can increase yellow saturation and lightness for all six colors.

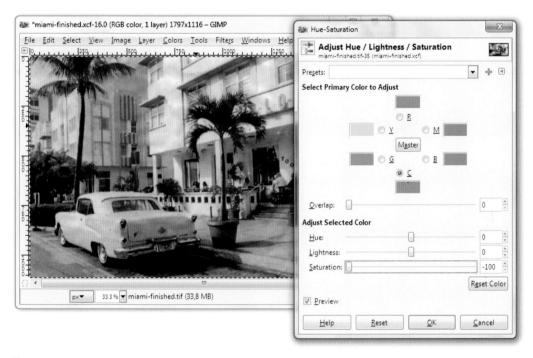

Figure 4.15
All colors except yellow and green have been desaturated

4.1.8 Infrared Effects

At the beginning of the 20th century, film manufacturers developed stock that was sensitive to light wavelengths shorter than those in the visible spectrum, thus giving birth to the art of infrared photography. Infrared techniques can be useful for:

- Military night reconnaissance and security applications. Infrared photography makes it possible to shoot using invisible light sources.
- Observation in low-visibility situations (e.g., in fog or with clouds). Infrared light is dispersed much less than visible light in such situations, making visible otherwise invisible details in objects and their surroundings.
- Nature shoots and plant observation. In addition to leaves, various other types of objects reflect infrared light differently from visible light, which has helped to make infrared techniques popular among hobby photographers.

Color infrared film first became available in the mid-1960s. The color shifts it produced perfectly caught the mood of the times and made it possible to produce psychedelic-looking images with conventional photo gear.

The sensors built into digital cameras are sensitive to infrared light too, although camera manufacturers often use built-in anti-infrared filters to enhance the visible light capture capabilities of their products. Removing a camera's infrared filter is possible, but complicated and expensive.

GIMP has functionality built in that enables you to simulate infrared photo effects, which can be effective when used to alter the look of landscapes, plants and trees.

From The GIMP Plugin Registry, registry.gimp.org/node/114, you can download the requisite Script-Fu (Eg-InfraredSimulation.scm) which is also located in the *Programme/GIMP /GIMP SKRIPT-FUS ALL OS* folder on the DVD provided with this book.

Once installed, the Script-Fu can be run by navigating to *Filters* > *EG* > *Infrared Simulation*. The script's window includes options for adjusting the opacity of the automatically created layers (*IR Layer Opacity*) and layer contrast (*Contrast/Glow Layer Opacity*). The *Blur Image* option enables you to reduce the grain effect in the resulting layers. Once you have confirmed your settings by clicking *OK*, the script automatically creates a series of black-and-white layers, which you can then fine-tune individually to achieve the desired effect. In our example, I reduced the opacity of the uppermost layer to about 60% in order to ensure that the shadow on the surface of the water remained visible.

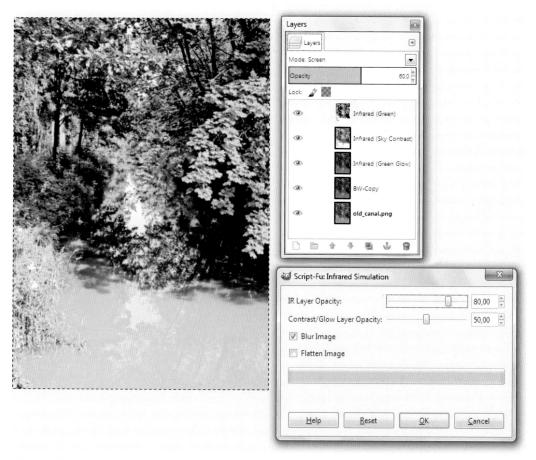

Figure 4.16
The Infrared Simulation Script-Fu window, the image window, and the Layers dialog showing the layers created automatically by the script

It is also possible to create infrared effects manually. Either open an image of your own, or use the *oldcanal.png* file in the *Samplelmages* folder on the DVD, and follow these steps:

- Duplicate the background layer using the Duplicate Layer command in the Layers dialog context menu and give the new layer a name like blackand-white.
- Now activate the new layer and convert it to black and white, either using
 the Colors > Desaturate command, or if you want to make the settings
 yourself, using Colors > Components > Channel Mixer, as described in
 section 4.1.3. I used the Desaturate tool with its Average option to give
 myself a comparatively dark source image. This provided me with better
 contrast for the next steps.

• NOTE

From the GIMP Plugin Registry, registry.gimp.org/node/8108, you can download the *elsamuko-grain.* scm Script-Fu (also included on our DVD). This script simulates the grain effects produced by high-ISO analog film.

- Duplicate the desaturated black-and-white layer again, rename it something like blur, and set the layer's blending mode to Screen. This mode is the clue to the whole procedure, as it significantly brightens the overlay we are creating. If the effect isn't bright enough, simply re-duplicate the layer as many times as necessary; the blending mode you have just set will remain in force for each new duplicated layer. If necessary, you can darken the overall effect by reducing opacity in the uppermost layer.
- Open the Gaussian Blur (Filters > Blur > Gaussian Blur) and set a Radius value between 5 and 20 pixels, depending on how much you want to brighten the highlights. If your highlights still appear too bleached out, you can rectify the situation by using either the Levels or the Curves tool from the Colors menu, or simply by adjusting the opacity of the layer you are working on.
- Infrared photos usually display strong grain, and you can simulate this
 effect too, by using the Filters > Noise > Pick tool with the Randomize
 option activated. You can then amplify the effect by selecting higher
 Random Seed and Repeat values.

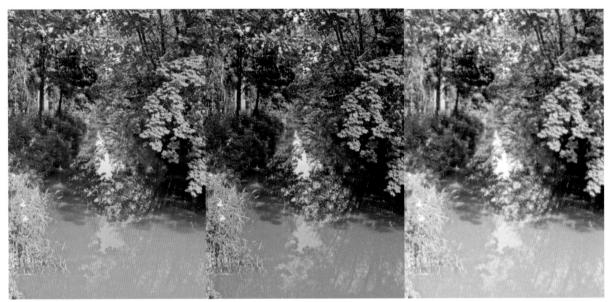

Figure 4.17
The original color image is shown on the left. The grayscale conversion is shown in the center and the infrared simulation is on the right.

Applying an infrared simulation to a color image severely reduces the intensity of the colors and produces a virtually monochrome image. To experiment, open an image of your own or use the *redpoppy.png* file from the *SampleImages* folder on the DVD.

- First, duplicate the background layer (see the previous section for details on how) and call the new layer *Inverted*.
- Use the Colors > Invert command to invert the colors in your new layer and set its blending mode to Color.
- Now duplicate the background layer a second time and place the new layer above the *Inverse* layer. Set the blending mode for this layer (redpoppy.png copy) to Screen.

And that's all there is to it. If you wish, you can add grain by using the technique described in the previous section. You can also enhance the color shifts in either or both of the new layers by using the *Hue-Saturation* tool from the *Colors* menu. Now is always a great time to start experimenting!

Figure 4.18Original image and simulated infrared effects

4.2 Touching Up Black-and-White Images—Levels, Brightness, Contrast

As mentioned in the introduction to this chapter, you can edit the brightness, contrast, and (color) values of images both in RGB mode and in grayscale mode.

Modifying black-and-white images is similar to modifying color images. For that reason, this section will be limited to providing an overview of the functions available in both modes and how they differ. The functions discussed below can be found in the *Colors* menu and in the *Tools* > *Color Tools* menu.

Function	RGB Mode	Grayscale Mode
Color Balance	Yes	RGB levels only
Hue-Saturation	Yes	RGB levels only
Colorize	Yes	RGB levels only
Brightness-Contrast	Yes	Yes
Threshold	Yes	Yes
Levels (tonality correction)	Yes	Yes, but main channel only (no individual color channels)
Curves (gradation curves)	Yes	Yes, but main channel only (no individual color channels)
Posterize	Yes	Yes
Desaturate	Yes	RGB levels only
Invert	Yes	Yes
Value Invert	Yes	RGB levels only
Auto:		
Equalize	Yes	Yes
White Balance	Yes	RGB levels only
Color Enhance	Yes	RGB levels only
Stretch HSV	Yes	RGB levels only
Normalize	Yes	Yes
Stretch Contrast	Yes	Yes

As shown in the preceding table, it is both possible and recommended to edit black-and-white or grayscale images in RGB mode. Keep in mind that many editing features can be utilized only in RGB mode.

Converting an image to grayscale mode is recommended in the following cases:

- To simplify the image
- When the options and tools available in grayscale mode are sufficient for your editing needs
- To produce certain graphic effects
- · When pure gray levels are sufficient for image rendering
- To optimize the file size of a black-and-white representation (grayscale reduces the number of colors to 256 values)

4.3 Extracting Hair from the Background—a Tricky Task

Masking out and extracting a portrait of a woman with cascading hair or a tree with a maze of branches are difficult tasks even for professional digital editors. You'll have more success if there is a good degree of contrast between objects you wish to extract and the background. You can tackle this task relatively simply by using the *Fuzzy Select* tool (*Magic Wand*) and the *Select by Color* tool. However, you may have to prepare your image first by increasing the contrast. Finding the correct tool (and tool options) requires practice. The next sections will give you insight into the use of these selection tools.

4.3.1 The Threshold Function

The *Threshold* function (*Colors > Threshold*) converts a color or grayscale image into a pure black-and-white graphic. More specifically, it represents areas with a brightness value of less than 50% as black and those with a brightness value of more than or equal to 50% as white.

If the *Preview* control is checked, you will see a pure black-and-white representation in the image window. The *Threshold Range* input boxes allow

you to manually select the upper and lower intensity ranges, i.e., the black-white distribution in the image. You can either enter numerical values in the intended fields or move the sliders beneath the histogram curve with the left mouse button.

The Linear and Logarithmic buttons in the upper-right corner can be clicked to determine how the histogram will be represented in the visual graph.

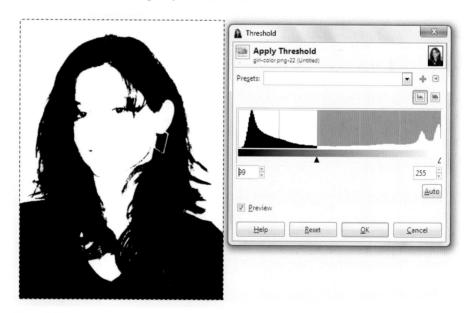

Figure 4.19
The Threshold window with a preview of the results in the image window

4.3.2 Using the Threshold Function to Extract Hair—the Task

The following example focuses on increasing existing contrast levels so you can achieve the most exact selection of fine structures possible. Though this solution is not perfect, it may serve as a brainteaser for developing your own solutions.

First you'll want to choose *Colors > Threshold* so that you can create a layer mask with high contrast. You can now use this layer to create a selection and then a layer mask. The retouched layer mask is then used to create a new selection that we will use to edit the original image.

The prerequisite is that the selected image object should stand out to some extent from the rest of the image.

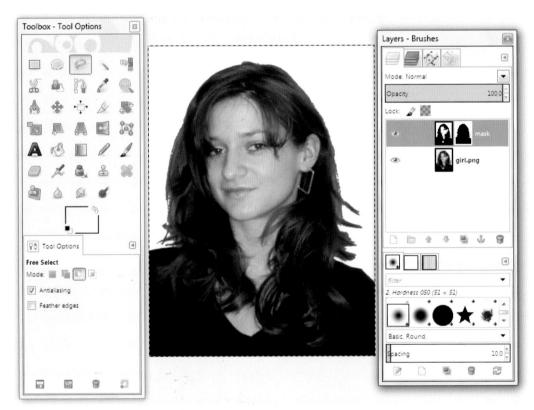

Figure 4.20
The layer mask is being created; it will serve to extract the hair.

- Open the girl.png image in the SampleImages folder on the DVD.
- Save it as extractinghair.xcf in the layer-enabled XCF format.
- Select the *Image* > *Mode* menu item and make sure the image is in *RGB* mode; if it isn't, change the mode.
- Duplicate the *background* layer (in the *Layers* dialog). Name the new layer *mask*.
- Make sure the layer has an alpha channel (transparency attributes) by right-clicking in the *Layers* dialog and choosing *Add Alpha Channel* from the context menu, thus adding transparency to the layer.
- Use the *Threshold* function (*Color > Threshold*) to set the *layer* mask so
 that the hair strands are fully displayed—there should be an adequate
 amount contrast between the hair and the background of the image. Be
 aware that a solitary hair is extremely difficult to capture, even with this
 wonderful tool. A value of 100 is a good starting point for producing welldefined results that capture most strands of hair.
- When the hair is defined by contrast, choose Select > By Color (or use the Select by Color tool) to create a selection on the white image areas on the layer mask. So that you can work as accurately as possible, the selection should be sharp edged, that is, with no feathering.

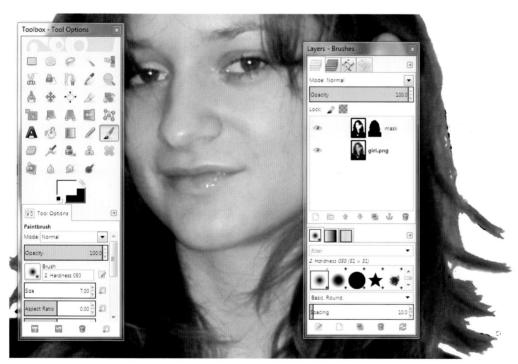

Figure 4.21
Touched-up hair strands on the mask with the background layer visible from underneath

• NOTE

Remember, black color paints a mask and white erases it. You can also use gray tones to paint semi-transparent transitions into a mask. The darker the gray tone, the greater the level of transparency.

- Create a selection across the image areas surrounded by the hair contour using subtractive selection mode. In this case, that would be the face and neck.
- Select the Add Layer Mask command from the context menu in the layer mask in the Layers dialog, and select the Initialize Layer Mask to: Selection option in the dialog that follows.
- The outline of the head and the hair should now be selected and visible.
 You can now delete the selection using the Select > None command.
- You can now retouch the mask. Select the *Paintbrush* tool with a thin, soft brush pointer (depending on the image and its resolution; in this case, use 5 to 9 pixels). Touch up the incomplete hair strands in the example image. You may have to paint or erase the mask to correct the hair jutting out.
- Duplicate the *background* layer *girl.png* and name it something like *hair-extracted*.
- Add an alpha channel to the duplicated layer (right-click in the *Layers* dialog and choose *Add Alpha Channel*).
- Click the eye icon in the *Layers* dialog to make the *background* layer invisible.
- Create a new selection on the *layer* mask using the *Mask to Selection* command from the context menu.
- Select a soft edge or feathering of approximately 7 pixels, and reduce the selection slightly. (Select > Feather and set to 7 pixels; Select > Shrink and set to 2 pixels. Remember that these values are contingent on the image and your intent.)
- Make the hair-extracted layer the active layer.
- Use the selection to delete the background from the hair-extracted layer (Edit > Clear).
- Remove the selection (*Select > None*).

A background with a different color would be useful in order to check the result of your selection. The background will make the subject of your photograph stand out better.

- In the Layers dialog, create a new layer named background-colored.
- Use a color of your choice to fill the new layer.
- Use the tonality correction (*Colors* > *Levels* and adjust the *mid-tones* slider) to make the *hair-extracted* layer a little lighter. The hair should appear shinier, and more strands will become visible.
- Use a large, soft eraser with reduced opacity to touch up transitions on the *hair-extracted* layer, if necessary.
- Save your image.

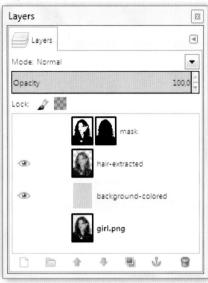

Figure 4.22
The finished image with layers

4.3.3 Using Channels to Extract an Object from the Background

What Are Channels?

As you know from section 1.3.3, the colors you see on your monitor are created from three primary colors—red, green, and blue. The same holds true for images in RGB mode: All colors in an image are mixed from these three primary colors. In accordance with this, each image in RGB mode consists of three channels: red, green, and blue. Each channel is a chromatic component representing the share of the corresponding color in the image.

You have been introduced to channels in the previous exercises, even though they may have been in the user interface of a tool or function dialog, such as when correcting the color-cast image in the *Levels* dialog (tonality correction), where only the red channel was edited.

Decomposing and Composing the Channels of an Image

You can use the *Colors > Components > Decompose* menu item to decompose an image into its color channels. These channels can be accessed for editing purposes in the *Channels* dialog. For example, you can target a single color and apply a filter or option to it. The *Colors > Components > Compose* menu item will combine the channels again, so you can go back to working with the full RGB channel in the image. However, when the image is decomposing, it will be converted into a grayscale image (*Image > Grayscale*). When it's composed, the image will be set to true color again. This is true for decomposing and composing when applying *Color model: RGB* in the settings of the *Decompose* dialog. When decomposing to CMYK, I've encountered some problems. The channels decomposed, but the resulting layers were too dark. When the image was composed again as RGB, the colors were shifted and the image was too bright.

Consider the following information about color channels:

- The red channel offers the best contrast.
- The green channel has the highest sharpness.
- The blue channel shows the image quality the most.

The Channels Dialog

You can find the *Channels* dialog in the *Layers, Channels* and *Paths* dock, or you can find it via the *Windows* > *Dockable Dialogs* menu item in the image window.

The *Channels* dialog works similarly to the *Layers* dialog. However, the *Channels* dialog is separated into two parts. The upper part shows the red, green, and blue color channels. In addition, there is an alpha channel to control transparency attributes. When you're working on grayscale images or images with indexed colors, a single channel called *Indexed*, which usually won't possess an alpha channel, will replace the three main channels. These channels cannot be renamed.

You can make each of these channels visible or invisible by clicking the eye icon. The visible colors in your image will be modified accordingly.

By clicking a channel in the *Channels* dialog, you can set it to active (blue) or inactive (white). When you edit an image, your changes affect only the active channels. Setting a channel to inactive will ensure that any subsequent changes to the image will not affect the channel.

In contrast to the *Layers* dialog, in which only one layer can be active at a time, the *Channels* dialog allows you to activate more than one channel at a time. In fact, when you work on an image in full RGB view, *all* color channels must be active.

An image can have more channels than the three color channels. These additional channels are displayed in the bottom half of the *Channels* dialog.

You can create these channels yourself. For example, you can select the *Select > Save to Channel* menu item to create a channel from a selection. This channel will then be listed in the *Channels* dialog as a custom channel (blackwhite image) and saved together with the image (but only when saving in the XCF format!). You can then load your custom channel whenever you want and create a new selection from it.

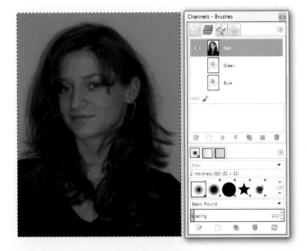

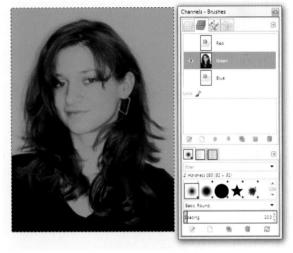

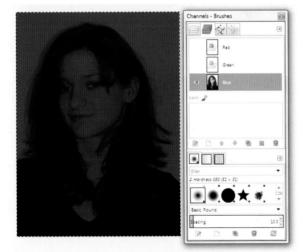

Figures 4.23, 4.24, and 4.25
The single color channels (of a black-and-white image in RGB mode) and their representations in the image window. An RGB representation does not necessarily mean that the image is colorized.

Notice that the channels of the three primary colors cannot be renamed. Duplicated channels and selections saved to channels can be custom named. In addition, the position of the three main channels cannot be moved within the dialog; custom channels can be repositioned in the layer stack.

Clicking the familiar chain icon in the *Layers* dialog can also link custom channels. Any changes you make will then affect all the linked channels.

The *Channels* dialog has its own context menu, which can be accessed by a right mouse click on a channel. The options in the right-click menu let you duplicate channels and quickly create a selection from a channel.

As long as there are only the three standard channels in an image, some of the functions will be grayed out; this means they are not available. The same holds true for the buttons at the bottom of the dialog, which offer the most important functions from the context menu.

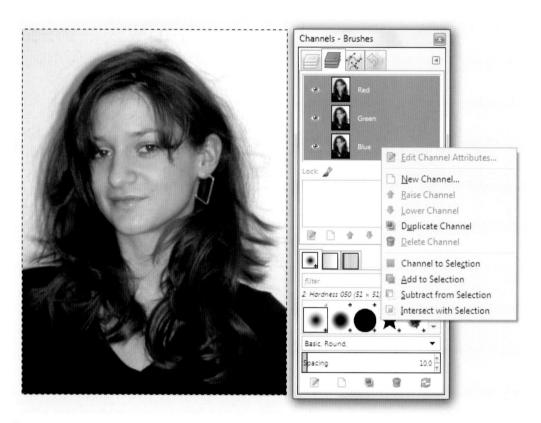

Figure 4.26All three color channels are initially set to active in an image (including black-and-white images in RGB mode). The context menu (right-click) is also displayed.

Using Channels to Extract Hair from the Background—the Procedure

You will basically perform the following tasks in this exercise: Use the *Colors* > *Components* > *Decompose* menu item to create a layer mask from the channel that has the best contrast values (the red channel). The layer mask (i.e., the channel) can then be touched up using a layer mask and painting tools and exported into another image. Using this layer, in turn, you can create a selection and use it to edit the actual image to emphasize and increase the contrast (see section 4.3.2 for more details).

- Open the *girl-color.png* image in the *SampleImages* folder on the DVD.
- Open the context menu in the *Layers* dialog and add an alpha channel to the image so that you can use transparency.
- Call the layer portrait.
- Save the image by a new name, such as *portrait.xcf*, in the XCF format in your practice folder.
- To keep the color channels available as layers for further editing, select the Colors > Components > Decompose menu item and click OK. A copy named portrait-RGB.xcf with the red, green, and blue channels as image layers will be created.

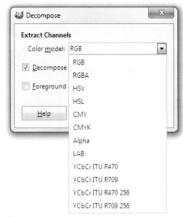

Figure 4.27The *Decompose* window. This tool can also be used to produce CMYK print colors.

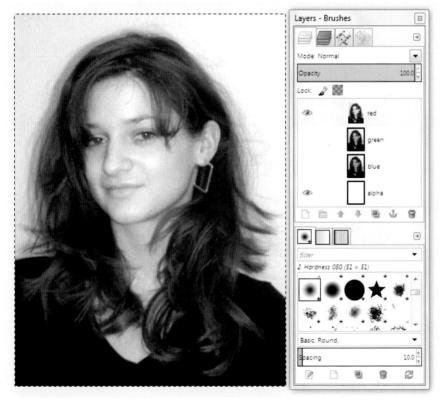

Figure 4.28The original *portrait.xcf* and *portrait-RGB.xcf*, the copy with the channels as image layers, which were created automatically

• NOTE

The CMYK option in the Decompose window can be used to separate the color channels as color extracts for prepress (CMYK color model for four-color printing).

• NOTE

To preserve edge detail, you can retouch a layer mask with a medium gray tone instead of black or white. This approach enables you to use the mask to produce a selection with soft edges.

In the *Decompose* window, you can select the color model in which the channels are to be created as layers. Select either RGB or RGBA (RGB with alpha channel), and check the *Decompose to layers* box. Without this selection, every single color channel will be depicted in a separate window.

- In the new portrait-RGB.xcf image, right-click to open the context menu and duplicate the red layer in the Layers dialog. Call the new layer red-copy.
- Make the new *red-copy* layer the only active layer and make it visible. Red provides the best contrast values.
- Use the tonality correction (*Colors > Levels*) to increase the contrast. The better you work here, the easier it is to do the following steps. The method does not work with such sharp contrasts as the method using the *Threshold* function does. The aim is to bring out the fine details. Access the *Select > By Color* menu item or use the corresponding selection tool to create a selection in the image window. Select the black image areas and experiment with the *Threshold* value in the tool to see which setting produces the best results. Setting the value to 80 produced a satisfactory look in my image. You may have to delete the selection and start fresh until you find the appropriate value.
- At the moment, all black areas are selected. However, we want to select
 just the hair, so we have to use the Free Select (Lasso) tool to subtract the
 currently selected areas of the face from the overall selection.
- Invert the selection to select the remaining white areas (i.e., the actual background).

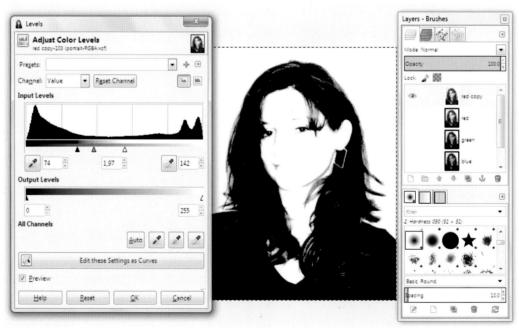

Figure 4.29
The tonality correction is used to increase the light-dark contrast on the image layer. It is preferably optimized toward black and white.

- Use the context menu to create a new layer mask on the Rot-Maske layer
 of the selection and then delete the selection.
- Open or load the *portrait.xcf* image.
- Export the *red-copy* layer from the *Layers* dialog of *portrait-RGB.xcf* by dragging and dropping it onto the *portrait.xcf* image.
- Now you'll find the red-copy layer in the Layers dialog of the portrait.xcf image. Set it to active. Right-click on this layer to open the context menu and select the Mask to Selection option.
- If you haven't used a gray brush to soften the layer mask's transitions, give
 your selection a soft edge (approximately 5 px) using the Select > Feather
 command.
- Hide the red-copy layer by clicking the eye icon next to it in the Layers dialog.
- Now create a mask on the portrait layer from the selection you have just made using the Select > Invert command. This hides the background.
- Set the portrait layer to active.
- Using the *Layers* dialog context menu, activate the layer mask made from the selection.
- You can now delete the selection (Select > None) and the red-copy layer.
- If necessary, retouch the new layer mask.
- Create a new layer called Background.
- Fill this layer with a color or feathering of your choice.
- · Save your image.

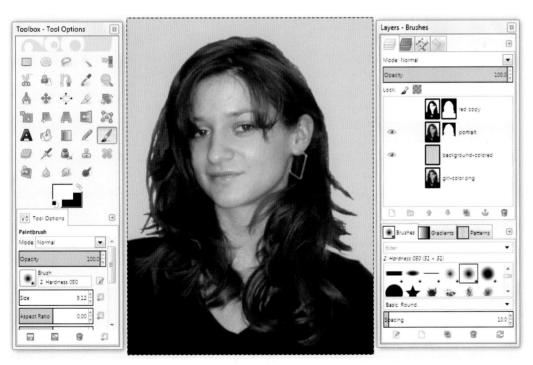

Figure 4.30
The finished image *portrait.xcf*. With the method shown you can work out the fine details.

• NOTE

The functions for colorizing black-and-white images work only in RGB mode.

4.4 Coloring Grayscale Images

Any black-and-white photo that can be opened in RGB mode can be colorized. There are several options available to apply a color tone to an image. You can even use sepia, which will make your image look like an old photograph. Various tools can be used to assign several different colors to an image or to colorize or brighten specific image areas.

You will probably use these options frequently when working with scanned images. If you scan an image with a color depth of 24 bits rather than in grayscale mode, the image will take on a slight color cast, corresponding to the color space of your scanner. In such a case, or when simply editing a color image in grayscale, it's best to use the *Colors > Desaturate* menu item to convert an image into pure gray levels. There is no need to convert it to grayscale mode.

However, if you scanned an image in grayscale mode (with a color depth of 8 bits total), you'll need to convert it to RGB in order to edit it. Just choose *Image > Mode > RGB* and make the change.

Please use the *garden.png* image from the *SampleImages* folder on the DVD for the following exercise.

4.4.1 Using the Colorize Function to Color an Image

You can use the *Colorize* tool to transform an ordinary black-and-white image into an old-fashioned-looking one by adding sepia brown, cobalt blue, or chrome yellow. This process colorizes image areas according to levels of brightness. You can access this function by selecting *Colors > Colorize* in the image window.

Here's how to perform the process:

- Move the Hue slider to select the desired coloration.
- Move the *Saturation* slider to the right to increase saturation, or to the left to reduce color and thereby add more gray values.
- Move the Lightness slider to make the image lighter or darker.

The Preview option (in the image window) should be checked.

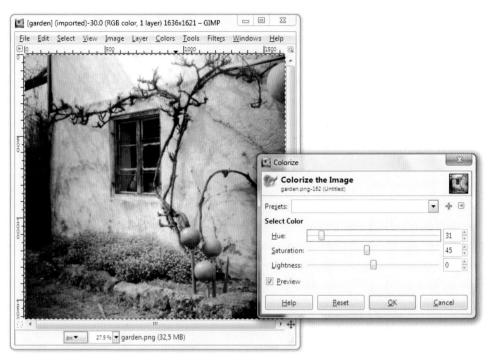

Figure 4.31
The Colorize options with a preview in the image window

4.4.2 Using the Levels Function to Color an Image

You have already learned how to use the *Levels* tool (tonality correction) to increase the contrast and color values of an image. And you know that this function allows you to edit the color channels separately (as discussed in section 2.4.3). Similarly, the brightness and contrast can be edited in grayscale images by selecting *Value* in the *Channel* drop-down menu (at the top left of the *Levels* window). Moreover, in black-and-white photos, you can add (or mix) optional colors by modifying a single color channel (e.g., blue) or by editing all three channels (red, green, and blue) at once.

Start by selecting a color channel from the *Channel* drop-down menu (top left) to edit the color range. In this exercise, you will edit the *blue* channel. Move the mid-tones slider—the middle triangle on the grayscale bar underneath the histogram curve—to select the desired color. If you want to use a mixed color for your image, select a second color channel and repeat the process.

This process will colorize all image areas equally according to their brightness. Using the sliders for shadows (the black triangle under the histogram curve) and highlights (the white triangle), you can adjust the brightness and contrast of the image.

Depending on the values you select, altering the *Output* Levels can even produce a two-colored toning effect.

If you want to use the same option settings to colorize several images, simply click the small arrow button at the top right of the *Levels* dialog window. In the menu that opens, choose *Export Settings to File* to save your settings in a folder. To apply the settings to other images, just click the arrow button again and choose *Import Settings from File*.

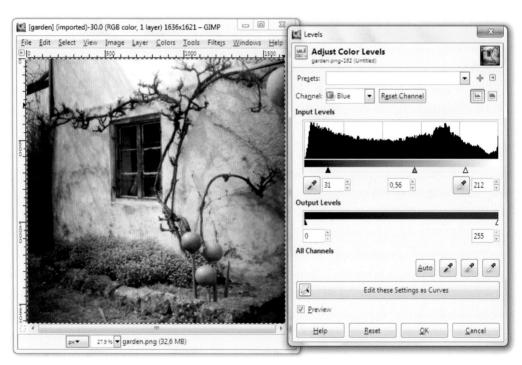

Figure 4.32
The *Levels* options dialog, with the options for saving settings

4.4.3 Using the Curves Function to Color an Image with One or More Colors

You should already be familiar with *Curves* (or gradation curves) as you used this function in section 2.3.2 to edit the brightness, contrast, and color values of the sample image. You can find this function by selecting *Colors > Curves*.

To colorize black-and-white photos with the *Curves* function, you must click the *Channel* button to select a color channel. In contrast to the *Levels* function, which is similar, the *Curves* function allows you to colorize an image with several colors; the number of colors available will depend on the quantity of points created on the color curve as well as how those points were moved on the histogram curve.

Since you can reuse the settings for each color channel, you can use one, two, three, or more colors to colorize images. This enables you to create sophisticated image designs comparable to solarized color images.

You can also save the Curves settings and reload them for future use.

The *Channel* default setting is *Value*. *Red*, *Green* and *Blue* color channels are edited at the same time when you use the *Value* setting. In the example image, I used the *Blue* color channel to tone the image blue first.

Next, I placed more points on the curve and moved them around in order to achieve a multicolor coloration of the image. You may repeat this process for each color channel. Whether it will result in mixed colors or a new color shade in the image depends on the shape of the curves.

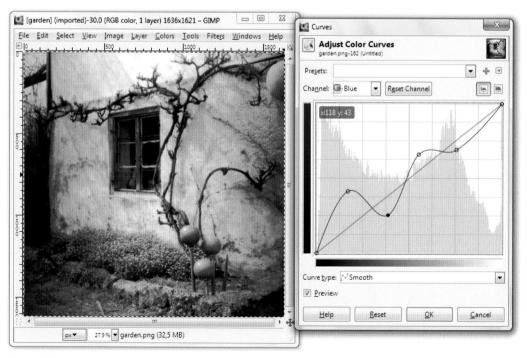

Figure 4.33The settings of the color curve for the *Blue* channel

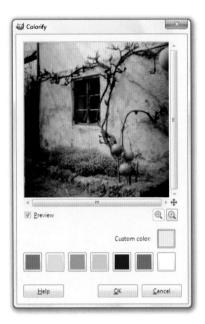

Figure 4.34
The Colors > Colorify dialog and its
Color Picker

4.4.4 Using the Colorify Filter to Color an Image

Filters provide yet another method of colorizing images. You can find the *Colorify* filter in the *Colors* menu.

When you select this filter, a dialog appears that allows you to select a color from a prepared color palette. You can also click the *Custom Color* button to select a color. Clicking this button will display the familiar *Color Picker*, where you can select any color. Using the *Color Picker* or the *Colorify* dialog, click *OK* to accept the color you selected.

The image will be uniformly colored with the chosen color. However, you may notice that the colorization looks rather like a color overlay, much more so than it would if you used the *Colors > Colorize* method. Be aware that additional options, such as saturation and brightness, are not available for this function.

There is only one way to modify the brightness, and that is by using the *Colors > Brightness-Contrast* or *Colors > Levels* menu item. You can also correct the lightness and saturation by using the *Colors > Hue-Saturation* menu item.

4.4.5 Using Transparency and the Colorize Filter to Color Image Areas by Brightness

The *Colors > Colorize* function can also be used to colorize image areas according to brightness and overlay them on the original black-and-white photos using transparencies. This results in an image with both gray levels and colored areas.

The Procedure

- Duplicate the background layer of your black-and-white photo in the *Layers* dialog. This layer must be active.
- Access the Colors > Color to Alpha menu item and select the From: [white]
 to Alpha option. Click OK to accept your changes. The white or bright
 image areas turn transparent.
- Access the Colors > Invert menu item to invert the dark areas of the layer.
 In the next editing step, the bright image areas will appear much more intense than the dark areas, while the transparent areas will remain transparent.
- Select *Colors > Colorize* and proceed to color the bright image areas of the layer with the color of your choice.
- Finally, use the *Dodge* mode on the active layer in the *Layers* dialog. This produces a natural-looking overlay with the original background layer.

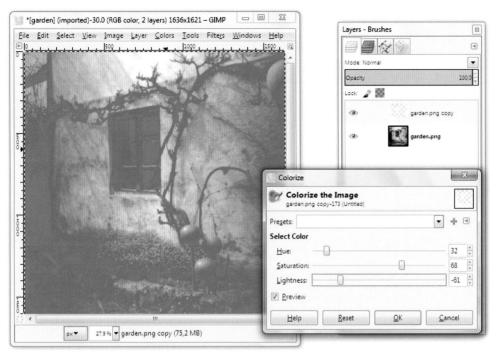

Figure 4.35
The coloring effect of the overlaying layer is opaque when the layer is set to *Normal* mode

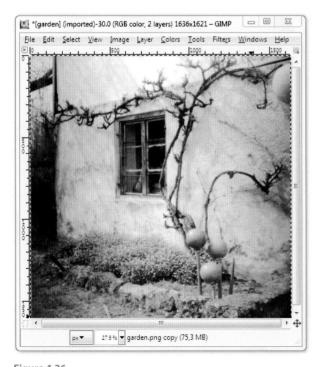

Figure 4.36
The layer mode of the overlaying layer creates a partial coloring effect (*Dodge* mode, in this case).

4.4.6 Using the Sample Colorize Function to Color an Image

You can find yet other methods of coloring an image in the *Colors* menu. These filters are found in the image window under *Colors* > *Map*. They allow you to colorize black-and-white images by mapping a color source image or a gradient from foreground and background colors. Therefore, you must first select both colors with the *Color Picker* from the *Toolbox*. We will have a closer look at the *Sample Colorize* filter. However, the *Gradient Map* filter (gradient from the foreground and background colors) and, especially, the *Alien Map* filter offer some rather special effects.

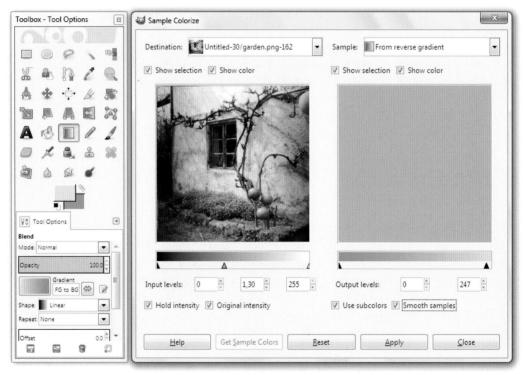

Figure 4.37The *Sample Colorize* window, with the setting *Hold intensity*. With the filter you can color an image with a preset gradient from the foreground and background colors.

When you select the *Sample Colorize* filter, a window opens that is split in two sections. On the left below *Destination* you can see what the image looks like after editing, and on the right below *Sample* the image is in the original condition. When you're editing, even color images are turned into black-and-white images and can only be colorized with one color or a gradient.

First, select the *Get Sample Colors* button to colorize an image. Then determine the sample color by double-clicking on the corresponding area in the image under *Destination*. You will have to determine which area

corresponds to the area with the desired color in the example image. The image in the preview is then colorized with the assigned color.

Below the two images are two color gradients with triangles that can be used as sliders. The sliders can be used as in tonality correction. By moving the sliders, you can control the brightness, tonality, and intensity of the colors. If the color transition is too severe, check the *Use subcolors* and *Smooth samples* boxes.

When you are satisfied with the result, click on the *Apply* button. The applied filter settings will be transferred to the image.

In my experience, the program is rather unstable; it crashed several times when I worked with a sample color from the image. However, colorizing with a gradient worked reliably. As previously mentioned, the program works with a gradient selected from the foreground and background colors.

To create the gradient select the entry in the menu at the top right, next to *Sample*. You may also select a reverse gradient. The image will be colorized instantaneously by the gradient. The gradient can be modified with the sliders below the preview images.

You might get interesting results if you deactivate the *Hold intensity* box. The intensity of the colors will be the same as the preselected colors in the gradient at first. But now you have the freedom to change all settings. Go ahead and experiment with it.

4.4.7 Using Filters to Color and Bleach an Image

Some filters offer the option to subsequently color your image, give it a vintage feel, or make it look like a pencil drawing or a grayscale photocopy.

An interesting filter for coloring images can be found under *Filters > Decor* > *Old Photo*. This filter can create more than just a sepia-toned photo. If desired, the image can be altered with various effects to give it an aged look. However, this Script-Fu doesn't have a preview function. You just have to experiment with this filter: activate or deactivate the various check boxes and see the outcome.

Another filter that is installed in GIMP turns both color and black-and-white pictures into grayscale images with great effects. This application is the *Photocopy* filter (*Filters* > *Artistic* > *Photocopy*), and it is very easy to use.

You can also find a wonderful filter called *Pencil drawing from photo* that turns pictures (both black-and-white and color), as the name implies, into pencil drawings. But note that this Script-Fu works only on images in RGB mode. You can find it on the website GIMP Plugin Registry (registry.gimp.org/node/11108) or on this book's DVD under *Script-Fus*. Once you have installed it and refreshed your Script-Fus (*Filters* > *Script-Fu* > *Refresh Scripts*), the script will appear in its own *ATG* menu in the image window.

Another grayscale filter that creates images that look like drawings is *Quick sketch* (registry.gimp.org/node/5921). This is also a so-called Script-Fu. Once installed, you can find it in the *Script-Fu* menu under *Artistic > Quick sketch*. The filter's window contains a slider for adjusting its effect. Try it!

• NOTE

When installed, the *Pencil drawing* from photo and *Quick sketch* Script-Fus create new entries in the menu of the image window.

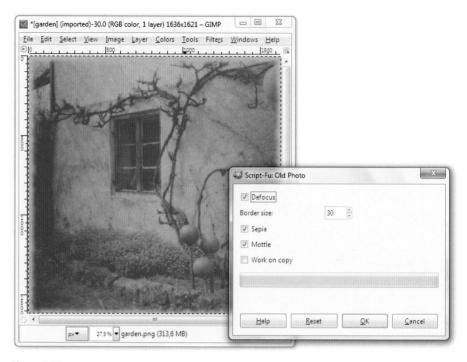

Figure 4.38
The Old Photo dialog and an aged-looking picture as a result of using the filter

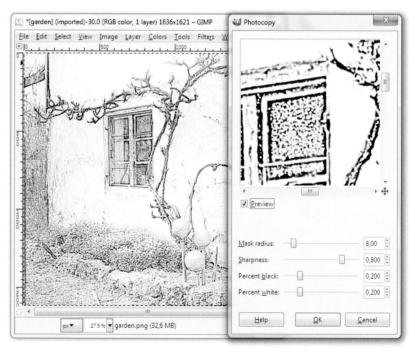

Figure 4.39
The window of the *Photocopy* filter (*Filter > Artistic > Photocopy*) with all the possible settings

Figure 4.40The *Pencil drawing from photo* Script-Fu dialog with the chosen settings and the outcome of applying it

Figure 4.41
The Script-Fu Quick sketch dialog, with the result after applying a value of 60.

4.5 "Hand-Colored" Images from Black-and-White Photos

The techniques described in the previous section taught you how to colorize segmented objects on separate layers in addition to colorizing entire images. To colorize distinct objects on separate layers, the basic steps normally involve the following: scanning a black-and-white image, duplicating the background layer (several times), selecting the area to be colorized on each layer, deleting the other image content, and applying the desired color to the remaining image content on the active layer. In the end, the layers must be stacked in the right order to properly render the finished image. This process allows you to apply several colors to images, and is similar to what you did with the *portrait*. *xcf* image in the previous exercise.

The steps necessary to complete the following exercise are quite repetitive. Furthermore, since they have been described in detail in the previous sections, I will just briefly outline the work involved.

- Open your extractinghair.xcf image. The rest of the work will be done
 using copies of the hair-extracted layer with the segmented hair. Save
 the image with a new name, such as portrait-colored.xcf, in your exercise
 folder.
- Rename the hair-extracted layer portrait-colored.

By copying the layers, you are successively creating new layers from the portrait-colored layer (right-click on the layers in the Layers dialog and select Duplicate Layer). In these new layers you will be selecting the appropriate sections. The unnecessary image contents will be deleted (Edit > Delete). Then the layers will be colored with the tonality correction options.

The first layer, which you create by duplicating, is the *portrait-hair* layer. Proceed as follows:

- Duplicate the portrait-colored layer.
- Rename the *new* layer *portrait-hair*.
- Select *Colors > Levels* and use the gray mid-tones slider to lighten the hair in the first step. Then create a dark-brown coloring of the layer by editing the image in the *Channel* mode. First edit the image with the *Red* channel, followed by the *Green* channel in the next step. Again, alter the image using mid-tones by moving the middle triangle in the histogram.
- Then correct contrast and brightness by using the Colors > Levels function.

The next layer is the *portrait-clothes* layer:

- Duplicate the portrait-colored layer.
- Give it the name portrait-clothes.
- Position it above the portrait-hair layer in the Layers dialog. Choose Colors
 Levels and move the mid-tones slider to lighten the clothes. Then use
 the Blue channel to apply dark blue color to the clothes and set the midtones for the channel.
- Use the Fuzzy Select tool (Magic Wand) to select the visible area of the clothes, and then use the Free Select tool (Lasso) to correct the holes in the selection. (Note: The back of the chair shows behind the left shoulder. The visible part extends from the top of the image to the hair curls on the shoulder.)
- Choose Select > Feather and set it to 8 pixels.
- Choose Select > Invert.
- Choose *Edit* > *Clear* to delete everything except the clothes.
- Then choose *Select > None* to close the selection.
- Finally, select *Colors > Levels* to correct the contrast and brightness.

Now create the *portrait-face* layer:

- Duplicate the portrait-colored layer.
- Rename the layer portrait-face.
- Position it above the portrait-clothes layer in the Layers dialog.
- Use the *Fuzzy Select* tool to select the face. Use the *Free Select* tool (*Lasso*) to remove areas from the selection that were not supposed to be selected.
- Choose Select > Feather and set it to 20 pixels.
- Choose Select > Invert.
- Delete all other contents except the face with the *Edit > Clear* menu item.
- Choose the Select > None menu item.
- Access the *Colors > Levels* menu and use the *Red* and *Green* channels, modifying the mid-tones, to color the face.
- Then choose *Colors > Brightness-Contrast* to correct or reduce the contrast and brightness.

Figure 4.42 without bottom line as decoration

Now we dedicate our attention to the details:

- Duplicate the portrait-colored layer.
- Rename the layer portrait-mouth.
- Position it above the *portrait-face* layer in the *Layers* dialog.
- Use the Free Select tool (Lasso) tool to select the mouth.
- Choose Select > Feather and set it to 8 pixels. Then invert the selection
 with the Select > Invert menu item.
- Delete everything except the mouth using Edit > Clear.
- Then choose Select > None to close the selection.
- Again, select the *Colors > Levels* menu and use the *Red* channel, modifying the mid-tones, to color the mouth.
- Choose the *Colors > Brightness-Contrast* menu item to correct the contrast and brightness of the mouth.
- What remains is to give the eyes a natural appearance. Return to the *portrait-face* layer.

Now use the Free Select tool to select the whites of the eyes and the pupils.

- Choose Select > Feather and set it to 5 pixels.
- Choose Colors > Desaturate.
- Choose Select > None.
- Use the *Ellipse* tool to select the pupil area.
- Then use the *Free Select* tool to remove accidentally selected areas from your selection.
- Choose Select > Feather and set it to 5 pixels.
- Choose Colors > Colorize to select a color for the pupils.
- Choose Select > None.
- Save your image.

Figures 4.43 and 4.44 Compare the original and the colored copy.

o far, we have worked exclusively with conventional file formats such as JPEG, PNG, TIFF, and GIMP's own native XCF. The following sections deal with the subject of capturing and processing RAW image files, the specifics of working with PDF files, and the process of reading and exporting to today's de facto layers format, PSD.

5.1 Opening and Processing RAW-Format "Digital Negatives"

5.1.1 Capturing and Processing RAW Image Files

In contrast to section 2.1.2 (Opening an Image) at the beginning of this book, the following sections will be of interest only to readers who own a camera capable of capturing RAW image files.

If you are taking pictures at dusk, at night, or with a flash, then JPEG is not the best format for good pictures. Photographs shot against the sun are problematic. Keep in mind that the JPEG format has a 24-bit color depth of (approximately 16.8 million colors). The results are images in true color. Nevertheless, the lossy compression of this file format saves file space by blending areas of similar color. This reduces the amount of information that needs to be stored. Thus, color information and details are lost.

To enssure optimal image quality, the manufacturers of digital single-lens reflex (SLR) cameras offer their own storage formats. Even some high-end bridge and compact cameras offer so-called RAW formats. If your camera offers a RAW format, you will find details in the manual and the settings in the camera's menu.

In general, these RAW data formats store the image data from the camera's sensor in the highest resolution without compression with a 48-bit color depth (about 2,815 quadrillion color shades). The size of the file is about three times as large as that of a JPEG with the same amount of pixels. The storage process takes considerably longer than it does for the JPEG format, which is why the RAW format is not suited for sports and wildlife photography, where fast consecutive series of photographs are taken. RAW images are often referred to as digital negatives. They first must be developed with the help of a suitable program and saved in another file format before they can be passed on for further editing. However, the results are usually worth the effort.

If your digital camera offers its own proprietary file format, such as its own RAW format, you should use it. The options for processing images, especially images taken during challenging light conditions (such as backlit photographs, pictures taken at dusk, etc.) are much better when the files are

saved in RAW format. You should also store images in this format as originals on your computer in order save them in high quality.

The Mac OS X and Linux file management utility can show preview images of RAW files. Windows can do this, but only after you install the corresponding **codecs. Microsoft** offers the codecs for several camera manufacturers on its website at www.microsoft.com/en-us/download/details. aspx?id=8802 (for Windows XP) and www.microsoft.com/en-us/download/details.aspx?id=26829. Similar raw codecs for the Windows operating system can also be downloaded from the **FastPictureViewer** website: www. fastpictureviewer.com/codecs. Another option is to look in the support section of the camera manufacturer's website or search the web for the name of your camera manufacturer combined with the word "codec."

5.1.2 GIMP and UFRaw

If you shoot in RAW format and wish to process your "digital negatives" with 16-bit technology instead of conventional 8-bit software, use a dedicated RAW converter such as **RawTherapee** or a program like UFRaw that works as a standalone or GIMP plug-in, as described in section 1.4.5. Once installed, **UFRaw** starts automatically when you open a RAW file from GIMP. This section goes into detail about the tools and options offered by UFRaw.

UFRaw can be used in three different ways. If it's used as a GIMP p lug-in, when you open a RAW file in GIMP, the UFRaw window will open automatically. You can then use the plug-in to set corrective options for color and brightness values.

Click OK on an open image in UFRaw to load it into GIMP. Then you can use GIMP's tools for corrections. However, the UFRaw program supports a color depth of 16 bits per color channel. This allows you to make detailed adjustments, whereas using GIMP's familiar tools limits the color depth to 8 bits per channel.

In addition, UFRaw can be used as a stand-alone program for developing digital negatives. During installation, the program creates a desktop icon or a *Start* menu entry on demand. With the UFRaw stand-alone, you can save images in the PPM, TIFF, and PNG file formats with 8-bit or 16-bit per channel color depth. The JPEG file format saves images at 8-bit per channel color depth. The example images in this section were produced with the UFRaw stand-alone.

UFRaw also offers a batch mode for the Linux platform. To obtain information about this feature, enter *man ufraw* or *ufraw—help* in the Linux console.

The main UFRaw window is designed so that the various working commands are displayed in the sequence in which they will be applied to the image. You can open an image in UFRaw and experiment with the options to see how they affect your image.

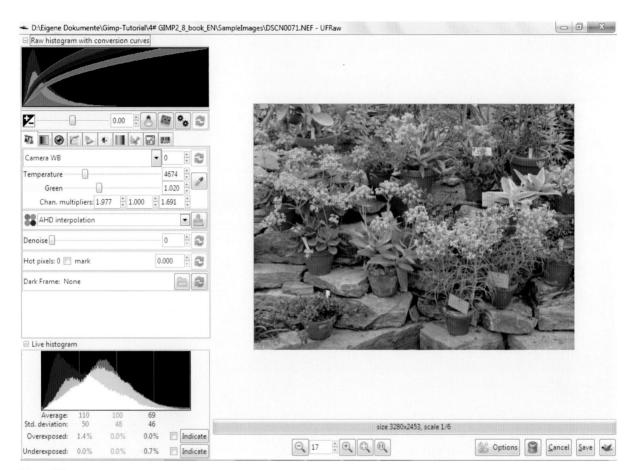

Figure 5.1

An unedited digital negative is open in the preview window. The left panes show color histograms and setting options.

• NOTE

During the preparation work for this book, we discovered that the UFRaw plug-in works fine with GIMP 2.8.0 but not with version 2.8.2. However, the standalone version can be installed and used in parallel with GIMP 2.8.2. We assume that the developers will address this issue and that a new version of UFRaw will be released soon.

This issue doesn't appear to affect RawTherapee, which can be set up to hand over processed digital negatives directly to GIMP.

In the next section, I will illustrate the development of a RAW image, a backlit photograph, and the steps necessary for editing the image with UFRaw before it's handed over to GIMP. Furthermore, I will introduce RawTherapee, a program resembling UFRaw for developing digital negatives yet with an additional range of functions and an ability to support a wider range of file formats.

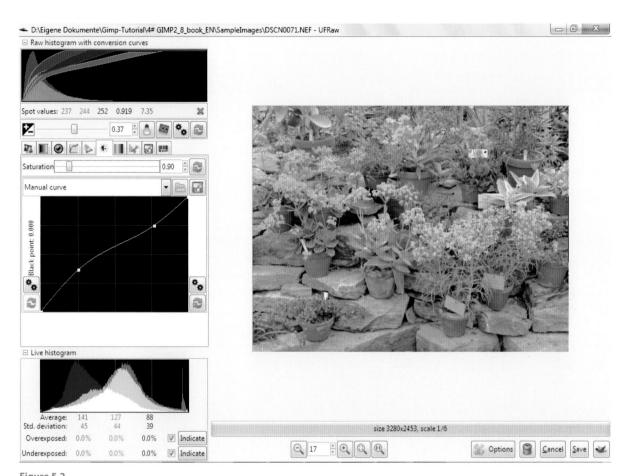

Figure 5.2
The edited image with minor color corrections. Note that the left pane reveals the slight changes that were made on the curve to correct luminosity and saturation.

5.1.3 Working with UFRaw

When you start the stand-alone version of UFRaw, you'll see the UFRaw window that you will use to open files. This window looks similar to the window in GIMP for opening an image using the *File > Open* menu option. Windows users may need some time to get accustomed to it because the window looks somewhat different from the *Open* window in standard Windows programs.

The window includes two panes. Double-click on the drive or main directory in the left pane, then in the right pane, and choose the directory in which you archived your image.

Above those panes in the *UFRaw* window, there are buttons that indicate the path in the directory. In case you get into the wrong directory, you can use those buttons to backtrack (figure 5.3).

In the pane on the right, you see the files that are in the directory you selected in the left pane. However, only the preselected file type is displayed in the drop-down menu at the bottom right. These are RAW images.

To the right of the windows are scrollbars to simplify the search in your directories. Unlike the window you use to open files in GIMP, the window in UFRaw does not have a third pane with a preview of the file you selected.

Select the image you want to open and then click the *Open* button, or simply double-click the filename. UFRaw's main window is activated and your image appears.

The window used to open images doesn't close automatically after you have chosen an image. You can minimize it later when you are opening more images. To close the window, you must click on the *X* on the upper-right corner or click the *Quit* button.

There are some functions in this window that can be guite useful:

- You can "bookmark" directories that you intend to use often by selecting
 the folder's name in the list in the left pane (before it is opened) and
 clicking the Add button.
- In the RAW Images drop-down menu, you can choose from the list of file formats that can be opened by UFRaw.

Figure 5.3The UFRaw window used to search for and open files. The *SampleImages* folder has been bookmarked.

5.1.4 Features and Elements of UFRaw's Main

Window

When you have an image open in UFRaw's main window, tabs with controls and functions appear on the left side of the window. The order in which the sliders and tabs are arranged suggests the order in which you should use them.

All the changes you make to the image appear on the right in real time. You can rotate your image with the *Crop and Rotate* tool, located in the eighth tab on the left side of the window. Most tabs have icons depicting the functions of the tools that are available, but some icons can be rather cryptic. Hover the mouse pointer over the icons to display tool tips, explanations, and descriptions of the functions (figure 5.4).

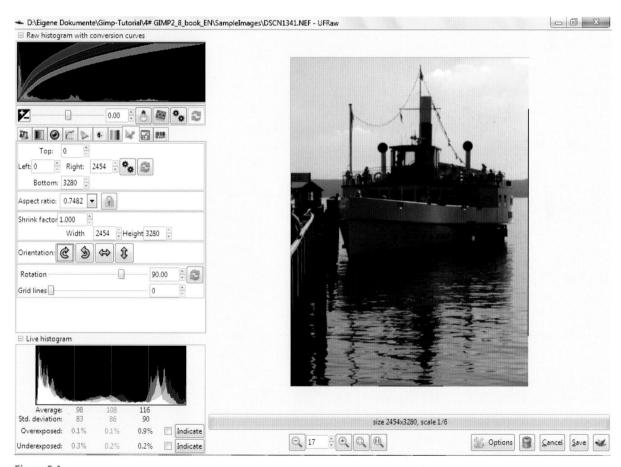

Figure 5.4
The UFRaw window with an open image. This is a backlit shot with the ship, the subject of the picture, in the shade. The image was rotated 90° with the *Crop and Rotate* tool on the left, and thereby turned right-side up.

Below the preview image there is a taskbar with options for enlarging the image, changing the defaults, and saving the image and passing it on to GIMP.

If you enlarge the preview image, you can use the scrollbars to move the picture detail around in the window. Once the preview image is enlarged, a crossed double arrow appears at the lower-right corner. Click it and hold down your left mouse button. A small preview image appears. Now you can slide around in this preview image with your mouse, thus moving the zoomed image area, the same way you can in GIMP (see section 2.1.5).

The RAW Color Histogram

The bent color curve in the upper-left corner of the window is the color histogram of the RAW image. It displays the luminosity, or the image brightness. The color curves beyond the histogram show how the RAW data will be converted on the finished image.

Right-clicking the RAW histogram opens a menu that allows you to choose whether to display a linear or logarithmic calculated diagram of the histogram curve. In my opinion, the linear curve is more meaningful.

Spot Values

You can measure the RGB values of a spot in your image by clicking on the spot to select it in the preview window (this can be done only when you are on the White Balance page, by selecting the first tab in the row of ten tabs, as shown in figure 5.5). The average RGB values are then shown in the Spot values display. The next value is the luminosity—the Y of the linear XYZ space (between 0 and 1). The last number is the Adams zone, another luminosity value.

Assuming that the RGB value 255-255-255 stands for the color white, you can, by using the luminosity values in the display, take the brightest value in the picture to set a manual white balance.

The first step in the workflow of image editing is usually to correct the exposure, and with it, its luminosity.

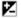

Exposure

You can digitally change the original photo exposure. In essence, you can select the luminosity, or brightness, of your picture by adjusting the Exposure compensation slider according to your own preference. Changing the luminosity of your exposure is rather simple. However, by changing the luminosity, you can also increase noise in the image (noise is the random appearance of colored pixels throughout the picture). Decreasing the exposure is a little problematic because the highlights (very bright regions) get clipped, a process that cannot be reversed. (If you want to increase the contrast, curtailing the shadow or highlights can result in the desired effect. On the other hand, clipping highlights too much can lead to overexposed and blotchy areas.)

When setting the exposure, you can control the way the highlight restoration is handled. To do this, use the bulb icon.

- The first setting (upside-down bulb; default) restores the highlights in the LCH space. This restores the luminosity while preserving the chrominance and hue. The results are soft, natural details in the highlights (symbolized in the bulb illuminating the object fully and directly from the top).
- The second setting (bulb lying on its side) restores highlights by using the HSV color space (Hue, Saturation, Value; Value stands for brightness). If you choose this setting, the value (which corresponds to luminosity) is taken as an average of the clipped and unclipped values. The results are sharp details in the highlights (symbolized by a bulb lighting the objects from the side).
- The third setting (scissors) clips the highlights completely and guarantees that there will be no artifacts when they are restored.

By applying the next setting, you can control the way in which the exposure is applied when you are highlighting an image. Notice that clicking this button changes the icon on it and thereby the setting.

- The first, default setting (the icon of a colored checkerboard resembles a camera chip) emulates the linear response of a digital camera sensor. Though it may be mathematically correct, the result may be contrast that is too harsh.
- The second setting (film) emulates the soft and balanced behavior of exposed film.
- Clicking the *Auto adjust exposure* icon will automatically correct the exposure settings. Since the correction is done prior to setting the color, the result is not very precise. Other functions in UFRaw also allow you to automatically set options, which will change the settings you have chosen here.
- Clicking the *Reset exposure to default* button resets the exposure to the program's default values.

You will notice that there is a reset button available for every option so that you can undo any changes and revert back to UFRaw's default values.

Be aware that the white balance setting behaves slightly differently if you select it manually (by selecting the appropriate point in the preview image). Rather than resetting the white balance to UFRaw's default values, this button resets the white balance to the value corresponding to the one that was loaded with the image.

For the example image, I raised the value of the exposure to 1.35 to correct the underexposed sections without bleaching out the sky too much.

Clicking the second button on the right of the *Exposure compensation* slider will show the status of the *Clip highlights for positive EV* option between *digital linear* and *soft film*. This way, I make sure the exposure has the balanced characteristics of developed analog film.

- NOTE

The three highlight restoration options play a role only when you are working with negative light values, hence when you are darkening an image.

• NOTE

UFRaw will "remember" any settings that you defined while editing an image; it will automatically apply those settings to the next image unless you click the *Reset* buttons to reset the option settings back to the program default before opening another image. More information on this topic can be found under *Options > Configuration*.

The remaining settings for RAW developing are grouped and can be opened in tabs. These ten tabs are positioned on the left in one row below the settings for exposure.

WB White Balance

UFRaw always adjusts white balance when developing RAW photos. The white balance settings control the ratio between the three color channels. UFRaw uses the white balance of the camera as a default if possible. If the image meets your expectations after the white balance has thus been adjusted automatically, you can forgo further adjustments and apply the default settings.

Figure 5.5
The image after setting the exposure and applying the white balance with the eyedropper

However, the white balance settings of cameras can often use some adjustment. Try some of the other settings that the drop-down menu at the top of the WB White Balance tab has to offer. You have the option of adjusting the white balance according to the camera default settings (Camera WB), by using automatic white balance (Auto WB), or by using manual white balance (Manual WB). Furthermore, you can use the Daylight, Incandescent (light bulbs), Fluorescent (neon light), Cloudy, Flash, and Shade presets.

The *Temperature* and *Green* slide controls and the eyedropper button (*spot white balance*) help with setting the white balance. You can set the color temperature of your image with *Temperature*, using higher values for warmer tones and lower values for cooler tones. The numbers to the right of the slide control describe the chosen value in Kelvin units. Kelvin degrees are is the standard units used to measure color temperature in photography. The *Temperature* adjustment controls the red and blue channels. However, adjusting the color temperature also influences the colors of the green channel. Therefore, the second slider, *Green*, offers a way to control and correct the green channel (green to magenta). As soon as you adjust the slider controls, the previously chosen white balance will be replaced by the *Manual WB*.

Spot White Balance

This function offers a simple way to correct colors if the image shows a color cast. Select the eyedropper and then click on an area in your image that ought to be white, neutral gray, or black. By holding down your left mouse button and dragging, you can enlarge your selection. Then click again on the eyedropper symbol. The colors in the image will be recalculated so that the selected point or area is white, gray, or black.

Through the selection of a white spot (or neutral gray spot), you tell the program what is to be considered white. This way you can remove a color tint in your image, assuming, of course, that you are able to discern white, gray, or black sections in the picture.

Interpolation

Interpolation defines how the image dots should be recalculated when you save the final image.

The default is *AHD interpolation*. It provides the best results but may enhance the noise in the photo.

VNG interpolation provides very good results.

VNG four-color interpolation should be used if you find Bayer pattern artifacts in your photo (for other disturbing patterns, see sections 2.2.3 and 2.2.10).

PPG interpolation is short for Patterned Pixel Grouping interpolation. This interpolation method is nearly as good as the previously mentioned methods, and it's much quicker.

Bilinear interpolation is a very basic interpolation method, but it is fast.

After interpolation, you can apply a color smoothing function by clicking on the brush icon. Color smoothing can help reduce color artifacts such as pixel noise and blemishes without losing any details.

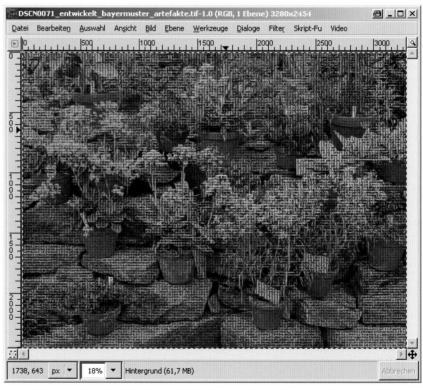

Figure 5.6An image that was saved and reloaded shows a disturbing colored grid pattern, commonly known as Bayer pattern artifacts

Wavelet Denoising

The *Denoise* slider controls the threshold value for wavelet denoising (i.e., the strength of the noise reduction applied to your image). The default setting, 0 (zero), doesn't reduce any noise. Be aware that the higher the setting, the more the image loses sharpness. Apply it only when necessary.

Hot Pixels

Hot pixels are individual pixels that show up brighter than they normally would due to excess environmental temperature or other external factors. Hot pixels often show up during long exposures or in images captured using high ISO values. This tool doesn't actually remove hot pixels, but instead applies a user-selected value to reduce brightness.

Dark Frame Subtraction

Many cameras apply dark frame subtraction for long exposures to reduce noise and remove so-called hot pixels. The disadvantage of this procedure is that it makes the exposure twice as long because the dark frame exposure time needs to be as long as the exposure time of the real image.

You can make your own dark frame by putting on the lens cover and taking a picture. However, you have to do this when taking the original shot, not afterwards. The camera sensor's temperature is a crucial factor responsible for the amount of noise. And of course, the file format (RAW) and the settings for ISO and exposure time ought to be the same as for the original photography. After copying the original and the dark frame to your hard disk, you can load the dark frame into UFRaw. Click the *Load dark frame* button (it looks like a folder) to open your dark picture. The option UFRaw offers is practical if your camera does not have the dark frame subtraction feature or if you decide to disable it to save time.

After having tried several of the white balance default settings, I used *Auto WB* as a basis and corrected it with the spot white balance eyedropper (figure 5.5). I set the value for *Temperature* to 5974 Kelvin and *Green* to 0.980. I left the interpolation method on AHD for the best image quality. With a mouse click I applied the button for color smoothing. To avoid reducing the sharpness too much, I refrained from denoising the image.

Grayscale

Since UFRaw 14.1, the program has offered the option of converting a picture into black and white. This option is deactivated as a default. If you are editing your image in color, you don't need to bother with the *Grayscale* settings.

However, if you want a black-and-white image, you can convert it in UFRaw. The program offers you options for automatic conversion with the following image characteristics: *Lightness* (controls the lightness of the colors), *Luminance* (controls the amount of light, brilliance), *Value* (controls the brightness of the image, luminance). In addition, you can use the *Channel Mixer* mode for manually developing your pictures according to your own preferences.

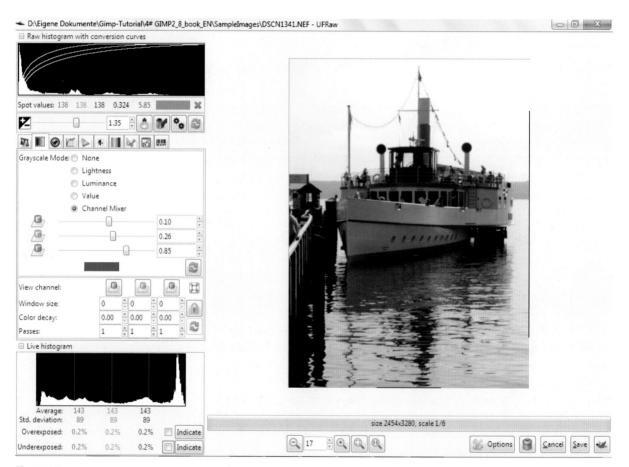

The UFRaw window when the *Grayscale* tab is selected. UFRaw offers boundless possibilities for developing photos as black-and-white images.

Lens Correction

Since the release of version 0.18, UFRaw has included the Lens correction tab with functionality for correcting chromatic aberrations, distortions, vignetting, and geometric errors caused by optical imperfections in camera lenses.

UFRaw first tries to determine which camera and lens were used to shoot the current image by reading its metadata. If that doesn't work, you can use the Search for camera using a pattern button or the Choose camera from complete list button to find the entry for your particular model.

The equivalent buttons next to the Lens box offer the same options for entering the lens type. If you are using a camera with a non-interchangeable lens, select Standard. The Automatically find lens and set lens correction button does exactly what its name suggests.

The Lens correction tool has four tabs for controlling each of its four main functions. These are (from left to right):

- 1. Lateral chromatic aberration (i.e., color smears at high-contrast edges)
- 2. *Vignetting* (i.e., dark image corners)
- Lens distortion (If you are in doubt as to which model to use, the PanoTools option usually produces great results for images with obvious barrel or pin-cushion distortion.)
- Lens geometry (for correcting partial unsharpness in individual image areas)

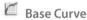

The Base curve tab includes brightness and contrast settings. It imitates the functionality of Nikon's tone curves, so if you are processing a native Nikon NEF RAW file, you can simply select the Camera curve option. This will display the tone curve embedded in the image if you activated the feature in your camera's firmware before shooting.

The Base curve drop-down menu offers you two choices to begin with: Linear curve or Manual curve. Linear curve corresponds to the image's existing settings. Manual curve lets you correct the brightness and contrast settings separately, using various brightness ranges (see section 2.3.2 on gradation curves).

If you click the lower area of the linear curve and drag it downward while pressing the left mouse button, you'll notice that the dark shades in the image become darker. Repeat the process for the upper area of the curve, dragging upward this time, and the bright colors become brighter. By experimenting, you can correct any brightness problems or just creatively play with the image. You can produce a color inversion of a photo negative by dragging both end points of the curve vertically. You can also create curves of your own and save them to reuse with your images by clicking the Save base curve icon (it looks like a disk).

The *Base curve* is applied directly to every color channel. You should apply it after you apply the exposure and white balance settings so that it affects each color channel equally. However, you should do this before the gamma correction so it affects only the linear data.

I use the *Base curve* function to bring light into dark areas of backlit photos and darken overexposed areas in photos to achieve more contrast. For best results, I place three dots on the linear, diagonal curve. First, I place the point at the bottom left. This section represents the shadows, the dark areas of the image. By holding the left mouse button and dragging the dot upward, I lighten up the dark regions in the photo, thereby altering the entire course of the curve. It shifts upward so that all colors become brighter. To counteract the brightening of the colors, I place the second dot in the middle of the curve and drag it back to the center. The middle tones now correspond to the initial setting again. Then I place one dot at the top right of the curve and drag it downward. This darkens the highlights and the bleached-out sky gains in contrast. One additional, last dot to correct the curve for the mid shadows and I'm done.

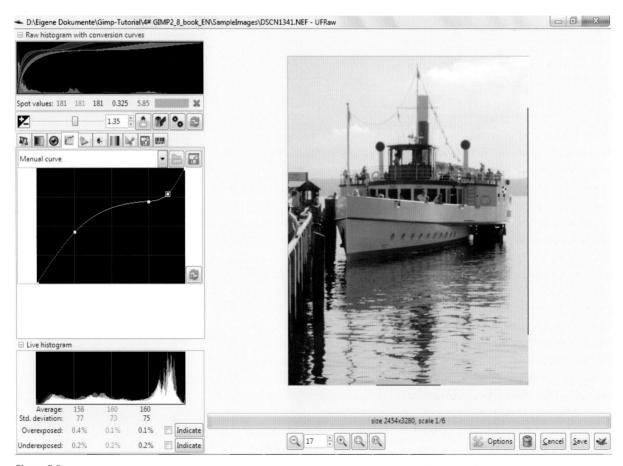

Figure 5.8
This backlit photo is brightened with the help of the base curve function. Simultaneously, the light areas are darkened. The overexposed sky gains in color and contrast.

-

Color Management Using Color Profiles

Color management, or color profiling, involves the color spaces of the different devices being used. The use of color profiles keeps the appearance of colors consistent between the various devices and programs when you're editing a picture.

For our purposes, sRGB is the standard color profile—it is essential for cameras and monitors. This is the only color profile UFRaw offers. Other color profiles, such as Adobe RGB (for printing purposes), can be found online. As soon as you save a color profile on your hard disk, you can load it into the program over the folder icon (next to the drop-down menu).

A click on one of the folder icons opens the *Load color profile* window. You can use it to search your computer for installed color profiles (ICC and ICM files). Under Windows Vista, you will find it in the Windows installation folder. On my computer, I found it at the following path: C:\Windows\System32\ spool\drivers\color. In the *System32* folder, I found subfolders (*Adobe* and *Color*) where color profiles are stored.

You can find information on color management on Udi Fuchs's website: ufraw.sourceforge.net/Colors.html. There you can find download information on color profiles for cameras and other devices. You can find the download link for the Adobe RGB color profile on Adobe's website: www.adobe.com/digitalimag/adobergb.html.

In UFRaw's program window, the first selection, the drop-down menu above (*Input ICC profile*), refers to the input device, in this case, that of your camera. If there isn't a color profile available for your camera, you can fall back on the sRGB color profile. Details on downloading various manufacturers' own color profiles can be found on Udi Fuchs's website.

As an alternative, you can choose *Color matrix* from the menu. When selected, this setting increases the color intensity, but some colors tend to become rather over- or underexposed.

The *Output ICC profile*, the second color profile that can be chosen, refers to the output, the result being your inkjet print or a print made by a lab. The default setting is sRGB. For an inkjet print, I recommend Adobe RGB, which is optimized for inkjet printers, having an extended color rendition compared to sRGB. It is better but not a must.

The third color profile, *Display ICC profile*, is the color profile of your monitor. However, color rendition with a calibrated monitor can be different than with the sRGB profile. That's why there is an option to choose the system default.

In the drop-down menus *Output intent* and *Display intent*, the selection *Perceptual* corresponds with the rendition on the screen. The other options are relevant for the printing process. In my own experience, the *Perceptual* option delivers very good results with inkjet prints and color prints from a lab.

Further settings on the *Color management* tab affect the appearance of the image more than the application of just one color profile alone.

I have already chosen the color profile for the input device (*Input ICC profile*) in the *Color matrix* menu, thereby increasing the color intensity. The *Gamma* slider controls the brightness of the midtones in the image. Lowering the value brightens the picture, while raising the value darkens it. I corrected the midtones with the *Base curve* setting, so I keep the default settings. The *Linearity* slider controls the contrast of the image. Higher values raise the contrast. For this example, I reduced the contrast slightly.

Correcting Luminosity and Saturation

The *Saturation* slider's default setting is 1, and moving it to the right increases the color saturation of your image while preserving both hue and brightness. Moving the slider to the left desaturates the image, reducing the colors until you have a pure black-and-white image (i.e., the setting has the value 0).

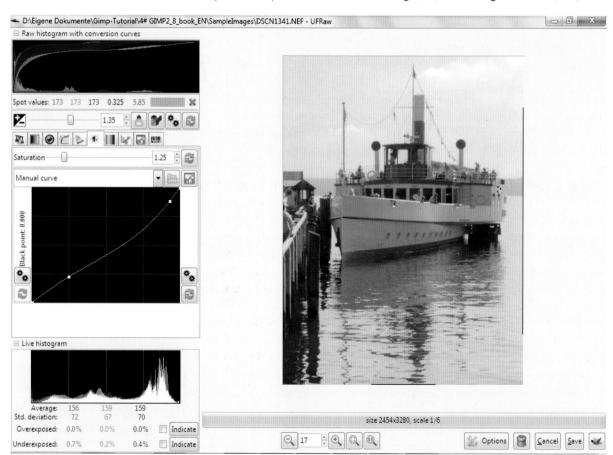

Figure 5.9
The Corrections settings increased the saturation, the shadows and highlights were darkened with the help of the curve function, and the midtones were brightened. The image now has fresh colors, without any over- or underexposed areas.

Like the curve in the Base curve tab, the curve in the *Correct Luminosity, Saturation* tab affects the lightness and contrast of an image, and can be handled in a similar way. The *Base curve* is designed for applying preset curves to an image, whereas you can use the *Correct Luminosity, Saturation* tool to fine-tune image contrast manually.

The settings left of the curve window control the black point. If your image seems foggy or washed out, you can try to correct the image by clicking the *Auto adjust black point* icon.

The Auto adjust curve (Flatten histogram) icon to the right creates a color histogram that flattens an image. The picture can gain immensely in contrast, but sometimes the result can appear artificial.

With the help of the curve *Corrections*, I correct and fine-tune the settings from the *Base curve*. I brightened the shadows a little while darkening the highlights by dragging the curve up or down in the appropriate places. However, I lifted the midtones to make the image appear brighter and fresher.

Saturation is an important setting. I raised the saturation a little in this example image from 1.00 to 1.25 to intensify the colors. However, I raised the saturation after correcting the curve, since this actually improves the colors.

Lightness Adjustments (Adapting Image Brightness)

The *Lightness Adjustments* tab is the last of the corrective functions available in UFRaw, and enables you to fine-tune the lightness of up to three colors.

But remember that color brightness is not the same as image brightness. The function doesn't brighten up the whole image, just the color you selected with the function's pipette.

To start, click the eyedropper symbol in the function's tab window. A new line with a slide control and three buttons shows up. The first is the *reset* button for this correction, the second is the *pipette* button to choose a color tone with, and the third (with the X) is a button to remove this adjustment and its effect from the image. After clicking the *pipette* button in this row, you can set a measure point in the preview window by clicking on the color you want to lighten in the image. You can adjust the lightness of the selected color in the image with the slide control. If the effect is not as desired, click the *reset* button, then click the *pipette* button again, and choose another color spot in the picture. Try the slide control again. By clicking on the button with the eyedropper symbol below, you can call up three separate adjustments for three colors.

Developing and correcting the image is now complete. The steps up to this point represent developing a RAW image. The actual editing begins after the handover to GIMP.

UFRaw does not offer a feature for sharpening images; you must use GIMP. Click on the icon with the GIMP mascot, Wilber, at the bottom right to shut down UFRaw and display the image in GIMP. You can, however, crop the image in FRaw before you hand it over to GIMP.

Click the *Save* tab if you want to save the image. The edited image will be stored as an 8-bit PPM file in the folder where you opened it. You can select the file format under the *Save* tab.

Figure 5.10

The edited and corrected image. Three different control points have been set to brighten up the gray tones and the red and blue colors. The effect is only slightly visible, but it's a real improvement.

Crop and Rotate

The functions under this tab provide the tools to crop, rotate, and shrink your images. You can also flip the image horizontally or vertically. I used it to turn the picture right-side up before starting the editing process.

You have the option of cropping your image by entering values. You can also crop your image by setting the margins. Click in the image and hold the left mouse button, then drag the frame to the desired position.

For aspect ratio, you can choose any of the presets or enter you own value in decimal notation (1.625) or as a ratio of two numbers (for example, 1:1.41) that represent your desired paper or photo format. You can crop the image without changing the aspect ratio by locking the aspect ratio values.

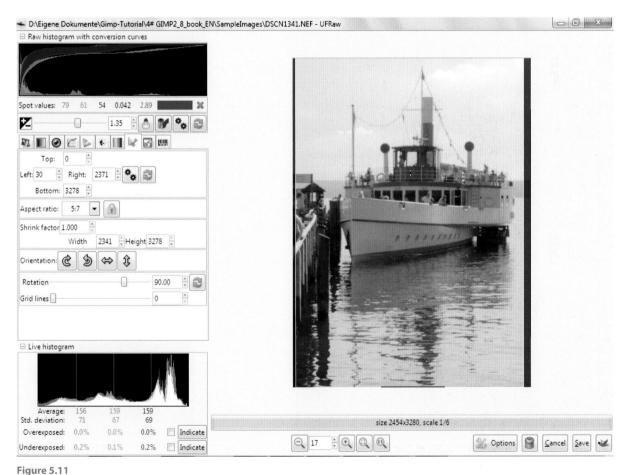

The image is set at an aspect ratio of 5:7. In the preview window, you can see black bars on the left and right that indicate where the image will be cropped. By clicking on the preview image, you can determine the section to be cropped.

Figure: 5.12The *Save* tab with the file type settings, filename, and path

You can reduce the size of your image by selecting an appropriate *Shrink factor*. The image does not need to be recalculated and image conversion is very fast.

All measurements are indicated in pixels. You can change the aspect ratio for the printer or for the lab, but the program does not let you adjust the setting to a specific size or resolution. You must use GIMP to edit the image size and resolution as well as the print size.

Saving Your Image

When you have finished editing an image, you can hand it over to GIMP. You can also save it as a stand-alone version directly out of UFRaw. The *Save* tab offers you the following options:

- Path—The path to the folder in which you want to save the file
- Filename—The name of the file
- File type or format—The format in which you want to save it: PPM, PNG,
 TIFF, or JPEG. Compared to earlier versions, you don't have the option of
 choosing the color depth (8 bits or 16 bits per channel). It is therefore
 assumed that PPM, PNG, and TIFF files can be saved with 48-bit color
 depth, but that JPEGs can only be saved as 8-bit files.
- The first three are high-quality formats. GIMP can read all these formats, but TIFF and PNG are the best options (high quality and widely used) for exporting into other programs.

If you want to save in JPEG, you can select the compression size. Leave it at the default setting of 83% or set it to the maximum level of 100%. You will find more on this topic in section 2.1.9. If you want to use the image for the web, choose the *JPEG progressive encoding* option (also known as "progressive mode").

When saving TIFF formats, you can choose the lossless LZW compression for reducing the file size—*TIFF lossless compress*. In any case, you should choose the option that embeds the camera's own EXIF data into JPEG and PNG files.

For Create ID file, you should select Also. UFRaw ID files have the same name as the output file but with a .ufraw filename extension. ID files contain all the settings for generating the output file. Choosing Create ID file Also is useful for keeping track of the setting used, or for making future changes on top of the saved settings. The only option is useful if you don't want to wait while the output file is being generated. The output file can be generated in the background using the command: ufraw-batch ID-FILE, although this particular approach will probably only work in a Linux environment. Save image defaults: Always means that the adjustments you have made to the current image will be saved as the default values for application to subsequent images. If you don't need the settings in the future, you can also select Never again. Select Just this once if you want to apply the setting on a case-by-case basis.

EXIF

Exchangeable Image File Format (EXIF) is a standard format used by digital cameras to store information about an image. The EXIF data includes the camera model, date and time the image was taken, ISO speed, shutter time, aperture, and focal length. You can find more information about EXIF data at en.wikipedia.org/wiki/Exif.

You can't change any of the settings that appear when you click the *EXIF* icon in UFRaw. You can only get basic EXIF data about the image. UFRaw can save the EXIF data only for the JPEG output for a few supported formats: Canon (CRW/CR2), Nikon (NEF), Pentax (PEF), Samsung (PEF), Sony (SR2, ARW), Minolta (MRW), Fuji (RAF) and Adobe's DNG.

If you are interested in editing the EXIF information for your image files after saving them on your hard drive, you should have a look at Phil Harvey's **ExifTool**. You can find more information at the following website: www.sno.phy.queensu.ca/~phil/exiftool (it includes a download for all three major operating systems).

Live Histogram

The histogram of the preview image is updated as the settings on the image are changed. You can right-click on the live histogram to set the curve's size and representation.

There are two modes in which you can control the exposure. Clicking the controls or buttons underneath the live histogram will show you the overexposed and underexposed pixels in the image.

Activate the check boxes by clicking them. The corresponding pixels will light up in the preview. Click each *Indicate* button to view the over- or underexposed pixels, respectively. The numerical values next to the controls indicate the amount of overexposure or underexposure per channel in percentages. These options provide you with objective guidelines to correct the exposure, always keeping an eye on the color combination and mood in the picture.

Options Under the Preview Window of UFRaw

Figure: 5.13
The options under the preview window of UFRaw

The Zoom Tool

This zoom setting allows you to zoom in and out of the image you are editing. This makes it easier to see details or get an overview of your image. Changing the zoom setting changes only the size of the image in the preview window, not its settings. The maximum zoom factor is 100%. That means one pixel of the image corresponds to one pixel of the monitor screen. This is the resolution needed to estimate the quality of the image.

The buttons with different magnifier icons represent the following zoom options:

When you click the Options button $^{\bigcirc Options}$, a dialog appears with the following tabs:

- Settings: The Settings option allows you to delete profiles and curves that you have previously loaded. The settings are not directly related to image editing.
- Configuration: This tab displays the configuration data that will be written on UFRaw's ID files and the resource file ending with the filename extension .ufrawrc. These are saved in the users home directory of the operating system, under Linux in home. By using the options on this tab, you can save the current configuration directly in the program. The data is only saved after you convert the image. Notice that if you press Cancel, the configuration data is not saved.
- Further information on these settings can be found on Udi Fuchs's website (ufraw.sourceforge.net/Guide.html) in the section "Taming UFRaw's configuration" on the User Guide page.
- Log: This tab includes technical information.
- About: This tab includes information about your version of UFRaw (i.e., the version number) as well as a link to the program's website.

Click the *Delete* button to open a window with the RAW file and all other files with the same name but a different filename extension. Here you can delete any files you might want to delete.

Cancel Cancel

Click this button to cancel any changes you have made without saving them.

Save

Click this button to save the current image using the settings you have selected in the *Save* tab.

Send image to GIMP

This button opens your image in GIMP, complete with any adjustments you have made using UFRaw.

5.1.5 RawTherapee for Developing RAW Images

Figure 5.14
The RawTherapee program window showing the File Browser view

GIMP developers recommend UFRaw for developing RAW images. It works as a plug-in to GIMP. UFRaw is integrated in distributions for Apple Macintosh.

Another easy-to-use, extensive, and free program for developing RAW photos is *RawTherapee*. It can be downloaded at www.rawtherapee.com and is available for Windows, Mac OS X, and Linux. RawTherapee is not a plug-in for GIMP. It's an independent program and a great alternative for developing RAW photos. Through an internal link, you can open your developed pictures in GIMP. Like UFRaw, RawTherapee is based on dcraw.

Unlike with UFRaw, you can open some other file formats in RawTherapee, such as JPEG, TIFF, and PNG. (UFRaw only supports RAW, RAW-JPEG, RAW-TIFF, and UFRaw ID files). Due to its large range of functions, the program is suitable for the most common steps in editing pictures, that is, white balance, shadows/highlights, sharpening, and noise reduction.

Figure 5.15
The program window showing the currently open image in its own tab

When you first start RawTherapee, it defaults to the *File Browser* tab. This view includes a thumbnail browser that you can use to select the images you wish to process. Double-click an image to open it for processing in the main program window.

Clicking the button marked in red in figure 5.14 opens the program's *Preferences* window.

The RawTherapee interface offers a wide range of functions and can appear somewhat confusing at first glance. Its high-end processing options include a number of tools that are not included in UFRaw, but which can be found in GIMP. RawTherapee also includes 16-bit image processing technology. The following overview offers an insight into a wide selection of options in RawTherapee

You can select your images in the *File Browser*, the left column of the program window. The program displays the images as thumbnails in the middle preview window. The size of the thumbnail preview images can be adjusted with the settings offered in the *Image Browser* section of the *Preferences* dialog, which you can open by clicking the button at the top right.

The preview window includes a *Navigator* window that displays an enlarged view of the currently selected detail outlined in red, and the *History* panel, which contains a list of your recent adjustments. You can use this feature to undo working steps of your editing. The central preview window shows the enlarged image and some tools for performing basic manipulations, such as rotating, straightening, and zooming the preview image. This real-time preview, displays the changes to your image as you make them. On the bottom of this window are buttons for saving the image or sending it to another editor (more about them shortly). The right column shows a histogram of your image.

The lower part of the right column contains the editing functions that can be accessed over several tabs:

- **Exposure** contains functions for adjusting the brightness of the image. You can correct brightness, contrast, and other values with the sliders of *Exposure*. You can apply several methods of *Highlight Recovery* and lighten shadows or darken highlights with *Shadows/Highlights*.
- **Detail** offers functions for sharpening an image and reducing noise.
- Color lets you adjust colors in the image. You have options for correcting
 the white balance and color temperature, changing the color with a channel
 mixer (see section 2.4.4), making color shifts and tonal adjustments with
 the HSV Equalizer, and applying ICM color profile settings.
- **Transform** lets you crop and resize the image, and correct vignetting and color fringing with the *Lens/Geometry* settings.
- **RAW** includes functionality for removing color casts (*Demosaicing* and *Raw White & Black Points*), for removing *Chromatic Aberrations*, and for reducing image noise (*Preprocessing and Dark Frame*).
- Metadata contains EXIF and IPTC information.

The buttons on the bottom of the preview window are as follows:

- Save Image: After editing, you can save the image in the TIFF and PNG formats with either 8 or 16 bits per channel. You can also save the image in JPEG with 8 bits per channel.
- Place image in queue: If you wish to process several images in one session without saving them in between, you can place them in the processing queue. Clicking the *Queue* button at the top of the *File Browser* window reveals a range of options for dealing with queued images.
- Edit current image in external editor: This button opens your image in the editor of your choice. If GIMP is installed, you will find GIMP as the default setting.

As I said, RawTherapee is a compact, autonomous program for the most common editing steps.

5.2 Using the PDF Format to Share Print Layouts

You already know how to use the *Text* tool, you have learned all about how to construct vector objects using paths, and you have used them to edit and save text-based documents. The best format to use for sharing such documents is Adobe's PDF (Portable Document Format), which is now the de facto standard format for sharing digital layouts online or via other electronic storage media. GIMP 2.8 is capable of opening existing PDFs and exporting documents that you have created or edited to the PDF format.

5.2.1 Opening PDF Files in GIMP

GIMP 2.8 is capable of processing existing PDFs and can also be used to save new documents to the PDF format. To import a PDF, use the *File* > *Open* command as described in section 2.1.2 and navigate to the location of the file you wish to edit. Clicking the *Open* button opens the *Import from PDF* dialog, where you can select the image attributes you wish to use to render your PDF in GIMP. Click the *Select All* button to import the entire document or enter a page range (for example, 3–5) or individual page numbers separated by commas (1, 2, 4, etc.) in the *Select range* box. You can also click the pages you wish to open in the preview window. Multiple pages can be selected by pressing the *Ctrl* key while selecting.

The *Open pages* as option lets you choose whether the pages are opened as layers in a single image or as multiple images.

The default import resolution is set to 100 pixels/in, but you can increase this value and alter the units manually in the *Resolution* box and the dropdown list next to it if you are preparing a document for printing.

Once you have made all of the necessary setting selections, click *Import* to open your PDF in GIMP.

GIMP can only open PDF content in the form of pixel data, which means you cannot edit imported text by using the *Text* tool. You can, however, insert additional text into the white space available in the document. You can overwrite existing text by filling the space with the document's background color and creating a new text element on top of it. All image elements can be edited and altered using the full range of GIMP tools described elsewhere, and you can add objects of your own to those already present.

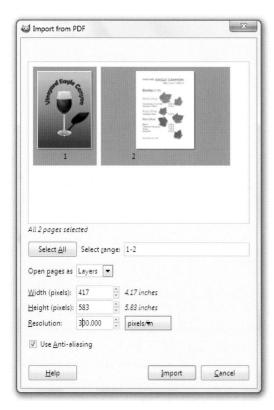

Figure 5.16
The Import from PDF window, showing the page selection and image attribute options

5.2.2 Using GIMP to Create PDFs

To create a PDF with GIMP, all you have to do is select the *File* > *Export* command and enter a filename with the *.pdf* extension before clicking the *Export* button.

The export process converts multiple layers, complete with layer masks and text, directly to PDF. All content (including text) is saved as pixel-based image data.

The exception to this rule occurs if you save a file that consists of just a single layer of text to PDF. In this case, the text will be saved with all its size, font, and color attributes as vector-based text. This means that text can be read and copied in appropriate software programs, such as Adobe's own Reader program.

Before exporting a document to PDF, you should consider its purpose and make appropriate settings. If your document is intended for sharing via the Internet and is only going to be viewed on a monitor, you can reduce resolution to the current standard monitor value of 96 dpi. This produces a smaller file that loads more quickly when it is accessed. In fact, 96 dpi is sufficient for producing adequate print quality too.

However, if you want to produce high-quality prints, you should increase resolution to at least 300 dpi, even if this means dealing with much larger files. See sections 2.1.7 and 2.1.8 for more details on adjusting image resolution.

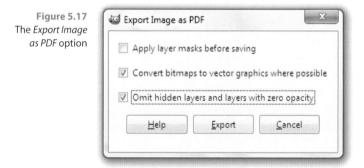

To help you get a feel for the PDF export process, we have included two files, winelist-cover.xcf and winelist-text.xcf, on the DVD for you to experiment with.

5.2.3 Free Alternative PDF Creation and Viewing Software

In the past, every program that could print a document was also capable of converting it to PDF by using a so-called PDF generator. Once installed, a PDF generator appears as an additional printer in the program's print dialog, although in this case, "printing" actually means "saving to PDF." Most PDF generators include their own settings dialog that appears as part of the host program's print dialog.

The most widely known PDF generator for Windows is the open source **PDFCreator** package, which can be downloaded from www.pdfforge.org.

- Download OpenOffice (for Windows, Mac OS X, and Linux): www.openoffice.org/download
- Download LibreOffice (for Windows, Mac OS X, and Linux): www.libreoffice.org/download
- Download PDF import Plug-in (for OpenOffice for Windows, Mac OS X, and Linux):
 - extensions.services.openoffice.org/en/node/874/releases

For LibreOffice version 3.5 and later, the PDF import plug-in is already part of the program, so there is no need to install it separately.

To round out this chapter, here is a list of free PDF readers. Some also work as browser plug-ins for direct web-based PDF viewing.

- Download Adobe Reader (for Windows, Mac OS X, and Linux; also available as a browser plug-in): get.adobe.com/reader
- Download Foxit Reader (for Windows and Linux; also available as a browser plug-in): www.foxitsoftware.com/Secure_PDF_Reader
- Download NitroPDFReader (for Windows; also available as a browser plug-in): www.nitroreader.com/download
- Information and download links for GSView (Ghostscript Viewer for Windows, Mac OS X, and Linux): pages.cs.wisc.edu/~ghost/gsview

Many of these programs include PDF creation functionality, and the **NitroPDFReader** even includes PDF editing tools.

• NOTE

With my home setup, I was able to save and print XCF files using PDFCreator from within GIMP, although the resulting files were purely pixel-based. For complex documents that contain text and images, I find that the OpenOffice and LibreOffice suites work better than most dedicated PDF generators. The word processing applications included in both suites make effective layout programs and all internal formats (Writer, Calc. Impress, etc.) can be saved directly to PDF. Text saved this way remains vector-based, making it possible to copy and even edit basic errors in the resulting PDF. Plug-ins for importing and editing PDFs are available for both suites.

• NOTE

Most commercial office packages (for example, Microsoft Office 2007 and later) can also save documents to the PDF format.

5.3 PSD Files

GIMP's native XCF file format is capable of saving sophisticated document features such as layer groups and layer masks, but is still a fairly unusual format that hardly any other programs can read. Adobe's PSD format is today's de facto standard for saving layer-based documents, and GIMP can read and export to PSD. The table below details the document attributes that are transferred or retained when using GIMP to view and process PSD files.

5.3.1 Opening Adobe PSD Files in GIMP

PSD Attribute	In GIMP
Guides	Retained
Pixel-based layers	Retained
Layer names	Retained
Layer masks	Retained
Saved selections	Retained
Paths	Retained
Layer opacity	Retained
Hidden layers	Remain hidden
Layer groups	Retained
Text layers	Get rasterized
Vector shapes	Get rasterized
Smart Filters	Get rasterized
In-image selection	Not retained
Layer mode	Not retained
Smart Objects	Not retained
Layer styles	Not retained
Adjustment layers	Not retained
Saved to RGB (24-bit)	Image and layers can be opened in GIMP
Saved to RGB (48-bit)	Image merged to a single background layer and reduced to 24-bit color depth by GIMP
Saved to CMYK 32-bit TIFF, merged to a single layer	Image opened in RGB mode in GIMP
Saved to CMYK 32-bit with layers, non-TIFF format	Cannot be opened in GIMP

5.3.2 PSD Files Exported from GIMP and Opened in Photoshop

GIMP PSD Attribute	In Photoshop
Guides	Retained
Pixel-based layers	Retained
Layer names	Retained
Layer masks	Retained
Saved selections	Retained
Layer opacity	Retained
Hidden layers	Remain hidden
Text layers	Get rasterized
Layer groups	Merged to a single layer
In-image selection	Not retained
Paths	Not retained
Layer mode	Not retained
Saved to RGB with a maximum of 24-bit color depth	Color depth and color mode can be appropriately adjusted in Photoshop

Appendix

A.1 The IWarp Filter— a Closing Comment

s compensation for all the hard work, I would like introduce you to something more cheerful. Take a look at the *IWarp* filter (*Filters* > *Distorts* > *IWarp*).

The filter allows you to deform an image interactively by using the *Settings* options. This procedure is also known as *morphing*. It is not only used for fun; It's the type of tool that is used for "beauty enhancement" in magazines and advertising.

You could animate an image you've modified with the *IWarp* filter. Therefore, you should save finished images with layers in the XCF format if you use the *Image > Mode > Indexed* command to save a file as an animated GIF. Check out the *autor-iwarped.gif* file in the *SampleImages* folder on the DVD.

Using the filter is easy. Select the desired deformation attributes and settings in the filter's dialog. By clicking on the preview image and dragging with the cursor, you can interactively deform the image. Enjoy!

Figure A.1
The author, warped

A.2 So Far, So Good—How to Proceed from Here: Tips and References

Congratulations! You made it through the tutorial. You've learned all the basic techniques for touching up and editing digital photos and images. Now you're acquainted with the most important tools necessary for producing composites from image elements. You should have a fairly good idea of how to create your own image and text elements and insert them into an image.

If you are looking for further suggestions and assistance in working with GIMP, you can find tutorials as well as pages with tips and tricks for digital image editing on the web. Have a look at www.gimp.org/tutorials and www.gimptalk.com. On www.gimp.org/links, you will find many links and tutorials to help you get started. And gug.criticalhit.dk/?page=tutorials is a great website from the GIMP User Group (GUG) with many amazing tutorials. Another website offering video tutorials on GIMP is meetthegimp.org. You can also search the web for video tutorials (search for "gimp" and "video").

A.3 The Future of GIMP

GIMP was created by a group of independent, noncommercial programmers and is continuously being developed further. In January 2004, GIMP 2.0 was released, followed by version 2.2 in December of the same year. GIMP 2.4 appeared in October 2007, followed by version 2.6 a year later in October 2008. GIMP 2.8 was released in May 2012. The program's developers are already considering the ins and outs of GIMP 2.10, which will include image-processing technology for bit depths beyond 8-bit. There is a roadmap of the prospective changes in GIMP 2.10 and 3.0 at wiki.gimp.org/index.php/Roadmap.

If you are interested in the changes the developers are currently working on, take a look at the following blogs and forums:

old.nabble.com/Gimp-Developer-f85.html developer.gimp.org www.chromecode.com (GIMP developer Martin Nordholts's blog)

A.3.1 Downloading and Installing Developer's Versions of GIMP

Information on the latest development versions can always be found at www. gimp-org. For Linux users, the program is available only as source code, so if Open Source is your OS of choice, you will have to compile the application yourself. RPMs and other installation packages are not available. Developer's versions are sporadically available for Windows (*-setup.exe). Linux and Windows users can find the source code or setup binaries on the SourceForge website: sourceforge.net/projects/gimp-win

When installing a GIMP developer's version, you should bear in mind that if you have a current GIMP version installed and want to continue using it, you have to change the file path when installing the developer's version. For Windows, instead of the default path C:\Program Files\GIMP 2\, apply the path C:\Program Files\GIMP-2.9 when installing the developer's version.

At any rate, it isn't easy to get the developer's version to run. It's possible that only one version will run. Any changes to the operating system could have an impact on the functionality of your entire computer. If you want to use the developer's version, you should definitely make backups of your hard disk, including the operating system and your installed programs. This author, as well as the developers themselves, denies all responsibility in the case of damage caused to your computer or installed programs through the installation of the developer's version, even if you have followed the directions given here.

A.4 Thank You!

This is the fourth extended edition of my book in English. First, I'd like to say thank you to my translator, Mr. Jeremy Cloot. I think he did quite a job of de-Germanizing this book, especially breaking up my German tapeworm sentences, thus making it readable to my English-speaking readers. And another big thank you goes to my copy editor for her great work on "debugging" this book. My thanks for the ongoing constructive collaboration go to all at Rocky Nook and dpunkt.verlag, especially to Mr. Matthias Rossmanith, who managed all and everything. I owe it to them that the book has been published in English. Last but not least, thank you to those developing GIMP for creating and offering a free image editing program that is reliable, powerful, and fun to work with.

A.5 Further Reading on GIMP: References

This book presents a comprehensive overview of GIMP's image processing and creative graphic capabilities. Go to www.amazon.com and search for "GIMP 2.8" in the Books section for an overview of other currently available literature. Also check out www.gimp.org/books.

A.6 What's on the DVD

First of all, you will find this book in PDF format (Goelker_GIMP2_8ebook.pdf) on the DVD. You may want to copy it to your computer so that you can quickly search for specific topics. The DVD also contains a folder named SampleImages where you'll find master copies of all images used in this book. You can use them to practice the exercises found in the tutorial. You will also find the finished images from most exercises in the FinishedImages folder so that you can compare your work.

In addition, the DVD includes the GIMP installation files for three operating systems: Windows, Linux, and Mac OS. To download more recent program versions or installation files, it is recommended that you visit the websites listed in this book. You can access them directly from the LinkList on the DVD.

Windows users will find all files necessary for installing GIMP version 2.8 on the DVD, including various helper programs and plug-ins and the RAW developer UFRaw. Linux users will find the GIMP source code for version 2.8.2.

Users of Mac OS versions 10.5 and 10.4 (for both Intel and Power PC Macs) will find the installation file for GIMP version 2.6.11, which still needs X11 or XQuartz installed. Users of versions 10.6, 10.7, and 10.8 (all Intel) will find native installers of GIMP 2.8.2, no XQuartz needed. The disc images already have UFRaw installed. The help function has to be installed separately.

GIMP is open-source software that can be distributed for free under the condition that the development software, or source code, is included in the distribution. You don't have to install the source code unless you're a Linux user or you want to further develop or reprogram the software. The source code is not required to work with GIMP.

Open-source software is distributed under the GPL license, excluding all warranties. Be aware of the fact that neither the author nor the publishing company provides a warranty for the software shipped with this book, nor do they guarantee that it will operate without problems on your computer.

The DVD includes the **IrfanView** freeware program for Windows. IrfanView is a free image viewer that does much more than view images. There are also 32-bit and 64-bit Windows and Mac versions of **XnView**, a free digital asset management tool for non-commercial use, and we have included Windows and Mac versions of **RawTherapee** as either an addition or an alternative to UFRaw.

For those interested, the free basic version of **FDRTools** for Windows and Mac OS X is included on the DVD, as is the **Luminance HDR** open source HDR processing package. You will also find the open source software **Hugin** for stitching panoramic pictures in both Windows and Mac environments.

Furthermore, you will find several other programs for managing your images, creating HDR images, and calibrating your monitor under Windows. The collection of programs is supplemented with the currently available versions of GIMP hacks as well as a collection of interesting plug-ins, Script-Fus, and GIMP themes.

Some of the files on the DVD, as well as most of the files available for download on the Internet, are compressed ZIP archives. To unpack or decompress such a file, you will need a piece of software or shareware, like the popular **WinZip** (www.winzip.com) for Windows or **Stufflt** for Mac OS, Linux, and Windows (www.stuffit.com). You will find the freeware programs **7-Zip** (Windows), **p7zip** (Linux), and **eZ7zip** (Mac OS) on the DVD, all of which can be used to unpack files.

To view the PDF version of this book from the DVD, you'll need a PDF viewer such as **Adobe Reader** (www.adobe.de/products/acrobat/readstep2. html), which is available for all three operating systems, or **GSView** (pages. cs.wisc.edu/~qhost/gsview) for Windows or Linux.

The DVD also provides the following files and directories:

- **FinishedImages**: This folder contains all images that have been used as examples in the photo sections of the book as reference. For the most part, the images contain the layers too.
- SampleImages: This folder, the subfolder Gardapanorama, and the subfolder Exposure Bracketing contain the images used in the workshop exercises in the book. (All images copyright by Klaus Goelker except for miami.tif, copyright by Julius Seidl, and moon.png, courtesy of NASA.)
- Programs: The subfolders contain all programs necessary for installing GIMP under Windows, Linux, and Mac OS X. Moreover, you will find plugins and additional auxiliary programs such as the programs mentioned earlier. Look up information quickly (Goelker_GIMP2_8ebook.pdf).
- **LinkList**: This html file contains the web addresses mentioned in the book. The file opens in your browser. Click on the links to visit the websites.
- Installation references and link lists for the installation of GIMP on Mac OS X (GIMP InstallationOnMacOS.html).
- E-book versions of the book (in screen size) lets you look up and find information quickly (*Goelker_GIMP2_8ebook.pdf*).

A.7 Native GIMP File Formats

Note: Since the release of version 2.6, GIMP has been able to save animations in MNG format, a format derived from PNG for animations for the Internet. However, most browsers, with the notable exception of Konqueror, don't support this format yet, or support it only when you have installed an additional plug-in.

File Type	Filename Extension	Open	Save
Alias Wavefront Pix image	*.pix, *.matte, *.mask, *.alpha, *.als	Yes	Yes
Autodesk FLIC animation	*.fli, *.flc	Yes	Yes
BMP—Windows bitmap	*.bmp	Yes	Yes
Bzip archive	*.xcf.bz2, *.bz2, *.xcfbz2	Yes	Yes
C header file	*.h	No	Yes
C source code	*.c	No	Yes
DICOM image	*.dcm, *.dicom	Yes	Yes
Encapsulated PostScript	*.eps	Yes	Yes
FITS—Flexible Image Transport System	*.fit, *.fits	Yes	Yes
G3 fax image	*.g3	Yes	No
GIF—Graphics Interchange Format	*.gif	Yes	Yes
GIMP Brush	*.gbr, *.gpb	Yes	Yes
GIMP Brush (animated)	*gih	Yes	Yes
GIMP Pattern	*.pat	Yes	Yes
GIMP XCF image	*.xcf	Yes layer-enabled	Yes layer-enabled
Gzip archive	*.xcf.gz, *.gz, *.xcfgz	Yes	Yes
HTML formatted table	html, htm	No	Yes
JPEG—Joint Photographic Experts Group	*.jpeg, *.jpg, *.jpe	Yes	Yes
KISS CEL	*.cel	Yes	Yes
Microsoft Windows icon	*.ico	Yes	Yes

File Type	Filename Extension	Open	Save
Windows Metafile	*.wmf, *.apm	Yes	No
MNG animation	*.mng	No	Yes
PBM image	*.pbm	No	Yes
PDF—Portable Document Format	*.pdf	Yes	Yes
PGM image	*.pgm	No	Yes
PNG—Portable Network Graphics	*.png	Yes	Yes
PNM—Portable AnJmap	*.pnm, *.ppm, *.pgm, *.pbm	Yes	Yes only *.pnm
PPM image	*.ppm	No	Yes
PS—PostScript	*.ps	Yes	Yes
PSD—Photoshop Document	*.psd	Yes layer-enabled	Yes layer-enabled
PSP—Paint Shop Pro	*.psp, *.tub, *.pspimage	Yes	No
SGI—Silicon Graphics IRIS	*.sgi, *.rgb, * bw, *.icon	Yes	Yes
Sunras—Sun Rasterfile	*.im1, *.im8, *.im24, *.im32, *.rs, *.ras	Yes	Yes
SVG—Scalable Vector Graphics	*.svg	Yes	No
TGA—Targa bitmap	*.tga, *.vda, *.icb, *.vst	Yes	Yes
TIFF—Tagged Image File Format	*.tif, *.tiff	Yes	Yes
XBM—X BitMap	*.xbm, *.icon, *.bitmap	Yes	Yes
XPM—X Pixmap	*.xpm	Yes	Yes
XWD—X Window Dump	*.xwd	Yes	Yes
ZSoft PCX image	*.pcx, *.pcc	Yes	Yes

If used with UFRaw, GIMP supports or can read the following RAW camera formats:

- Adobe Digital Negative: *.dng
- Canon RAW: *.crw, *.cr2
- Casio RAW: *.bay
- Contax RAW: *.raw
- Epson RAW: *.erf
- Fuji RAW: *.raf
- Hasselblad RAW (3F RAW): *.3fr
- Kodak RAW: *.dcr, *. k25, *.kdc (for EasyShare P850)
- Leaf RAW: *mos
- Leica RAW: *.raw
- · Mamiya RAW: *.mef
- Minolta RAW: *.mrw, *.mdc
- · Nikon RAW: *.nef
- NuCore RAW: *.bmg, *.raw
- · Olympus RAW:*.orf
- Panasonic RAW: *.raw, *.rw2
- Pentax RAW: *.pef
- Phase One RAW: *.tif
- Rollei d530flex: *.rdc
- Sigma RAW: *.x3f
- Sony RAW: *.sr2, *.srf, *.arw (for Sony DSLR c cameras)
- Sinar CaptureShop RAW for Macintosh:*.cs1, *.sti

A list of supported cameras can be found at http://ufraw.sourceforge.net/ Cameras.html.

It can also read the following RAW formats for software programs:

- DesignCAD: *.dc2 (CAD files)
- PrintMaster Gold: *.fff (image file)
- UFRaw-RAW: *.ufraw (UFRaw settings file)

And the following file formats:

- Cine
- HDR
- IA
- JPEG
- KC2
- PXN
- QTK

Index

Channels Dialog 316

A Add Alpha Channel 172 Cinepaint 32 Adobe Photoshop 131 Clone Tool 53, 127, 131, 133 Adobe Reader 367 CMYK 15, 320 Airbrush Tool 53 codecs 339 aliasing 11 collages 332 Alignment Tool 52, 253 Color Area 53 Alpha Channel 172 Color Balance 125 Alpha to Selection 172 color cast 120, 125 color channel 123 color depth 13 coloring 322 B Colorize Function 322 background 172 color management 85, 353 backlit photographs 110 color model 12 batch processing 26 Color Picker 52, 192, 326 bitmap 9 color profile 83 black-and-white images 296 compression artifacts 118 Blend Tool 53, 200 context menu 65 Blur/Sharpen Tool 53, 137 converging verticals 177 **BMP** 18 copy 267, 268 books 375 Create Template 82 brushes 127, 128 crop 357 brush pointers 127, 128 cropping 72, 73, 100 Bucket Fill Tool 53, 196 Crop Tool 52, 72, 100 bzip archive format 81 cross-fading 258 Curve 351 Curves 106 (Curves function 325 calibrating 83, 84 canvas 73 canvas size 73, 262 D card reader 23 decomposing 316 Change Foreground/Background color 53 denoising 349 Change Foreground Color 195 desaturate 297 Channel 323 Despeckle filter 141 Channel Mixer 298 digiKam 23 channels 315 digital negatives 338

dithering 302 Filter **DNG** 19 Add Bevel 216 dock 41 Apply Canvas 151 Document History 63 Colorify 326 Dodge/Burn Tool 53 Colorize 326 drivers 86 Curve Bend 181 drop shadow 216, 239 Despeckle 141 Duplicate Layer 170 Difference Clouds 197 dust 126 Gaussian Blur 101 Gradient Map 205 HSV Noise 149 Infrared Simulation 306 E Warp 372 editing 94 Layer Effects 219 editing images 60 Lens Distortion 181 Ellipse Select tool 52, 157 Lens Flare 246, 248 Eraser Tool 53 NL 145 Exchangeable Image Format (EXIF) 359 Oilify 150 EXIF 359 Old Photo 329 Export 82 Pencil drawing from photo 329 exporting to JPEG 117 Photocopy 329 export PDF 366 Pixelize 152 export PSD 369 Quick sketch 329 exposure 344 Red Eye Removal 164 exposure bracketing 284 RGB Noise 149 eyedroppers 123 Selective Gaussian Blur 102, 143 Sharpen 117, 138 Sparkle 248 Spread 150 feather 160 Supernova 209 file browser 26 Unsharp Mask 138 file format 16,378 Filters menu 136 file manager 64 flatbed scanner 90 fill with BG Color 162 Flip Tool 53 Film Grain 148 fonts 211 Foreground Select Tool 52, 157 Four-color printing 12, 15 frames 220 Free Select Tool 52, 157, 234 Fuzzy Select Tool 52, 157

G	900
GAP 6, 31	image Size 74
Gaussian Blur 101	image viewers 26
GEGL 300	Image View Size 69
GEGL Operation 300	image window 65
GhostScript 31	import 20
GIF 18	import layers 206
GIMP 6, 31	indexed 12, 14
GIMP 2.8 374	indexed colors 302
GIMP Animation Package (GAP) 6, 31	Infrared 306
GimPhoto 32	infrared effects 307
GIMPshop 32	infrared photography 306
GIMP user manual 31	InkTool 53
glazing technique 229	inserting layers 173
gPhoto 23	installing GIMP Plug-ins 37
gradient 200	installing the GIMP 34
grain 308	interpolation 348
grayscale 12, 227, 296, 310, 322, 350	IrfanViewer 26
guides 66	
Gutenprint 86	
gzip archive format 81	J
	JPEG 116
	JPG/JPEG 17
Н	Jr d/Jr Ed T/
hand colored 332	
handles 241	K
Hardness 131	Krita 32
HDR 284	
Healing Tool 53, 136	
help 54	
Help Function 54	layer masks 289
hexadecimal numbers 14	layer mode 174, 270
high dynamic range (HDR) 284	
Histogram 103, 344, 359	Layers 16 , 166 Layers dialog 166, 168, 174
HSV Noise 149	Layers dialog 100, 100, 174 Layers dialog context menu 170
Hue 112	,
Hue-Saturation 112, 232	lens correction 351
	lens distortion 181
	Levels 103, 121, 310
	Levels function 323
	lightness 355
	lightness 112, 355

luminosity 354

M marching ants 156 mask 156, 312 layer mask 289 painting a mask 278 mask mode 156 Measure Tool 52, 98 measuring 98 Menu Colors 114, 310 Edit 161 Select 159 menu bar 65 mode 174, 270 moiré effect 91, 97, 101 monitor settings 83 monospace 211 morphing 372

Move Tool 52, 157, 199

N

Navigate the image display 66 navigation window 71 negative 107 new image 226 New Layer 170 NL Filter 145 noise reduction 141 non-destructive editing 289

0

Oilify 150
opacity 167, 169
open 60
Open as Layers 62
open files 341
Open Location 63
Open PDF 364
Open PSD 368
Open Recent 63
operating system 20
optimize 118
options 360
overexposed 174

P

Paintbrush Tool 53, 229 panoramic images 262 partial desaturation 305 Paste 162, 267 path from text 251 Paths Dialog 243 Paths Tool 52, 157, 239 pattern 223 PDF 364 PDF generator 367 PDF programs 367 PDF reader 367 Pencil Tool 53 Perspective Clone Tool 53, 184 perspective corrections 181 Perspective Tool 52, 179 pixel 9 plug-ins 37 PNG 17 Polygon Lasso. see Free Select tool printing 26,86 print size 76 PSD 16, 368

Q

Quick Mask 258

R

RAW 27, 338

RawTherapee 29, 339, 361

Rectangle Select Tool 52, 157

Red Eyes 163

resolution 10, 11, 74, 76, 92

retouch 120

Revert 81

RGB 12

RGB Mode 310

RGB Noise 149

rotate 68, 357

Rotate Tool 52, 99

rotating 99

rulers 66

S

Sample Colorize function 328

SANE 89

sans-serif 211

Saturation 112, 354

Save 80, 358

Save a Copy 81

Save as 80

saving 78

saving for the Internet 116

scale 208

Scale Image 76

Scale Layer 171

Scale Tool 52

scaling factor 93

Scanner Access Now Easy (SANE) 89

scanning 89, 94

Scissors Select Tool 52, 157

scratches 126

Script-Fu

Eg-InfraredSimulation.scm 306

elsamuco-grain 308

Script-Fus 136

Script-Fus. see Plug-ins

select by Color Tool 52, 157, 189

selection 156

selective Gaussian Blur 102, 143

Select Tools 157, 158

serif 211

Shadows - Hightlights 110

Sharpen 138

sharpening 137

Shear Tool 52, 243

shrink 357

Single-Window Mode 67

size 10, 76

slide scanners 90

Smudge Tool 53

solarization 111

Spread filter 150

sRGB 86

status bar 66

Stroke Selection 162

T

text 211

text along path 249

Text Tool 53, 212

threshold 311

TIF/TIFF 19

title bar 65

Toggle QuickMask 156

tonality correction 121

Tool

Paintbrush Tool 229

Toolbox 51

tool options 180, 189, 193, 196, 199, 204

Tool Options Blend Tool 204 Bucket Fill Tool 196 Color Picker 193 Move Tool 199 Paintbrush Tool 229 Select tools 189 Transform Tools 180 Tools

Alignment Tool 253 Blend Tool 200 Bucket Fill Tool 196 Clone Tool 127, 133 Color Picker Tool 192 Crop Tool 72 Ellipse Select tool 157 Foreground Select tool 157 Free Select tool 157 Fuzzy Select tool 157 Healing Tool 136 Measure Tool 98 Move Tool 157, 199 Paths Tool 157, 239 Perspective Clone Tool 184 Perspective Tool 178, 179 Rectangle Select tool 157 Rotate Tool 99 Scissors Select tool 157 Select by Color Tool 157, 189 Shear tool 243 Text Tool 212 Zoom Tool 69 tools overview 51 touchup 120, 126 transforming a selection 228

U

UFRaw 28, 339, 341, 343 underexposed 176 undo 49 Undo History 135, 162 Unsharp Mask 138 user manual 54

V

vector graphics 10 vignette 181, 220, 225

W

White Balance 346 window 41 Windows Explorer 64 wizard 21

X XCF 16, 368 XnView 26 XSane 89

Zzoom 69, 360
Zoom Tool 52, 69